AMISH QUILTS

Young Center Books in Anabaptist & Pietist Studies

Donald B. Kraybill, *Series Editor*

AMISH QUILTS

CRAFTING AN AMERICAN ICON

JANNEKEN SMUCKER

THE JOHNS HOPKINS UNIVERSITY PRESS

BALTIMORE

This book has been brought to publication with the generous assistance of the
Coby Foundation, Ltd., *Coby* and the Robert & Ardis James Foundation.

The Johns Hopkins University Press
2715 North Charles Street
Baltimore, Maryland 21218-4363
www.press.jhu.edu

Library of Congress Cataloging-in-Publication Data

Smucker, Janneken.
Amish quilts : crafting an American icon / Janneken Smucker.
pages cm. — (Young Center books in Anabaptist & Pietist studies)
Includes bibliographical references and index.
ISBN 978-1-4214-1053-1 (hardcover : alk. paper) — ISBN 978-1-4214-1054-8 (electronic) —
ISBN 1-4214-1053-2 (hardcover : alk. paper) — ISBN 1-4214-1054-0 (electronic)
 1. Amish quilts. I. Title.
 NK9112.S625 2013
 746.46088'28973—dc23

 2012047088

A catalog record for this book is available from the British Library.

*Special discounts are available for bulk purchases of this book. For more information,
please contact Special Sales at 410-516-6936 or specialsales@press.jhu.edu.*

The Johns Hopkins University Press uses environmentally friendly book materials,
including recycled text paper that is composed of at least 30 percent post-consumer waste,
whenever possible.

TO RICK AND CALLA

IN MEMORY OF
MARY HOSTETLER BEECHY,
ESTHER BEECHY MCDOWELL,
AND ARDIS JAMES

Contents

Preface

BEFORE 1971 NO ONE bothered pairing the adjective "Amish" with the noun "quilt." Few people outside Amish settlements knew there was anything distinct about the types of patchwork bedcovers Amish families kept folded in their cedar chests or displayed on guest beds. The Amish themselves just called them "quilts" or used the Pennsylvania German word *debbich*. But in 1997, when noted art critic Robert Hughes wrote his sweeping survey of American art history, he called Amish quilts "America's first major abstract art." This book explores how, in a mere quarter century, these objects shifted in status from obscurity within a relatively closed religious community to artworks considered by a prestigious critic as precursors to great modern American abstract paintings.

Today Amish quilts regularly appear in arenas quite distinct from one another. In 2010 the de Young Museum of San Francisco hosted *Amish Abstractions: Quilts from the Collection of Faith and Stephen Brown*. The exhibition, featuring quilts suspended flat on white walls, with labels offering only speculative geographic attributions rather than names of artists, was in many ways typical of the countless Amish quilt exhibitions that have graced the walls of galleries and museums since 1973. It showcased quilts hung as one would hang paintings rather than as bedcoverings. It offered scant information about the Amish women presumed to have crafted these objects. And it signaled to viewers that quilts pieced from dark, solid-colored fabrics in simple geometric patterns were indeed works of art.

By contrast, quilts also regularly appear in small country stores located in Amish settlements. Here one can find quilts stacked horizontally on beds, hanging vertically over bars like newspapers at a public library, as well as hung on walls like paintings. One can sift through piles of pillows, quillows (a combination of a quilt and pillow),

Amish quilt shop in Lancaster
County, Pennsylvania, 2010.

(Photograph by Nao Nomura)

potholders, placemats, tote bags, and wall hangings, purported to be pieced and quilted by Amish women. Few of these objects, also collectively called "Amish quilts," bear much resemblance to the quilts at the de Young Museum. Yet these quilts and quilted objects—marketed to tourists visiting Amish country—are also typically made by unnamed Amish makers (as well as by unnamed women of other religious and ethnic backgrounds). Does a contemporary quilt sold at Country Lane Quilts have anything in common with the work of art hanging at the de Young other than attribution to makers of the same Anabaptist faith?

These objects indeed have a shared story, rooted in the slow change and negotiated boundaries of Amish families and church districts of the late nineteenth and early twentieth centuries, and in the parallels art enthusiasts and craft revivalists have identified between old quilts and abstract art in the late 1960s and 70s. They all share the role of commodity, as objects of consumer desire. Collectively, these objects tell the story of an ongoing search for authenticity and simplicity, a quest that has taken many forms since humans—with eyes, minds, and hearts situated in the

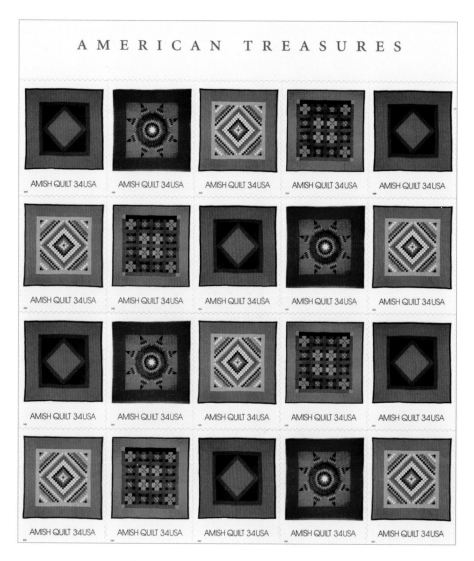

United States Postal Service stamps "American Treasures" series issued in 2001 featuring quilts from the Esprit corporate collection.

(Courtesy of the USPS)

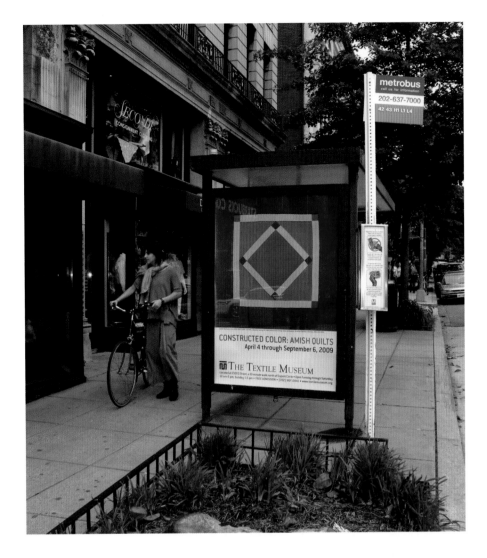

modern experience—began seeking out goods that reflected a simpler, seemingly more authentic past.

My own story also connects me to these quilts. I am a fifth-generation Mennonite quiltmaker who learned the craft from my own grandmother. When many of my ancestors first immigrated to North America in the eighteenth century, they were members of the Amish faith, but they joined the Mennonites following a late nineteenth-century division. When my great-great grandmother first began making quilts, she would have been closely connected to the Amish church. My cultural heritage inspired me to begin studying Amish quilts more than ten years ago, serving as the curatorial assistant at the International Quilt Study Center & Museum at the University of Nebraska–Lincoln, the home of the world's largest publicly held collection of quilts, including several hundred attributed to Amish makers.

Like many others before me, I thought these old Amish bedcoverings were beautiful aesthetically and found them intriguing because they were made within the confines of a conservative religion. As I learned to identify commonly used patterns and fabrics

"Arie," rug from the "Legacy of Starry Crowns" series.

(Hansine Pedersen Goran, Current Carpets)

"Susan," rug from the "Legacy of Starry Crowns" series.

(Hansine Pedersen Goran, Current Carpets)

while caring for these quilts—folding them in acid-free tissue paper and storing them in a state-of-the-art textile storage facility—I began to think about why we now treat these objects like valuable works of art. And as I became acquainted with collectors who owned many fine Amish quilts and dealers who bought and sold them, I understood that like other art objects, these quilts were commodities. I also knew, growing up near an Amish settlement in northern Indiana, that Amish women have continued to make quilts that look nothing like the older dark quilts owned by museums and private collectors. The new cheery, light-colored quilts, often adorned with flowers and hearts, were sold at shops catering to tourists and auctioned at benefit sales raising money for local schools and fire departments. This world seemed quite distinct from that of art museums and private collectors. Yet I knew that these disparate quilts must have shared origins. In this book, I explore this and other paradoxes surrounding Amish quilts.

Since the late 1960s, many people have fallen in love with Amish quilts. These old bedcovers have become iconic recognizable objects, distinguished by their bold graphics and saturated colors. In recent years they have appeared on U.S. postage stamps, on Washington, D.C., bus stops, and as the design inspiration for high-end handcrafted carpets. How did objects made in a fairly closed, conservative religious culture, in which the ideals of modernity and fashion are anathema, become ubiquitous parts of late twentieth- and twenty-first-century visual culture? I answer this question by investigating intersections of art, craft, fashion, globalization, and consumer culture. Both Amish and non-Amish individuals, influenced by understandings of theology, modernism, connoisseurship, nostalgia, "Amishness," consumerism, and authenticity, crafted the value of Amish quilts during the late twentieth century.* This value was of course monetary, but it was also aesthetic, emotional, and cultural.

This book is organized with a loose chronological structure, first examining the practice of Amish quiltmaking as it relates to the history of American quiltmaking at large, and then grounding it within the values of Amish culture and religion. Shifting to the perspective of those outside the religious group who "discovered" Amish quilts in the late 1960s and 70s, the next several chapters explore how individuals reinterpreted old Amish quilts as art objects and in doing so created a thriving market for these objects. In response to outsiders' interest in their old quilts, Amish entrepreneurs began making new ones to sell on the consumer market. The final chapters investigate the history and structure of these Amish businesses, along with non-Amish businesses that similarly marketed quilts with the "Amish brand." Here the story of Amish quilts has global reach, extending far beyond the pastoral fields of Amish country into Chinese factories and Thai refugee camps. This unexpected outcome, explicitly connected to the art world's interest in Amish quilts, is just one of the many twists and turns of this story of seemingly humble Amish quilts and the people who have loved them.

*Here "consumerism" means an "emphasis on or preoccupation with the acquisition of consumer goods" (Oxford English Dictionary online, www.oed.com).

Acknowledgments

THIS BOOK IS ABOUT the relationship between people and quilts. As such, I am grateful to the many individuals who told me stories about quilts. Likewise, I must thank the many quilt owners, both private and institutional—who granted me access to their quilts. The complete list of both individuals and institutions appears in the bibliography. Some individuals went beyond mere interviews, cooking me meals, showing me quilts, sharing contact lists, and putting me in touch with museums, collectors, and dealers who have also enriched this project. Special thanks go to Julie Silber, Jonathan Holstein, Patricia Herr, David Wheatcroft, Eve Granick, Joe Cunningham, and Benuel Riehl for these invaluable gifts. I am equally grateful to the many Amish individuals I was fortunate to talk with about quilts and quilt businesses.

The Johns Hopkins University Press understood that images of quilts and related objects were essential to tell this story. The Coby Foundation and the Robert and Ardis James Foundation also recognized the importance of full color images and high quality production. On behalf of the Press, I thank these family foundations for generously underwriting this book's production costs. I also thank West Chester University's College of Arts and Sciences for supporting this work. I thank Greg Nicholl at the JHU Press and Donald B. Kraybill at the Young Center for Anabaptist and Pietist Studies for their guidance and support through this process.

Quilts are beautiful objects. While no photograph can replicate the feel of cloth and the texture of stitches, the images within this book are possible due to the generosity of many collectors, including the American Folk Art Museum, Faith and Stephen Brown, Heritage Center of Lancaster County, Heritage Historical Library, International Quilt Study Center and Museum, Illinois State Museum, Indiana State Museum, Metropolitan Museum of Art, Michigan State University Museum, and Winterthur Museum. I also thank Almost Amish LLC, Amish Country Quilts, AmishQuilter, Andy Warhol Foundation for the Visual Arts, Artists Rights Society, Barnett Newman Foundation, Judi Boisson, Conde Nast, George and Susan Delagrange, Good Books, Hansine Pederson Goran, Eve Granick, Bryce and Donna Hamilton, Jonathan Holstein, the Josef and Anni Albers Foundation, Bettie Mintz, the Estate of Kenneth Noland, Nao Nomura, Philadelphia Folklore Project, Sharon Risedorph, Jane Rohrer, Kate Rothko Prizel and Christopher Rothko, and Emma Witmer for granting me permission to reproduce images.

I have spent significant portions of the past several years crisscrossing the country to conduct interviews, visit archives, and drool over quilts. This would not have been possible without generous funding from the American Quilt Study Group's Meredith Scholarship, the International Quilt Study Center and Museum's visiting fellowship, the University of Delaware's National Endowment for the Humanities funded Public Engagement / Material Culture Fellowship, the University of Delaware's Graduate

Fellowship and Women's Studies Fellowship. I also benefited from residential fellowships: the James Renwick Fellowship in American Craft at the Smithsonian Institution and the McNeil Dissertation Fellowship at Winterthur Museum and Library.

Many colleagues with a common interest in quilts shared their insights, answered my questions, and supplied me with sources. Thank you to Connie Chunn, Ginny Culver, Carolyn Ducey, Barbara Garrett, Eve Granick, Marin Hanson, Amy Henderson, Patricia Keller, Jacques Légeret, Marsha MacDowell, Nao Nomura, Dorothy Osler, Cynthia Prescott, Linda Pumphery, Diane Tepfer, Merikay Waldvogel, Jan Wass, and Mary Worrall. George and Susan Delagrange generously loaned me materials related to their business, Amish Design.

My dissertation director and mentor, Susan Strasser, provided keen editing, invaluable advice, and general wisdom that helped me transform my research into a book. I also thank Katherine Grier, Bernard Herman, Donald Kraybill, and Arwen Mohun for their feedback on this work, as well as members of my dissertation reading group at the University of Delaware. I also thank Jennie Noakes for editing an earlier version of this manuscript.

I benefited from presenting portions of my work at the American Historical Association annual meeting, the Business History Conference, the Hagley Seminar, the International Quilt Study Center's biennial symposium, the American Quilt Study Group's annual seminar, the Young Center for Anabaptist and Pietist Studies at Elizabethtown College's conference on the Amish in America, the National Museum of American History Tuesday Colloquium, the Smithsonian American Art Museum's Fellows Lectures in American Art, and the University of Delaware History Department's History Workshop for Technology, Society, and Culture. My work improved from the insightful feedback I received on each of these occasions.

I thank my friends and family for their patience, their support, their ability to distract me when needed, and their continual belief in me. I especially thank Steve and Krista Yutzy-Burkey, David Roth, Lucas and Tara Swartzendruber-Landis, Heather Boyd, Bess Williamson, Ryan and Janell Olah, and Nao Nomura. I am grateful to my family members: George and Barbara Smucker; Matt Smucker and Andrea Allen, along with Ulysses and Finnegan; Annie and Rich Sieber; and Rebecca Sieber and Jonathan Denlinger, along with Solomon and Jude. I hope my daughter, Calla Wiley, will one day read this and be proud.

And finally, I must acknowledge the most patient, supportive, and helpful individual of all, Rick Sieber. Thank you for listening, reading, editing, locating sources, scanning images, and somehow putting up with more than I could possibly list here. Rick, I dedicate this to you. Every scholar should be so lucky as to marry a librarian.

AMISH QUILTS

INTRODUCTION

In the late 1960s, artist and therapist Sue Bender felt something

was missing from her fast-paced urban life. What initially drew her to the Old Order Amish was not their agrarian lifestyle or old-fashioned ways but seeing what she described as quilts in "odd color combinations" displayed at a department store in Long Island. In her 1989 memoir, *Plain and Simple: A Woman's Journey to the Amish,* she described these quilts: "Deep saturated solid colors: purple, mauve, green, brown, magenta, electric blue, red. Simple geometric forms: squares, diamonds, rectangles. A patina of use emanated from them. They spoke directly to me. They knew something. They went straight to my heart."[1]

Over the next several years, Bender's fascination with the "haunting spiritual quality" of the Amish and their quilts became what she described as an obsession. "Objectively it made no sense," she wrote. "I, who worked hard at being special, fell in love with a people who valued being ordinary."[2] She sought out an Amish family who would let her live with them and allow her to escape to what she initially perceived as an Amish utopia. After living with two separate Amish families for several months each, she wrote about what she learned from the Amish, describing each lesson as a square in her Nine Patch quilt—a simple pattern often made by beginning quiltmakers, consisting of nine squares stitched together to form a larger square (fig. I.1). Bender eventually learned that Amish society was not a utopia. She also discovered, among other things, how to value "meaning in work itself," to "celebrate the ordinary," and to "experience each moment," lessons people like Bender more often gleaned from Zen Buddhism than from Amish Anabaptism.[3] And she continued to love the simple beauty of old Amish quilts, the objects that drew her to this religious community.

Growing up in the Old Order Amish church in Indiana in the 1930s and 1940s, Sara Miller could not be any more different than Sue Bender. She considered her family's dark-colored quilts "extremely ugly," preferring store-bought bedspreads. Her mother taught her to make quilts as a child, using white and pastel-colored fabrics rather than the dark blues, blacks, and purples common on many older quilts. As an adult, Miller and her parents moved to Kalona, Iowa, home to the largest Amish settlement west of the Mississippi River. In the late 1970s, as a middle-aged Amish woman, Miller began operating a successful craft consignment and fabric shop out of her rural Iowa home. She sold fabric that appealed to both local Amish women and to the non-Amish quiltmakers who began to flock to her store. She often had a few old Amish quilts in dark

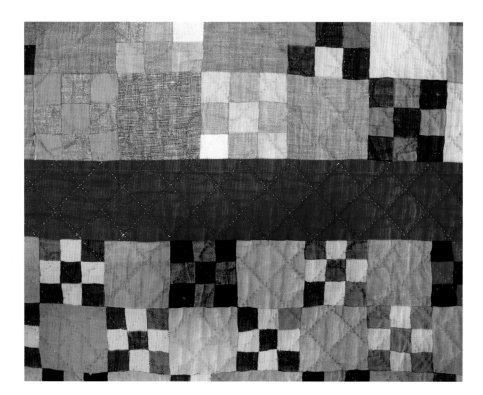

Figure I.1. Detail, Nine Patch,
Barbara Yoder, c. 1920.
Weatherford, Oklahoma.
Cotton, 90 x 71 in.

(International Quilt Study Center &
Museum, University of Nebraska–
Lincoln, 2005.039.0005)

colors in her consignment inventory, but she still did not care for these quilts of her childhood—that is, until urbanites from Chicago and Iowa City expressed so much interest in them. Then she began to look at them with new eyes.

While outsiders liked the bold graphics and striking color combinations of the older, darker quilts—finding that they looked great as art pieces hanging on walls—Miller began to feel that old quilts connected her to her Amish heritage. She knew that each quilt had a story that she wished she could unravel—perhaps about a child sleeping under a cover specially made for him or an innovative quiltmaker creatively expressing herself in fabric. Eventually, Miller amassed her own collection of Amish quilts, choosing to buy them from antiques dealers because she thought it would be too intrusive to knock on her Amish friends' and neighbors' doors in search of quilts they were no longer using. She too began hanging old quilts on her walls, valuing them as art objects.[4]

THE OLD ORDER AMISH

At its heart, the story of Amish quilts is a tale of intersecting cultures, a nexus between the Old Order Amish and "the world," as members of this church have often referred to the larger society.[5] Exploration of this late twentieth-century interaction of the Old Order Amish and the outside world requires a basic understanding of Amish religion, history, and culture. Like many general overviews of Amish life, this one will be painted in broad brushstrokes despite recent scholarship emphasizing the diversity of

the 273,000 Amish individuals scattered among 463 distinct settlements across North America in 2012. Local and regional contexts, distinct migration histories, ethnicity, and local governance have all shaped Amish identities.[6]

Amish from Switzerland, the Palatinate (in present-day Germany), and Alsace (in present-day France) began immigrating to Pennsylvania in the mid-eighteenth century, seeking both religious tolerance and economic benefits. Since then, they have fanned out to establish settlements in twenty-eight states and the province of Ontario. Districts, the local churches within settlements consisting of twenty-five to forty households, have their own structures and leadership rather than answering to a national or regional office or conference.[7] Local leadership, usually consisting of a bishop, two ministers, and a deacon, guides the religious life and discipline within each district. As a result of this decentralized structure, the cultural rules and regulations in Amish communities, known as *Ordnung,* differ significantly among districts. In some districts *Ordnung* may be kept in written form, although these guidelines often exist as unwritten group knowledge and learned, yet adaptable, practices.

As Steven Nolt and Thomas Meyers describe in their study of the diversity among Amish communities, "*Ordnung* is a way of life and a way of going about life." *Ordnung* regulates the "symbolic separators" that distinguish Amish from other Americans, such as limited use of technology, distinctive dress, and prohibition of formal education beyond the eighth grade. *Ordnung* also governs church discipline, in particular the practice of "shunning," in which members of the church refrain from many forms of contact with ex-members unless these individuals publicly confess their sins. This ritual practice, like other aspects of the *Ordnung,* varies among church districts. Some districts regard strict shunning as a lifelong practice unless the individual publicly repents, while others may lift the ban if the offender joins another Anabaptist church, such as the car-driving Beachy Amish or a conservative Mennonite group.[8]

A key aspect of *Ordnung* and the Amish way of life is that contrary to popular perceptions, neither exists in a fossilized form. Both have evolved over time, often in response to new issues the church has faced, such as technological innovations, commercial market forces, and changes to state or local laws. For example, during the late 1960s milk companies insisted that Lancaster County, Pennsylvania, farmers store milk in large stainless steel tanks refrigerated with electricity rather than in milk cans. Using high-wire electricity—prohibited by the local *Ordnung*—and losing the milk market were both undesirable options to Amish in this settlement. In order to get out of this catch-22, Amish bishops and milk inspectors negotiated a compromise acceptable to both parties. Farmers could use a diesel engine—a device many already used selectively for other purposes around the farm—to operate the required bulk tanks. This deal enabled Amish dairy farmers to refrain from using high-wire electricity or generators—which had recently been banned by the district's *Ordnung* except for electric welders used to repair farm equipment—while enabling them to adopt the technology required by the milk companies.[9]

Although it is difficult to summarize Amish doctrine, due in part to its variation among settlements, an important feature of the religion is that faith is embodied in all aspects of life. The Amish view themselves as a redemptive community separate from the world, the corrupt larger society. This manifests in the group's restrictions on automobiles, high-wire electricity, and worldly dress. Community, rather than individualism, is of utmost importance, and the *Ordnung* often evolves as a means of fostering and protecting community—rather than individual—needs. Other beliefs include adult baptism and pacifism.[10]

The Amish have never existed as an isolated society completely separate from the dominant culture. Rather, this small religious group has always lived in relationship to the world. Since the mid-twentieth century, population growth, both Amish and non-Amish, coupled with increased commercial and industrial development, has spurred some Amish families to give up agriculture as their primary livelihood. In many communities there was not enough farmland for young couples to begin farming, and some families began to find other ways—such as construction, small businesses, cottage industries, and in some settlements, factory work—to earn a living.[11] With these changes, members of the Amish church had even more interaction with the outside world. Moreover, in the second half of the twentieth century the world increasingly looked to the Amish with a gaze of fascination.

OUTSIDERS' PERCEPTIONS OF THE AMISH

By the 1970s and 1980s, Americans knew about the Amish from a variety of popular sources, aside from quilts. From idealized articles in the popular press, tourist visits to "Amish Country," a major motion picture set in Lancaster County, and a best-selling memoir of a woman's sojourn to Amish country, Americans learned that the Amish represented a simpler, purer expression of authentic living. Not only had the Amish apparently maintained elements of the preindustrial country life, but they did so despite their close proximity to mainstream Americans and contemporary culture. The Amish had long fascinated outsiders, particularly as the increasing pace of contemporary life created a stronger contrast to Amish ways. By the time urbanites began collecting Amish quilts in the 1970s, some Americans had begun to see the Amish as a model society that represented what mainstream culture had lost in its rush toward progress and that could serve as an example for the future.[12]

The dominant society's perceptions of the Amish had shifted gradually since members of the religious group first began to immigrate to colonial America from Europe in the mid-eighteenth century. For the first century and a half, the group was small—fewer than five thousand Amish lived in the United States in 1900—and attracted little attention. The Amish were lumped with other German speakers, collectively known as the Pennsylvania Dutch and characterized as the "Dumb Dutch": ignorant, stubborn, and unrefined.[13] The Amish began to attract more attention as their German-speaking neighbors increasingly assimilated into mainstream culture, adopt-

ing the technologies, consumer culture, and bureaucracy of industrialized America. During the 1920s and 30s, popular publications portrayed the Amish as exotic by focusing on the practice of "bundling," a courtship ritual in which unmarried teenagers of the opposite sex shared a bed fully clothed. As tourism to southeastern Pennsylvania's Amish country increased following the opening of the Pennsylvania Turnpike in 1940, new images of the Amish emerged out of the growing "Amish culture industry." Ideas about the Amish disseminated during these postwar years through increasing tourism and portrayals in popular media.[14]

Plain and Fancy, a popular musical set in Pennsylvania's Amish country, debuted in 1955 and ran for over a year on Broadway before productions in Chicago and Los Angeles. It presented an affirmative and sympathetic view of the Amish and of country life in general. When the play's Amish family invites a young New York couple visiting Lancaster County to stay overnight in their home, audiences witness the gulf between the sophisticated lifestyle of the New Yorkers and the simple pleasures of the Amish. Rather than poking fun at the less cosmopolitan Amish hosts, the story portrays them as honest and moral, suggesting that New Yorkers might benefit from Amish influence. In addition to disseminating this positive view of the religion and life in Lancaster County, *Plain and Fancy* advanced the commercialization of Amish culture and encouraged outsiders to make their own ventures to Amish country.[15]

Through such affirmative, albeit idealized, representations, many of the more negative perceptions of the Amish had lifted by the 1970s. The Amish became an admired alternative community and a source of inspiration to Americans seeking simplicity and authenticity in their own lives. To some, the Amish represented a successful alternative to fast-paced contemporary society. They showed a way to be true to one's beliefs, find meaning in everyday tasks, and live modestly through frugality and austerity. While previous generations had perceived the Amish as strange and backward, during the mid-twentieth century many outsiders had developed a nostalgic and sympathetic admiration for this religious group that seemed to keep the pressures of modern society at bay.[16] Popular symbols of Amish culture included the one-room school, evoking rural simplicity and nostalgia for a preindustrial past.[17] Ubiquitous portrayals of the Amish barn raising suggested the pleasures of hard work, the community's self-sufficiency, and the fine craftsmanship possible with the traditions of yesterday. And quilts, finely stitched objects romantically (and incorrectly) associated with the frugality of the past, added to commonly held notions of Amish simplicity and adherence to tradition.

These idealized perceptions did not always reflect Amish realities. Americans from the dominant culture looked to the Amish as a true agrarian society, yet increasingly during the second half of the twentieth century, fewer Amish families relied on farming as their primary livelihood. Americans imagined the Amish living without modern conveniences like electricity and cars, a perception that simultaneously traded on associations with an imagined preindustrial past and set the Amish apart as exotic and other-worldly. In general, most Amish church districts' *Ordnungs* did prohibit the

ownership of automobiles and the use of high-wire electricity, but not riding in cars or using propane, battery, or compressed air power tools and appliances. Amish families both lived in the seemingly traditional world of their church community and also participated in the modern world, embracing aspects of consumer culture and modernity in selective ways.[18] This very contradiction—maintaining old-world values despite the pressures of contemporary society—was a point of even greater fascination for non-Amish observers.

By the 1940s, urbanites yearning to experience a simpler past had easy access to Lancaster County's "Amish Country," a quick drive from many East Coast cities. As local residents noted the surge in visitors who came to see their plain-dressing, buggy-driving Amish neighbors, entrepreneurs began to establish amenities and attractions for tourists. The first Amish-themed tourist attraction, "The Amish Farm and House," opened along Route 30 in Lancaster County in 1955. The non-Amish proprietor claimed that his staged Amish farmstead would educate visitors about Amish culture, something the Amish, in their desire to have minimal interaction with "the world," were unwilling to take on themselves. Here visitors could learn about Amish customs, see the austere decor, view examples of Amish clothing, and briefly experience life without electricity and other modern conveniences. Eventually, a few of the Amish themselves began to participate in the tourism industry. By 1960, organized tours were visiting what a tourist brochure called the "delightful hinterland" of Holmes County, Ohio, complete with meals served in genuine Amish homes. By the early 1970s, Ohio tourism included visits to Amish one-room schools. By the 1970s and 1980s, the Amish-focused tourism industry was also thriving in northern Indiana, raking in hundreds of millions of dollars through its romanticized portrayals of Amish life.[19]

In the early years of Amish-themed tourism, it was predominantly non-Amish who benefited economically by guiding tours, running commercial operations like The Amish Farm and House, and selling souvenirs. A few Amish families profited by serving meals to tourists in their homes or selling homemade ice cream from their farms. But this changed in the 1980s when many Amish families began to supplement or replace their farm income by operating small businesses from their homes. Some of these Amish businesses catered to tourists, selling Amish-made foods and crafts. These proprietors welcomed tourists to their farms, giving visitors a glimpse of their homes, children, and lifestyle.[20]

During the postwar decades, popular magazines published articles about the Amish, usually accompanied by photographs best described as pastoral, often featuring agricultural life, smiling children, and perhaps a quilt. *National Geographic Magazine* trafficked in such sensitive renderings of exotic cultures, and it frequently featured the Amish, publishing its first story about the "Pennsylvania Dutch" in 1938.[21] The magazine's 1984 article, "The Plain People of Pennsylvania," praised Amish ability to maintain Old World sensibilities despite the advancements of the modern world they live in: "The strength of their beliefs is seen today in a culture that thrives on the borders of metropolitan America but remains true to teachings forged in Reformation Europe."

Accompanying photographs emphasized practices long gone from contemporary culture, such as craftsmen working on wagon wheels, a village of men raising a barn, women canning and making quilts, and young children feeding ducks and chickens.[22]

Some popular magazine portrayals, rather than presenting the exotic fossilized Amish society as seen in *National Geographic*, emphasized Amish potential for teaching the rest of society a better way to live. In a 1972 article called "Rediscovering the Simple Life" in the women's magazine *McCall's*, famed poet Archibald MacLeish waxed lyrical about how the Amish—unlike the rest of Americans—had been able to identify and extract genuine and lasting meaning from life. More than an admiring description of Amish values and practices, MacLeish's article was a critique of contemporary culture and the processes of industrialization, urbanization, and capitalism that created it. His description of "the vast, unmanageable cities into which three quarters of us have crowded ourselves" contrasted with the accompanying photographs of a silhouetted farmer working in his field, quiet austere interiors, and contented children helping around the farm. "The strength of the Amish is precisely that their past is alive in their present," he wrote, encouraging readers to trust the "unused and wasted greatness" of the American past as they look toward the future.[23]

Some cultural critics were even more explicit about the potential of the Amish as a usable model for an alternative to industrialized, urbanized society. A 1981 article in *The Futurist*, the magazine published by the World Future Society (WFS), posited that the Amish offered a blueprint for a more productive society at large. WFS, a nonprofit educational organization founded in 1966, focused on "how social and technological developments are shaping the future." Thomas W. Foster, the author of the article "Amish Society: A Relic of the Past Could Become a Model for the Future," compared the Amish to economist E. F. Schumacher's vision of an "ecologically balanced conserver society" or "frugal community." Schumacher, author of the influential *Small Is Beautiful: Economics as if People Mattered* (1973), envisioned a "balanced and humane social order" that united "the joy of work and the bliss of leisure." His imagined community understood the "therapeutic value of real work," promoted self-sufficiency, and relied on "appropriate technology." Foster's essay argued that Amish society "contain[ed] each of the hallmarks of an ecologically balanced conserver society," and as such was an ideal model for advancing Schumacher's philosophies.[24]

By 1985, when Australian film director Peter Weir released *Witness*, his Hollywood portrayal of the Amish, many Americans had experienced a taste of Amish culture through magazine articles or by visiting Amish country tourist attractions. The film presented a sympathetic depiction of Amish life. *Witness*, like many of Weir's films, centers on the clash of cultures, juxtaposing rural Amish life and the harsh realities of urban crime. On a trip to Philadelphia a young Amish boy, Samuel (Lucas Haas), witnesses a gruesome crime while in the train station's restroom, unbeknownst to the corrupt cops responsible for the murder. In order to protect this witness, detective John Book (Harrison Ford) drives the boy and his mother back to their home in Lancaster County, where Book collapses due to a bullet wound he received while investigating the

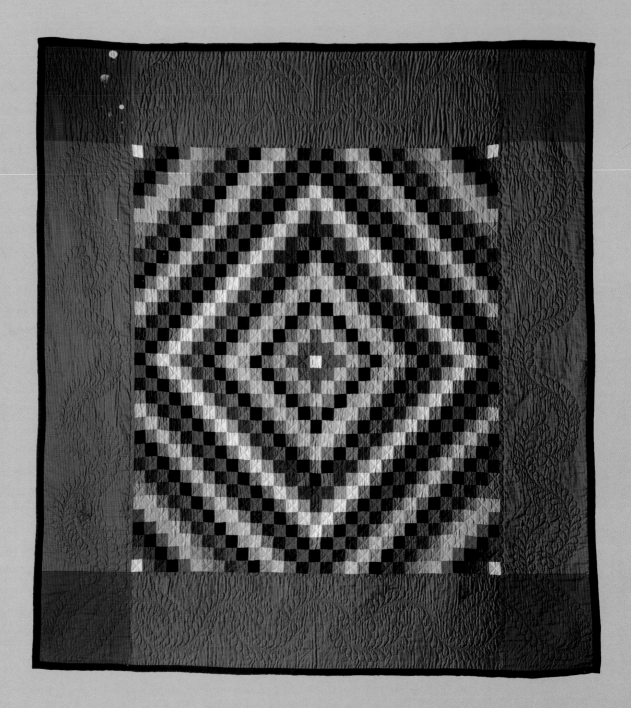

Figure I.2. Sunshine and Shadow, unknown Amish maker, c. 1930. Pennsylvania. Wool and cotton, 81 x 76 ½ in. Purchase, Eva Gebhard-Gourgaud Foundation Gift, 1973 (1973.94).

(The Metropolitan Museum of Art, New York, NY, U.S.A. Image copyright © The Metropolitan Museum of Art. Photo: Art Resource)

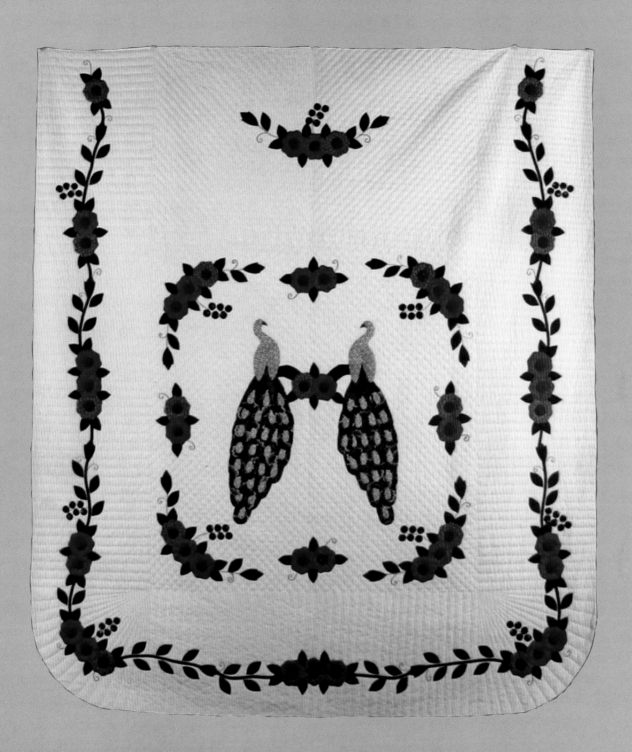

Figure I.3. Peacock Amish Quilt
with Border, unknown maker, 2012.
Lancaster County, Pennsylvania, (Image courtesy of Amish Quilter,
104 x 113 in. Shippensburg, PA, www.amishquilter.com)

crime. The Amish family nurses the city cop back to health, concealing him in plain clothing. Book's crime-filled world stands in sharp contrast to the pastoral world of the nonviolent Amish in Lancaster, complete with barn raising, hymn singing, fresh lemonade, and a lovely Log Cabin quilt draped across a bare-chested Harrison Ford. Just as Book was able to encounter, briefly, the purity of the Amish community, the film transported viewers to a world far from their own, even if it was a Hollywood portrayal of the religious group. The critically acclaimed film received eight Academy Award nominations, won two, and reached number one at the box office during March 1985.[25]

Another mass-market presentation of Amish life came through Sue Bender's best-selling memoir, *Plain and Simple: A Woman's Journey to the Amish* (1989). Bender's book explicitly linked the lessons she learned while living with an Amish family to the community's most popular material culture, quilts. She wrote: "I thought I was going to learn more about their quilts, but the quilts were only guides, leading me to what I really needed to learn, to answer a question I hadn't formed yet: *'Is there another way to lead a good life?'* "[26] She concluded that yes, the Amish did model an alternative, one that valued simplicity and humility rather than success and self-expression. As religious historian David Weaver-Zercher notes, Bender is optimistic that the lessons she learned are "fundamentally transportable—with the tangible assistance, of course, of her newly installed Amish kitchen and some strategically hung Amish quilts."[27]

CROSS-CULTURAL OBJECTS

As the following chapters explore, Amish quilts are objects with a complex story rooted in intersections between the Amish and the outside world. By making quilts, Amish have participated in industrialization and mass consumer culture, using factory-produced cloth and commercially published patterns to create handcrafted bedcovers. These objects, in turn, have captivated countless non-Amish individuals, who have assigned quilts their own meanings and values. Both Amish and non-Amish entrepreneurs have catered to the demand for Amish-made and Amish-style quilts, producing new ones to sell to consumers.

As with the Amish themselves, perceptions about Amish quilts are often quite different than the quilts themselves. The ideas outsiders have held regarding Amish quilts are a significant part of this story. Today, non-Amish might perceive of Amish quilts in one of two distinct ways. Many picture a darkly colored, geometrically patterned quilt, perhaps like one they may have viewed on a U.S. postage stamp or hanging on a museum wall (fig. I.2). In contrast, some might imagine a large, light-colored, appliqué quilt with cheerful hearts and flowers, like those available for sale in shops in many Amish settlements (fig. I.3). Both perceptions are accurate depictions of Amish-made quilts. But neither encompasses the full outpouring of quilts by Amish quiltmakers or the products commercially sold as "Amish quilts."

What, then, are the hallmarks of Amish quilts? What makes an Amish quilt Amish? In answering this question it is far too easy to oversimplify and generalize, adding to the misperceptions about what makes an Amish quilt "Amish." Quite simply, an Amish quilt is one made or owned by an Amish family.

A quilt itself consists of three layers: a decorative top, an inner layer of batting, and a back typically of one piece of fabric. The two sewing techniques Amish quiltmakers have used most are piecing and quilting. Piecing is the process of seaming cut sections of fabric together to form a pattern that appears on the quilt top (fig. I.4). Amish quilt-makers typically used treadle or other non-electrically powered sewing machines rather than piecing by hand and generally pieced alone (fig. I.5). Today, Amish women use modern sewing machines retrofitted to run on diesel, compressed air, or treadle power.

Quilting is the small running hand-stitches connecting the three layers together (figs. I.4 and I.6). In preparation for quilting, a quiltmaker stretches the pieced or appliquéd quilt top, an inner layer of batting, and a backing fabric together on a quilt frame that may take up considerable space in a household. Amish women have often quilted in groups, either informally among mothers and daughters, or at quilting frolics—daylong events organized to efficiently finish a quilt in one day.

Amish women have used two other techniques with less frequency: embroidery and appliqué, both of which have enabled them to embellish quilt tops with figurative forms rather than solely geometric designs possible with piecing. Embroidery involves fancy stitches with a coarse multi-strand thread, usually to create flowers, initials, or dates (figs. I.7 and I.8). Appliqué is the technique of sewing a piece of fabric, also often a figurative element, onto the background fabric (figs. I.9 and I.10). Embroidered or appliquéd elements might be a minor or major part of a quilt's design. With knowledge of these techniques, a quiltmaker chose the pattern, fabrics, size, colors, and many

Figure I.4. Detail, Sunshine and Shadow, unknown Amish maker, c. 1940–1960. United States Midwest. Cotton, synthetic fibers, wool. These squares are pieced together using a sewing machine and hand quilted with a simple grid design.

(Courtesy of Winterthur Museum, Gift of Marilynn Ann Johnson, in memory of Ann LaPorte Johnson and Lynn H. Johnson, 2007.24)

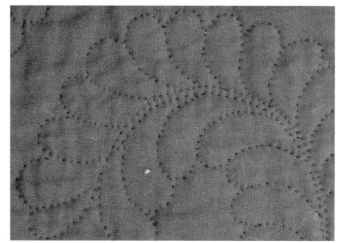

Figure I.5. **(top)** "Church Amish" home, with treadle sewing machine and quilt top in process, 1941.

(Photograph by Irving Rusinow. Department of Agriculture. Bureau of Agricultural Economics. Division of Economic Information. U.S. National Archives and Records Administration)

Figure I.6. **(middle)** Detail, Sunshine and Shadow, unknown Amish maker, c. 1940–1960. United States Midwest. Cotton, synthetic fibers, wool. The outer border featured this elaborate feather quilting motif, executed in small running stitches.

(Courtesy of Winterthur Museum, Gift of Marilynn Ann Johnson, in memory of Ann LaPorte Johnson and Lynn H. Johnson, 2007.24)

Figure I.7. **(bottom)** Detail, friendship quilt, 1956, Nappanee, Indiana. Martha Helmuth's friends contributed embroidered blocks for this friendship quilt.

(Historical Heritage Library)

Figure I.8. Detail, North Carolina
Lily, unknown Amish maker, c. 1925–
1945. Possibly made in Ohio. Cotton,
74 x 81 in. This maker hand embroi-
dered the flower's stem.

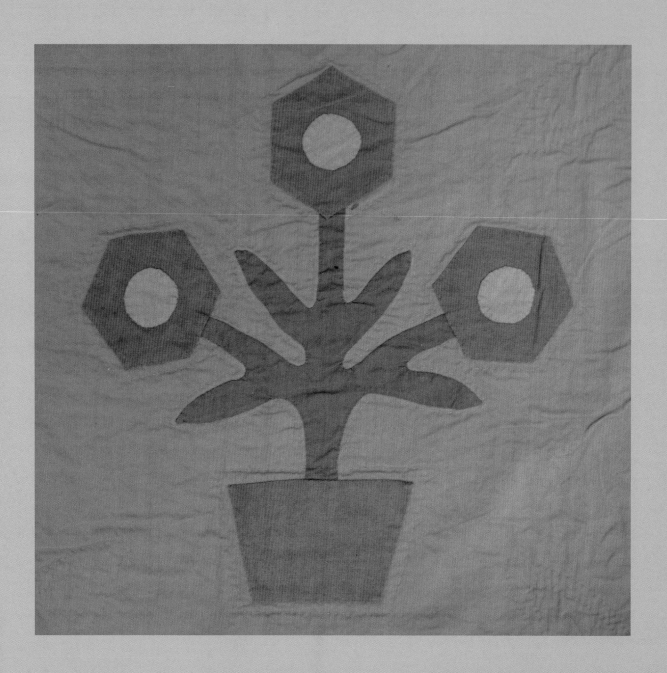

Figure I.9. Detail, Dutch Roses, unknown Amish maker, c. 1935. Probably made in Holmes County, Ohio. Cotton, 85 x 72 in. Twenty hand-appliquéd pots of flowers appear on the quilt, executed in a pattern published in the *Chicago Tribune*'s Nancy Cabot column in 1935 and likely syndicated by *Progressive Farmer.*

(International Quilt Study Center & Museum, University of Nebraska–Lincoln, 1997.007.0558)

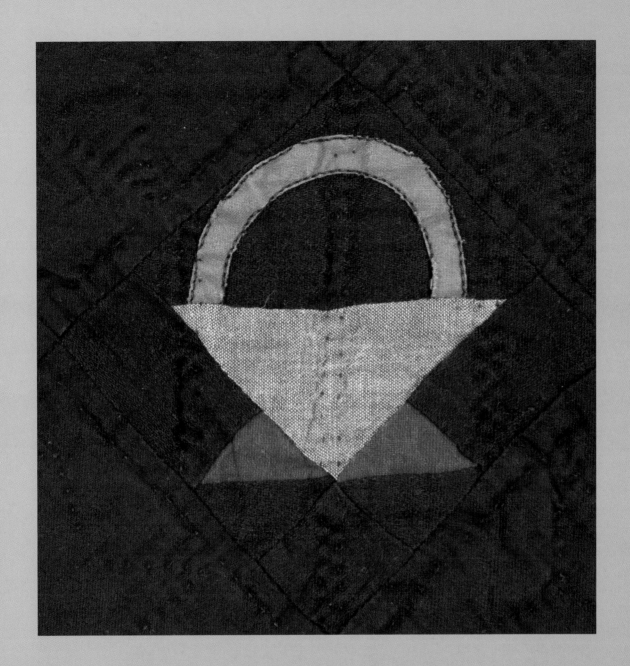

Figure I.10. Detail, Baskets, unknown Amish maker, c. 1920–40. Attributed to Hutchison, Kansas. Cotton, 36 x 32 in. The maker machine appliquéd the basket handles on this crib quilt. (International Quilt Study Center & Museum, University of Nebraska–Lincoln, 2000.007.0088)

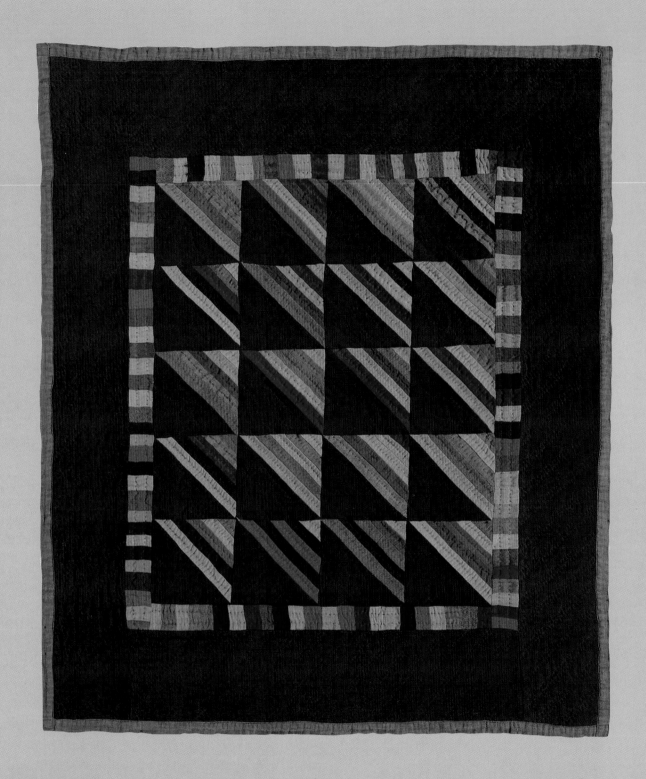

Figure I.11. Roman Stripes,
unknown Amish maker, c. 1930.
Probably made in Ohio.

(© Faith and Stephen Brown)

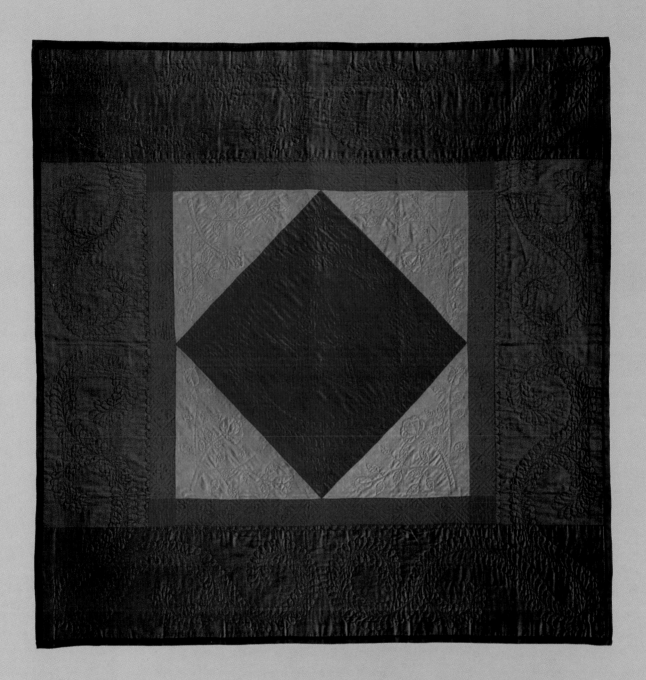

Figure I.12. Center Diamond,
unknown Amish maker, c. 1930.
Probably made in Lancaster
County, Pennsylvania. 80 x 80 in. (© Faith and Stephen Brown)

other minor elements that created the quilt as a whole. Some of these choices were only apparent to the quiltmaker—or to the connoisseurs who studied her work years later.[28]

A quilt pattern is the arrangement of pieced or appliquéd fabrics or embroidered motifs to form a design. Often quiltmakers repeated a pattern—sometimes called a "quilt block"—many times to form the design on the quilt top (fig. I.11). Other times the pattern is a medallion, with a center-focused design rather than repeated blocks (fig. I.12). As quilt expert Barbara Brackman has shown in her well-documented encyclopedias of quilt patterns, there are thousands of patterns, each often having several names, depending on region, religion, ethnicity, time period, and family lore.[29] Patterns are adaptable; creative quiltmakers might use patterns as starting points and arrange elements to create original quilts.

Batting, the inner layer of quilts, has been commercially manufactured since the mid-nineteenth century. Although quiltmakers could make their own batting using homegrown wool or cotton, little evidence suggests that Amish quiltmakers did this with any regularity. Stearns and Foster, a Cincinnati-based company, produced the first commercial batting in 1846. Prior to the introduction of polyester batting around 1960, most Amish quiltmakers used cotton batting or a thin woven cotton blanket to fill their quilts; once it became available, many chose to use polyester batting.[30] Occasionally, Amish quiltmakers reused old worn quilts as the batting for new tops.[31]

CRAFTING MEANING

The following chapters describe and illustrate Amish-made quilts in more detail than the preceding brief overview of quiltmaking provides, demonstrating the great diversity of quilts made by Amish makers. But this book's purpose is not to serve as a guide to identifying regional styles, common patterns, or fabric preferences. Rather, I attempt to break down the generalizations and stereotypes about Amish quilts that have emerged in the decades since outsiders first became enamored with these old bedcoverings.

But of even more interest to me than what Amish quilts look like and how they are made is what they have meant to various groups and individuals, Amish and non-Amish alike. Embedded in the stitches, in the weaves of the various fabrics, and within the three layers of each quilt, are stories of individual quiltmakers and quilt owners. The same quilt could have quite distinct meanings to each of the women introduced at the beginning of this chapter, urban professional Sue Bender and rural businesswoman Sara Miller. But each woman has a valuable perspective that helps tell the full story of these objects. The structure of the quilt—a patchwork of fabrics layered together with soft batting and strong backing, stitched together to unify all the parts—has served as an apt, if overused, metaphor to describe how distinct components fit together to produce meaningful results. In this book the individual stories of making meaning through sewing, using, displaying, selling, and preserving quilts are the pieces that when bound together make a more interesting and beautiful whole.

MADE IN AMERICA

Ask an Amish quiltmaker when Amish women started making quilts, and she'll likely answer that Amish women have "always made quilts." In the twenty-first century, even as fewer and fewer Amish women create quilted bedcovers for home use, the craft is ingrained in Amish understandings of their own tradition and conceptions of their own history. In their understanding of quilt history, the long-standing practice of making useful bedcovers fits with other principles that have guided the practice of their faith and culture—self-sufficiency, women as resourceful and hardworking contributors to their families, and the elevation of utility over ornament.

Yet in reality, when Amish families began emigrating from Europe to North America in the mid-eighteenth century, they brought neither quilts nor quilting know-how with them. Like most women in this era, Amish women did possess sewing skills, since they were responsible for stitching their family members' garments and other household textiles. However, quilts were not traditional bedcoverings in the German-speaking areas of Europe from which the Amish came. Amish families relied on the same bedding kit as did most German and Swiss transplants to the New World: a chaff bag (a homespun linen bag filled with straw chaff or cornhusks) that served as the mattress, a featherbed (a fustian—typically a cloth woven from linen and cotton—bag filled with feathers) as the top cover providing warmth, and perhaps a woven coverlet as the decorative top layer.[1]

But within a century and a half of the first Amish families' arrival to North America, Amish women began making quilts. The details of when, why, and how women of this small religious group started piecing and quilting bedcovers remain unknown. But by understanding the origins and practices of American quiltmaking at large during the nineteenth century and the processes of innovation and adaptation within Amish culture, we can begin to speculate about the genesis of Amish quiltmaking. Although quiltmaking itself is a centuries-old practice with origins in the far corners of the globe, Amish quiltmaking has its roots in the widespread practice of stitching quilts that was popular among many American women in the late nineteenth century. American quilts of this era were simultaneously products of increasing industrialization and commercialization and objects of nostalgia for a simpler era.[2]

Already in the late nineteenth century, Americans understood quilts as old-fashioned, as products of a preindustrial world in which making one's own household goods was the norm and creative reuse was a sign of women's ingenuity. Americans living in an age of rapid industrialization, urbanization, and modernization saw quilts through a lens of nostalgia for an imagined past in which self-sufficiency, fortitude, and thrift were commonplace.[3] Surely quilts were part of colonial women's repertoire of domestic skills that contributed to the success and well-being of colonial households, many Americans assumed. Despite the popular belief ingrained in the American imagination that their colonial foremothers made quilts to keep their families warm, very few women living in British North America in fact made quilts in the eighteenth century.

This myth was formulated during the Colonial Revival that began brewing in the last decades of the 1800s and that continues to this day, despite material and documentary evidence to the contrary.[4] As early as the 1860s (before Amish women made quilts in any significant number), benevolent women who raised funds for the Civil War effort through Sanitary Fairs publically performed the old-fashioned activities of their foremothers, including quiltmaking.[5] The myth of colonial American quiltmaking, originating in the "colonial kitchens" of Sanitary Fairs and world's fairs of the late nineteenth century, persists because it resonates with enduring American ideals of self-sufficiency and ingenuity.[6] In the early twentieth century, when the first proto-quilt historians—who not coincidently were also avid colonial revivalists—began thinking and writing about the origins of American quiltmaking, they believed that the earliest European women living in America had made quilts but that the material evidence of these objects was unavailable because the owners of these quilts, in appropriate frugality, had "used them up."[7]

More recent studies of probate inventories and other estate records demonstrate that few eighteenth-century Americans owned quilts, and when they did, they were considered highly valuable rather than as objects stitched together in order to "make do."[8] Textiles in general were typically among the most expensive objects in colonial homes, for the industrial revolution had not yet made cloth abundant and affordable, at least on this side of the Atlantic. Aside from linen and wool, laboriously carded, spun, and woven by colonial women and itinerant weavers, most fabric was imported from England and France and was thus out of reach to many eighteenth-century American families. Domestically produced homespun and home-woven goods were usually used for everyday toweling and handkerchiefs rather than as bed hangings or quilts; quilts assembled from these home-wrought materials rather than from finer imported cloth are exceedingly rare.[9] Quilts, then, were more often owned by wealthy, cosmopolitan urban dwellers with access to imported goods—including elaborately printed chintzes, dyed worsted wools, or glazed wools called calamanco.[10] While it is challenging to determine what the quilts listed in colonial-era probate inventories looked like, scholars have surmised that they were probably whole cloth quilts, assembled from one or

more pieces of these fine imported fabrics rather than by piecing or appliquéing a design on the quilt top.[11]

Often accompanying the myth of colonial quiltmaking is its partner in fantasy, the scrap-bag quilt, supposedly made up of bits and pieces of recycled clothing.[12] While twentieth-century quiltmakers with limited economic means have indeed recycled all sorts of used materials into their patchwork quilts, this was not a common practice among earlier American quiltmakers throughout the nineteenth century.[13] The material evidence in the form of extant quilts suggests that American quiltmakers largely used new rather than used fabric to make quilts.[14] For quilts created before the innovations of the industrial revolution, the format itself—typically a whole cloth quilt—indicates the absence of what has been referred to as a "scrap-bag mentality" or reuse of fabrics, although bed hangings and quilted petticoats were sometimes reused in whole cloth quilts.[15]

With the advent of industrialized textile production, most American quiltmakers continued to use new fabrics to make quilts. By the 1830s, Americans on the East Coast were experiencing the industrial revolution's impact on textiles in full force. New England textile mills produced much printed cotton fabric, providing dressmakers—and in turn quiltmakers—with a wealth of choice. In addition to improvements in spinning, weaving, and printing, an expanded transportation and distribution system increased access to these goods. Rather than a salvage craft, quiltmaking was a craft of abundance, with quiltmakers utilizing the widely available goods made in factories to make something beautiful and useful. Some quiltmakers indeed used scraps, but these typically were leftovers from dressmaking rather than used bits of clothing or furnishings. With cheaply available factory-produced cottons, women could afford to make multiple sets of clothing and garments with more tailored fit that left a profusion of scraps perfect for quiltmaking. This excess fabric could be cut to size and stitched into pieced or appliquéd quilts. Women also bought fabric specifically to use for making quilts, with some fabric printers designing printed cottons for this purpose.[16]

Adding to the ease in producing quilts was another product of industrialization: the sewing machine. Although a variety of machines had limited consumer availability prior to the 1850s, during the last several decades of the nineteenth century women eagerly acquired sewing machines to assist them in what many considered the drudgery of home sewing.[17] The Singer Company's promotion of a convenient payment plan allowed families to acquire sewing machines with five-dollar monthly payments beginning in the late 1850s; widespread ownership occurred after 1870. Although domestically stitched clothing was likely the primary use for sewing machines, women also embraced the technology in their quiltmaking, with machine-stitched borders commonly appearing on quilts.[18] Amish women, who, as we will see, had begun making quilts by the last decades of the century, seem to have quickly adopted the use of sewing machines, for early Amish quilts dated to the 1870s and 1880s were stitched by machine.[19]

In addition to its close link to industrialization, quiltmaking was also a commercialized pastime. As early as 1835, *Godey's Lady's Book,* a popular women's magazine,

published a quilt design, a practice that greatly increased toward the end of the century.[20] Published patterns appearing regularly in women's magazines and farm periodicals during the last decades of the century were frequently realized into completed quilts. Some magazines also solicited readers to send in quilt designs for publication. Taking a cue from the success of such patterns, commercial enterprises including the Modern Art Company and the Ladies Art Company began selling quilt patterns on mail order in the 1890s.[21] Around this same time, coinciding with increased access to and proliferation of quilt patterns, Amish women picked up the craft. Whereas many of their English, Scots-Irish, Welsh, Quaker, and other Germanic neighbors had been making quilts for many decades, evidence—in the form of extant examples and probate records—suggests that Amish women began making quilts in earnest around 1880, a century later.

THE ORIGINS OF AMISH QUILTMAKING IN CONTEXT

Today quilts are among the objects most specifically associated with the Old Order Amish, but Amish quiltmaking is actually a relatively recent phenomenon. For decades after many of their neighbors began making quilts, the Amish continued instead to use bedding common to their Germanic heritage—chaff bag, featherbed, and a woven coverlet. However, during the mid- to late nineteenth century, Amish women in settlements in Pennsylvania, Ohio, Indiana, and Illinois began to make quilts.[22]

Despite much speculation, there is no coherent narrative that explains the development of quiltmaking among the Amish. Unfortunately, many of the details are probably lost to history. Since the "discovery" of Amish quilts in the late 1960s, authors have written at length about Amish women borrowing the quiltmaking practices of "English" neighbors, about the design sources for patterns, and about the linear evolution of Amish quilts from simple to complex. Some have speculated that Amish quiltmakers found inspiration in their environment, drawing on hymnal covers, ploughed fields, and fencerows as sources for patterns.[23] Others have studied quiltmaking traditions from other ethnic and religious groups to conclude that Amish women may have adapted their practices from those of Welsh, Quaker, or other non-Amish quiltmakers.[24] Some authors have surmised that quiltmaking spread among Amish communities from east to west, with Pennsylvania Amish beginning quiltmaking before those in settlements in Ohio, Indiana, or Illinois.[25] Simply stated, no study has drawn on enough dated examples of quilts to document credibly when, where, or why Amish quiltmaking began. Much of the evidence is stylistic and assumes that Amish quiltmaking practices must have evolved from simple plain quilts to more complex pieced patterns.[26]

Historian Patricia Keller found in her exhaustive study of probate records of Lancaster County residents from 1750 to 1884 that quilt ownership among Pennsylvania Germans in the Cocalico Valley in northeastern Lancaster County began during the decade 1825–34 and increased throughout the end of her study period. Keller argues

that quilting was disseminated across social and economic lines rather than across ethnic lines, with rural women adopting the quiltmaking practices of wealthier, more sophisticated Pennsylvania German women living in the relatively more urban borough of Lancaster. This conclusion is in contrast to studies assuming that rural Pennsylvania Germans must have learned to quilt from "English neighbors." Keller's study does not differentiate among Pennsylvania German groups; the probate inventories she surveyed were from sectarian Anabaptist groups, including individuals of Amish, Mennonite, and Brethren affiliations as well as from Lutheran and Reformed congregations (sometimes called "Church Germans").[27] Thus, details regarding when and why Lancaster County Amish quiltmakers in particular began quilting (as opposed to Pennsylvania German quiltmakers in general) were beyond the scope of Keller's study.[28] If what Keller demonstrates is true for rural Pennsylvania German women at large is also true for the Amish, then Amish women in this region likely adapted the quiltmaking practices of more worldly Pennsylvania German women, such as Mennonite or Brethren neighbors, or from Church Germans, with whom they also interacted. In the nineteenth century, there were fewer distinctions separating Pennsylvania German groups, who shared broader religious practices of Pietism and the Pennsylvania German dialect, attended schools together, and conducted business at the same mills, distilleries, markets, and shops.[29] Many rural Church Germans had cosmopolitan friends and relatives in cities, including Lancaster and Philadelphia. Given Keller's findings, quiltmaking practices could easily have trickled down from urban Pennsylvania Germans to rural ones, and eventually to the more conservative Amish.

Quiltmaking likely began in earnest after Amish settlers founded new communities in western outposts, rather than originating in eastern Pennsylvania and transplanting with quiltmakers to new communities.[30] As discussed above, the craft requires an excess of fabric as well as time to laboriously piece and quilt, resources abundant only after settlements on the frontier were firmly established.[31] Amish had already founded settlements in central and western Pennsylvania by the last quarter of the eighteenth century. Some Amish from these newer Pennsylvania settlements moved further west to Ohio in 1808; others settled in Indiana in 1841, with additional settlements soon to follow.[32] Many of these Amish pioneers settled in close proximity to other Germanic groups, especially Mennonites. Intermingling occurred at church, at school, and in commerce; and perhaps in a pattern similar to that of Lancaster Amish, quiltmaking spread through a social network of German-speaking friends and relatives.[33]

The number of extant dated quilts from the late nineteenth and early twentieth centuries increases right alongside the growing Amish population. When Amish women began making quilts, the group's population was quite small; accordingly, a mere twenty-five quilts have dated inscriptions prior to 1890.[34] In 1900—the earliest year with reliable population estimates—there were only 4,800 Amish scattered among fewer than twenty settlements stretching from eastern Pennsylvania to as far west as Oregon. Although they established many small settlements, drawn west by government and railroad advertisements for cheap land, Amish population was centered in

settlements in Lancaster (established c. 1760), Mifflin (1791) and Somerset Counties (c. 1772) in Pennsylvania; Holmes County, Ohio (1808); Lagrange and Elkhart Counties in Indiana (1841); Douglas and Moultrie Counties in Illinois (1864); Johnson County, Iowa (1846); Reno County, Kansas (1883); and in Ontario (1824).[35] Estimating that children made up at least half of the Amish population in 1900 (as they do today), there were only around 1,200 adult Amish women who could have engaged in quiltmaking at the turn of the twentieth century. Population grew fairly rapidly, reaching an estimated total of 8,550 by 1910 and 16,500 by 1930.[36]

Quiltmaking took root after a division in the Amish communities produced two groups: the more tradition-oriented Old Order Amish and the more change-minded Amish-Mennonites. This division occurred without a well-defined date, since the process transpired slowly and at different moments in different communities. The Old Order Amish emerged as a distinct group around 1865 when the more tradition-minded Amish bishops and ministers stopped attending meetings at which both conservative and somewhat more progressive Amish leadership discussed issues including church discipline, dress standards, political participation, baptism practices, and the use of lightning rods.[37] Making quilts—an act that did not factor into the schism—perhaps became an acceptable cultural practice only after the lines between progressive and conservative groups had been established. Quilts usually did not play a controversial role in Amish life.

Only among the most traditional groups that emerged following subsequent divisions have quilts become subjects of religious contention. For example, after the splinter group commonly known as the Nebraska Amish broke away from other Amish in Mifflin County, Pennsylvania, in the 1880s, they embraced an ultra-conservative interpretation of the *Ordnung*, choosing more traditional styles of peasant dress reminiscent of eighteenth-century Europe, unpainted houses and barns, and quilts made in the most simple pieced patterns—Four Patch and Nine Patch. Quilts did not factor into the schism, but quilts made after the division reflect the Nebraska Amish decision to retain conservative practices that would distinguish them from their more progressive Amish neighbors.[38]

Perhaps in more obvious ways, other objects similarly served as symbolic reminders of division. Telephones, while not at the root of a 1909 schism in Lancaster County, became contentious objects. Some Amish families had installed telephones when they became available early in the twentieth century. But around 1908 Amish bishops in this settlement decided to ban telephone ownership. Coinciding with this prohibition was a division among the Lancaster Amish, with the more progressive faction known as the Peachy church leaving the Old Order. Members of the Peachy church soon installed telephones in their homes, resulting in a new symbol separating the two factions. As anthropologist Donald Kraybill explains, the Old Order Amish could not adopt the use of telephones in homes "without a severe loss of face" because it would result in a "de facto endorsement of the insurgents."[39] Because quilts played no such significant role in the late nineteenth-century schism between the Old Order and Amish-Mennonites,

quiltmaking emerged in the decades to follow as an acceptable cultural practice rather than a controversial one like the ownership of telephones.

By exploring how Amish communities have experienced gradual change and adaptation in other daily life practices, we can hypothesize how women adopted a new cultural practice of making quilts. Typically, individuals have been the instigators of change, pushing the community from its edges to adopt objects and practices outside the group's range of conformity: decorative molding in a bedroom, snaps rather than hooks and eyes to fasten clothing, electric lights on horse-drawn buggies, or quilts instead of woven coverlets. These new "fashions," however, have typically already been out of date or irrelevant to mainstream society, so they have not affected the cultural fences separating the Amish from the world. Thus, they posed no direct threat to the stability of the community.[40] As one Amish bishop explained, "Well, change just kind of happens." It happens when someone on the periphery of Amish culture adopts a new practice and it meets little complaint; if others also adopt the practice, it soon becomes acceptable, perhaps even the default.[41] Likely, an innovator within the Amish community learned to quilt in the mid- to late nineteenth century, borrowing patterns and techniques either from friends or neighbors of non-Amish sectarian groups such as Mennonites or Church of the Brethren, or perhaps from Quakers, Scots Irish, or Welsh quiltmakers. As other friends and relatives adopted the practice, quiltmaking soon became common.

Ever since Jacob Ammann, the leader of the breakaway Amish group in late seventeenth-century Europe, admonished against fashionable clothing in the 1690s, members of the Amish church have used dress as a distinctive marker.[42] In the spirit of *Gelassenheit*, dress reminded believers that they were to remain separate from the world, yielding to the community rather than following individual will. Conforming to one another in dress was a means of boundary maintenance, but it was also a means of keeping pride at bay: by not following mainstream American fashions, Amish church members did not share the world's status cues.

When individual Amish women pushed the limits of their communities' standards by trying a shorter skirt or a fancier sleeve, these subtle changes were irrelevant to mainstream fashions. Such adaptations did not alter the cultural fences separating Amish from the outside world; thus, while they may have raised a few eyebrows among coreligionists, they were not necessarily against the *Ordnung*. Similarly, when Amish quiltmakers experimented with techniques, fabrics, colors, or patterns that stretched the usual repertoire of quiltmakers within their community, these adaptations were noticeable but were of little consequence because they did not change the church's cultural boundaries. Only outsiders who later studied Amish quilts from a connoisseurship perspective considered these changes relevant. In most communities—some strictly conservative Amish offshoots like the Nebraska Amish being the exception—there were no exacting rules governing how a quilt should look.[43] Yet because the Amish valued conformity over individualism, some common design characteristics emerged.

Despite these commonalities, there were always innovators when it came to quilts, just as in other aspects of Amish culture.

QUILT MYTH MAKING

Perhaps members of Amish communities readily embraced quiltmaking during the late nineteenth century in part because the dominant culture understood quilts as old-fashioned objects, as discussed in the first part of this chapter. The Amish themselves would not have been active participants in the visual culture of the burgeoning Colonial Revival, yet they may have bought in to some of its underpinnings, just as other Americans who were confronting the rapidly changing world of the late nineteenth century attempted to hold tight to perceptions of a simpler, more virtuous past in which people made things at home.[44] The Amish may have perceived quilts—regarded as old-fashioned objects within society at large—as a safe form of cultural production removed from the fashionable mainstream, even though quilts were just as influenced by industrialization and consumer culture as they were imbued with nostalgia. The Old Order Amish, the group that emerged post-schism, actively worked to define their boundaries with the swiftly progressing world at large, and quilts may have fit perfectly into their mindset of a culture yearning to be grounded in the past.[45]

Today, when Amish women recall that women of their faith have "always" made quilts, they are participating in the ongoing work of quilt myth making. By adopting the craft of making quilts only after the dominant culture had imbued these objects with a heavy dose of nostalgia, Amish women solidified their own place within the quilt narrative. By embracing a cultural tradition not their own, they inserted Amish heritage into the story of quilts as emblems of virtue, hard work, and thrift. Even though they were late to the quilting party, Amish women made it their own, emerging as the torchbearers of the preindustrial world long gone. Just as Americans flocked to see the "colonial kitchens" at late nineteenth-century world's fairs, people from all over the world now see the Amish, and in turn their quilts, as remnants of a colonial past. The quilting myths continue to resonate.

CHAPTER **2**

- -

AMISH QUILTS,
AMISH VALUES

On Palm Sunday in 1965, a series of thirty-seven tornados swept across

the Midwest, killing more than 250 people and causing some of the worst damage in northern Indiana. Among those experiencing the brunt of the storm were members of the Old Order Amish settlement in LaGrange County, Indiana, including Olen and Irene Wingard, who lived near Shipshewana. Olen Wingard recalled that when he and his young family with five children ages two to seventeen saw the funnel cloud approaching, "we did not walk for the basement, we ran." Moments later, when the Wingards returned above ground, their barn and other outbuildings had been leveled, and the roof and rafters of their house had blown off.[1]

As had long been Amish custom, coreligionists relied on mutual aid rather than on commercial insurance to cope with their losses.[2] Amish from as far away as Lancaster County, Pennsylvania, organized transportation and work crews to travel to LaGrange County, where they helped Amish and non-Amish families alike clean up the debris and rebuild. An estimated one thousand Amish men from Lancaster traveled to northern Indiana during the weeks following the storm to volunteer with Mennonite Disaster Service, an organization that responded to natural disasters with volunteer labor.[3]

Along with labor, food, and rebuilding supplies, coreligionists from the East sent quilts. The Wingards received a Center Diamond quilt, a favorite pattern in Lancaster County that was rarely made in Indiana. The quilt—with a faded red diamond, intricate feather quilting, and the initial "K" cross-stitched in red in one corner—was not new but was likely made during the first several decades of the twentieth century (fig. 2.1).[4] The Amish family in Lancaster who parted with their quilt recognized that someone needed it more than they did and hoped that it might provide comfort, both physically and symbolically.[5] Despite the distance between these two communities and the differences in their *Ordnungs*, the guidelines governing their settlements, both the donor and the recipient understood the quilt's role in binding their communities together. In this and many less dramatic ways, Amish quilts functioned within the community not only as bedcovers but as objects reflecting Amish cultural values.

Prior to the late 1960s, "Amish quilts" were just quilts—made, used, and displayed in Amish homes—rather than iconic works of art worth lots of money. It is easy to forget, after more than forty years of exhibitions, books, postage stamps, and magazine spreads highlighting their bold colors and strong geometrics, that these objects

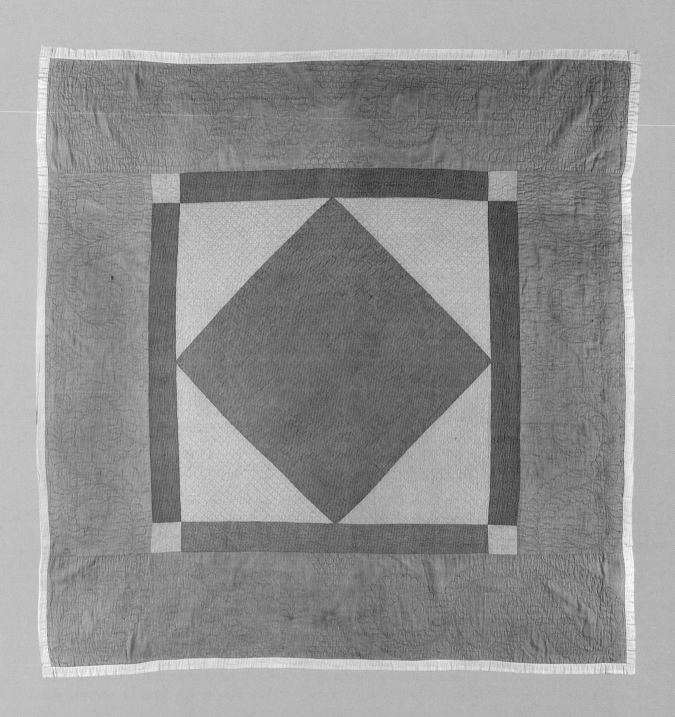

were the products of homes and were used, loved, neglected, cherished, or stored away before they were ever sold, photographed, or hung on walls. When non-Amish became intrigued with these quilts and were willing to pay significant sums of money to own them, Amish people in turn reevaluated their old bedcoverings, often choosing to sell them—despite cultural and emotional attachments—rather than to own objects that outsiders considered desirable pieces of art.

Within Amish families and communities, quilts and quiltmaking were part of two divergent but persistent aspects of Amish culture: *Gelassenheit* and adaptation. Scholar Donald Kraybill explains *Gelassenheit,* one of the guiding ideals shaping Amish culture, as an "abstract concept that carries a variety of meanings—self-surrender, resignation to God's will, yielding to God and to others, self-denial, contentment, a calm spirit." In daily practice, *Gelassenheit* is the principle behind Amish practices of material detachment, thrift, humility, serving and respecting others, obedience to the community and to God, and an emphasis on conformity rather than individualism. Aspects of this concept, which have roots in the church's history, are what most clearly separate Amish believers from "the world."[6]

The persistence of the Amish as a religious group can be attributed to the subculture's ability to adapt their cultural practices and traditions with limitations.[7] Selective change, often in the form of compromise, has prevented additional schisms between more progressive Amish and those who preferred to adhere to tradition. Although the outside world, with its romantic notions of Amish simplicity and authenticity, may view any modifications within this seemingly fossilized culture (or its quiltmaking) as corruption, members of the Amish church have not judged so harshly. Changes that have no direct impact on worship practices, family solidarity, or symbols of Amish identity—use of horse and buggy or plain dress, for example—have been more acceptable than those deemed more disruptive.[8] Within this context, change has occurred at a slow pace and according to Amish principles that value the community over the individual. When a break with tradition poses little threat to communal values—the use of synthetic fabrics in clothing and quilts, for example—there is little reason for members not to embrace it.[9] Thus, the religious group's practices—and in turn its quilts—have not been static. Since the 1970s, outsiders' fascination with these objects has been a significant stimulus for changes both in Amish quiltmaking practices and in how members of the church valued their quilts.

Indeed, the Amish have never existed in a vacuum removed from the outside world. Although Amish doctrine's emphasis on separation of members of the faith from the "the world" has dictated distinct cultural practices—plain dress, use of horse and buggy, a ban on high-wire electricity—members of the church have long been aware of the fashions and technologies of the surrounding culture.[10] As individuals adopted (and adapted) fashions of the world at large, these trends—like synthetic fabrics or commercial quilt patterns—became Amish fashions. However, Amish fashions have lagged behind, with individual choices influenced much more by coreligionists than by outsiders.[11]

Figure 2.1. Center Diamond, unknown Amish maker, c. 1910. Pennsylvania. 72 x 72 in. The Wingard family in Indiana received this quilt after a devastating tornado struck their farm in 1965.

(From the collection of the Indiana State Museum and Historic Sites, 71.989.001.0371)

The outside world has become primarily familiar with quilts that the Amish have long referred to as "old dark quilts," and many collectors, curators, critics, and dealers have called these "classic Amish quilts."[12] Collectors sought out these quilts, stitched from rich, solid-colored natural fiber fabrics into geometric forms, because of their resemblance to modern art. Many of these were considered "best quilts" in Amish families, were given as gifts from parents to children, and received limited use on guest beds or were displayed on beds only when families hosted church in their homes.

As a result, the quilts in private and public collections tend to be of a certain variety: the old dark ones that remained in excellent condition because they were not used much. But Amish women did not limit their efforts to making quilts that would look especially striking from the long sight lines of a museum gallery. Nor did they strictly make quilts that adhered to outsiders' idealized standards of what an Amish quilt should look like: appropriately plain, with solid-colored fabrics, dark colors, and unexpectedly modernist design. Instead, Amish quilts and quiltmaking practices share much in common with the diverse traditions of dominant American culture. Many Amish quiltmakers have made quilts that do not look distinctly Amish to outsiders. But most of the quilts that non-Amish collectors have purchased, written about, and exhibited conform to the "rules" for what an Amish quilt should look like. Sociologist Karin Peterson describes the "modern eye" as "a particular way of seeing and appreciating art that draws on modernist aesthetics."[13] When viewed through the filter of a modern eye, only certain Amish quilts—the ones that looked sufficiently modernist—were considered truly Amish. Yet these select quilts do not reflect the historical development, complexity, or diversity of Amish culture and among Amish quilts. Rather, they reflect the collecting preferences of late twentieth-century Americans with a penchant for modernist art, as subsequent chapters will demonstrate.

Amish quiltmaking—like Amish culture itself—has been much more diverse than most exhibitions and coffee table books surveying Amish quilts would suggest. By referring to certain bedcovers as "old dark quilts," Amish individuals have distinguished these from ones that were not old and not dark. Quilts pieced from dark, solid-colored fabrics in graphic, geometric patterns were distinct from mainstream American quilts and thus looked conspicuously Amish. But Amish quiltmakers made many other kinds of quilts, like blue and white "everyday" quilts (fig. 2.2), appliquéd quilts, knotted crazy-patched comforters (fig. 2.3), white whole cloth quilts, and embroidered friendship quilts. Pickers—wholesale antiques dealers who bought quilts directly from Amish families—tended to ignore these sorts of quilts or soon disassociated them from their Amish origins. Yet many non-conspicuously Amish quilts also reflect aspects of *Gelassenheit* and adaptation, as we will discover in this chapter.

THE CULTURAL VALUE OF QUILTS

While outsiders may have valued Amish quilts primarily as art objects and commodities, Amish have valued quilts they owned for more symbolic reasons. Quilts had

Figure 2.2. Ocean Wave variation crib quilt, made by Anna Kauffman Miller, 1925–26. Middlebury, Indiana. Cotton, 43 x 32 in. This is an example of a blue and white quilt, a color combination common within some Amish communities but generally overlooked by quilt collectors.

(From the collection of the Indiana State Museum and Historic Sites, 71.989.01.452)

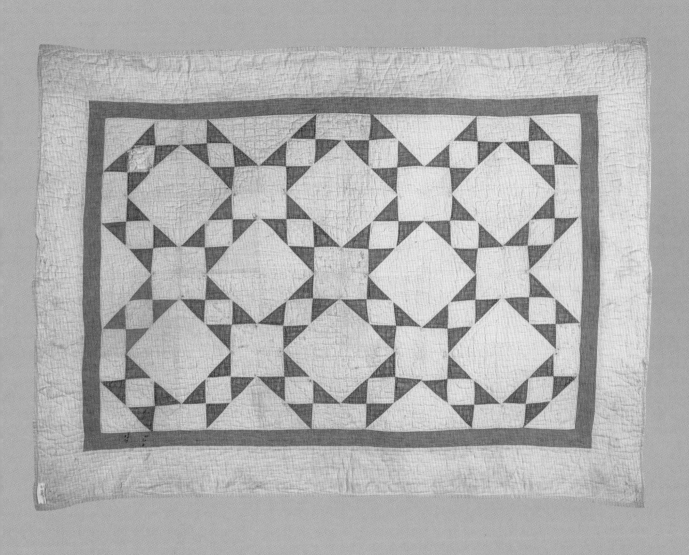

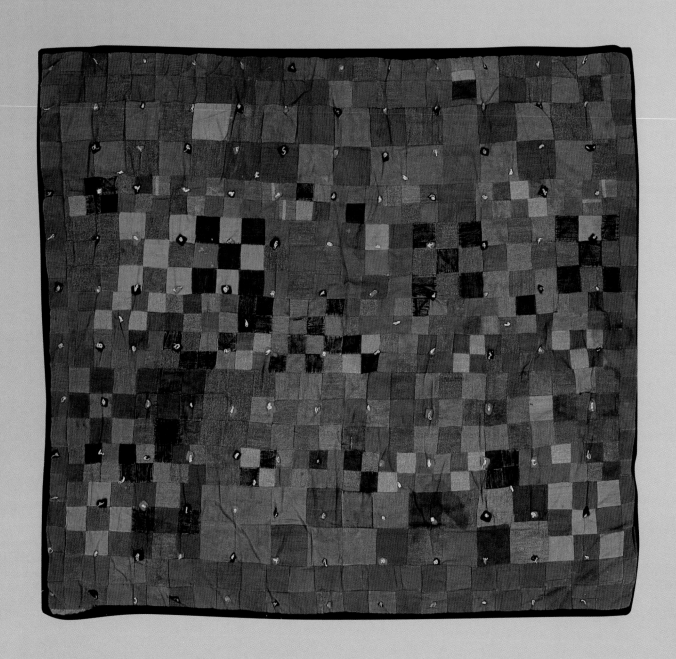

the ability to reinforce aspects of *Gelassenheit.* Through gift-giving traditions and quiltmaking organized by members of the community to mark events or solidify ties, quilts reminded members of the Amish faith that individuals were subordinate to the community.

Within Amish homes, quilts were often valued primarily because they tied one generation to another. Many Amish women made quilts with the intention of giving them to grown children as a "gift from home" or "to fit for housekeeping," a practice called *Aussteier* in Pennsylvania German. Parents typically gave gifts from home when children prepared for marriage or for living on their own as adults. Earlier non-Amish dowry practices often had legal precedents relating to gendered property rights. Gifts from Amish parents to both daughters and sons, however, were culturally rather than legally determined rituals that enhanced familial bonds. Although comparable dowry traditions date from centuries earlier, the Old Order Amish were one of few tradition-minded groups that continued practices of "advancing" household goods to the next generation throughout the twentieth century. Although the objects given as part of this tradition varied, the act of receiving gifts from home tied each generation to tradition, another of the guiding tenets of *Gelassenheit.*[14]

Some mothers made quilts to "advance" to their children, while others hired women in the community to do aspects of the work. Not every Amish woman enjoyed making quilts or felt she had the necessary skills. Amish women from the Lancaster County settlement recalled that "making quilts" referred primarily to the act of quilting rather than the piecing, appliqué, or embroidery creating the decorative quilt top. Both mothers and their offspring described quilts as "made for my daughter" or "made by my mother" even if another seamstress was hired to make the quilt top.[15] In Lizzie Zook's words, "There were always people who enjoyed [piecing], and some are better at it than others." Rebecca Esh agreed: "I quilt, but I'm not a piecer!"[16] Malinda Stoltzfus, a Lancaster Amish woman born in 1900, pieced quilt tops for pay for many others in her community. Customers supplied Stoltzfus with the fabric for patterns of their choice, such as Center Diamond or Philadelphia Pavement. Upon completion of the top, the customer held a "quilting frolic" to finish the piece.[17] Young women preparing for marriage helped with the quilting; sons were not expected to contribute to the project.[18] Occasionally, families hired out the quilting. For example, in the early twentieth century Hannah Stoltzfoos's grandfather hired a widowed neighbor woman with particularly excellent quilting skills to stitch the quilts made for his children.[19]

As early as the 1920s, some Amish children received "spreads" in addition to or instead of quilts. Bedspreads, a catchall term for store-bought blankets, were popular in many Amish homes largely because they were easily washable compared to quilts, which required more delicate handling, especially those made from wool.[20] One Amish woman even referred to "the time of bedspreads," the mid-twentieth-century decades when store-bought bedcovers were considered more fashionable than quilts as part of *Aussteier* practices.[21] Later in the century, particularly after the emergence of outsider

Figure 2.3. Nine Patch Four Patch, knotted comforter or "hap," unknown Amish maker. LaGrange County, Indiana. 63 x 72 in.

- - - - - - - - - - - - - - - - - - - -

(From the collection of the Indiana State Museum and Historic Sites, 71.989.001.0993)

- - - - - - - - - - - - - - - - - - - -

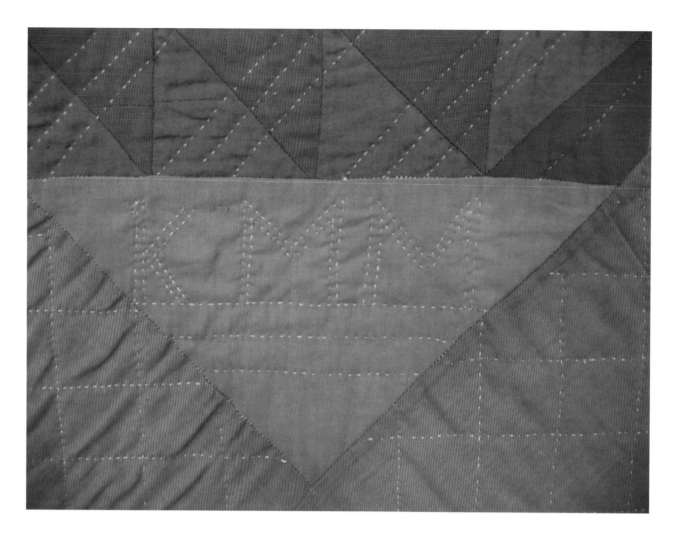

interest in Amish quilts, families once again viewed quilts as more desirable gifts from home.

Bedding was just part of a typical advancement from Amish parents. Twentieth-century parents provided their offspring with a variety of other housekeeping gifts, such as furniture pieces, sets of dishes, and linens. Other advancements might include a horse and buggy, agricultural implements, and land. These gifts helped maintain familial ties and also represented the earnings of children who had contributed to the family's income either by working on the farm or hiring out as wage laborers. While children lived at home their parents generally kept the income they earned, a practice that adheres not only to tradition but also to *Gelassenheit*'s concept of yielding to the community, in this case the family.[22]

Sometimes the recipients of quilts "from home" kept them stored away, occasionally wrapping them in tissue in a chest for safekeeping.[23] In this respect, many individuals did not consider these quilts utilitarian. They cherished them as heirlooms, displaying them only on guest beds or when the family took its turn hosting church in their home. As a result, these well-preserved quilts survived in excellent condition for generations, eventually becoming sought-after art objects.

Figure 2.4. Detail, Flower Baskets, by Mary Yoder and Katie M. Yoder Miller, dated March 11, 1925, inscribed "KMM" for Katie and "MJM" for Monroe J. Miller. Honeyville, Indiana. Cotton, 77 ½ x 66 ¾ in.

(From the collection of the Indiana State Museum and Historic Sites, 71.989.001.249.)

Although practices varied from community to community, many quilts from home bear the initials of the recipient (fig. 2.4). Collectors and dealers, however, typically assumed that initials indicated a maker's name—a quiltmaker signing a quilt much as an artist signs a painting. Such is sometimes the case for signed quilts made by the non-Amish. But within the Amish church, initials marking who made the quilt could be considered an act of pride, going against the grain of *Gelassenheit*. The recipient was more important than the quiltmaker. In Indiana and Ohio, many gifted quilts also have a stitched date. The initials and dates functioned as emblems that reminded owners of quilts' significance as gifts tying generations together.

Amish people also valued quilts because they tied together members of their larger community. Groups made friendship quilts with blocks signed by friends and relatives. Members of the Old Order Amish also made quilts for relief, either to give to coreligionists in need of warmth and comfort or to people in need living far away in foreign countries. Charitable auctions sold Amish-made quilts, raising money to help the local community or an international cause.

Friendship quilts had been popular among American quiltmakers since the 1840s, well before Amish women began quiltmaking. Sometimes quilts were presented to a church's minister when he left for another parish. Others were made to celebrate a

Figure 2.5. Detail, Fans. Unknown Amish makers. Dated May 10, 1899. Topeka, Indiana.

- -

(International Quilt Study Center & Museum, University of Nebraska–Lincoln, 2009.039.0064)

- -

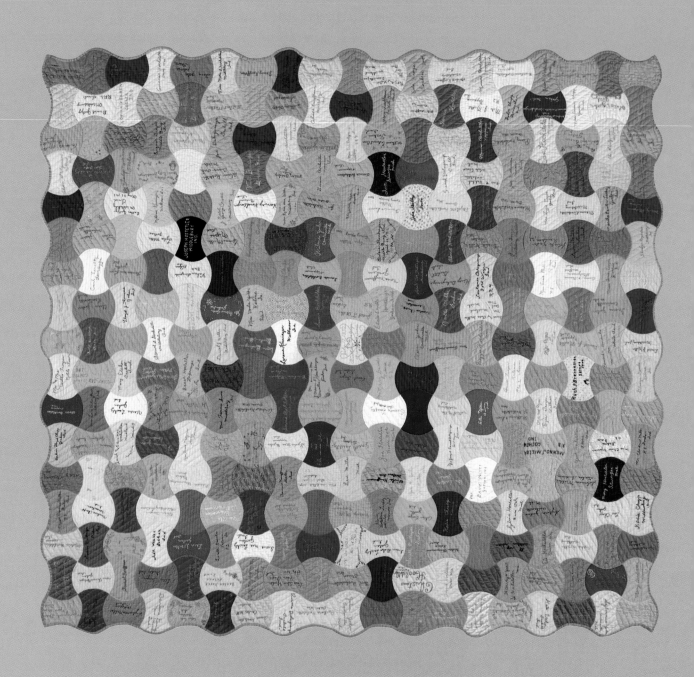

marriage or engagement or to send with a friend who was moving away.[24] Mid-nineteenth-century quiltmakers typically signed their names with indelible ink. Toward the end of the century when the friendship quilt fad resurfaced, particularly among more rural women, makers embroidered their names into quilt blocks rather than using ink.[25]

Like the non-Amish quiltmakers before them, groups of Amish women added their initials and names to quilts as a means of symbolically linking together members of a community. This adaptation of a non-Amish quiltmaking practice was particularly well suited to *Gelassenheit*'s emphasis on elevating the community above the individual. These quilts often served as gifts, solidifying relationships stretching beyond immediate family. Groups of friends executed these quilts to mark various occasions using a variety of styles and formats, usually signing their names or initials in embroidery stitches. In contrast to gifts from home, it was common for contributors to sign their own names and initials on friendship quilts. The earliest identified Amish friendship quilt, dated May 10, 1899, includes messages such as "Remember Me," and "Forget Me Not," sentiments also common on non-Amish friendship quilts (see fig. 2.5).[26]

Sometimes friendship quilts were created from a geographically dispersed community, solidifying bonds among midwestern Amish who moved frequently throughout the twentieth century.[27] Cora Etta Harshberger of Nappanee, Indiana, organized one such example for her son Lewis (fig. 2.6). She mailed spool-shaped templates to his friends and relatives prior to his twenty-first birthday and marriage to Lizzie Hochstetler. The response to her request for embroidered blocks was so great that she completed one quilt for Lewis and then gave enough extra blocks to his wife for her to complete a second one. The resulting quilts include names from friends and relatives in Indiana, Illinois, Wisconsin, Iowa, Kansas, Oklahoma, and Michigan.[28] Amish in northern Indiana made a number of these spool friendship quilts, which likely spread as a fad with friends and neighbors making blocks for one another.[29]

When Amish individuals or families moved from one community to another, friends sometimes sent them off with a friendship quilt. Earlier in the twentieth century, these tended to be embroidered modestly with initials, like the one neighbors made for Andrew Mast's family in 1921 when they left Middlebury, Indiana, to move thirty miles away to Nappanee (fig. 2.7). By the 1950s, quilts made for families moving away sometimes included full names and even mailing addresses, so these friends could keep in touch across distances (fig. 2.8).[30]

Other Amish quilts embroidered with names tied together individuals who shared a specific experience. In 1926 Anna V. Miller of Honeyville, Indiana, embroidered each of her schoolmates' names on a quilt to mark the year she finished her formal education in eighth grade. Rather than having them help, Anna embroidered the names herself, using bright red floss that stood out on the lavender and green blocks (fig. 2.9).[31] This quilt was a keepsake that could remind her of her classmates long after she was through with school.

Just as families rallied to one another's sides to help rebuild barns destroyed in fires, they comforted each other with gifts of quilts. The Amish church has had a strong

Figure 2.6. Spools, by Cora Etta Harshberger and friends of her son Lewis, dated July 17, 1932. Nappanee, Indiana. 85 x 75 in.

(From the collection of the Indiana State Museum and Historic Sites, 71.989.001.0403)

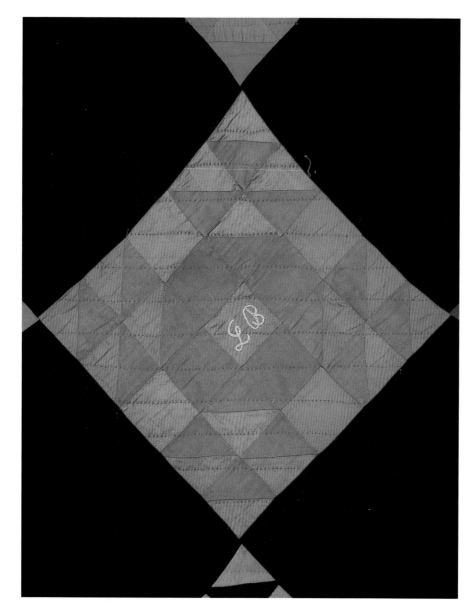

Figure 2.7. Detail, Geese on the Pond, by friends of the Andrew and Dena Mast family, 1921. Middlebury, Indiana. 94 x 79 in. Neighbors of Andrew and Dena Mast's family made this friendship quilt for them before they moved from Middlebury to Nappanee, Indiana.

- -

(From the collection of the Indiana State Museum and Historic Sites, 71.989.001.0233)

- -

tradition of service and mutual aid, another characteristic closely associated with *Gelassenheit*. One of the most recognizable manifestations of this practice is the barn raising, in which a community comes together to rebuild a barn in one day.[32] When fire destroyed Ammon Yoder's northern Indiana home in 1940, neighbor women made his family a navy and red quilt, quilted with a dove motif.[33] Many Amish quiltmakers provided bedcovers for Christian Aid Ministries, an Anabaptist charitable organization that sent material and monetary resources to Christians living in Latin America, Africa, and Eastern Europe.[34]

During the second half of the twentieth century, in addition to making quilts for relief, quiltmakers created quilts for benefit auctions. Here quilts, along with other used and new goods and traditional foods, were sold to raise money for a good cause such as a local Amish school, a volunteer fire company, a family with medical bills, or a charitable

Figure 2.8. Detail, friendship quilt, by friends of Martha Helmuth, 1956. Various Midwestern Amish settlements.

Figure 2.9. Detail, One Patch, by Anna V. Miller, dated March 16, 1926. Honeyville, Indiana. 76 ¼ x 68 ¾ in. Miller embroidered this quilt with the names of her classmates and teacher at Roderick School.

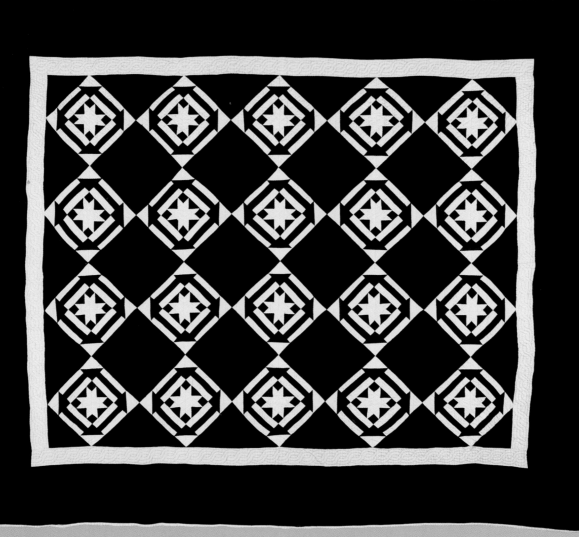

Figure 2.10. Hole in the Barndoor
variation, by Susie J. Christner
Yoder, dated March 16, 1948,
initialed "D.M.Y." for Daniel Menno
Yoder. Topeka, Indiana. Cotton,
92 ½ x 77 in. One of 11 identical
quilts made by Yoder for her four
children and seven step-children.

(From the collection of the Indiana
State Museum and Historic Sites,
71.989.001.0285)

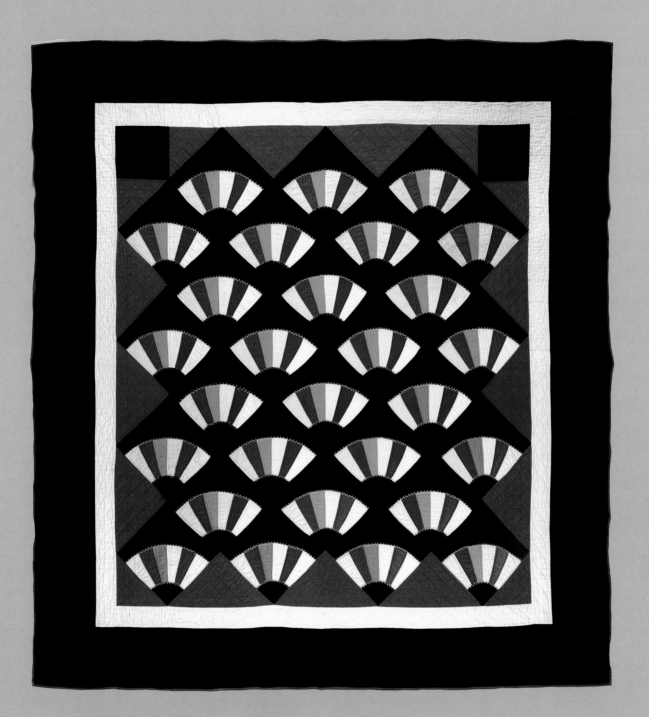

Figure 2.11. Fans, by Annie
Hochstetler Lehman, 1963. Topeka,
Indiana. 85 ½ x 78 ¼ in. One of
5 quilts in the same pattern that
the maker made between 1915
and 1963.

(From the collection of the Indiana State
Museum and Historic Sites, 71.989.01.336)

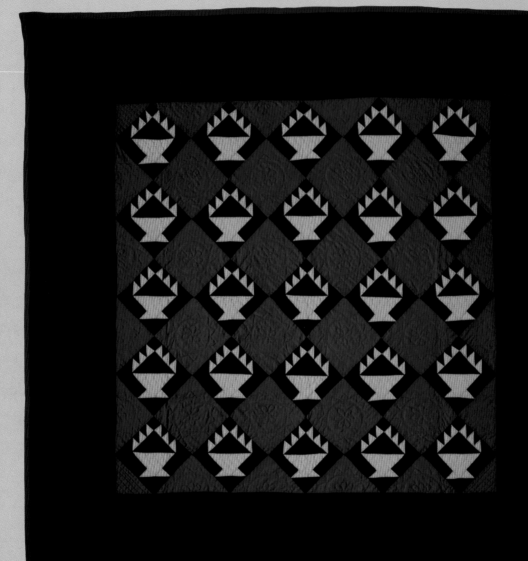

organization like Mennonite Central Committee. These quilts had not only symbolic value but also monetary value. When Amish quilts began to attract the attention of outsiders, non-Amish consumers attended auctions in hopes of acquiring authentic Amish quilts. Bidders—both Amish and non-Amish—might pay more, knowing that the income generated would support a worthy cause.[35]

CONFORMITY AND ADAPTATION

Amish quiltmakers made choices about what sorts of quilts to make based on familial and community preferences, availability of materials, and access to commercially published patterns. Many Amish quilts demonstrate that the cultural fences separating the Amish from the outside world were permeable rather than fixed. Although communally accepted design preferences emerged within individual settlements, Amish quiltmaking fashions were not static. Individuals used their favorite patterns and also adapted new ones. They looked to friends and relatives for inspiration, sometimes even hiring those with superior skills to do the work. And they created many quilts, some of which looked distinctly Amish and others that did not. The variety of Amish quiltmaking practices reflects the faith's enduring ability to conform to community standards yet to adapt as necessary.

Quiltmakers within some families used the same pattern repeatedly, reinforcing familial connections in the spirit of *Gelassenheit*. During the 1930s and 1940s, Susie Yoder made seven copies of a yellow-on-black Hole in the Barn Door quilt, each monogrammed with one of her children's initials and the date she began quilting it. These quilts conformed to one another, emphasizing that each child was equal in their mother's eyes. Susie chose a favorite pattern of her northern Indiana settlement but enlivened it with a creative addition of an eight-pointed star at the center of each block (fig. 2.10).[36] Another Indiana quiltmaker made quilts in the same color and pattern throughout her life. She made her first Fans quilt, dated January 8, 1915, in preparation for her own wedding. She made identical quilts for three of her sisters and then another in 1963, which she continued to use on her bed until 1984, when a collector offered her a price she could not refuse (fig. 2.11).[37]

The use of favorite patterns within a family could impart distinct meaning within familial gift giving traditions. An innovative quiltmaker in Lancaster County made repeated use of a particular Baskets pattern, resulting in quilts that her descendants have continued to consider distinct (fig. 2.12). Actually, this repeated block pattern (executed multiple times in rows, forming the quilt top's design) was common in Amish communities in Indiana and Ohio but unusual in Lancaster, where center medallion-style quilts like Center Diamond and Sunshine and Shadow dominated.[38] According to research conducted by the Lancaster County Quilt Harvest, Mary Stoltzfus Lapp (1875–1955) was the first Lancaster County Amish quiltmaker to use the pattern.[39] Lapp pieced quilts for her children, grandchildren, and coreligionists who requested quilt tops of particular patterns. Children and grandchildren named after Mary or her

Figure 2.12. Baskets, probably made by Mary Stoltzfus Lapp, c. 1935. Lancaster County, Pennsylvania. As of 2000, fewer than ten similar Baskets quilts had been identified, each originating within one of two families.

(From the collections of the Heritage Center of Lancaster County)

PRICE of PATTERNS 25c each; 5 for $1.00

No. 50 Size 18 in.
Columbian Star.

No. 51 Size 18 in.
Noon Day Lily.

No. 55 Size 18 in.
Basket of Lilies.

No. 57 Size 9 in.
Flower Basket.

No. 58 Size 12 in.
Cherry Basket.

No. 59 Size 10 in.
Cake Stand.

No. 60 Size 20 in.
Double Irish Chain.

No. 61 Size 18 in.
Odd Fellow's Chain.

No. 62 Size 15 in.
Shell Chain.

No. 63 Size 18 in.
Barrister's Block.

No. 501 Size 12 in.
Bleeding Heart.

No. 66 Size 18 in.
World's Fair Block.

No. 67 Size 24 in.
Railroad Crossing.

No. 68 Size 18 in.
Beggar Block.

No. 69 Size 12 in.
Tea Leaf.

No. 502 Size 12 in.
Autumn Leaf.

No. 75 Size 24 in.
Pinwheel Star.

No. 76 Size 9 in.
Double X, No. 1.

No. 77 Size 12 in.
Double X, No. 2.

No. 78 Size 9 in.
Double X, No. 3.

No. 79 Size 15 in.
Double X, No. 4.

No. 80 Size 15 in.
Cut Glass Dish.

No. 81 Size 16 in.
Pickle Dish.

No. 82 Size 18 in.
Five Patch.

—7—

Figure 2.13. Ladies Art Company catalog, published from 1897 through the mid-twentieth century. No. 59, "Cake Stand," is identical to the Baskets pattern made repeatedly by Mary Stoltzfus Lapp (fig. 2.12). This copy of the catalog was from the home of Amish woman Mrs. Noah J. Hostetler, Wayne County, Ohio.

- -

(From the collection of George and Susan Delagrange)

- -

Figure 2.14. **(opposite)** Whole cloth, made by Anna Christner Miller, c. 1932. Topeka, Indiana. Cotton sateen. 83 x 74 in. This design was inspired by a quilt marketed by the Wilkinson Quilt Company of Ligonier, Indiana. Miller gave it to her daughter Sylvia prior to her marriage to Jonas Hostetler.

- -

(From the collection of the Indiana State Museum and Historic Sites, 71.989.001.0316)

- -

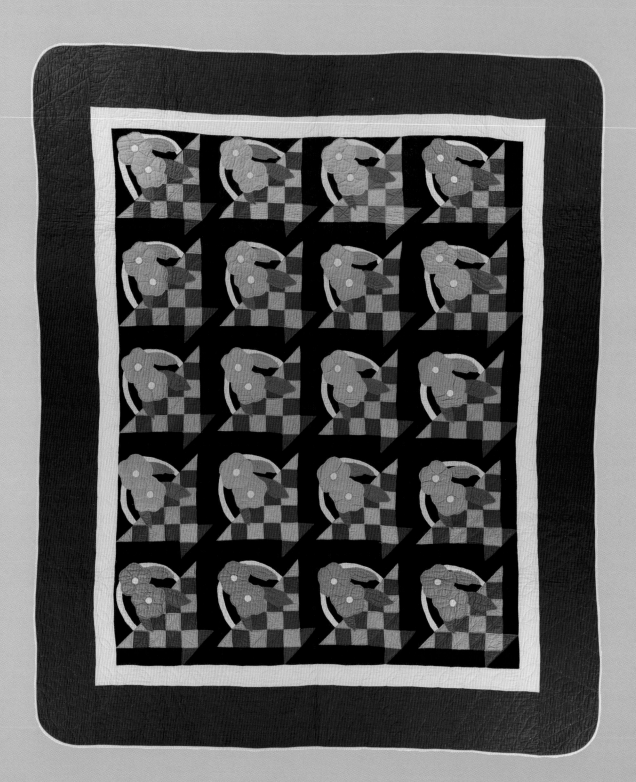

Figure 2.15. **(opposite)** Basket of Flowers, unknown Amish maker, c. 1935. Possibly made in Ohio. Cotton. 95 x 80 in. The maker adapted Mountain Mist pattern #K (fig. 2.16), probably acquired by purchasing a roll of batting.

(International Quilt Study Center & Museum, University of Nebraska–Lincoln, 2003.003.0108)

Figure 2.16. Mountain Mist pattern #K, "Basket of Flowers." *Stearns & Foster Catalogue of Quilt Pattern Designs and Needle Craft Supplies.* Mountain Mist has published this particular pattern since 1930.

husband Daniel—"namesakes"—received a Baskets quilt, while other descendants received quilts in other patterns. Family members considered the Baskets quilt pattern special because it was unusual and required more intricate piecing than many of the patterns common in the community.[40] Mary Lapp was a trendsetter who tried a new quilt pattern rather than conforming to what others typically did. Upon seeing these family quilts displayed on guest beds, others soon borrowed the pattern.

Around 1940, Amanda Smoker Stoltzfus saw a Baskets quilt displayed on a bed at the home of her sister Katie Smoker Glick (Mary Lapp's niece by marriage). She liked it so much she decided each of her own children should have one made in this pattern. Amanda asked her teenaged daughter, Sarah, to make the quilts since she did not piece herself. At the age of sixteen or seventeen, Sarah received the pattern and instructions for piecing the Baskets quilt from Barbara "Babbie" Glick, Mary Lapp's sister, and began piecing quilt tops for herself and her four younger siblings. Sarah's mother hosted quilting frolics, inviting aunts, cousins, and friends to help complete the tops her daughter pieced. When asked about these quilts as elderly women, Sarah and her sister referred to these identical bedcovers as "our quilts," distinguishing them from those made in other families. The pattern, while borrowed from Mary Lapp's family, was still distinct to Amanda Stoltzfus's children, and even as women in their 80s who had sold their quilts years before, they felt that this pattern bound the siblings together.[41]

Although Mary Lapp's family members assumed that she had conceived of the Baskets pattern with her own artistic imagination, she had undoubtedly seen the pattern published or executed on another quilt.[42] Like other American quiltmakers,

Figure 2.17. Detail, Nine Patch,
Barbara Yoder, c. 1920.
Weatherford, Oklahoma. 90 x 71 in.

(International Quilt Study Center &
Museum, University of Nebraska–Lincoln,
2005.039.0005)

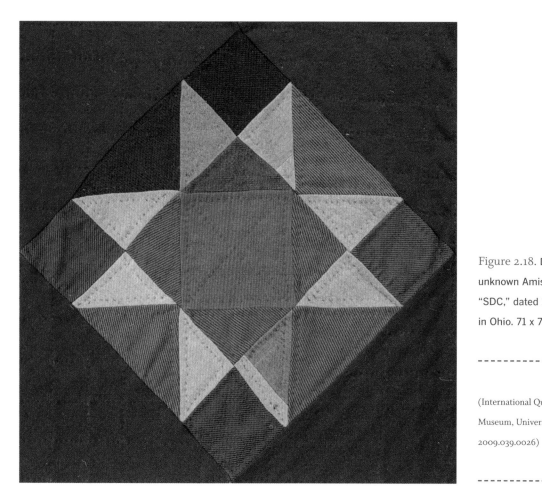

Figure 2.18. Detail, Ohio Star,
unknown Amish maker, inscribed
"SDC," dated 1906. Possibly made
in Ohio. 71 x 79 in.

(International Quilt Study Center &
Museum, University of Nebraska–Lincoln,
2009.039.0026)

Figure 2.19. Double Wedding Ring,
Susanna Miller Raber, c. 1940.
Topeka, Indiana. 58 ½ x 40 ½ in.
Raber recycled feed sack for some
of the background fabric.

(From the collection of the Indiana State
Museum and Historic Sites,
71.989.001.0444)

Figure 2.20. Detail of back of quilt shown in fig. 2.19. Printing from cloth sack label is visible.

- -

(From the collection of the Indiana State Museum and Historic Sites, 71.989.001.0444)

- -

some Amish women learned of designs through published patterns. Popular magazines such as *Godey's Lady's Book* published quilt patterns as early as 1835, well before Amish women started making quilts with regularity. By the time Amish women picked up the craft, syndicated newspaper columns in farm journals like *Ohio Farmer, Successful Farming,* and *Farm Journal* were publishing patterns. In addition, as early as 1895 the Ladies Art Company sold patterns through mail order, although clever Amish quiltmakers could have drafted their own patterns based on thumbnail images printed in its widely available catalogue. Among the dozens of images published in its catalog from 1895 through the mid-twentieth century was "Cake Stand"—the exact pattern of Mary Lapp's Baskets quilts (fig. 2.13).[43]

During the first several decades of the twentieth century when Amish women were making quilts in great numbers, they were part of a nationwide quiltmaking trend, and they drew inspiration from commercially available design sources. Creative use of patterns, kits, and catalogs expanded the variety of quilts made in conformity-minded Amish communities.[44] During the 1910s through 1930s, the Wilkinson Quilt Company of Ligonier, Indiana, marketed what it called "art quilts" through its catalog. In the early 1930s an innovative Indiana Amish woman used a Wilkinson quilting motif, based on an image from Wilkinson's catalog or from an "art quilt" itself, to make the whole cloth quilt she gave to her daughter (fig. 2.14).[45]

By the late 1920s, Stearns & Foster's Mountain Mist quilt batting line included a free pattern with each roll, and some Amish women purchased this product to use as quilts' inner layer, granting them access to a new pattern. In contrast to non-Amish quiltmakers, Amish women typically used solid-colored fabrics left over from dressmaking to execute these patterns, resulting in distinct interpretations of commercially

available patterns. One Amish quiltmaker adapted Mountain Mist's "K," available since 1930, to make her Basket of Flowers quilt (figs. 2.15–16).[46] When the pattern first was available through the batting manufacturer, many American women were piecing quilts in cheery shades often described as "Easter egg colors," making frequent use of fabrics with printed images of flowers, animals, and small geometric figures. This Amish quiltmaker also chose to use the popular solid-colored pastel blue, yellow, green, and pink fabrics but framed them in a typically midwestern Amish setting, with a wide outer border of blue fabric, black background fabric, and a narrow inner border of yellow. Her large, sparse, and visible appliqué stitches suggest that she may have been unaccustomed to the technique of appliqué, which not all Amish quiltmakers used. Quiltmakers skilled at appliqué tended to hide their miniscule stitches that held the figurative elements to the background cloth.

Other Amish seamstresses also experimented with appliqué, combining it with elements more common to Amish quilts. A number of Amish women tried the technique with varying degrees of success. Sometimes quiltmakers used appliqué selectively for rounded basket handles or other figurative elements difficult to achieve by piecing. Rather than executing the appliqué technique with small hand-stitches, at least a few Amish women attempted machine appliqué as a quick means of accomplishing what often required fine hand stitches. Other quiltmakers used appliqué as a primary technique, adapting patterns from published sources or from friends' and neighbors' quilts. Lancaster County Amish woman Miriam Stoltzfus recalled that in the mid-1940s her mother borrowed an appliqué pattern from a sister-in-law who was not Amish. Their worldlier relative executed the pattern in calico prints, while the Amish mother and daughter chose green and white solid-colored fabrics.[47]

Figure 2.21. Detail of printed back and initial, Center Diamond, unknown Amish maker, c. 1900. Probably made in Lancaster County, Pennsylvania.

(International Quilt Study Center & Museum, University of Nebraska–Lincoln, 2003.003.0100)

Although Stoltzfus likely purchased these fabrics specifically to make this appliqué quilt, many Amish quiltmakers used leftover, cheap, or free fabric to make quilts. The Amish have considered "making do" as wholesome behavior. Recycling remnants from dressmaking into quilts and reusing worn-out clothing to weave or hook rugs have exemplified Amish frugality. This use of leftover fabric made quiltmaking a practice that fit neatly into another ideal of *Gelassenheit*: thrift. Avoidance of luxuries and unnecessary conveniences is at the center of the faith's emphasis on self-denial. In addition to using leftovers, thrifty Amish women used inexpensive or free fabric when possible, including printed fabrics that they did not use to make clothing.[48] This adaptive use of leftover, cheap, or free fabric also resulted in quilts made from a wide variety of different weaves and hues, sometimes using up scraps smaller than an inch in width (figs. 2.17 and 2.18).

Like many non-Amish quiltmakers during the 1920s, 30s, and 40s, Amish women also integrated fabric from feed, flour, and sugar sacks into quilts, removing the product's logo with bleach or dye if necessary. This act of recycling was more common for utilitarian quilts than for ones given as gifts and reserved for display on guest beds.[49] In the early 1940s, Susie Miller Raber made an everyday quilt for her children using off-white feed sacks for the background fabric and the quilt's back; "Dairy" and "32%"—part of the product's label—can still be dimly seen on the reverse (figs. 2.19 and 2.20).[50]

Although thrifty use of leftover fabric from dressmaking, other remnants, and feed sacks accounts for the small bits of fabric in many repeated block quilts, it does not explain the wide expanses of fabric in patterns such as Center Diamond or Bars, in borders and quilt backings, or in quilts that uniformly feature the same blue fabric rather than bits and pieces of many different blues. The yardage required for these quilts was new fabric—sometimes purchased specifically for quiltmaking—rather than reused or leftover fabric. But this fabric was not necessarily a luxury item. Traveling salesmen catering to the Amish offered discounts on bulk purchases or threw in out-of-fashion fabrics for free, including printed fabrics that women in some communities used to back quilts (fig. 2.21). Salesmen who established long-term relationships in Amish settlements even gave young women bolts of fabric as wedding gifts in an effort to encourage customer loyalty. The use of such yardage in quilt borders and backs, while not necessarily the piecemeal sort of thrift that we romantically imagine inspired quilts, nonetheless reveals how Amish quiltmakers used up what they had available.[51]

Combining an assortment of fabrics to create a quilt suggests a characteristic that Amish quiltmakers shared with all quiltmakers: a love of fabric. The materiality of cloth captivated these women, and they enjoyed mixing colors and textures to create quilts that teased the eye. Some Amish women loved the way shiny synthetic fabrics caught the light, especially when juxtaposed with other fabrics on a Sunshine and Shadow quilt.[52] Other women recalled fabrics from their youth as particularly fine or soft. As seamstresses responsible for stitching their families' clothing, they were connoisseurs who knew the difference between fabrics with names such as Indianhead, Brilliantine, Batiste, Henrietta, and Challis.[53] One Amish quiltmaker from Morgantown, Pennsylva-

nia, remembered that as a teenager she delighted in choosing cloth to make clothes and quilts: "And Romaine crepe! That was a fabric! It started to come in when I was a teenager. And whoever had a Romaine crepe dress that following season, man, they were top, on top of the mountain! Oh, everybody had Romaine crepe. It came in such beautiful colors."[54] While Amish doctrine abhorred mainstream fashion as worldly, members of the church nevertheless participated in their own fashion culture, keeping up with one another on the latest styles that fit within both prescriptive standards of plainness dictated by the *Ordnung* and the conventions of their community.

Fabric served as an important keeper of family and community memories. In some settlements brides gave each wedding guest a scrap of fabric from the bolt used to make her wedding dress. This swatch tied the recipient to her community, reminding each of their shared history and beliefs. Sometimes women saved these scraps as keepsakes, painstakingly labeling each bit of blue, purple, or maroon—typical colors of wedding dresses—with the name of the couple and the wedding date. Eight large basting stitches in black thread hold a paper label written in pen in neat cursive script to a small piece of royal blue, plain-weave wool: "John Beiler Sallie Esh married Nov. 14 1929" (fig. 2.22). Over a lifetime of attending weddings, a woman might accumulate hundreds of fabric fragments, which could recall memories of days gone by. Fabric swatches sometimes marked less celebratory occasions as well: one Amish woman saved a scrap labeled "Nov. 17 1934. This is a patch of Katie Kings dress the one she had on the day of her wreck."[55]

Mary Yutzy Nissley saved leftover scraps from the clothing she made for her family members, cataloguing each according to its purpose. She basted or pinned labels to the swatches or wrote on them with a pen. On a light pink scrap she wrote, "Fannie Mae's underdress," referring to a petticoat that her young daughter wore underneath her outer dress. On one swatch of what must have seemed a particularly all-purpose blue twill, she wrote, "dress, 2 aprons, 3 girls dress & apron, Andy & Johnny a shirt." Sometimes she recorded where she bought the fabric: "Purchased from Wards in a clearance sale @ .05 [cents] yd. 1935 Poplin Cotton," or "Rest are all feed bag material purchased (with feed) at Garnett, Kan." (fig. 2.23). Despite *Gelassenheit*'s emphasis on anti-materialism, Nissley clearly felt a certain attachment to the clothing she made for her family. Each swatch could conjure up a memory: wearing a black head-covering to church before she was baptized, bringing up children on the Kansas prairie, fabric shortages during World War II, or the traveling salesmen who knocked on her door to sell her discounted wool challis or cotton broadcloth.[56]

When women used the same fabrics that conjured up such memories to make quilts, these bedcovers similarly evoked the past. Around 1920, Maude Miller made a Nine Patch quilt from maroon and black fabrics. Both fabrics were left over from making her sister's dresses. According to family tradition, the maroon fabric was from the last Amish-style dress her sister wore before leaving the faith. As the quilt was

passed down to subsequent generations, this family story, embedded in the fabric itself, stayed with the quilt.[57]

MONETARY VALUE AND AESTHETIC VALUE

In addition to sentimental value derived from ties to family and community, quilts have also had—and gained—monetary value. Traditionally, this value was determined within the culture. Amish families held "family sales" at which children could purchase the belongings of previous generations. When parents or grandparents reached a certain age or had passed away, relatives often gathered together for such a sale. This event functioned much like a public auction or estate sale, but only direct descendants could attend. Family members, who may not have been able to outbid antiques dealers, bid on treasured items—heirlooms such as special rocking chairs, desks, glassware, and quilts. Siblings might bid against one another for these prized possessions, but those with the most financial means could take their pick of the family heirlooms. Sometimes bidding was quite competitive. One elderly Indiana farmer recalled how his children fought over a small steam engine he had owned since he was a child, each eager to own the piece because of its connection to their father. With large families, it was difficult for parents to give each child an equivalent heirloom, and family sales were an effective means of distributing cherished belongings. Typically the money raised at these auctions was divided among the children attending so that everyone benefited.[58]

The criteria Amish individuals used to assign monetary value to quilts changed when outsiders to the community became fascinated with these old bedcovers in the 1970s and 80s. Pickers, dealers, and collectors sought out certain types of Amish quilts, primarily the ones Amish individuals called "old dark quilts." Interest from outsiders in turn changed how Amish people valued their own quilts. When dealers and collectors were willing to spend a good deal of money on heirloom quilts, prices at family sales also rose. Sometimes an individual at a family sale might bid high on a quilt, confident that the piece could later be sold to a dealer later at a profit.[59]

Other families kept their old quilts back from family sales, recognizing that the outside world's value system had inflated their monetary worth. When Lydia Miller died, her daughter found five quilts stored away in an upstairs chest. She chose to "dispose of the quilts ahead of time," selling them to a local collector rather than have descendants bidding against one another on objects outsiders considered both works of art and commodities with rapidly increasing resale value.[60] Selling valuable quilts to outsiders allowed each of the offspring to benefit; the money from a lucrative sale could be split among children instead of only one child receiving a quilt as an heirloom.

Although Amish individuals cherished quilts for sentimental rather than utilitarian reasons, this emotional attachment became a liability. Once the outside world determined that their old quilts conveyed ideals that ran against the grain of *Gelassenheit*—high monetary value and aesthetic worth—this appraisal often overshadowed the meaning derived from familial ties. A quilt perceived as a status symbol by members

Figure 2.22. Swatch from Sallie
Esh's wedding dress, 1929.
Collected by unknown Amish
woman.

Figure 2.23. Fabric swatches
saved by Mary Yutzy Nissley.
Fabric Notebook.

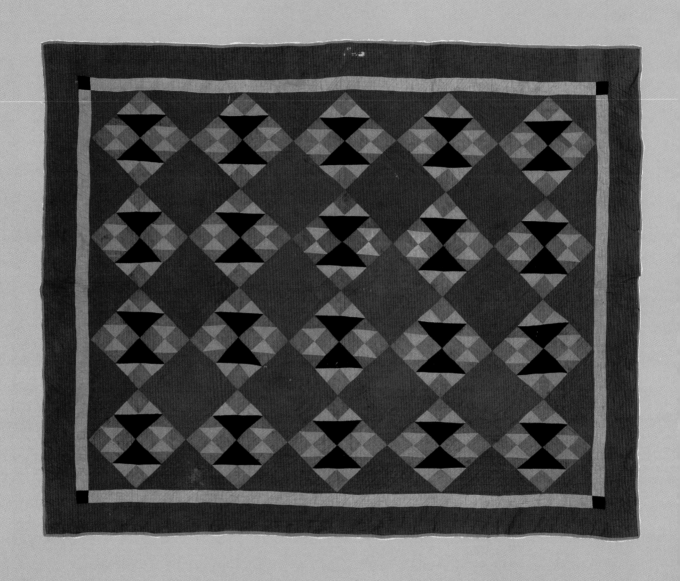

outside the religious group had no appropriate place within the Amish home. To many Amish individuals, this was a sensible decision. As one Amish man observed of the decision to sell old quilts: "The practical function of [a quilt] was really gone. They were attached to them too much sentimentally to wear them out, because they were heirlooms, and yet they were uncomfortable having a $10,000 heirloom in their house. . . . You don't keep art objects like that in your house; you get rid of them and turn them into cash and pay your debts."[61]

Recognizing the cultural burden of keeping valuable old quilts, some Amish communities exerted peer pressure on those unwilling to sell their family quilts. A woman in a western Ohio settlement refused picker David Wheatcroft on ten separate occasions. She wanted to keep her old family quilt as an heirloom, even though her husband repeatedly encouraged her to sell. Other coreligionists could not understand her stubbornness, considering it, as Wheatcroft recounted, "silly and frivolous to have this quilt worth $1,000." When she finally submitted to the community's will, she told Wheatcroft, "Everybody in the community said I should sell it, so I'm going to sell it."[62]

While it may have seemed sensible to sell old quilts, some individuals approached the decision with much ambivalence, reluctant to make money off ancestors' handiwork. Indiana Amish woman Ida Miller Lambright owned a quilt that was decidedly a family heirloom and treasured it as such. A gift to Ida's grandmother Elizabeth, dated 1875, the quilt is one of the earliest known dated examples (fig. 2.24). In 1977 a collector came knocking at her door, offering her money for the heirloom. Lambright sold it, but she struggled with her decision. Within a week, the collector received a postcard from her explaining that she felt bad for selling the keepsake and asking if he would return it to her. He promptly did so. Four years later he received another postcard from Lambright in the mail, this time saying that she was ready to sell. Although the going rate for quilts had multiplied several times during the intervening years, Lambright asked the same price, giving the collector a bargain.[63]

Although a few Amish individuals cited familial attachment as a reason to keep an old quilt, most perceived ample reasons to sell. By the 1970s, when outsiders were knocking on their doors offering money for old bedcoverings, many regarded "old dark quilts" as too small, too difficult to care for, and too old-fashioned. Few Amish quilts from the late nineteenth century or first half of the twentieth were big enough to cover the standardized bed sizes Amish families increasingly owned later in the twentieth century. The old quilts, made from natural fibers that could shrink and dyes that easily faded, were more of a challenge to care for than those made from resilient synthetic fibers like polyester, which Amish women frequently used to make both their families' clothing and quilts by the 1960s.

And Amish aesthetic taste had also changed. One Amish man commented in the mid-1980s that people in his community "wouldn't be seen with the old quilts. They think they're ugly."[64] A Lancaster Amish woman agreed, saying that she had no qualms about selling her old family quilts because "we just didn't like the old style."[65] Over the decades, Amish quiltmakers had increasingly used lighter-colored fabrics rather than

Figure 2.24. Crosses and Losses, Fannie Yoder for daughter Elizabeth, dated 1875. Purchased in 1977 in Topeka, Indiana. 80 ¼ x 64 ¼ in. Ida Lambright was initially hesitant to part with this quilt made by her great-grandmother.

- -

(From the collection of the Indiana State Museum and Historic Sites, 71.989.001.0236)

- -

the navy, black, brown, purple, and other dark hues they often favored earlier in the twentieth century. With greater frequency, quiltmakers purchased yardage specifically for quiltmaking rather than using leftovers from dressmaking. Quiltmakers also experimented more with techniques other than piecing, particularly embroidery. Whole cloth quilts—often made from white fabric—with fancy quilting stitches in figurative designs became popular as the best quilts reserved for Sunday use and given as gifts from home.[66] These newer quilts looked quite different from the ones collectors and dealers began snapping up in the 1970s because of their resemblance to abstract art. But to Amish eyes, *these* were the beautiful quilts rather than the old dark ones.

The influence of non-Amish quilt enthusiasts changed the way Amish individuals looked at their own quilts. Collector David Pottinger recounted two stories that illustrate this point. He recalled visiting an Amish family with quilts to sell. As Katie, the wife, unfolded a few quilts, Pottinger asked her husband, Dan, to help hold one particular quilt vertically at the far end of the room so he could look at it with a long sightline, squinting to exaggerate the pattern's graphic effects. Satisfied, Pottinger was ready to make an offer. But Dan, the Amish man, asked him to wait a minute and had Pottinger hold the quilt while he went to the other end of the room, squinting. After a moment, he asked, "What the heck am I looking for?" He did not appreciate the quilt's visual qualities and simply regarded it as an old bedcovering the family did not use with regularity and could easily live without.[67]

A decade later, in the late 1980s, Pottinger visited a young Amish woman in the same Indiana settlement and inquired if she owned any quilts, the same question he had been asking Amish families for at least fifteen years. By that time many in the community were familiar with how Pottinger and other collectors liked to enjoy quilts by displaying them like paintings rather than as bedcovers. The young woman answered that yes, she had a quilt, and she welcomed Pottinger into her living room. Hanging on her wall was a large quilt displayed like a painting. Pottinger described it as "uglier than sin." A light-colored, full-size quilt that he estimated was made in the 1950s or 60s, it bore little resemblance to the quilts he prized for their strong design and resemblance to abstract art. The young Amish woman now knew that one might hang a quilt on a wall and call it art. Her aesthetic taste was quite different than Pottinger's, but they both appreciated quilts not only as bedcoverings, not only as gifts from home, but as objects one might display on a wall.[68] In true Amish fashion, she adapted, creating a new means of honoring her community's tradition.

OBJECTS OF ADAPTATION

Quilts have not always been central to the Amish way of life, and, as later chapters will demonstrate, they play a role in contemporary society that is much different from that of one hundred years ago. The same is true of other objects of material culture, including automobiles, telephones, and tractors. Only through selective and slow adaptation did the telephone go from a novel invention to a convenience some families embraced,

from a worldly object forbidden by most Amish *Ordnung* to a necessity installed at the end of farm lanes, and now to a wireless device many Amish men carry hidden in their pockets. Each object, each technology, has its own arc: a flexible path that has continued to reflect aspects of *Gelassenheit* within an adaptable yet persistent worldview.

In contrast to the telephone, which shapes how family and community members communicate with one another and the outside world, a quilt's fabrics, colors, and pattern do not alter the values of the Amish religion. It is not the way quilts look but what they mean that really matters. The ways Amish individuals have used, valued, and derived meaning from quilts have continued to reflect the faith's emphasis on the community over the individual, humility over pride, thrift over extravagance, and familial bonds over material attachment. Furthermore, the flexibility of Amish culture, its de facto recognition that negotiation, compromise, and adaptation rather than strict adherence to tradition are the keys to survival, has allowed quiltmaking to be a fluid practice instead of one permanently fixed around 1880.

CHAPTER **3**

- - - - - - - - - - - - - - - -

OFF OF BEDS
AND ONTO WALLS

To young art enthusiasts in the late 1960s and 70s, Amish quilts were a "discovery"— a new, authentic art form that fit into the visual culture of modern art with which they were already well versed. The quilts' resemblance to paintings of artists like Mark Rothko and Josef Albers (figs. 3.1–3.2), along with their convenient apartment-wall size and relatively low price, made them appealing to urbanites eager to hang a work of abstract art on the wall. When Jonathan Holstein and Gail van der Hoof, a couple who formed one of the foremost collections of Amish quilts during the 1970s, bought their first one in 1968, they were not alone in their appreciation of the aesthetic merits of old bedcovers. Beginning in the 1960s and increasingly in the 1970s, artists, art critics, antiques dealers, exhibition curators, feminists, and other cultural entrepreneurs reinterpreted quilts as art objects. This new perception, as this and the following chapters will show, was part of a larger cultural conversation about tradition, craft making, and aesthetics occurring among both urban and rural people both inside and outside of academic and art world circles.

JONATHAN HOLSTEIN AND GAIL VAN DER HOOF

"I was always interested in visual phenomena in one way or another," says Jonathan Holstein. In the early 1960s, when he was in his late twenties, Holstein moved to New York City. After growing up in Syracuse, New York, he had graduated from Harvard, tried law school for a year, served in the army, and traveled across Mexico. By the time he settled in Manhattan, he had developed a predilection for pre-Columbian and modernist American art. He also had discovered that predictable work did not suit him; he had the financial means to avoid workaday jobs and instead began to immerse himself in the world of art and artists. He worked as a photographer of fine art, tackling the problem of how to capture the vibrancy of new synthetic paints on black and white film. He wrote about art. And he made friends with artists. Before long, he was thoroughly part of the New York art scene, associating socially with important artists such as abstract expressionist Barnett Newman and prominent pop artist Roy Lichtenstein.[1]

His partner, Gail van der Hoof, surmised "[I]must have been a rag picker in my last life." Holstein called her a "museum brat" because her father was a museum director. After studying art and English at the University of California, Santa Barbara, she

Figure 3.1. Mark Rothko, untitled, oil on canvas, 1961.

(© 2005 Kate Rothko Prizel & Christopher Rothko / Artists Rights Society (ARS), New York)

worked for a few years in fashion merchandising. She then used her savings to travel throughout Europe and West Africa in the mid-1960s, living for stints in Holland and England. When she returned to the United States, she ended up in rural Colorado. Living communally with no electricity, she gardened, sewed, and learned beading and leatherwork crafts. In Colorado she began to notice some "pretty wonderful quilts." She stitched together some blocks of an old crazy quilt that she bought for a few bucks at a rummage sale. In 1967, van der Hoof met Holstein in Aspen while he was visiting his brother. He convinced her to join him in New York City the following year.[2]

Even when the couple escaped the city for the countryside of Bucks and Lancaster Counties in Pennsylvania, they both continued to think about art and design, particularly the abstract paintings of the New York School, the informal group of American abstract expressionists.[3] When they wandered through junk shops and flea markets, van der Hoof would rummage through old trunks looking at textiles, while Holstein would marvel at the joinery on old chests. After seeing countless quilts, she began to point out to him "how much they looked like works of art." As they continued to search for antiques, they started to take mental note of the hundreds of examples of historic quilts they encountered. The objects appealed to them, not because they might serve as charming bedcovers, but because they were, as Holstein later recalled, "attuned to

Figure 3.2. Josef Albers, Study for *Homage to the Square,* oil on masonite, 1966.

- -

- -

modernism." Holstein and van der Hoof recognized some quilts as powerful visual objects that, in his words, "in many ways anticipated some of the movements in modern art." In the lively patchwork of a Tumbling Blocks quilt, they saw "op art"—a geometric painting style that creates a sense of movement through the use of optical illusion—as the sixty-degree diamonds played with their eyes in a dizzying way (figs. 3.3–3.4). Repeated baskets formed from bits of red fabric running across the surface of a quilt top reminded them of Andy Warhol's penchant for sequence and repetition (figs. 3.5–3.6). They compared Kenneth Noland's manipulation of color—his late 1960s work often featured parallel stripes running horizontally along the width of a landscape-shaped canvas—to the visual effects created by repeated stripes featured on a Pennsylvania Rainbow quilt (figs. 3.7–3.8).[4] These quilts—created in two dimensions on a similar scale as the large works generated by New York's abstract artists—were typically crafted fifty to one hundred years earlier than their painted counterparts.

In a matter of months, the couple realized they were building a collection of this art. "I've always been an accumulator," says Holstein. "So it was natural for me to see five great quilts on a weekend and say we ought to really buy them; they're so fabulous and they are $12 each. . . . We'd take them back to New York and we'd look at them and we'd go down another weekend and we'd buy five more." As the couple became more

Figure 3.3. Tumbling Blocks, unknown maker, c. 1880. Possibly made in Massachusetts. Cotton, 81 x 79 in.

Figure 3.4. Victor Vasarely, *MEH2*, from the series of eight prints *Homage to the Hexagon*, screenprint, 1969. Vasarely (French, born in Hungary, 1908–1997) is considered one of the founders of "op art."

intentional about this collection, they limited their purchases to those "which were . . . of great aesthetic merit, which worked for us as 'paintings.'"[5]

In 1968, during one trip through Pennsylvania's Lancaster County on Route 30, the couple stopped at a small antiques shop. They spotted what they considered an unusual quilt covering the springs of a brass bed. The proprietor wanted to sell the quilt and bed as a lot, asking $11 for the two pieces. "I said to the guy, 'You know, I really just want to buy the quilt,'" recounted Holstein. After considering for a moment, the proprietor agreed, charging the couple $5.75 for the quilt.[6] They brought it home to their New York apartment, and, as Holstein remembers:

> We looked at the quilt in New York, at first thinking it was some extraordinary work of genius. And then, after looking at it for a week realizing that it was too precise, the materials were too consistent, the quilting was too consistent for it to be a singular example from any culture we knew anything about. . . . We carried around [the quilt] or pictures of it for a long time until someone finally said, "That's an Amish quilt." So then we thought, "How are we going to get more of these?" . . . We asked them, "Are they all like this?" "Yeah, they're like this." So I thought, "Oh my God, how are we going to find more?" So we began looking around for Amish quilts. Slowly we began to find them.[7]

Among the many quilts stitched from abundantly available printed cotton fabrics in repeated geometric block patterns that Holstein and van der Hoof would have seen, this quilt would indeed have stood out (fig. 3.9). Its wide borders were a lush rust-orange wool suiting fabric framing a field of alternating green and orange strips of wool fabric—which Holstein dubbed "bars" and the Amish called *strema*, the Pennsylvania German term for "strips." Framing these strips was a narrow violet border that separated the design field from the outer border with an electric vibrancy. The binding holding the three layers of the quilt together echoed the green from the design field, sealing in what Holstein considered the quilt's perfect proportions: the balance between the outer border and the inner field. The consistent quilting that Holstein noted was a hallmark of Lancaster County Amish quilts. In the wide rust outer border, intricate stitches formed swirling feathers. This curving ornament contrasted with both the rigid geometry of the strips and the fine cross-hatched quilting stitches that covered the alternating green and orange wools. These colors, combined with the simple lines of the quilt's design, would indeed have seemed extraordinarily out of place compared to the busy prints found on most non-Amish quilts the couple encountered on their collecting jaunts. To them, this quilt was a "first clue" that led them to pursue these bedcovers as art objects. Eager to take credit, Holstein later recalled, "In effect, we discovered them. We were there first."[8]

Figure 3.5. **(opposite)** Baskets,
unknown maker, c. 1900–1920.
Possibly made in New Jersey.
Cotton, 68 x 67 in.

- -

- -

Figure 3.6. Andy Warhol, *100
Cans,* acrylic on canvas, 1962.

- -

- -

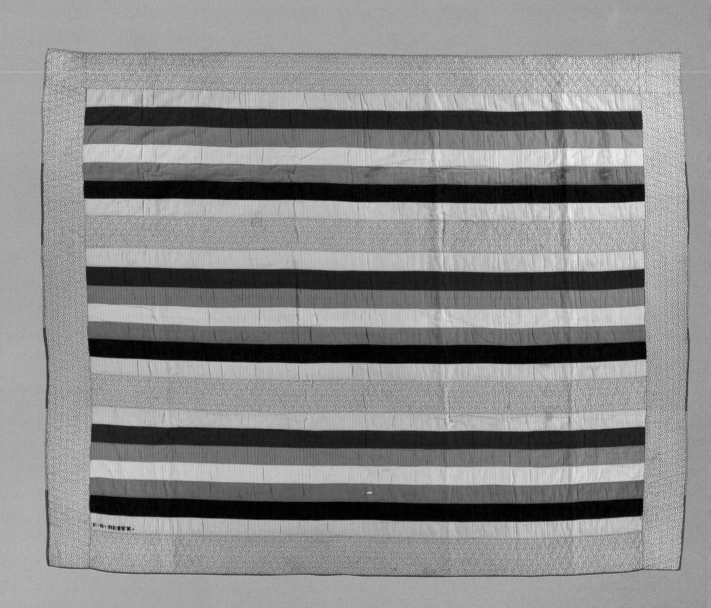

Figure 3.7. **(opposite)**
Rainbow Stripe, inscribed E.S.
Reitz, c. 1890–1910. Possibly
made in Pennsylvania. Cotton,
73 x 80 in.

Figure 3.8. Kenneth Noland, *Wild Indigo,* acrylic on canvas, 1967.

- -

- -

(Jonathan Holstein Collection,
International Quilt Study Center & Mu-
seum, University of Nebraska–Lincoln,
2003.003.0041)

(Art © Estate of Kenneth Noland/
Licensed by VAGA, New York)

- -

- -

From their perch in the art world, Holstein and van der Hoof had started proselytizing to their friends about the aesthetic merits of old bedcoverings (figs. 3.10–3.11). As Holstein recalled, these artists immediately understood his perspective:

> We took a group of slides down to show to our friends Roy and Dorothy Lichtenstein, and they were just gassed. And then I showed them to our friend Barnett Newman, especially I wanted him to see the Amish quilts because of the nature of his work. And again, he was just gassed. Everyone we showed them to was totally overwhelmed by their power. . . . So when artists—practicing artists—looked at them they understood immediately what had been done. . . . When we told people like Roy and Barney the dates of these, they were just gassed because they knew art history and they knew that here were women making these things that in many ways anticipated some of the movements of modern art. And there was that thing, "Well how could that have happened? These were just very often unschooled women living in rural areas of the United States far from the centers of culture. Well, how the hell did they pull this off?" And that really was the issue for us too. Accomplished artists understood this right away and understood what they were seeing. We didn't have to explain anything to Barney.[9]

Implicit in this reaction was the notion that art happened in the city—particularly in New York City—and not normally in the sewing rooms of rural America and rarely by unschooled women. Yet decades earlier women had created art that Holstein identified as predicting aspects of some of the current movements in abstract art—pop art, hard edge, color field painting, op art, and minimalism. Holstein and van der Hoof considered quilts works of art, but they had to convince the art world that the quilts' resemblance to paintings was not just an interesting coincidence, that quilts were worth exploring as visual objects in their own right.

Holstein and van der Hoof did not argue that *all* quilts related to various movements of modern art. They were quite selective about the quilts they purchased. They recognized particularly the graphic pieced quilts—those made from geometric pieces of cloth seamed together—as the ones that "provide a cohesive and strong visual statement." Appliqué quilts, Holstein argued, with figurative or stylized designs, "are usually more decorative, and while often beautiful, seem to lack the stronger visual characteristics we see in pieced quilts."[10] Like Clement Greenberg, the esteemed art critic who wielded immense influence on the interpretation of twentieth-century art, Holstein disdained the decorative in favor of the flatness and lack of ornamentation that characterized the New York School art as well as many pieced quilts.[11] Among all quilts, Amish ones best fit these criteria: by typically making quilts without the use of appliqué and printed fabrics, Amish quiltmakers created bedcovers that perfectly fit Holstein's (and

Figure 3.9. Bars, initialed S.L., unknown Amish maker, c. 1890–1910. This is the first Amish quilt Holstein and van der Hoof purchased. Lancaster County, Pennsylvania. Wool, 84 x 71 in.

(Jonathan Holstein Collection, International Quilt Study Center & Museum, University of Nebraska–Lincoln, 2003.003.0013)

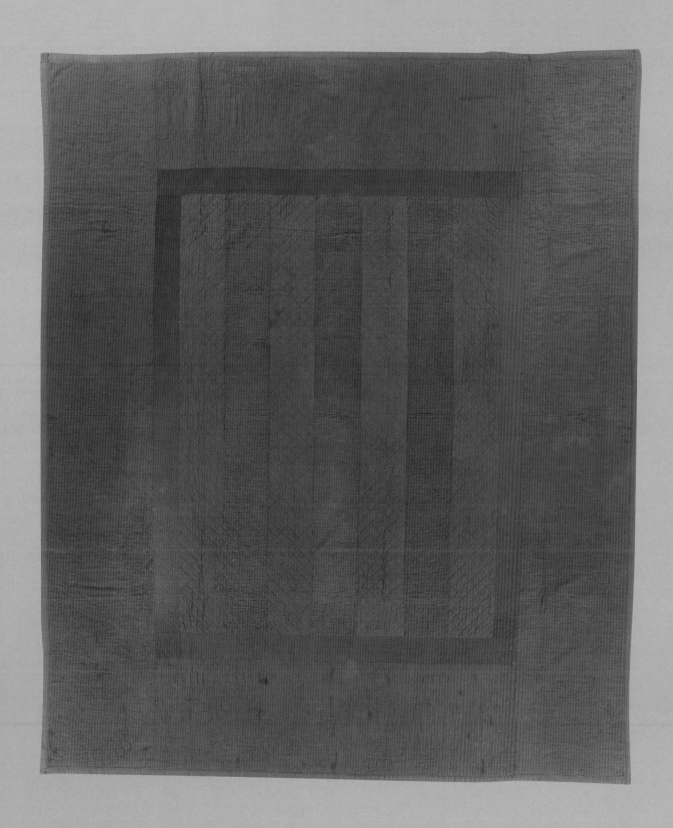

Figure 3.10. Barnett Newman, *Voice of Fire,* acrylic on canvas, 1967.

(© 2012 The Barnett Newman Foundation, New York / Artists Rights Society (ARS), New York. Image © National Gallery of Canada)

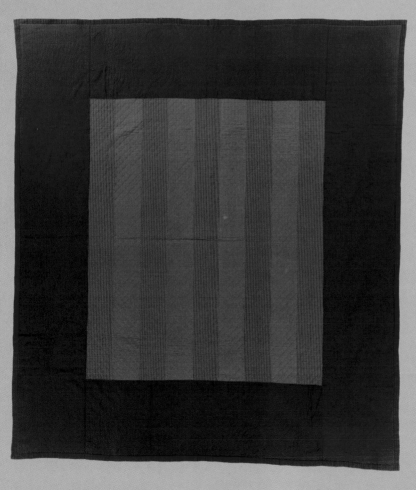

Figure 3.11. Bars, unknown Amish maker, c. 1900. Probably made in Pennsylvania. Wool, 85 x 79 in. Holstein identified shared aesthetic qualities between quilts like this one and the "zip" paintings of his friend, Barnett Newman (fig. 3.10).

(International Quilt Study Center & Museum, University of Nebraska–Lincoln, 2003.003.0123)

Greenberg's) perception of the sparseness and reduction that were the hallmarks of the "strong visual statement" he sought out in quilts.

In seeking to elevate pieced quilts to the status of art, Holstein had to convince others of his elite New York crowd that they were not mere craft. "Museum curators," Holstein hypothesized, "would say they belonged in institutions that showed craft and Americana." He argued that it was necessary to take a wide-angle-lens view of quilts so that the viewer could "strip away . . . the awe of handwork," emphasizing the designed elements that could be seen from across a room rather than the technical skills—the fine stitching—that could only be seen up close. He and van der Hoof concentrated solely on "great aesthetic merit" rather than on workmanship, condition, or age—the typical criteria of connoisseurship.[12] Only then, when the elements of craft were ignored, could quilts become art.

To achieve the distance required to view these objects as art rather than craft, Holstein and van der Hoof chose to, in Holstein's words, "symbolically and actually . . . take them from the setting of the bedroom and . . . hang them on the wall." Viewing quilts as canvases enabled the graphic power, rather than the minute quilting stitches, to dominate. With the distinction between art and craft situated at the point of contemplation (art demands cognition, whereas craft is merely decorative), Holstein and van der Hoof had to display the quilts so that their formal aspects, such as line and form, overshadowed their utilitarian, technical, or decorative aspects—their crafted-ness.[13] As the couple began to cull their collection, they spread the quilts out on the grass at Roy and Dorothy Lichtenstein's Long Island home and went to the roof so they could fully appreciate them from the distance required by fine art.[14]

In the spring of 1971, Holstein and van der Hoof networked their way into a meeting with Robert Doty, the curator at the Whitney Museum of American Art. Since 1966 the Whitney had made its new home on Madison Avenue in Manhattan's Upper East Side in a distinctly modern building co-designed by architect Marcel Breuer. The couple's friend Diane Waldman, then an assistant curator at the Guggenheim Museum, had put Holstein and van der Hoof in touch with Doty on the hunch that the Whitney's interest in American art traditions might make it a good venue for a quilt exhibition. In part to fill galleries during the slow summer months, the Whitney accepted their proposal for *Abstract Design in American Quilts*, an exhibit that would "cut instantly through a trained American art historian's preconceptions of what quilts were supposed to be and look like" by presenting them as art rather than craft. The museum agreed to show sixty quilts. Of these, only one was Amish-made, although Holstein later regretted not showing more of these distinctive quilts.[15]

In this public forum, Holstein and van der Hoof made their argument to their museum-going audience by hanging these pieced, graphic quilts on white gallery walls. They worked with museum staff to develop a hanging system that allowed the quilts to float on the wall like paintings. They stitched sleeves made of fabric webbing to the upper backside of the quilts and inserted strips of 2¼-inch lathing to fit the width of each quilt. With hardware typically used for hanging mirrors, they mounted the quilts

Figure 3.12. Installation of *Abstract Design in American Quilts,* Whitney Museum of American Art, 1971.

(Photo by Jonathan Holstein. Collection of Jonathan Holstein)

Figure 3.13. Installation of *Abstract Design in American Quilts,* Whitney Museum of American Art, 1971. See the Bars quilt from figure 3.9 at the end of the gallery on right.

(Photo by Jonathan Holstein. Collection of Jonathan Holstein)

to the wall with screws through the lathing, creating an invisible mounting mechanism that allowed the textiles to hang evenly without creases or bulges. Breuer had designed the Whitney's gallery spaces to showcase the large format paintings artists had favored in the postwar era. Quilts, similar in size, could equally fill these generous walls.[16] By presenting them in this environment, detached from their utility, Holstein and van der Hoof demonstrated that these quilts were aesthetic objects. And by and large, the viewing public bought their argument (figs. 3.12–3.13).

"The exhibition put quilts where they would be seen by the intellectual establishment," wrote Holstein, remembering the exhibit on its twentieth anniversary.[17] He was right. Led by Hilton Kramer, a *New York Times* art critic known for his relatively conservative views on art, critics in leading newspapers and magazines embraced the Whitney exhibit. Holstein felt vindicated when these prestigious critics understood his

vision.[18] One reviewer even elevated the quilts above the abstract art to which Holstein compared them: "[T]hese practical, useful quilts have a vitality that canvases created today for the elite and the intelligentsia frequently lack."[19] Janet Malcolm, writing in the *New Yorker,* proclaimed that "viewers were stunned by the strength and beauty of design" achieved by hanging quilts "on the big white walls of the museum as if they were paintings."[20]

Such critics, who usually focused on the paintings and sculpture displayed at museums and galleries, played a significant role in creating quilts' newfound status as art objects. In his review of *Abstract Design in American Quilts,* Kramer, a mainstay of the *New York Times* Arts section, noted that the Whitney had "rarely condescended to acknowledge the 'decorative arts,' as they are called, as a significant contribution to American artistic achievements." He considered the exhibit a success not only visually but because it "prompts us to rethink the relation of high art to what are customarily regarded as the lesser forms of visual expression." He argued, "This is an issue that any serious historian of American art is going to have to come to terms with in future dealings with his subject." Kramer's stature as an art critic in the "newspaper of record" ensured that his thoughts on quilts would be widely read by members of the New York art scene as well as around the country. If Kramer—who did not hesitate to offer harsh criticism when he saw fit—believed that quilts belonged at the Whitney, then many of his readers would be willing to give bedcovers hanging on walls a chance.[21]

The public attended the exhibit in large numbers. The museum sold out the 3,000 copies it printed of Holstein's slim catalog, and the show broke previous attendance records at the Whitney. The museum even extended the run three weeks until October 5, enabling New Yorkers returning from summers away from the city to enjoy the show.[22] Bronx native Blanche Greenstein, a photo stylist for television commercials with no prior interest in antiques, attended the show. "I can't even remember what propelled me to go there, but I did and I was really blown away," she recalled. "It was almost a mystical thing actually . . . I really just fell in love with the quilts."[23]

The public and critical reception spurred other institutions to request to host the exhibit following its run at the Whitney. The Smithsonian Institution Traveling Exhibition Service (SITES) wanted to tour Holstein and van der Hoof's quilts around the country to smaller regional museums. The couple agreed, and within months, versions of *Abstract Design* and the SITES exhibit, *American Pieced Quilts,* reached a wider audience beyond the New York art intelligentsia. The SITES version traveled to twenty-one regional museums and received frequent attention in local newspapers, popular magazines, and wire stories.[24] Additional assemblages of the couple's quilts were hung at prominent museums such as the Los Angeles County Museum of Art and the Smithsonian's Renwick Gallery in Washington, D.C. as well as in major European venues.[25]

Among the quilts hanging at the Whitney that summer and fall of 1971 was the one Holstein had haggled over at the antiques shop on Route 30 in Lancaster County. This orange, green, and purple Bars quilt was the only Amish one to hang in *Abstract Design in American Quilts.* But by this point, Holstein and van der Hoof had begun to find more.

Van der Hoof bought a home in Lancaster to be closer to the hunt; Holstein began work on a book about pieced quilts. He discussed this project with the New York Graphic Society, a publishing company specializing in art books. They agreed to publish a large-format multi-plate book highlighting quilts from Holstein and van der Hoof's collection in full color and featuring text by Holstein.[26] This format, usually reserved for paintings, would further the idea that pieced quilts were art and would be recognizable to the art enthusiasts familiar with museum catalogs and monographs on artists and their work.

While the Whitney exhibit promoted quilts in general—or at least those van der Hoof and Holstein identified as bearing a resemblance to modern paintings—*The Pieced Quilt* (1973) highlighted Holstein's new love, Amish quilts. He devoted a whole chapter and 13 color plates to them. On the cover was a particularly graphic quilt, one of the signature patterns made by Lancaster County Amish women, who typically called it "Nine Times around the World," while Holstein referred to it as "Sunshine and Shadow."[27]

Whereas many patterns used in the Lancaster County settlement featured large pieces of fabric, Sunshine and Shadow's design field consisted of small two- or three-inch squares of fabric radiating in waves of color and forming concentric diamonds from the center of the quilt. The one on the cover of *The Pieced Quilt* pulsated with alternating bands of warm pinks and reds and cool blues and greens. Maintaining the typical proportion of Lancaster Amish quilts—a square format with wide outer borders containing the central design field—the bright blue frame restrained the energy of the small patches.[28] The effect was similar to that of op art, which experimented with color and geometric forms to produce graphic patterns that stimulated the eye. Holstein no doubt chose this quilt for his cover because these similarities would be apparent to viewers familiar with this very current artistic style. But he also wanted to prominently showcase an Amish quilt.[29]

Holstein approached the subject of Amish quilts with a language coded for art world insiders. Of an early Amish quilt form he named "Center Square" (see fig. 3.14), he wrote: "The repetitive use of highly reduced geometric forms [compares to] the work of the systemic painters."[30] Art critic Lawrence Alloway had coined the term "systemic art" in 1966 to characterize the geometric abstraction of minimalist art. That year he had curated an exhibit of the same name at the Guggenheim Museum, where he worked as a curator. Alloway's catalog lauded the work of Holstein's close friend Barnett Newman, citing his influence on this new generation of minimalists. The exhibit highlighted many of the same artists—including Kenneth Noland, Frank Stella, and Ellsworth Kelly—that Holstein, van der Hoof, and art critics now linked to the aesthetics of pieced quilts.[31] A reference comparing Amish quilts to systemic painting, a term no doubt unfamiliar to many outside Holstein's New York art circles, would have been understood by the elite sophisticates Holstein aimed to convince.

Although Holstein suggested that some quilts resembled abstract paintings aesthetically, he did not imply that artists and quiltmakers approached the creative process with the same motivations. He granted that painters such as Albers and certain

quiltmakers arrived at similar "visual results," but not that these quiltmakers shared the "intellectual process which ties the work of an artist to his aesthetic ancestors and his peers."[32] The abstract artists Holstein most often referenced, such as color field painters like Newman, Noland, and Rothko, intended for their work to evoke psychological, emotional, or intellectual reactions. As Newman's widow commented when a folk art curator compared her late husband's work to a quilt, his intention was to explore the "subtle relationships between stripes and ground," whereas a quiltmaker was "carrying out a simple pattern."[33] Yet to Holstein and to many of the soon-to-be Amish quilt enthusiasts his book inspired, both paintings and quilts were ultimately visual objects—rather than intellectual objects—that looked great hanging on white walls. A study of why New Yorkers from particular neighborhoods liked certain types of art found that those who displayed abstract art in their homes did so largely for visual reasons. These art owners—people who displayed nonrepresentational twentieth-century art prints and paintings on the walls of their homes—gave reasons such as "I like the colors and the way it looks" rather than making statements about artists' emotional expression.[34] When considering abstract paintings as decorative or designed objects rather than as intellectual ones, viewers could easily substitute the similar formal visual qualities—color, line, flatness—of quilts for those of paintings. As Holstein wrote in 1973, although quilts "are decidedly not paintings in the formal sense, their method and design can best be described through comparisons to that medium."[35]

Artist Warren Rohrer got Holstein's message. In the early 1970s, Rohrer was an up-and-coming painter based in Philadelphia with deep roots in a Mennonite family in Lancaster County, Pennsylvania. Mennonites have a significant presence in southeastern Pennsylvania and are close religious and often ethnic relatives of the Amish. Many Mennonites, including Rohrer's family, trace their roots back to Amish ancestors who immigrated to North America in the eighteenth century. Despite growing up in close proximity to Lancaster's Amish community, Rohrer had never seen an Amish quilt before the Whitney's exhibit in 1971. He described the Amish Bars quilt on display as "simple in design, like 'modern art,' and brooding in color, like Rothko." Over the following years, Rohrer began collecting Amish quilts and developed a theory about Amish quilt design as a reflection of day-to-day experiences with agrarian land. The square format and grid-like structure of quilts began to influence his paintings, as did work by Rothko and Newman (figs. 3.14–3.15). To Rohrer, the work of anonymous Amish women was on par with that of these modernist artists.[36]

Other soon-to-be collectors also understood Holstein's argument about quilts. One reader who eagerly soaked up Holstein's *The Pieced Quilt* was Patricia Herr, a veterinarian from Lancaster, Pennsylvania, who claimed to have been born with a collecting gene. She—like many other locals who enjoyed spending weekends at auctions and antique shops—had always disregarded the "old dark quilts" that often were the dregs at Amish estate sales. But following the publication of Holstein's book, she came to view these quilts with new eyes. During a visit to one of her favorite local antique shops, Herr borrowed the proprietor's telephone to describe a particular "old dark quilt" to

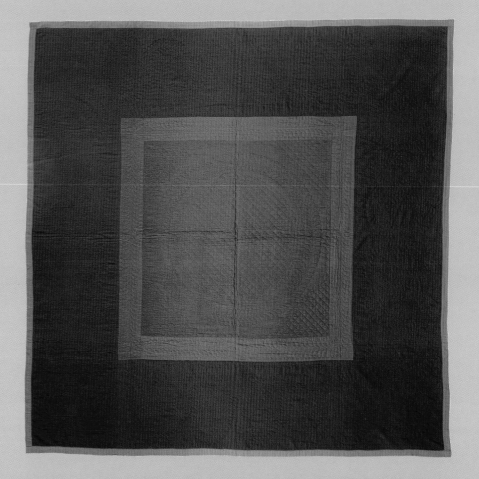

Figure 3.14. Center Square, unknown Amish maker, c. 1890. Lancaster County, Pennsylvania.

(From the collections of the Heritage Center of Lancaster County)

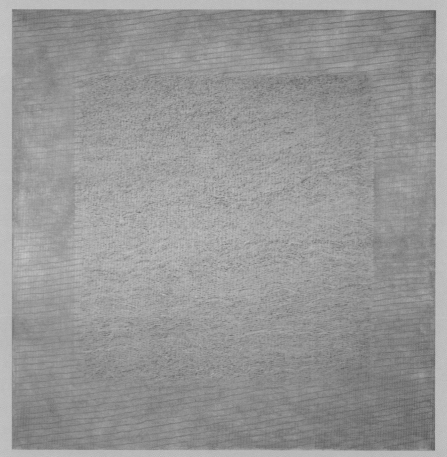

Figure 3.15. Warren Rohrer *Hornet 1,* oil on linen, 1975, 72 x 72 in. Rohrer's painting resembles the Lancaster County Amish quilt pattern, Center Square (fig. 3.14).

(Image courtesy of Jane Rohrer and Locks Gallery)

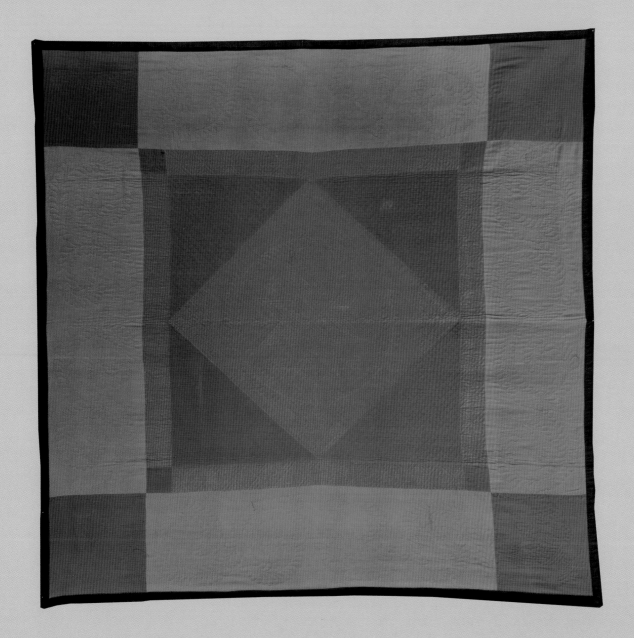

Figure 3.16. Center Diamond,
Rebecca Fisher Stoltzfus, dated
1903. Vicinity of Groffdale,
Lancaster County, Pennsylvania.
Wool with rayon binding (added
later). 77 x 77 in.

(Collection of the American Folk Art
Museum, New York. Gift of Mr. and Mrs.
William B. Wigton, 1984.25.1. Photo by
Schecter Lee, New York)

her husband. In order to evaluate it, her husband asked her, "Is it as nice as the one on Holstein's cover?" When she replied that it indeed was, he responded that she should buy it.[37] And thus began the Herrs' collection of Amish quilts.

REVERBERATING REVIEWS

From the mid-1970s into the 2000s, many art museums displayed Amish quilts on their walls.[38] With such regular appearances, there was no longer any need to discuss whether these objects were art. Yet with each subsequent exhibition, art critics would draw the same conclusions upon seeing Amish quilts, once again comparing them to abstract paintings, while noting the paradox of works of this caliber coming from a culture that did not value art. The 2011 comments of *New York Times* art critic Roberta Smith, reviewing an American Folk Art Museum quilt exhibit, bear a striking resemblance to the reviews of critics who "discovered" Amish quilts in the 1970s. She wrote:

> Amish quilts are generally considered the most purely abstract and have long been appreciated as precursors of Minimalism's rigor and scale. That thinking is confirmed here by the "Diamond in the Square Quilt," made in 1903 by Rebecca Fisher Stoltzfus of Groffdale in Lancaster County, Pa. Using only three colors and nothing but squares, this work consists of a red diamond (or tilted square) on a blue square banded in red on a green field banded in blue, all pinned down at the corners with four large blue squares. The resulting spread-eagle composition—worthy in its boldness of the young Frank Stella—is a marvel to dissect and reassemble with the eye.[39]

This was not the first time a renowned art critic had highlighted Rebecca Fisher Stoltzfus's Diamond quilt (fig. 3.16). Robert Hughes, a prestigious and influential art critic, chose to feature Stoltzfus's Diamond with its striking red center as an example of what he called "America's first major abstract art." Writing in his widely read 1997 art history survey, *American Visions: The Epic History of Art in America,* which accompanied the PBS television series of the same name, Hughes discussed Amish quilts not as textiles, folk art, or even quilts. To him, they were art of the finest order. And with that proclamation, he bestowed a final verdict on the argument Holstein and van der Hoof began over twenty-five years earlier through their successful push to hang quilts on the walls of a major art museum. Now, when students of American art read his survey, they too discover Amish quilts.[40]

CHAPTER **4**

- -

FOLK ART AND
WOMEN'S WORK

Although the Whitney's *Abstract Design in American Quilts* was the event that received the most widespread attention within the art world, a growing appreciation for and awareness of quilts predated and followed this landmark exhibition. Throughout the 1960s and 70s, due to a renewed interest in "folk art," efforts to promote quiltmaking as a viable source of income within impoverished communities, the feminist celebration of traditionally female crafts, and the growing feminist art movement, quilts received newfound attention after years of relegation to attics and cedar chests.

By the time those sixty quilts debuted on the walls of the Whitney Museum in 1971, both fiber art in general and quilts in particular had already begun to permeate the art world. The ever-expanding experimentation within "high art" during the 1960s—from pop art, minimalism, and performance art to forms of new media—had made room for new definitions of art to continue to emerge. The Museum of Modern Art showed an exhibit of fiber-based work in 1969. Called *Wall Hangings*, it featured woven works within the context of high art rather than applied art or craft. At least three museum exhibitions presented quilts in an art context prior to the Whitney exhibit, including the New York City's Museum of Contemporary Crafts' (now Museum of Art and Design) 1965 exhibition, *Fabric Collage*, featuring fifteen nineteenth-century American quilts alongside appliqués by the San Blas Indians and fiber art by contemporary artists; the Newark Museum's 1965 exhibit, *Optical Quilts*; and the Rhode Island School of Design's 1970 exhibit *Mountain Artisans*.[1] And none other than artist, socialite, and fashion icon Gloria Vanderbilt had covered the walls, ceilings, and floors of a room in her East 67th Street home with American quilts, featured in a photo spread in *Vogue* magazine in 1970.[2] Such events demonstrate that by the time the Whitney embraced quilts, similar objects had already received a warm welcome on the New York art scene. This friendly reception continued in the years following *Abstract Design in American Quilts*, although discussions about quilts and other handmade objects became more nuanced and at times combative, reflecting differing opinions about the place of folk art and craft within the art world.

In the 1960s a growing aesthetic appreciation of quilts stemmed from two distinct trends—a continuing interest in American folk art and a craft-making revival—both of which celebrated non-high arts, objects outside the traditional scope of art museums. A typical definition of "folk art" identifies *who* makes the art, rather than *what* the art is. That is, it is the art and handcrafts made by those who have no formal art training but instead draw on traditional styles and techniques.[3] Interest in American folk arts first emerged in the early decades of the twentieth century when some Americans expressed ambivalence toward the industrialized, commercialized, urbanized culture in which they now lived. This form of nostalgia did not reject ideas of progress outright but looked longingly to the past in search of an antidote for the anxieties of modern life. Artists and cultural critics influential in the art world turned to an imagined folk past in search of something usable. Inspired in part by European counterparts such as the Fauvists, some American modernist artists began acquiring American "primitives" such as hooked rugs, weathervanes, and decoys, drawing on them for inspiration in their artwork. Colonial revival projects such as historic villages Greenfield and Colonial Williamsburg, established in the 1920s by industrialists Henry Ford and John Rockefeller, respectively, also helped reinvigorate public interest in America's past as well as in American homespun design.[4]

A part of this interest in folk art that was brewing during the 1920s and 30s was particular attention to quilts as pieces of interior design, with fashionable homeowners using nineteenth-century American and European quilts not only on beds but also as wall hangings and furniture upholstery. Trendsetters who used quilts in such ways include H. F. du Pont, whose home later became Winterthur Museum; fashion designer Elsa Schiaparelli; and other contemporary authorities on interior design. As an interior decorating trend, magazines such as *Arts & Decoration* featured illustrations of how quilts could be used as furniture covers.[5]

In the 1930s and 40s, Americans learned about folk art through publicly funded projects, especially the Index of American Design. The New Deal's Works Progress Administration's Federal Art Project employed artists to work on the Index, creating watercolor renderings of furniture, textiles, ceramics, and other folk and decorative art forms. This project, administered by curators, art critics, and artists, intended to disseminate interest in folk art through an image archive, exhibits, and publications. A key part of the Index's mission was to provide inspiration to artists and designers who might draw on historic American sources rather than turn to European examples. Publications and exhibitions associated with the Index, along with resulting popular manifestations of folk-art-themed consumer products, including Pennsylvania Dutch–style linoleum and reproduction painted furniture, attracted widespread commercial attention in the 1940s and 50s.[6]

In the 1960s, folk art generally appealed to those who knew they were not of the "folk," namely, middle- and upper-class art and antique collectors. These were the sorts

of individuals who founded the Museum of Early American Folk Art in New York City in 1964. The museum mounted exhibitions featuring decoys, weathervanes, "primitive" paintings, and other pre-twentieth-century objects falling under its folk art designation, which initially precluded objects "influenced by machine-made articles or modeled on elite or popular sources." This predilection for early pieces stemmed from a belief that folk of the preindustrial sort did not survive into the twentieth century. Trained artists in urban centers—rather than "folk"—created current art.[7]

1960s CRAFT REVIVAL

During the 1960s a craft revival emerged alongside other countercultural trends, exemplified by the macramé craze (the popular craft of knotting coarse thread into a decorative pattern). Handmade objects and the processes in which people created them were valued as part of the same cultural trajectories that led Americans to make their own bread, garden, and live off the land. Proponents of the craft revival valued technique—skills such as weaving and basket making—and utility—an object's function.[8] What further separated craft objects from "fine art" such as painting or sculpture was the notion that these high arts placed a demand upon the viewer. Art required a level of contemplation and analysis, whereas craft was merely decorative and useful. The fiber arts fell clearly into the realm of "craft" and were distinguished not only by their medium but also by *who* generally weaves, knits, quilts, and spins: women. These crafts, then, remained associated with femininity and domesticity.[9] In the 1960s and 70s, some women reclaimed this association: feminists who celebrated traditional women's arts as their own artistic heritage.[10]

Objects made by people without either academic training or modern technologies also appealed to the countercultural sensibilities that favored authenticity and simplicity. To some young countercultural Americans, the Amish, along with Appalachians and Native Americans, provided an alternative, authentic representation of American culture.[11] During the 1960s and 70s, these young Americans made excursions into the world where the "folk" lived, sometimes by moving "back to the land" in search of something more authentic. An estimated one million Americans moved from metropolitan to rural areas.[12] They wanted to abandon urban chaos with its pollution and commercialized lifestyle in favor of a quieter, more rural existence. Part of what some back-to-the-landers and hippies sought out was the "common" people who made handcrafted objects, because they seemed more in touch with the natural rhythms of life.[13] In his 1970 best-selling celebration of the counterculture, *The Greening of America*, Charles Reich praised the "new generation" (his term for the counterculture) for not using technology for "status or conspicuous consumption, nor for power over people, or competitive 'success.'"[14]

The Amish had a special appeal to the counterculture in part because of their seemingly simple lifestyle and their reluctance to adopt modern technologies. "The Farm," a Tennessee commune founded in 1971 by several hundred San Francisco hippies, was

located near an Amish settlement. Members of the commune made friends with these neighbors, emulating them by referring to themselves as the "Technicolor Amish."[15]

Some young Americans also ventured to rural areas as a means of becoming more involved in society. Through participation in the civil rights movement and federal programs such as Volunteers in Service to America (VISTA), a domestic Peace Corps program started in 1965 by the Kennedy administration, altruistic young middle- and upper-class Americans from the North came to the Black Belt and Appalachia in hopes of advancing civil rights, alleviating poverty, and discovering authentic folk cultures. As part of anti-poverty programs, some volunteers developed cooperatives encouraging the production of crafts like woodcarvings and quilts for the retail market.[16]

In 1965, civil rights activist Father Francis X. Walter saw quilts in "bold, inventive designs" hanging on a clothesline in Wilcox County, Alabama, near a crook in a river known locally as "Gee's Bend."[17] Another northern civil rights worker found some old quilts in a shack near the Gee's Bend home he was staying in, declared, "It's a kind of southern psychedelic Op Art!" and tacked them to the wall as decoration.[18] Striving to empower impoverished residents of the South's Black Belt, Father Walter imagined a market for these quilts. Through New York connections, Walter arranged for an auction of quilts held in photographer Peter Basch's Manhattan studio in 1966. Just as Amish quilts would intrigue sophisticated buyers a few years later, members of New York's art intelligentsia—including well-known modernist furniture designer Ray Eames, abstract painter (and widow of Jackson Pollock) Lee Krasner, and influential contemporary art curator Henry Geldzahler of the Metropolitan Museum of Art—bought these quilts made by the new quilting cooperative, the Freedom Quilting Bee, established near the community of Gee's Bend.[19]

During the late 1960s department stores, including Bloomingdale's, Saks Fifth Avenue, and Lord & Taylor, sold Freedom Quilting Bee quilts; fashion writers promoted them in the pages of *Vogue, House and Garden*, and *Life*; and interior designers decorated with them in elite homes.[20] Sometimes New York design firms provided designs and patterns to the quiltmakers, to the point that some Freedom Quilting Bee participants regretted the standardization enforced by the cooperative.[21] In addition to the economic benefits the cooperative brought to Gee's Bend, the quilts that made their way into artists' homes and onto the pages of shelter magazines (the industry term for periodicals devoted to interior design, architecture, and home furnishings) paved the way for the widespread celebration of quilts as art objects that was in full swing by the mid-1970s.

In 1968, in West Virginia, another nonprofit quilt cooperative took root, helped by funding from the U.S. government's Office of Economic Opportunity. Started through the efforts of former members of VISTA, Peace Corps, Appalachian Volunteers, and other volunteer organizations, Mountain Artisans aimed to preserve Appalachian quilt-making traditions while providing economic aid to women with quiltmaking skills. More than two hundred women from West Virginia worked on projects as part of the cooperative, earning about $2.00 an hour. Mountain Artisans garnered particular

success due to the interest of Sharon Percy Rockefeller, wife of Jay Rockefeller, the great-grandson to the oil tycoon and later U.S. Senator from West Virginia, in the organization.[22] Her connections helped Mountain Artisans hire fashion designer Dorothy Weatherford, who helped make "the patch a status symbol in high fashion and home furnishings." Rather than only making bedcoverings, Weatherford also designed patchwork garments, patchwork fabrics, and various home furnishing accessories in an effort to establish patchwork as part of contemporary fashion rather than a quaint relic of the past.[23]

Thanks in part to Rockefeller's endorsement, prestigious interior design firms contracted with Mountain Artisans. The editor of *Vogue* was impressed with the cooperative's garments and helped them show their work in the spring of 1969. Renowned fashion designer Oscar de La Renta designed two gowns using patchwork produced by Mountain Artisans. They continued to receive much attention in the media, which slowly resulted in increased sales. In 1970 the Museum of Art at the Rhode Island School of Design mounted an exhibition of the Mountain Artisans' quilts on its gallery walls, affirming that the cooperative was not only about alleviating poverty but also had a place in the art world.[24]

"FOLK ART" AND THE AESTHETIC VALUE OF QUILTS

Although fascination with "nonacademic" art in the 1960s and 70s stemmed in part from political stirrings that celebrated the "common people," its attitude echoed one that originated decades earlier when New York curators began to detach objects they called "folk art" from their cultural contexts and proclaim them as precursors to modernist American art and design rather than as objects merely belonging to curio cabinets.[25] During the 1920s some American artists began to turn to the American past rather than to European precursors as inspiration for their work. These early American modernists considered objects of folk art such as weathervanes, store signs, and "primitive" paintings as a precedent to abstract painting and sculpture and began to collect examples. Following the artists' lead, wealthy art collectors also became interested in these objects, and museum exhibitions soon followed. One of the first was in 1924 at the Whitney Studio Club, the precursor to the Whitney Museum.[26]

In the 1920s and 30s, curators and collectors well-versed in contemporary art analyzed weathervanes, decoys, cigar store Indians, and paintings on velvet, using the art historian's tools of "formal analysis," which focus on properties like modeling, color, and line, and deemphasize utilitarian function in favor of aesthetic qualities. They exhibited the objects removed from any context of use, so that cigar store Indians and other commercial art pieces were understood as works of sculpture rather than as part of a marketing scheme.[27] Decades later, in this same spirit, the Whitney's *Abstract Design in American Quilts* isolated objects by lifting them out of their original contexts in an effort to accentuate their painterly qualities. Although *Abstract Design* was notable for hanging quilts on walls like paintings, it was part of a decades-long practice

of exhibiting folk art in a fine art setting, emphasizing design elements over histori-cal significance.

Following on the heels of its 1971 quilt exhibit, in 1974 the Whitney undertook a major exhibit, *The Flowering of American Folk Art*. As the introduction to the exhibition's catalog reads, "The emphasis here is upon the art in folk art, not the folk. That is another way of saying that the approach is esthetic rather than historical."[28] The curators, Alice Winchester and Jean Lipman, presented objects such as weathervanes, commercial signage, and quilts as works of art decontextualized from workmanship and use, adopting the approach that had originated among artists in the 1920s and went unchallenged until later in the 1970s. Winchester and Lipman asked Holstein and van der Hoof to select one quilt from *Abstract Design* for display in this survey exhibition. They chose that first Amish Bars quilt purchased on Route 30 in Lancaster County.[29] Reiterating some of Holstein's points, the curators commented on the "provocative parallels between the work of folk artists and artists who came to prominence in the mid-century decades," highlighting among other pieces Holstein and van der Hoof's "Amish quilt pieced the way the 'stripe painters' paint." Among the other twenty quilts in the show was another one identified as a Pennsylvania Amish quilt, this one from the collection of art and antiques dealer George Schoellkopf, who specialized in Amish quilts in the mid-1970s at his Madison Avenue gallery.[30]

With this aesthetic-focused or "good design" approach to folk art, the collector with a trained eye—Holstein, van der Hoof, or Schoellkopf—became the celebrated figure rather than the often anonymous creator.[31] The collection of art then reflected the collector's values and taste rather than the creativity of the unnamed artist.[32] Indeed, art critics bestowed praise upon Holstein's "discovery" of a previously unidentified art form rather than singling out makers of individual quilts for their artistic achievement.[33] The same trend occurred as elite collectors sought out carvings, paintings, and other vernac-ular objects made by identified non-elite "folk."[34]

This issue of power and class proved contentious as folklorists, art historians, art dealers, and collectors debated the meaning of "folk art" during the 1970s. Folklorists, anthropologists, and other academics began to challenge the aesthetic orientation that had dominated the discourse on folk art since the 1920s. In 1977 Winterthur Museum, home of H. F. du Pont's unparalleled collection of decorative arts, collaborated with the Brandywine River Museum in Chadds Ford, Pennsylvania, to mount the exhibit *Beyond Necessity: Art in the Folk Tradition*. Conceived by curators as a response to exhibits like the Whitney's *Flowering of American Folk Art* (1974), which "show folk art . . . from a purely aesthetic point of view," the installation aimed to "place the objects in a concep-tual framework, basically a social perspective of the relationship between object, maker, and user."[35] The curators took painted boxes, punched tin, cross-stitched linen towels, iron trivets, and quilts out of Winterthur's period rooms where they "played second fiddle to the artifacts of the affluent" that made up the bulk of du Pont's collection, and displayed them in the modern galleries of the Brandywine River Museum. The exhibit established several categories as a framework, including function (e.g., lighting, stor-

age, rest, or recreation) and type of maker (e.g., children, women, sailors, or black-smiths).[36] Kenneth Ames, a young professor of art history and instructor at Winterthur who had previously written a handful of essays about furniture, wrote the essay in the accom-panying catalog, which "shocked the world of folk art."[37] Ames questioned the definition of "folk art," bringing the rigor of recent critical analysis, particularly French deconstructionist thought, to his discussion. He interrogated the power relations embedded in the term "folk art." Folk art implied that there was another sort of art intended for the "aristocracy." Calling objects made by a certain sort of people folk art "depreciat[ed] their makers or users," Ames wrote. He also critiqued recent folk art exhibitions for their lack of "inclination to place objects in historical context" in favor of isolating objects in a manner that shows off their artistic merit. "Deprived of his-torical context," he wrote, "an object becomes art. In other words, by severing fact from artifact, one can 'make' art."[38] Ames could have been critiquing *Abstract Design in American Quilts* for its isolation of objects from their historical context and its denigra-tion of the quiltmakers.

Without a doubt, four years earlier, young feminist art historian Pat Mainardi, had taken *Abstract Design* on directly. Mainardi not only issued her complaint that when displayed as works of art, quilts were detached from their historical context; she partic-ularly took issue with the appropriation of quilts as art objects within a male, modernist art context, naming Holstein as the primary perpetrator.[39] "Because our female ances-tors' pieced quilts bear a superficial resemblance to the work of contemporary formalist artists such as Stella, Noland, and Newman," she wrote, "modern male curators and critics are now capable of 'seeing' the art in them." She understood quilts' significance in different terms, identifying their production as part of "a universal female art" in which "women controlled the education of their daughters."[40]

Holstein did not take Mainardi's attack too seriously. He found this criticism of his interest in quilts "laughable." "Naturally, I was interested in aesthetics, because that was what I was trained in," Holstein said years later. "I was not a trained folklorist. I wasn't interested in folklore. I wasn't interested in sociology. I was only interested in aesthetics. So that was the aspect of quilts I chose to study." In retrospect, Holstein acknowledged that he overlooked quilts as carriers of social history, but he made no apologies for advancing the "good design" approach. He contended that "had we not stuck ruthlessly to looking at them as aesthetic objects," such a broad public would not have embraced quilts.[41]

Holstein's reaction toward Mainardi's critique echoes some of the contentious discussions taking place about the nature of folk art, such as those at the "'shoot-out' at Winterthur," a 1977 conference held in conjunction with the Winterthur / Brandywine River Museum exhibition *Beyond Necessity*.[42] The conference's primary point of discus-sion was Ames's controversial critique of folk art centering on issues of power. In the simplest of terms, the debate pitted curators, collectors, and dealers—those who tended to value objects such as quilts for their aesthetic merit—against folklorists and other academics—those who favored using various methodologies and theories to conduct

cultural analysis in order to learn about the objects, their makers, and users. Holstein clearly fell into the camp defending its right to appreciate folk art objects without consideration of non-aesthetic factors.[43] Yet this position was increasingly under attack, particularly as the women's movement embraced quilts and other needlework as part of women's artistic heritage.

FEMINISM AND QUILTS

As the feminist movement began to gather steam during the 1960s, women artists and art critics developed a renewed appreciation for traditional women's crafts such as weaving, embroidery, and basketry. Through feminist artists and feminist art criticism many of these "crafts" were validated as "art," specifically as women's art that could make both a powerful visual statement and empower women.[44] Exemplifying this new status is the 1983 statement by feminist artist Miriam Shapiro: "Only now is [quilts'] significance as an indigenous American art form created exclusively by women beginning to be recognized. The quilting tradition illuminates the darkness of women's history like a torch, showing us the strength and power of women as artist-makers and the consolidation of women as a sharing community."[45]

Although Pat Mainardi's 1973 article, "Quilts, The Great American Art," was in part a response to and critique of Holstein's influence on *Abstract Design in American Quilts*, it was also a feminist declaration that quilts were a vital part of women's artistic heritage. She bemoaned that quilts "are omitted from all general reference within the history of art" and, like jazz, were "underrated—because the 'wrong' people" made them.[46] As some feminist artists began to embrace quilts as their artistic heritage, the iconography of needlework as well as its techniques appeared in their work. Artists trained in other media, such as Miriam Shapiro and Judy Chicago, utilized quiltmaking, embroidery, and other needle arts in their works along with traditionally feminine iconography. Projects such as *The Artist and the Quilt*, started in the early 1970s and completed in 1982, were attempts at encouraging female visual artists to experiment with quiltmaking techniques. This effort, which resulted in a touring exhibition and catalog, united quiltmakers and established artists in the creation of quilts based on feminist artwork. Judy Chicago's landmark installation piece, *The Dinner Party*, first exhibited in 1979, also integrated traditional quiltmaking techniques into dinner place settings celebrating noted women from throughout history.[47] In these ways, feminists embraced quilts as art, but in a way that contrasted with Holstein and van der Hoof's modernist approach emphasizing strong design alone.

Seeing or hearing about the Whitney's successful *Abstract Design* in 1971 prompted some women to create their own alternative responses that emphasized the role of quilts in women's lives rather than only aesthetics. When a group of women in the Bay area in California heard about the hoopla surrounding the exhibit, they knew they needed to take action. Julie Silber, along with friends Pat Ferraro and Linda Reuther, had made their own "discovery" of quilts in the mid-1960s. They countered *Abstract*

Design by demonstrating how these objects could enrich and validate the stories from historical women's lives. Like Holstein and van der Hoof, they agreed that quilts looked great hanging on walls because of their graphic qualities. But they viewed quilts as an entrée into women's history, a new and unexplored field of study.[48]

These women organized and curated *Quilts in Women's Lives,* a 1976 exhibit hosted by the Emanuel Walter Gallery of the San Francisco Art Institute. Silber recalled this small exhibit as their direct response to *Abstract Design,* which they perceived as a male way of viewing quilts, with aesthetics overshadowing all other aspects of quilts' significance. Rather than isolating the quilts on white walls, they used quilts to present the life cycle of nineteenth-century women, complementing the quilts with quotes from women's letters, journals, and biographies. Although the exhibit was small, the critical response was great, and this trio of women began formulating a means to expand the exhibit in content and allow it to reach a greater audience. In 1981 their exhibit, *American Quilts: A Handmade Legacy,* opened at the Oakland Museum, attracting 120,000 visitors in three months and breaking the museum's previous attendance record. The quilts themselves contrasted with those in Holstein and van der Hoof's collection: quilts with stories embedded in the stitches or inked inscriptions replaced those that most looked like paintings. Whereas the catalog to the Whitney exhibit pictured quilts floating like stretched canvases with little accompanying text so that the visual elements could speak for themselves, the Oakland exhibit's catalog included interpretive essays, stereoscopic images of women with their quilts, excerpts from diaries, and detail images that allowed readers to see the craftsmanship of the individual stitches as well as the overall aesthetic elements of the quilts.[49] To these curators, quilts were one of many types of "cultural documents" that could help elucidate women's history.

Patricia Cooper and Norma Bradley Buferd attended the Whitney's *Abstract Design* in 1971 and "recognized that the show signaled a renewed interest in quilts, especially quilts as an art form." These southwestern women, who had learned to piece quilts as children and cherished their own family quilts, already held a deep appreciation for these objects. In 1972 they began their own project, collecting quilts for an exhibition of southwestern quilts. They too loved the "sophisticated, singular, bold, pleasing" designs they found. But as they collected and looked at quilts, they began to develop theories about the role of quilts in women's lives: "The best elements of teaching were often combined over the construction of a quilt: early and often loving instruction, tradition, discipline, planning, and completing a task, moral reinforcement. Quilting was a virtue." They launched an oral history project in which they talked to around thirty women, participating in their quilting bees and listening to their stories. Cooper and Buferd recorded their stories in a 1977 book, *The Quilters: Women and Domestic Art,* integrating women's quiltmaking into a cultural history of New Mexican and Texan women.[50]

Other feminists embraced quiltmaking as art by encouraging women who made quilts to consider themselves artists. Jean Ray Laury, an academically trained artist, started making quilts in the late 1950s, long before the late twentieth-century's

so-called "quilt revival."[51] She began teaching and writing about quilts in the 1960s, publishing quilt patterns in magazines, including *House Beautiful* and *Woman's Day,* as well as how-to guidebooks. Laury understood the chasm that divided "high art" from crafts and considered quilts a means "to bridge the gulf between art and craft," similarly espousing that women could be artists as well as mothers and wives. To Laury, the process of making quilts could be akin to other sorts of consciousness-raising activities that feminists were undertaking. Through Laury's writing and teaching, many women discovered quiltmaking as an artistic practice that allowed for emotional expression and political statements. As quiltmakers inspired by Laury embraced their artistic abilities, the status of quilts shifted in their minds from traditional craft to contemporary work of art.[52]

AN ESCALATING BUZZ

Cultural currents swirling both prior to and after the landmark *Abstract Design in American Quilts* exhibit played a significant role in shifting the status of quilts. New perceptions of the importance of handmade objects, a feminist reclamation of needlework from drudgery to art form, and an awareness of contemporary women making quilts as a means of escaping poverty all factored into the growing buzz surrounding quilts. After receiving relatively little attention since the folk art and colonial revival craze of the 1920s and 30s, quilts' spot in the limelight only increased in the years surrounding the American Bicentennial because of nostalgic nationalism centered on an imagined colonial past.[53]

By the mid-1970s, a good deal of the buzz about quilts began to home in on Amish ones in particular, with a focus that extended well beyond ideas of folk art and women's work. With exhibitions, publications, and collections focused specifically on Amish-made quilts, fascination with these objects emerged as a unique subset of the new quilt revival. With a dual appeal, Amish quilts could paradoxically function as primitive works of folk art while also adding unexpected modern flair to the homes of collectors and art enthusiasts.

CHAPTER **5**

THE FASHION
FOR QUILTS

In the years following the Whitney Museum's *Abstract Design in American Quilts* exhibition, Amish quilts became fashionable objects. Museums and galleries rushed to exhibit and collect quilts in general and Amish quilts in particular, popular magazines encouraged readers to decorate their homes with them, art collectors showcased them in both modernist and rustic settings, and a prominent fashion company made them an essential element in its aesthetic and philosophy. In all of these instances, individuals embraced the argument that quilts were indeed art.

In some ways, Amish quilts, with their strong graphics and bold colors, simply substituted for other works of abstract art. But the paradox of objects deemed, in art critic Robert Hughes's words, "inescapably modern," coming from a culture that had attempted to keep modernity at arms' length, only increased the appeal of Amish quilts to outsiders.[1] Furthermore, quilts' hand-wrought stitches, the tactility of fabric, and their associations with warmth and comfort—in short, their materiality—made them much more than simply visual artworks. Few other cultural objects—except perhaps Shaker furniture—have been able to play this dual role of serving visually as modern art and culturally as a tangible reminder of tradition, authenticity, and rural values—the imagined aspects of the pastoral ideal.

Within Amish theology, fashion was anathema. Yet these old bedcoverings became vogue to individuals far removed from the Amish community with only limited understanding of its faith. But to some of these same individuals, the allure of Amish quilts led them to emulate qualities they perceived in the Amish, including simplicity, authenticity, and fine workmanship.

MUSEUM VOGUE

Museums and galleries continued to validate the status of quilts as art objects, following the Whitney's example by hanging them on walls. While the Smithsonian's touring exhibition (SITES), combined with the outpouring of press attention following the Whitney's exhibition, was important in publicizing and disseminating the aesthetic merits of quilts to a wide audience, the Metropolitan Museum of Art provided added gravitas in the center of the art world. The Met hopped on the quilt bandwagon, thanks to associate curator Marilynn Johnson Bordes, who later asserted that "the Met was not interested

in quilts; I was."[2] Although she had a difficult time selling the esteemed museum on her proposed exhibition, in 1974 the Met launched *12 Great Quilts from the American Wing*, and Bordes wrote catalog entries for its accompanying publication. Of the twelve quilts, two had been donations to the museum from the 1920s and 30s and had detailed family provenances. The museum had likely displayed these early quilts from upper-class homes on beds as part of the American Wing's colonial revival–inspired period rooms, rather than on gallery walls as they were now. Donors had given another quilt to the museum in 1962, but the remaining nine were acquisitions that had occurred after 1971's *Abstract Design*, including at least two quilts the Met had purchased directly from Jonathan Holstein and Gail van der Hoof.[3]

Bordes formally thanked the couple in the catalog's acknowledgments, and their influence is visible in her emphasis on quilts that are "the best of their kind visually."[4] Her catalog did, however, provide more background information than Holstein's *Abstract Design* catalog did for individual quilts, including family histories and a bit of cultural context. For example, of one of the two Amish quilts, she wrote, "The fabrics of Amish quilts were usually taken from clothing, the more brightly colored patches from children's clothing." She also echoed Holstein's emphasis on the connections to abstract art, albeit with a bit more speculation about the origins of the quilt patterns: "For obvious reasons, the Amish quilts have often been compared to modern paintings, particularly those of Albers, Noland, and Vasarely. Despite their appeal to contemporary taste, the Amish patterns such as the Square, the Diamond, and Sunshine and Shadow probably represent a highly schematic rendering of traditional center medallion patterns."[5]

Smaller museum exhibits prominently featuring Amish quilts began to occur with some frequency in the mid- and late 1970s. With each exhibit, viewers previously unfamiliar with Amish quilts made the same connections that Holstein and Bordes had made. Philadelphia antiques dealer Amy Finkel, who curated Moore College of Art's 1978 exhibit, *Pennsylvania Quilts: One Hundred Years, 1830-1930*, recalled that "everyone, whether they came in to see me [at my shop] or saw an exhibit like that, they would think they'd discovered it: 'Oh my god, look at these! They look just like modern art!' "[6] The University of Pennsylvania's Institute for Contemporary Art made sure viewers would make this link at their 1976 exhibit, *Made in Pennsylvania*. They projected slide photographs of abstract art alongside Amish quilts hanging on their gallery walls. The exhibit's publicity materials referred to the objects as "Amish quilts that could have been contemporary paintings."[7]

MAGAZINES INDUCE A "CRAZE FOR QUILTS"

It was not only urban museum goers who read Holstein's books, visited traveling versions of the SITES *American Pieced Quilts* exhibit, or read about the craze for quilts in shelter magazines and wire newspaper stories. Non-urbanites living in the areas Holstein referred to as the "hinterlands" did not comprehend why big city museums were suddenly so excited about quilts, such ordinary objects. In many areas of the coun-

try, quilts continued to be part of the repertoire of women who knew how to sew and liked to do so in creative yet productive ways. Many households across the country owned quilts, perhaps passed down from previous generations. These may have been well-used and worn, preserved as family heirlooms or forgotten in chests and attics.[8]

Popular magazines, most based in New York, could reach out to readers across the country and transmit big city trends beyond elite city circles. In October 1972, *Life* published a photo spread under the title "Craze for Quilts." Alongside images of graphic log cabin and crazy quilts, the author noted: "The current craze for quilts is part of a burgeoning interest in crafts. But it also reflects modern taste in abstract art. Crowds have flocked to a quilt show, organized by New York's Whitney Museum and soon to open in Paris, in which coverlets made a century ago display such a dazzling kinship with the geometric and op styles of recent painting that they seem perfectly up-to-date."[9] *Life* suggested that quilts were both craft and art: an image of Lulla Pettway, an African American quiltmaker from Alabama, stitching on a quilt demonstrated that living craft makers continued to create quilts, while photos of Holstein and van der Hoof's quilts presented as flat objects isolated from their crafted-ness helped readers understand how they worked as pieces of modernist art.[10]

Shelter magazines also helped spread aesthetic ideas about quilts, particularly by showing how they could function as artworks in contemporary houses. *House and Garden* featured shots of Holstein and van der Hoof in their Upper West Side apartment, highlighting various ways one could use quilts as part of an interior decorating scheme. "Some quilts are so special they should only be hung like paintings," the article said, emphasizing in a language more accessible than Holstein's how quilts resembled modernist art. A widely published newspaper wire story made this point visually as well; a photo featured a large round abstract painting by Holstein's friend Terry Syverson hanging adjacent to a String Star quilt.[11]

Following the publication of these articles, Holstein and van der Hoof's mailbox was flooded with letters from readers from all across the country who wanted to talk about their family quilts. Holstein assumed readers from small towns and rural areas did not understand that the quilts on exhibit "looked like modern paintings, not like the quilts their grandmothers had made," suggesting that not all ordinary family quilts worked as paintings for him.[12] Yet because Holstein and his New York art scene started to care about quilts, the quilts stored in attics and chests across the country—even if they did not look like the latest abstract paintings—benefited from the increased attention. Quilt owners started to care about preserving these objects, and some considered selling them once they understood that individuals like Holstein and van der Hoof were looking to buy.

Holstein and van der Hoof received dozens of letters from individuals who owned family quilts they now wanted to sell. Sometimes the letter writer—usually a woman—would describe the quilt or send a snapshot. Their descriptions of their family quilts were often a far cry from the sorts of visual elements Holstein celebrated: a North Carolina woman's quilt, for example, featured "beautiful needlepoint figures and designs,

i.e., golden butterflies, crimson roses, golden and black little kittens." After reading about the couple's collection in the January 1972 *Newsweek* article "The Joy of Quilting," a Minnesota woman sent Holstein a letter describing her quilt: "scalloped edged with a scroll appliqué and rosebuds and 2 shades of appliquéd hearts."[13] These were cute quilts, not ones that looked like modernist art, and were of little interest to the collectors. To Holstein's credit, he diligently and politely responded to the letters, often commenting on how nice the quilt was but that it was not the sort he was interested in buying. However, this grassroots response accentuated for him that people living far from his art world did not get the point he was trying to make.[14]

Holstein did not see these non-urbanites with quilts in their attics as his primary audience. He later recounted reading reviews of the traveling exhibit in small midwestern newspapers. The reporters were asking, "Why is everyone going crazy" about quilts? "We tried to explain it, and they didn't get it," he commented. "They didn't have enough background in modern art to understand what critics in New York were seeing." While Holstein felt he could not communicate his theories about the aesthetics of quilts to these folks in the "hinterlands," he noted that popular magazines had the ability to reach midwesterners in a way they could comprehend. He called it "a big city dialogue among art critics and collectors" that spread "from the city through mass-circulation journalism."[15]

Photo spreads of rooms with quilts published in popular shelter magazines were often prescriptive staged creations rather than objective representations of how quilts functioned in modern homes. Rachel Newman, the former editor of *Country Living*, a successful magazine that presented quilts in nearly every issue during the 1980s, explained that when homeowners slated for a spread in her magazine did not own quilts, "we would bring quilts in. . . . We were lucky enough to have wonderful antique dealers here in New York that allowed us to borrow these quilts and take them with us. If we were shooting out of town, often we would go around the town and scout first and talk to antique dealers there."[16] Quilts were ideal in these settings because they had strong graphics, appealing to those with an appreciation for abstract art, yet their association with a seemingly simpler past made them much more than mere visual artworks. Furthermore, dealers were happy to loan quilts to display in picture-perfect spaces, particularly if they received a credit line that lured potential consumers to their gallery doors. Conversely, dealers could attract customers by promoting their connections to shelter magazines. For example, in a 1978 issue of *American Art & Antiques*, quilt dealer Phyllis Haders ran an advertisement featuring an Amish Center Diamond, touting it as "from my collection featured in the October 1978 issue of *House and Garden* magazine."[17]

The article Haders referenced showed several of her quilts installed in her own white-walled, upscale New York City apartment (fig. 5.1): "The vivid colors of Amish quilts—often the only decorating to be found in Amish homes—are all the color this modern, light-filled room needs. Hung like contemporary paintings in Mr. and Mrs. Richard Haders's city apartment, they enliven a setting designed by Melvin Dwork to

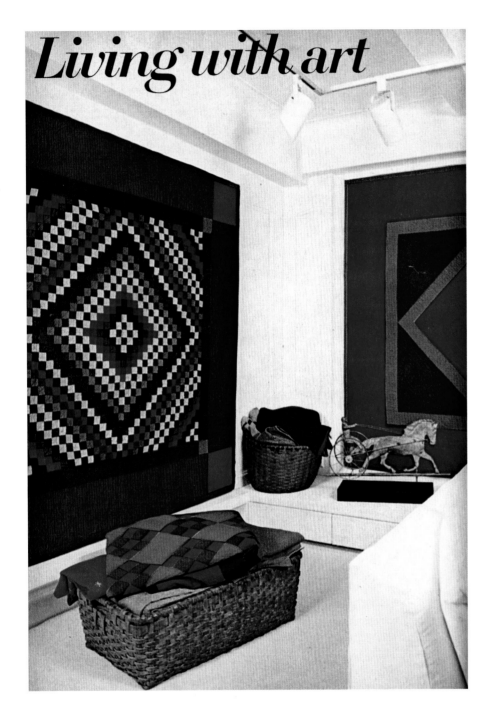

Living with art

show off their dazzling geometrics."[18] These few words emphasized that Amish quilts were designed objects in a designed space; Dwork was a well-regarded New York interior designer, and his name may have signaled cachet to the magazine's more up-market readers. But the article and accompanying images also conveyed that one could emulate Amish simplicity by displaying similar quilts in one's home.[19]

Antique Collecting, a magazine aimed at young collectors accumulating various sorts of antiques and folk art in the late 1970s and 80s, promoted the idea that one could use

these to dramatic visual effect in contemporary spaces. The magazine profiled antique collectors Bettie and Seymour Mintz's country house in 1978 (fig. 5.2). The structure featured a contemporary glass-walled addition attached to an older stone cottage house. In a photo taken from a distance, one could make out a work of bold red art on the wall through the large glass windows. From this perspective, it looked much like any other modern art lover's home, with a graphic abstract painting on the wall. But in an interior view, readers saw that this searing red was a Lancaster County Center Diamond quilt, one of several Amish quilts displayed alongside a few choice pieces of pottery and commercial art.

The photo's caption read: "The hanging quilts, hooked rugs, and scattered objects of folk art are very much at home in the contemporary surroundings. Following no traditional guideline, [the Mintzes] have brought together the simplicity of country antiques with modern architecture in a home that celebrates the harmonious combina-

Figure 5.2. Bettie and Seymour Mintz's country house. Notice the red Center Diamond quilt hanging inside.

- -

(Image courtesy of Bettie Mintz)

- -

tion of old and new."[20] Not just any quilt, or any antique for that matter, could convey tradition while still looking great in this contemporary setting. Because of the parallels that art enthusiasts identified between Amish quilts and abstract paintings, Amish quilts could function on both levels—as great works of design and as symbols of the traditions of the past.

Prior to the advent of modernist art forms like color field painting and op art, interior designers creating looks for shelter magazines likely would have considered Amish quilts merely old-fashioned. But with their eyes tuned to these forms of abstraction, both professional and amateur decorators came to value Amish quilts' ability to function at once as works of modernist art and as symbols of a rural past. Photo spreads in shelter magazines and in Mary Ellisor Emmerling's "American Country" design sourcebooks showed how Amish quilts could look great in austere, modernist settings, functioning much like paintings. But unlike a similar work of abstract art, a quilt could demonstrate the owners' sense of authenticity and appreciation for a simpler past—both characteristic of the modernist thought of this era.[21]

ESPRIT AND THE SEARCH FOR AUTHENTICITY

In attendance at the 1971 Whitney exhibit was Doug Tompkins, cofounder of the Esprit de Corp clothing company. He immediately understood the argument Holstein and van der Hoof were making about quilts. What Tompkins did as a result of this visual evidence helped further disseminate the idea that Amish quilts were works of art and objects of fashion. Tompkins and Esprit played a prominent role in creating the meaning and value of Amish quilts during the 1970s and 80s.

Tompkins, an avid hiker, skier, and climber, met his future wife, Susie Russell, when she picked him up in her 1957 Volkswagen Bug as he was hitchhiking near Lake Tahoe in 1963. After moving to San Francisco, they started North Face, an outdoor equipment and clothing company. A few years later they sold it and used the money to start Esprit de Corp, manufacturing women's clothes based on Susie's designs. After attending the Whitney exhibit in 1971, Tompkins became intrigued with how bedcovers looked on the walls, and he bought his first quilt the next year, a non-Amish red and white Baskets quilt. His next two quilts were Amish—a Sunshine and Shadow and Center Diamond, both from Lancaster County. That same year, Esprit moved to new headquarters converted from a turn-of-the-century winery near San Francisco's Potrero District a few blocks from San Francisco Bay. As Tompkins' collection grew, he hung quilts on the walls—filling the offices, workrooms, and every other spare space.[22]

In 1976 an overnight fire destroyed Esprit's headquarters along with many of the quilts hanging on the walls. Tompkins had protected some of his favorites by storing them in his home. As he rebuilt the space, he designed it as a "mini-museum" showcasing the undamaged quilts and the ones he continued to acquire.[23] Exposed brick walls with long sight lines framed some of the quilts he now collected. Others hung on white walls as at the Whitney Museum. Soon he limited his quilts solely to those made by the

Figure 5.3. Esprit corporate head-
quarters, San Francisco. Published
in *Esprit: The Comprehensive
Design Principle* (1989).

(Sharon Risedorph Photography)

Figure 5.4. Amish quilts on display
at Esprit corporate headquarters,
c. 1983.

(Sharon Risedorph Photography)

Amish, choosing ones with visual effects echoed by the design, color, and workmanship the company strived for in its fashion lines.[24]

In 1977, with the newly remodeled space, Tompkins began to share his under-standing of quilts by opening Esprit's headquarters-cum-art gallery to the public (figs. 5.3–5.6). While many other corporations welcomed the public into corporate art galler-ies on their premises, Esprit uniquely invited visitors to wander through the building, nose into offices and workspaces, and follow Tompkins's instruction to "make your-self at home."[25] In 1985, Esprit published its first catalog, featuring glossy images of the quilts along with a map and checklist of the quilts hanging throughout the build-ing, which visitors received when they paid a modest fee to conduct a self-guided tour through Esprit's headquarters.[26]

Tompkins, like Holstein and van der Hoof, primarily celebrated Amish quiltmakers' design contribution: "Give me a choice between a great graphic quilt with no history and a mediocre one with a complete family history," Tompkins said in an 1983 inter-view, "and I'll take the great graphic piece every time."[27] But for Tompkins, as well as

Figure 5.5. Esprit corporate headquarters, c. 1983. Here the colors and graphics of this Ohio quilt in the foreground play off of those of the kilim on the floor, another of Doug Tompkins' collecting interests.

- -

(Sharon Risedorph Photography)

- -

Figure 5.6. Tumbling Block quilt on display in Esprit design work-room. Doug Tompkins' credo, "No Detail is Small," appears on the back wall. Published in *Esprit: The Comprehensive Design Principle* (1989).

- -

(Sharon Risedorph Photography)

- -

for many other Amish quilt collectors, it was not only about the quilts' strong graphics and bold use of colors. Unlike the contemporary paintings with which art enthusiasts compared quilts, Amish quilts' "pastoral" origins intrigued their new owners. The Old Order Amish, long seen by mainstream Americans as an unchanging sect existing on the edges of contemporary life, seemed to have much to offer the new owners of old quilts. While the attraction may have initially stemmed from the quilts' visual resemblance to abstract paintings, fascination with the Amish themselves also became important as collectors learned about this religious group. By hanging quilts in contemporary, often urban settings, these new owners attempted to transport elements of Amish culture—simplicity, authenticity, self-sufficiency, fine workmanship, and tradition—into their modern lives.

Quilt enthusiasts like Tompkins engaged in a modernist search for authenticity similar to that embarked on by American artists and collectors since early in the twentieth century. Part of this quest had been for "authentic" cultures and "authentic" art, characterized by interest in objects deemed "exotic" or "primitive," and therefore more

organic and pure than those stemming from Western traditions. Throughout the twentieth century, generations of collectors had appropriated Native American and African objects, rechristening them as artwork once displayed in their modern homes, while they celebrated their "primitive" qualities, including simple forms, clean lines, and reduced shapes. Collecting Amish quilts was a similar pursuit.[28]

Doug Tompkins understood his Amish quilt collection as part of a larger, self-consciously "authentic" lifestyle choice. The fashion company's San Francisco headquarters embodied the paradox of quilts functioning both as works of abstract art and as "authentic" objects evocative of simplicity and humility—qualities rarely found in the fashion industry. Julie Silber, the longtime curator of the Esprit collection, described why the quilts resonated so much with Tompkins: "These quilts *appear* simple. But they required discipline and persistence and they demonstrate highly developed skills and sensibilities. . . . Lancaster quilts are understated, unpretentious and focused, all qualities Doug personally admires. Lancaster quilts are objects of uncompromised integrity."[29] Tompkins himself noted that the presence of a Lancaster County Amish quilt "comes across as a sort of truth."[30]

Tompkins took on the title of "image director" and promoted what he called a "comprehensive design principle" that unified the company's products, marketing, and architecture, creating an identifiable brand. This principle resulted in practical clothing with clean lines and bold colors, advertising campaigns featuring real people rather than models, and a corporate office that doubled as an Amish quilt museum. At the company's San Francisco headquarters, Tompkins' design principle manifested itself in an open floor plan, transparent building techniques from 100-year-old recycled wood, handmade unembellished furniture, and the straightforward geometrics of Amish quilts. Like other collectors, he wanted quilts that worked graphically for him as paintings, but he also understood that these textiles related to the strong simple designs the company sought in its clothing lines. He hoped that the presence of these objects would transfer elements of Amish culture to his company's workplace and in turn to the fashion lines it produced. In the company's 1985 souvenir catalog of its quilt collection, he wrote: "As most of our visitors already know, we are a clothing manufacturer; and fabrics, color, texture and shape are ingredients found in both our products and in quilts. Workmanship also plays a big part in the final product. Our interest in quilts really emerged quite naturally from this close affinity. We have found that living among such masterpieces of design, color, and workmanship has inspired designs, tuned all of our senses to design and left us all a little bit, if not a lot richer."[31]

Esprit's open floor plan, while clearly a modern aesthetic, also evoked the interior of Amish homes in its minimalism, open spaces, and heavy use of solid wood. The design featured brick walls, exposed beams, and plants everywhere, many of them rooted into sparse wooden boxes. Pendant lamps hung from cords dangling among the exposed beams; transparent glass separated design studios, offices, and conference rooms from the open space, allowing visitors to peek in at the quilts hanging behind closed doors.

Although Tompkins hung each quilt so viewers could see it with no distractions, his arrangement also created visual interaction among the quilts and the other designed elements within the space. For example, an Ohio Amish quilt in an unusual unnamed pattern featured a deep red "streak o' lightning" border, intricate stars, and diagonal black sashing dividing up the complex ground. Esprit hung this quilt on a white wall above a kilim, a tapestry-woven Persian rug, placed on the floor (fig. 5.5). The rug echoed the red from the quilt's ground and featured similar use of borders, symmetry, and intricate patterns.[32] Clearly, this arrangement of quilt and rug was intended to show the visual and cultural connections between these objects, each removed from its original context. Each came from a seemingly "exotic" culture with a craft-making tradition he considered "pure" and "essential." While Tompkins undoubtedly relished their visual aspects, his quilts (and in parallel, his rugs) also added intangible benefits to the workspace, encouraging Esprit's workers to think about cultural aspects of Amish quilts—simplicity, authenticity, workmanship—that he wanted to accompany the company's designs.

Tompkins sought out authentic experiences in his life as well as authentic design and marketing in his work. In his mind, one could achieve authenticity by living according to one's ideals, striving for excellence in all things, and being transparent in both design and advertising. His philosophy was an ideal typical of the sort of American modernism culminating when Tompkins was coming of age during the 1960s, characterized by quests for wholeness, expanded consciousness, and new experiences.[33] Esprit staff referred to Tompkins' preference for rock climbing rather than sitting in an office as MBA (Management by Being Absent). He similarly wanted Esprit's employees to have fulfilling, authentic lives that integrated their work with a variety of other experiences. Doug and Susie Tompkins' innovative human resources strategy, which among other things subsidized employees attendance at cultural events like museums, the opera, and theater; rafting and skiing trips; and foreign language lessons, garnered the pastoral nicknames "Camp Esprit" and "Little Utopia."[34] Tompkins explained that with these perks "the individual will heighten their sensibilities about being alive, and if they are alive and more dynamic, the byproduct goes to their organization."[35] Amish quilts contributed to this aura that Tompkins hoped would transfer to the company's products.

Esprit's design perspective also reflected Tompkins' pursuit of authenticity. His wife and business partner, Susie, described the company's fashion lines as having "a kind of eclecticness and an integrity of design. Mixing old things with new things," which doubles as an apt description of the exposed brick walls, plants, handcrafted desks, and Amish quilts that comprised the company's work environment. Doug imagined Esprit's customer as someone who "knows the difference between 'substance and superficiality.'"[36] He analogized, "We sell the crayons—the customer makes something of it," describing the iconic mid-1980s lines featuring "vivid colors and bold prints . . . meant to be mixed and matched according to the wearer's whim (see fig. 5.7)."[37] And Esprit's designers drew inspiration for some of these bold prints from the "authentic"

pieces of design hanging all around them. Tompkins recalled that he specifically sent designers to the quilts for inspiration one season.[38] While it is difficult to pinpoint the tangible results of this approach, one particular mid-1980s vest in the vivid colors of a Midwestern Amish quilt bears close resemblance to a checkerboard quilt that hung on the company's walls (figs. 5.8–5.9).

As Esprit's image director, Tompkins ushered in unconventional marketing tactics. Rather than use models in its clothing advertisements, in 1985 Esprit began to feature its employees and customers in its "Real People" advertising campaign. The ads included short biographies of the participants, condensed from longer interviews, and were designed with Esprit's trademark geometric color blocks (fig. 5.10). Replacing professional models with staff members or shoppers at Bloomingdale's gave Esprit's ads some of the authenticity the company sought. In 1989 Tompkins took his authenticity in marketing approach even further, instituting a "Buy Only What You Need" campaign in Esprit's catalog and on its hang tags to encourage consumers to buy less and use what they have longer. His increasing discomfort with consumer culture coupled with his passion for environmentalism and "deep ecology" led Tompkins to sell his shares in Esprit to Susie in 1990 (around the same time as their divorce) for $125 million. He has since used his fortune to buy land in Chile and Argentina with the purpose of preserving natural spaces and has provided grants to environmental organizations around the world.[39]

The quilts that hung on Esprit's walls for two decades were part of Tompkins' search for authenticity in design, in marketing, and in living. His next passion—deep ecology—allowed him to continue to pursue his ideals: collecting land instead of quilts. And even in his South American land preserves, he seemed to look to the Amish for inspiration, building a one-room schoolhouse for local children, starting organic gardens, replacing tractors with horse-drawn vehicles, and living in a restored Chilean ranch with no electricity or modern appliances. In recent years, he has brought some of the remaining Amish quilts from the Esprit collection to Chile to hang alongside the

Figure 5.7. **(bottom left)** Esprit advertisement, 1986.

Figure 5.8. **(opposite)** Checkerboard, unknown Amish maker, c. 1900-1920. Cotton, 68 x 68 in. Esprit owned this quilt in the 1980s. Based on visual analysis of the quilt and an Esprit vest (fig. 5.9), one can see explicit links between Esprit's Amish quilts and their resulting fashions.

(International Quilt Study Center & Museum, University of Nebraska–Lincoln, 1997.007.0469)

Figure 5.9. **(bottom right)** Esprit vest, c. 1980s. This garment bears a strong resemblance to the quilt in figure 5.8.

(Author's collection)

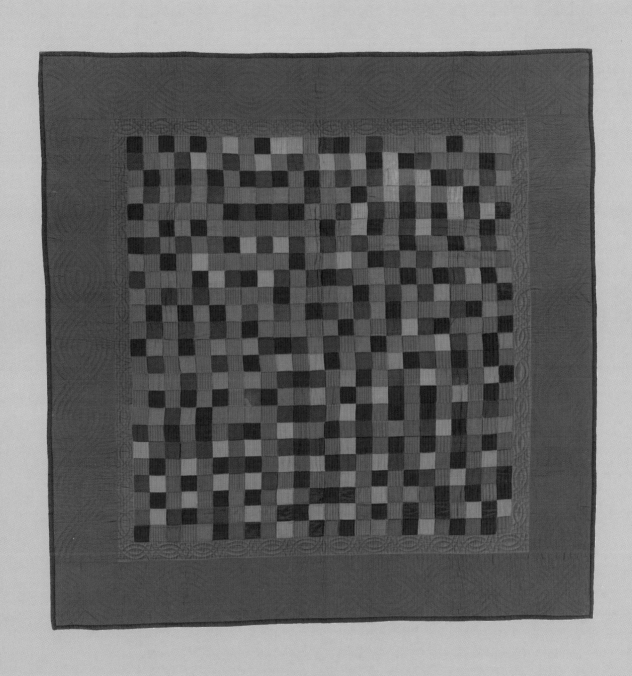

Figure 5.10. Esprit advertisement, c. 1985. From "Real People" advertising campaign, featuring staff members rather than models.

Chilean weavings he had begun acquiring, once again integrating distinct aspects of his search for authenticity into an aesthetic representation.[40]

AMISH: THE ART OF THE QUILT

The culmination of celebrating Amish quilts as great works of art occurred when Doug Tompkins and Julie Silber partnered with the San Francisco Museum of Fine Art's de Young Museum for the 1990 exhibition *Amish: The Art of the Quilt*. As with most of Tompkins' successful undertakings, he wielded power over decisions large and small leading to this exhibit. He imagined a darkened gallery with dramatic spotlights illuminating the center of each quilt. From every vantage point in the gallery, one could view more than a dozen quilts, each glowing from the inside. Tompkins insisted on only the most minimal signage in the gallery, not wanting any distractions to disrupt the dramatic impact of the quilts emerging from the darkness. In this setting, Tompkins could visually make his argument about Amish quilts, just as Jonathan Holstein and

Gail van der Hoof had about quilts in general nearly two decades before at the Whitney Museum. In a small adjacent gallery, Julie curated an addition to the exhibit, highlighting the cultural context of Amish quilts, where viewers could see photos of Amish communities and learn about the Amish way of life.[41]

Accompanying the de Young exhibit was a tome of a catalog, weighing in at five pounds, measuring fourteen inches square, and priced at a hundred dollars. Designed by Esprit's graphics department, the book featured glamorous full-color photos of the eighty-two quilts displayed at the de Young. In an effort to add even greater gravitas to the undertaking, Silber and Tompkins persuaded art critic Robert Hughes to contribute the lead essay to the book. Hughes was reluctant at first, but upon meeting Tompkins and touring Esprit's headquarters, where he could see the quilts in the full glory Tompkins intended, he signed onto the project. Hughes, famous for his documentary series and book, *The Shock of the New*, exploring the development of modern art, knew nothing about the Amish or their quilts prior to his introduction to Esprit. With tutoring from some of the established experts on Amish quilts, Hughes provided an adequate overview of Amish quiltmaking within the context of its culture. But his essay's primary purpose was not to elucidate Amish culture or quiltmaking practices. He was bestowing Amish quilts with a final verdict, guaranteeing their status as art objects.[42]

Praising quilts' transition from beds to walls, Hughes took aim at the historical line distinguishing handcrafted, utilitarian objects such as quilts from other arts: "Seen out of their original context of use, hanging on a wall, they make it very plain how absurd the once jealously guarded hierarchical distinctions between 'folk' and 'high' art can be." Like numerous art critics from the previous two decades reviewing various exhibitions of Amish quilts, Hughes drew comparisons to abstract artists working in geometric forms. He was not offering new information in his essay; rather, he was delivering the closing statements of a decades-long case arguing for greater aesthetic appreciation of quilts.[43] Amish quilts indeed were in fashion.

CHAPTER **6**

- - - - - - - - - - - - - - - - - -

FROM RAGS
TO RICHES

Following art enthusiasts' revelation that Amish quilts were aesthetic objects worth displaying on walls, a market developed linking quilts in Amish homes with consumers willing to pay money for them. As in any economic system, the relationship of supply and demand influenced the price of Amish quilts. But like any other real-world market, the trade in Amish quilts was not rational, as intense competition among dealers, frequent use of gimmicks, connoisseurship evaluating quilts' patterns and construction, and the suspicion of fraudulent practices often intervened. Emotional reactions to quilts also affected value, as did criteria that were even less quantifiable, such as romantic notions about Amish culture. Collector David Pottinger recalled having emotional responses to particular quilts. He remembered waiting in an Amish family's living room for an old Amish woman to appear with three folded quilts in her hands. "You had no idea what was going to happen. . . . She'd pick one up. She'd start to unfold it. We'd each take a corner. And that moment went on and on, over and over. Most of the time, it was OK but not wonderful. But that one time, it will just knock your socks off."[1]

In the moment Pottinger described, the Amish woman's quilts gained "commodity potential." She likely had either stitched these quilts herself as a young woman or had received them as gifts from her parents or grandparents. They were not created as commodities. But when a "quilt man" such as Pottinger knocked on her door, her quilts gained potential exchange value as the marketplace diverted them from both their sentimental position as heirlooms and their utilitarian status as a means of keeping warm.[2] This chapter explores the arenas in which these objects gained commodity potential, along with some of the individuals who mediated and negotiated quilts' meaning and value.[3] The trade in quilts brought together individuals from the country and the city, who often had only limited understandings of each other's culture, into a mutually beneficial situation. A collector like Pottinger might acquire a quilt that "knocked his socks off," while an Amish family could gain cold hard cash in exchange for an old, seldom-used bedcover. Within this commodity context, Amish families, pickers, dealers, consumers, and collectors negotiated and constructed quilts' value.

Before 1973, the market for Amish quilts was virtually untapped. "The Amish weren't interested in selling things from their homes, and people didn't know they existed," recalled collector and curator Jonathan Holstein. "There wouldn't have been a market for them unless one was created." Indeed, Holstein helped create it. The buzz

around Amish quilts grew as individuals began to learn about these objects through exhibits inspired by the Whitney Museum's *Abstract Design in American Quilts* (1971) and Holstein's book *The Pieced Quilt* (1973). As Holstein described it, in 1973 "the market for antique quilts heated up. . . . It was like a gold rush."[4] That summer antiques dealer George Schoellkopf showed fifty Amish quilts in his Madison Avenue gallery in New York, the first public showing consisting exclusively of these objects.[5] During that same summer, Holstein and van der Hoof concentrated their efforts on building a collection of Amish quilts, buying more than one hundred of them from sources in Lancaster County, Pennsylvania. The couple's friend Linda Gruber, who helped scout out quilts from her home in Lancaster, noted that Holstein "knew how to create a market for art. He had done this with other things before. Native American art and oriental rugs had been his forte. To be an art dealer and discover something that is going to take off is incredible."[6] Although Holstein and van der Hoof were primarily collectors and curators, not dealers whose primary intention was to sell objects for a profit, they did frequently sell quilts—often on commission to galleries or to high-profile museums, including the Metropolitan Museum of Art and the Los Angeles County Museum of Art. They also promoted quilts through writing and speaking about their aesthetic merits, appraising their value for museums and other dealers, and curating museum and commercial gallery exhibitions in North America, Europe, and Japan.[7] The couple was instrumental to the processes that brought quilts out of Amish homes and into the commodity context.

Helping to establish the market were New York art dealers who recognized, as Jonathan Holstein later described, how "the idiom of Amish quilts coincided with the New York art market."[8] Dealers such as George Schoellkopf, Kate and Joel Kopp at America Hurrah, and Tom Woodard and Blanche Greenstein at Woodard Greenstein immediately saw the aesthetic links between abstract art and Amish quilts and targeted art collectors as the ideal market for these goods. But the New York galleries could not entice their elite consumers to buy unless they had plenty of quilts to show them. They soon did, as local antiques dealers in Lancaster County began to hear that "old dark quilts," previously the dregs at estate auctions and junk shops, were now worth money.[9]

PICKING FOR QUILTS

For this market to function, Amish quilts—often stored folded in chests or displayed on guest beds—had to leave home, assisted by mediators who both knew where the quilts were and understood the budding market. Typically, the first step in this process was a knock at the door. Pickers—private dealers who sold to other dealers rather than to the public and who specialized in knocking on doors—often needed a means of entrée into Amish homes. Clyde Hall, for example, was a picker who was already familiar to the Amish as a "hauler." Although most, if not all, Amish communities have maintained a strict prohibition against the ownership of automobiles, Amish since the 1950s have hired drivers as "haulers" to take them to auctions, job sites, funerals, weddings, and

family gatherings.[10] Clyde Hall lived among the Amish in eastern Lancaster County and provided this service. In the 1970s, when he learned that non-Amish were seeking their quilts, he began to buy them from his customers. Collectors, including Holstein and van der Hoof and collector-dealer Patricia Herr, began to buy from him.[11]

Holstein and van der Hoof developed a friendly relationship with Hall, gaining them entrée into Amish homes as well. "Clyde eventually figured out that it was silly for him to invest his own money in these things if he could get you to pay for it," Holstein recalled. "So he became a commissionaire." Hall would drive the couple to the home of an Amish acquaintance, and they "would negotiate for the quilt . . . and give him a commission."[12] Van der Hoof recalled that "if what I offered for a quilt was enough for a new water pump, they'd take the money."[13]

One rainy day while driving with Holstein and van der Hoof through the Amish settlement, Hall spotted a familiar Amish woman and her daughter waiting at a bus stop. He pulled up and asked where she was headed, then followed with "I'll take you there if you'll sell me that quilt," referring to one he had his eye on. The woman laughed; Holstein theorized that "it was a good country joke." The carload headed to her home, where she sold Holstein and van der Hoof "a stunning quilt."[14] The individuals in the car may have shared little in common, but they were able to agree to terms of exchange, presumably arriving at a deal from which all parties benefited.

Dealers working in New York galleries valued their relationships with pickers who had access inside Amish homes. Thomas Woodard considered pickers in the field their best source for quilts rather than mid-level dealers working away from the source. Pickers, he said, "could find things that nobody else could find." Once pickers developed loyal relationships with dealers, they would reliably be able to make sales in order to sustain their relationships. "We had to sometimes buy things that we wouldn't have normally bought just to keep [our pickers] going and keep them on our side," recalled Woodard. Many pickers would reciprocate this loyalty and would rarely "sell outside the chain." For example, in the early 1980s picker David Wheatcroft chose to sell to dealers Joel and Kate Kopp at America Hurrah even when presented with the opportunity to sell directly to their regular client, Esprit's Doug Tompkins, because Wheatcroft felt that the Kopps had treated him well, and he wanted to maintain that relationship.[15] Pickers with a particularly good reputation for finding quilts in Amish homes attracted city dealers. Fran Woods of Lancaster County had such status. On Thursdays she would go from farmhouse to farmhouse, buying quilts from Amish families. To mitigate the intrusiveness of these visits, she hired an Amish woman to accompany her. Dealers up the ladder anticipated her weekly shopping excursions, and on Friday mornings "there were always four or five dealers there waiting for [her] to open the shop."[16]

Linda Gruber, Holstein and van der Hoof's Lancaster friend, went on picking trips with Clyde Hall on the couple's behalf when they could not be in the field themselves. Holstein and van der Hoof gave her $5,000 to spend on Amish quilts for them while they were out of the country from July through September 1973. "Jon said, 'Buy them all,'" she recalled. "If I did anything, I didn't buy enough." Hall brought Gruber along to

Amish homes where a family had a stash ready to sell, collected from their friends and neighbors.[17]

When a local Lancaster newspaper reported on New York dealer George Schoellkopf's Amish quilt exhibit, noting the quilts' prices, selling stalled as both Amish families and pickers in the field wanted a bigger cut, and New York dealers had to increase what they were willing to pay. Members of the Amish community read the article and learned that their family quilts were priced at $300 to $1,200. Gruber noted the date that the article ran on the inventory list documenting purchases she made that summer so that Holstein and van der Hoof would understand the shift in prices the article caused. In July, pickers charged Gruber $100 to $200. "The Amish are anything but stupid," she recalled. By the end of the summer, both Amish families and pickers had raised their prices.[18]

Pickers had to negotiate with the quilt owners, a delicate process in which they tried not to reveal just how valuable these old quilts really were. "I did not want to tip my hand," recalled Gruber of her picking trips with Clyde Hall. In the early 1970s few Amish individuals had a good sense of the market, and any amount sounded like a lot of money, so pickers knocking at their doors could name a price. One Lancaster Amish woman recalled that a local dealer who came to buy quilts from her pored over them, pointing out flaws, stains, and faded areas before making an offer.[19] Another Amish woman recalled selling a family quilt for a price she later wished was higher: "It seemed like a lot of money at the time, and there's no use crying over spilled milk."[20] Eventually, Amish families became more knowledgeable about quilt prices. In 1983 Eli Miller, writing in *The Budget*, a nationally circulated weekly newspaper widely read in Amish communities, warned, "Do not sell your old quilts too cheap as they are collector's items, especially those in perfect condition. . . . Some will pay $500 to $750 for your quilt if it's in demand, and you don't let them have it for cheaper."[21]

Some pickers didn't seek an inside connection to the community. They simply drove through Amish country, identifying the farmhouses with plain clothes hanging on the line and buggies parked in the lane. Knowledgeable pickers used the church directories published in Amish settlements, which included addresses as well as genealogical information. David Pottinger employed the directory as a tool to determine where the best quilts were: "You'd see a quilt that was really wonderful, and it was made by Emma Schrock, and you'd look in the directory and see that she had eight children, and that's where you'd go next."[22] Picker Michael Oruch recalled driving all night after a family told him about a relative living out of state who had a nice red and black Tumbling Block quilt to sell.[23] Other pickers were more methodical. David Wheatcroft and Eve Granick described their process as akin to an archeological dig: door-knocking from morning until evening, crossing off houses on a map, which was easy in the grid-like landscape of Indiana, where one could cover territory systematically.[24] Sometimes pickers used gimmicks to try to win over Amish families. David Pottinger arrived at Amish farms in his hot air balloon. Eugene Rappaport showed up dressed in Amish garb, attempting to convince Amish families that they were coreligionists. Other

pickers were downright belligerent: one Amish family resorted to calling the police when a certain picker would not take no for an answer.[25]

In addition to knocking on doors, some picked for quilts less intrusively. In 1973 New York dealer Rhea Goodman began placing classified ads in *The Budget*. Nestled amid classifieds seeking "a cow suitable for nursing baby calf" and "a small chicken house that can be moved," Goodman's earliest ad read:

> I PAY HANDSOMELY for ANTIQUE Amish quilts. I am interested in acquiring patchwork quilts for my collection and for my gallery. Write with description and prices and a photograph, if possible.[26]

By publishing an advertisement in this faithfully read newspaper, Goodman and the many dealers who subsequently published ads announced to the Amish as if with a megaphone that old quilts from Amish homes were now valuable objects.[27]

Over the following two decades, pickers and dealers continued to place classified ads in *The Budget*, enhancing their copy and graphics to distinguish themselves from one another. Dealers and pickers, eager to get a leg up on the competition, used these ads as a way to find quilts and develop name recognition in distant Amish settlements.[28] A frequent tactic involved marketing oneself as a "serious collector" rather than as a dealer out to make a profit. For example, Ohio dealer Darwin Bearley proclaimed in a 1982 classified: "Don't be fooled by others who claim to pay more—I'm a serious collector and I'm willing to pay much more to get good old quilts." Another ad claimed, "We are one of the few authentic collectors advertised. If you sell to dealers who say they are collectors, they get half your profits." Barbara Janos attempted to persuade Amish quilt owners to avoid selling to local dealers and go straight to the top: "New York City is the largest market place for fine old Amish Quilts—Highest prices are paid for them. Don't allow local dealers to cut into your profits—sell directly to us. We are serious buyers/ collectors." In the same edition of *The Budget*, both Darwin Bearley and David Wheatcroft echoed the language, calling themselves "serious" about buying Amish quilts.[29] These advertisers used sans serif fonts, dark backgrounds, and flashy graphics to make their ads stand out from the typical classifieds printed in *The Budget*. And Amish families took notice.

Families with quilts ready to sell contacted potential buyers advertising in *The Budget*. Pickers David Wheatcroft and Michael Oruch, who both regularly advertised, each recalled receiving a letter from an Amish woman in Arthur, Illinois, describing a quilt that was "sort of like a log cabin." Wheatcroft and his wife Eve Granick assumed that they probably were not the only dealers who had received a letter about this quilt. They debated whether the long drive to Illinois would be worth their time but decided to "make a beeline for it." They arrived late in the evening after driving for eight hours. Oruch and Wheatcroft were old college friends who had started out as partners in the antiques business and maintained regular contact while out on the road hunting for quilts, so once they arrived in Illinois, Wheatcroft talked to Oruch on the telephone.

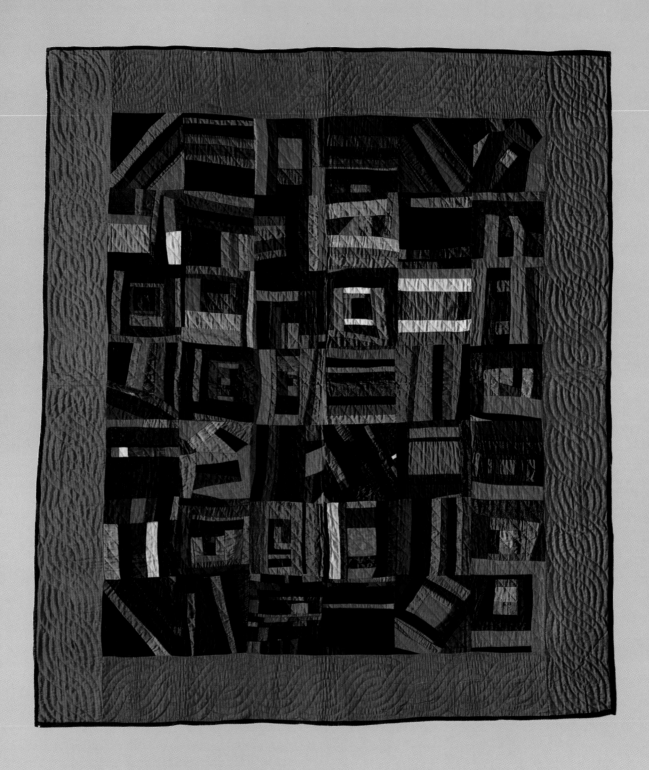

Wheatcroft recalled that Oruch suddenly sounded nervous, asking, "Where are you? You're not in Arthur, are you?" Resigned and disappointed, since he could have beat them there with a short drive from his home in Chicago, Oruch said, "Well, I'm not going then," knowing he'd missed his chance on this particular quilt. Based on the letter from the Amish woman, neither picker knew how special the quilt was. As one of only a handful of quilts created in this distinct crazy quilt style particular to the Arthur settlement, this quilt and ones similar to it became sought-after artworks. Wheatcroft estimates that the quilt he chased down may have eventually become the most expensive Amish quilt ever sold (fig. 6.1).[30]

Occasionally pickers didn't bother manipulating the market with gimmicks or strategies. They stole the quilts outright. According to Hannah Stoltzfoos, a Lancaster County Amish woman who has sold thousands of old and new quilts since 1972, some pickers knocked on doors, asked to see quilts, and then opted not to buy some or all of the bedcovers offered.[31] Anyone with basic familiarity with Amish practices knew that there was one time when Amish families would definitely be away from home: Amish church districts hold Sunday services every other week in the home of a member.[32] On Sunday mornings, pickers supposedly returned to empty homes where they had previously passed on buying quilts. Stoltzfoos recounted that meticulous pickers would carefully lift a dozen pieces of glass and china off a chest to steal a quilt and then replace each piece with such attention that the woman of the house would not notice until the next time she needed to dig into the chest.[33] With similar accounts circulating in Amish communities, many families decided to sell: "My husband said if we weren't using it, and we weren't—it was folded in a chest—we might as well sell it." Another woman agreed, "It's kind of scary to know you have a quilt worth that much money in the house."[34]

Rising prices, coupled with the fear of stolen quilts, prompted some Amish individuals to be quite protective of quilts they were not ready to sell. Stoltzfoos recalled that one of her aunts pulled a prized quilt from a public auction when the bidding did not reach the minimum price her knowledgeable niece recommended. The next church Sunday, Stoltzfoos's aunt was afraid that someone who had seen the quilt at the sale would break into her home to steal it. In an act of defensive materialism, she carried the quilt to church, storing it under her carriage seat.[35]

To pickers and dealers working in the field, part of the quilt trade's appeal stemmed from the alternative lifestyle it engendered. A search for authenticity and freedom from the constraints of mainstream middle-class life led many young Americans in the 1970s to form communes and cooperatives, establish their own forms of commerce, and avoid "workaday jobs."[36] "You've got to admit, this quilt dealing is a crazy business," one picker recalled. "We're all a bunch of malcontents who either couldn't fit into a regular job or didn't even try. We're nomads, constantly moving, afraid to stop."[37] After initially buying quilts only on the weekends, in 1974 Bryce and Donna Hamilton put all their belongings in storage and traveled the country in their Volkswagen bus, filling it with quilts they picked along the way (fig. 6.2). As they bought quilts in Amish communities, they saw how the religious group's "self-sufficient, nonmaterialistic way of life coin-

Figure 6.1. Crazy quilt, by Mattie Mast Kauffman, c. 1910–20. Arthur, Illinois. 71 x 80 in. David Wheatcroft and Eve Granick chased down this quilt after receiving a letter in response to their *Budget* advertisement.

(Image courtesy of Eve Granick and David Wheatcroft)

cides with our own philosophy of living."[38] Other young dealers, including partners Julie
Silber and Linda Reuther in San Rafael, California; Roderick Kiracofe and Michael Kile
in San Francisco; and Sandra Mitchell in Michigan, also embraced the quilt trade in
part because it allowed them freedom from mainstream institutions and the daily grind
of typical day jobs.[39]

To some, hunting for quilts had a "seductive power" that provided endless pleasure
that a conventional job could not.[40] Gail van der Hoof recalled that the "thrill of the
chase" was part of the appeal of her quilt collecting days, which included sleeping in a
Volkswagen bus outside a flea market, waiting for dawn when the local dealers would
hang their quilts on clotheslines and the hunt would begin. David Pottinger looks back
on his time living among the Amish, getting to know them through buying their quilts,
as one of the "greater experiences of [his] life." Wheatcroft imagined the quilt hunt as
a race, with everyone knowing "that there was a finite group of [quilts]; there was a
bottom to every blanket chest." Similarly, New York dealer Kate Kopp recalled feeling
urgency upon coming across a great cache of quilts because she feared that "someone
[was] going to be right behind us."[41]

Figure 6.2. Bryce and Donna
Hamilton with quilt bus.
The Hamiltons were early quilt
pickers who traveled around
the country buying quilts.

(Image courtesy of Bryce and Donna
Hamilton)

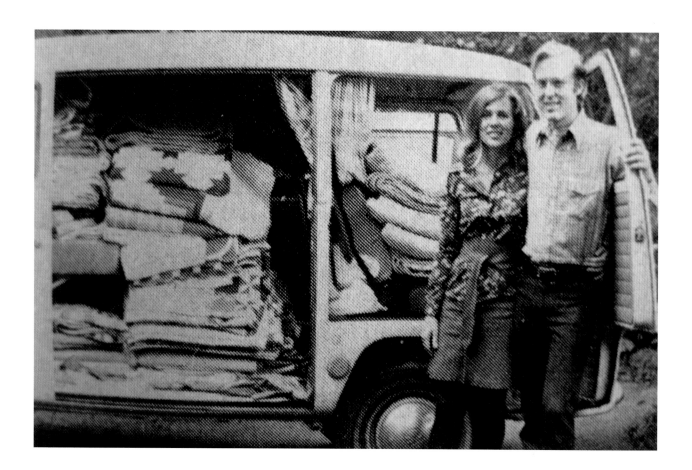

"If you're a dealer, if you are buying, you have to be selling. Otherwise you're a collector," observed Philadelphia antiques dealer Amy Finkel.[42] Some dealers *cum* collectors who lived near Amish settlements could not quite decide which they were. As one described another, "He was a dealer to feed his collecting habit."[43] They mostly bought but sometimes sold, and by building their own collections of Amish quilts, they helped create the thriving market for these objects.

In the early 1970s, David Pottinger ran an antiques shop outside Detroit. But this job was really a hobby; he owned a plastics manufacturing company. The plastics business brought him regularly to Elkhart County in northern Indiana, a center of recreational vehicle production and home to the third-largest Amish settlement in the United States. As an antiques dealer who ventured to the East Coast for major shows, Pottinger was already familiar with Lancaster County Amish quilts by the early 1970s, having seen them hanging on museum and gallery walls in New York City. He was acquainted with galleries such as America Hurrah and Woodard and Greenstein, which were beginning to deal heavily in these objects. He was already buying and selling a few Pennsylvania Amish quilts from his Michigan shop. When he was in Indiana on business, he would spend free evenings out knocking on Amish doors picking for quilts.[44]

At first Pottinger was decidedly a dealer, taking what he bought home to Michigan, where he sold them at his shop. He sold the first twenty-five to fifty quilts he purchased from Amish families, and then he realized that no one else was paying much attention to midwestern Amish quilts and that there was an abundance of them available for him to purchase. Unlike most dealers who ran antiques shops, Pottinger was buying directly from the source, "sitting down with these people and having dinner and eating ice cream."[45] He even purchased quilts directly off of people's wash lines, and once out of a garden where a quilt was being used to protect young celery plants.[46] He knew he had a rare opportunity to build a collection of Indiana Amish quilts with both depth and breadth. Abandoning dealing, he became a voracious collector. Soon Pottinger was no secret among the Indiana Amish community. "There was nobody who didn't know about the guy from Michigan who was buying quilts," he recalled. He began buying everything Amish families offered him, including clothing, dolls, and furniture. He also began documenting his burgeoning collection with the details pickers typically ignored. On each quilt he bought, he affixed a muslin label with a hand-written note describing anything he learned about the quilt from the Amish family who sold it (fig. 6.3). He believed that as his collection grew, it would become more valuable because of this documentation.[47]

In 1977, at the urging of Amish friends he had met on these collecting trips, Pottinger sold his plastics company, antiques shop, and suburban home and relocated to the rural Amish community of Honeyville, Indiana, in search of what he called "honest living of the country." The move was not merely geographic; he hoped it would enable him to

Figure 6.3. David Pottinger's
quilt label.

(From the collection of the Indiana
State Museum and Historic Sites,
71.989.001.0220)

experience more joy and meaning from his work while discovering the country's simple pleasures and pursuing his new hobby as a hot air balloonist. Pottinger purchased the old general store in Honeyville, which had sat empty for many years. With the help of an architect's blueprints and an Amish carpenter, he added a contemporary addition to the country store to serve as his home.[48] Here he displayed his quilts and other antiques isolated from one another, often spot lit against white walls just as the Whitney Museum's curators had displayed objects removed from any context of use. Alongside his quilts hung folk paintings; several feet away a simple tripod table might serve as a pedestal for a decoy. "This is the ultimate way to enjoy antiques," said Pottinger, emphasizing that he had no desire to live in an "authentic eighteenth-century setting" and preferred "practical, nondescript furniture" for actual use.[49]

With Pottinger as a permanent fixture in Indiana's Amish country—and his accompanying checkbook—the price tag for local quilts began to rise. Both Pottinger and local collector Rebecca Haarer recalled the moment when the northern Indiana Amish community realized just how valuable their quilts were. One particular Saturday in the late 1970s, an Amish family held an estate auction, a fairly typical occurrence in this settlement. As at most such sales, the household textiles were the last items auctioned, not as an anticipated grand finale, but as the dregs. But here in this public setting, with hundreds of Amish people looking on, Pottinger and Haarer bid against each other.

Pottinger prevailed, buying a quilt for over $1,000, although as he later recalled, "Up until that time I had been buying quilts for $50 or $200." Now everyone knew how much collectors and dealers were willing to pay.[50]

As prices went up, estate auctions became contentious sites, with Amish families expecting high prices and bidders developing new tactics. In Indiana, the "quilt mafia"—as Haarer referred to the growing number of dealers and collectors seeking quilts—made pacts before the bidding started that only one of them would bid and later held private auctions among themselves. The group compensated each participant either with cash or a quilt, ensuring that all would profit.[51] Similarly, in Lancaster County buyers formed pools, agreeing not to bid against one another in order to keep prices low. Savvy Amish individuals caught on and set their own minimums at auction rather than fall prey to a quilt cartel.[52] This was just one way that some Amish began to find ways to gain more control of the quilt market.

ELITE DEALERS

Once quilts had left Amish country and sat folded neatly on display shelves or hung like paintings on the walls of urban shops, they maintained the other-worldly quality of their Amish origins while distinctly treated as commodities. They became objects to be mediated in the hands of dealers, who reinterpreted their meaning and value. Urban dealers gave the quilts new import by treating them not as outdated bedcoverings—as many Amish families understood them—but as works of art with which their clients could imagine living.

Gallery spaces served as important places for dealers to demonstrate the ability of quilts to act as art objects. M. Finkel and Daughter's shop in Philadelphia converted its second floor into a display gallery for quilts. Amy and Morris Finkel exhibited three or four quilts on walls in a contemporary spare fashion rather than in a country or period room setting. They implemented a pulley system to hoist quilts up onto the wall for full dramatic effect, allowing customers to see quilts they were interested in unfolded and vertical, like paintings. With their location at the intersection of Pine and 10th Streets, two one-way thoroughfares in center city Philadelphia, they had maximum ability to show off quilts in their large front windows to passengers in cars stopped at the traffic light in each direction. They installed walls and lighting in these display windows that could perfectly show off their frequently changing inventory of quilts. Occasionally someone would pass the shop, attracted to a striking quilt in the window. Finkel described how such casual customers would say, " 'Great, tell me about that. . . . God, that would look fabulous on the wall,' like they had discovered it. 'Honey, wouldn't that look fabulous hanging on our wall?' " In the 1980s, with rising prices, this casual consumer was sometimes deterred from purchasing a quilt. When they learned how many thousands of dollars a quilt was selling for, they realized that they actually could buy a contemporary painting for the same price, or perhaps were priced out of the market completely.[53]

Tom Woodard and Blanche Greenstein's shop in New York's Upper East Side, Woodard and Greenstein American Antiques, functioned similarly, attracting customers into the store by prominently displaying striking quilts. In 1972 they began renting their first shop on Lexington Avenue at 73rd Street. Their shop had big windows in which they hung quilts like paintings. Woodard and Greenstein recalled that this location attracted many passers-by, including quite a few Europeans in taxis coming off of East River Drive from the airport. "To hang them up in a window . . . had an impact," Woodard surmised. He recounted that a "very famous neurosurgeon just happened to be walking along and spotted a quilt in our window and came up"; eventually, he "became one of the important quilt collectors in the country."[54]

America Hurrah, Joel and Kate Kopp's antiques business specializing in quilts, started out in 1968 in a cramped basement space on East 70th Street. They attracted media attention in part because of their unconventional hours—open from 12:30 p.m. to 7:00 p.m. and always open on Sundays, a rarity in New York at that time. As one of the first shops selling quilts in New York, they attracted a range of customers, from celebrities like Bob Dylan and Andy Warhol to cash-poor enthusiasts who paid in installments over several years. With their growing success, they expanded their space, extending into a gallery where they could display quilts on white walls rather than in stacks on the floor. In the early 1980s America Hurrah became, as Kate describes, "a more serious business," when they relocated to a Madison Avenue location with prices more geared for art world collectors.[55]

Urban shops generally acquired their inventory from pickers and other dealers who brought quilts for them to buy. Darwin Bearley, who began buying and selling Ohio Amish quilts full time in 1974, brought his first carload to New York that summer. Bearley encountered a dealer's intense scrutiny when he tried to sell what he thought was a "mint condition" Pennsylvania Amish quilt he had picked in rural Ohio for a mere $11 to a Greenwich Village gallery during his first year of dealing. "I started out asking $75, but he got me down to $45 by pointing out a few rough spots," he said in a 1978 interview. This was all the more discouraging because Bearley had heard rumors that "in New York City you can't buy a good Amish quilt for less than $1,000."[56] This contentious negotiation happened particularly when a picker and dealer did not have an established working relationship, in contrast to loyal picker/dealer relationships in which dealers were less apt to haggle.[57]

Some gallery dealers on the East Coast and West Coast catered specifically to elite customers. The Bay area in California became a hub of the Amish quilt market beginning in the late 1970s, with several prominent dealers setting up shop and attracting wealthy clientele. Like America Hurrah in New York, Julie Silber and Linda Reuther's shop, called Mary Strickler's Quilts (named after a woman who signed her nineteenth-century quilt) in San Raphael, California, became a destination to collectors who visited whenever they were in the area on business or leisure.[58] Such upscale galleries could give a collector "the confidence to spend a certain amount of money." For example, Esprit's Doug Tompkins was not interested in a particular Amish crib quilt when

David Wheatcroft offered it to him, so Wheatcroft sold it to America Hurrah. But when America Hurrah—a gallery Tompkins regularly dealt with—offered him the same quilt for twice as much money, he bought it.[59]

Partners Roderick Kiracofe and Michael Kile started out buying in the Midwest and selling to other California dealers until they refashioned themselves as elite dealers. They announced this transition in 1980 with a full color ad in *The Clarion*, the Museum of American Folk Art's quarterly magazine. Kiracofe and Kile chose not to have a storefront or gallery shop, dealing instead by appointment only from their San Francisco townhouse. This was a matter of convenience in that they did not have to keep open gallery hours or a full inventory, but it also allowed them to "create an exclusivity about it." Private dealing also enabled Kiracofe and Kile to develop close relationships with clients. Such a rapport entailed both shared trust and shared taste; they "could take a risk on a piece and know that chances are [the client] would be interested in it." A close dealer/client relationship also allowed dealers to influence a collector's taste, because dealers could introduce quilts and make an argument about why they were worth owning. For example, Kiracofe and Kile introduced Doug Tompkins to midwestern Amish quilts, convincing him that these were important objects to hang on Esprit's walls. Similarly, Kiracofe walked the corporate art buyer for BankAmerica through a quilt exhibit in order to convince her of quilts' artistic merit.[60]

AUCTION HOUSES

Major New York auction houses—Christie's and Sotheby's—shared the top end of the quilt market with elite gallery dealers, attracting consumers willing to pay prices much higher than those for quilts bought at rural flea markets or from dealers "in the field." Although folk art objects—cigar store Indians, redware pottery, and Pennsylvania German fraktur painting—occasionally appeared at auction houses prior to the 1970s, museum and media attention toward folk art spurred a significant collecting audience that began frequenting auctions during this decade. Quilts were often part of the mix and tended to sell reliably as part of "Americana" auctions, the term auction houses used for sales featuring American furniture, decorative arts, and other collectibles. Sometimes blanket chests consigned to auction were filled with quilts, and these bedcoverings eventually became what Nancy Druckman, Sotheby's director of American folk art, called the "meat and potatoes" of Americana auctions.[61]

Following the Whitney's exhibitions *Abstract Design in American Quilts* (1971) and *The Flowering of American Folk Art* (1973), a new public awareness attracted more potential consumers to auction houses. Prior to the 1970s, art and antiques dealers and interior decorators were the primary bidders at Christie's and Sotheby's, buying objects to fill their inventories. By the 1980s, the presence of a new generation of young collectors interested in various American antiques and folk art had transformed auction houses into retail markets where consumers and gallery dealers bid against one another.

These new bidders hoped to pay less at auction than a gallery dealer would ask for equivalent pieces.[62]

Sotheby's and Christie's auctions could be dramatic. In her advice book on antique collecting, Emyl Jenkins encouraged collectors to visit pre-auction viewings to learn about antiques. But she cautioned: "If you're going to bid at a New York auction, you won't have time to think about what you are doing. You must know how much you are going to bid ahead of time and act immediately. This is not the place for the timid, shy or hesitant bidder. But while you may get passed by, you can also get caught up in the auction fever and overspend."[63]

During the peak of the Amish quilt market in the mid-to-late 1980s, educated collectors knew that they might walk away with a great deal, paying the equivalent of wholesale price rather than retail—potentially thousands of dollars less than quilts offered at Madison Avenue antiques galleries. On the other hand, if a buyer fell in love with a quilt and ended up in a bidding war, he might pay in excess of the going gallery retail rate, letting the momentum of the auction carry him along. As one antiques dealer described, "In some cases you get buyers who simply want to win, and they bid against each other without thinking in terms of the value of the piece."[64]

This phenomenon of emotions taking over during an auction resulted in inconsistent pricing with the occasional bargain. For example, at a 1989 Christie's auction, a bidder purchased a Lancaster County Center Diamond quilt for $10,450, though the presale estimate was $6,000–$9,000. This price was near the high end of the going rate in galleries, so the buyer did not get a bargain. The following year, a Christie's bidder walked away with a steal, taking home a similar Center Diamond quilt with a presale estimate of $4,000–$6,000 for a mere $1,540. These quilts—executed in the same pattern, from the same community, with nearly identical quilting motifs and similar color palette—sold for drastically different prices.[65] The potential of such a bargain or profit was what gave buying and selling quilts at auction houses such appeal to collectors.

The public nature of auctions—and their resulting prices—validated quilts as desirable commodities. In contrast to private sales at storefronts, galleries, or antiques shows, auctions resulted in published prices. Once the hammer fell, anyone could know how much a given object sold for, whereas in galleries this information usually remained undisclosed. Nancy Druckman considers price the strongest determining factor in the way people perceive collectables like quilts. She notes that high prices provide "a level of validation and importance" to objects.[66] When an individual paid $12,000 for an Amish quilt at an auction house that published its price, this public transaction signaled to others at the auction and to those reading the published pricelist that similar quilts must have a certain cachet.

Certain quilts had pedigrees—or provenance, as it is known in the art world, the history of ownership—that influenced monetary value. Beginning with the first Amish quilts offered at Sotheby's in 1973, catalog descriptions have always mentioned a quilt's Amish origins, in contrast to non-Amish quilts, which were attributed simply as "American." Auction catalogs also listed information such as where an image of the quilt was

published as a selling point. For example, in 1987 Sotheby's auctioned a quilt that had appeared on the cover of *A Gallery of Amish Quilts* (1976), selling the piece for $6,200. Other provenance listings included ownership by high-end dealers, including George Schoellkopf or Thomas Woodard, whose reputations added a seal of approval to objects at auction. Sometimes provenance might include the phrase "purchased from family," indicating that a direct lineage could be traced to the original owner.[67] As the following chapter focusing on the connoisseurship of Amish quilts demonstrates, provenance was but one way that those involved in the quilt market of the 1970s, 80s, and 90s constructed Amish quilts' monetary value.

TRANSACTIONS OF VALUE

Negotiations over quilts' value, whether emotional, aesthetic, or monetary, resulted in fluctuating relationships between people and their quilts. When Gail van der Hoof bought a quilt for $150 from an Amish family in 1973, this was a big deal for each party. Van der Hoof had a quilt to take home and hang on her wall; she could compare it to the many others she owned, admire its strong graphics, and relish what she called its "soulful quality."[68] On the other end of the deal, the Amish family parted with an heirloom quilt with little utilitarian value but gained cash they could put to practical use. When Thomas Woodard and Blanche Greenstein sold an Amish quilt to a collector for $40,000 at the Winter Antiques Show in 1991, these elite dealers could enjoy the satisfaction in knowing that their years of connoisseurship were paying off as this prize from their carefully selected inventory found a new home.[69] And that collector no doubt had an emotional reaction to the quilt, prompting the exchange of such a large sum of money. The quilts themselves did not change in pattern or color or size, but individuals reinterpreted their meanings and values as they moved them out of homes and into the commodity context.

CHAPTER **7**

- -

AMISH

INTERMEDIARIES

Though the interest in Amish quilts grew as outsiders to the faith learned about them and sought them out, the market that developed was not simply one in which big city dealers took advantage of poor country farmers. Not only were many Amish families willing sellers, but some became active participants in the market, helping to facilitate transactions between dealers and their coreligionists, selling quilts on their neighbors' behalf, and starting their own businesses dealing quilts. The market for quilts was a two-way street in which some particularly savvy Amish individuals found ways to benefit directly from art world interest in their community's old bedcoverings. In addition to at times profiting financially, these Amish intermediaries viewed their role as providing a service to their friends and neighbors who wanted to sell quilts but did not want to seek out buyers directly. Each of the intermediaries described in this chapter played an atypical role within his or her community, showing a high degree of worldliness and business-savvy. Unlike some of their fellow Amish, these individuals were quite comfortable interacting with outsiders.

It is easy for outsiders to perceive the Amish as a monolithic group in which members dress, worship, and act the same as one another. Indeed, conformity has long been an important aspect of the faith. Yet as in society as a whole, the Amish community has been home to individuals who are not afraid to act independently. The Amish emphasis on submission to the will of the community (rather than that of the individual) has not suppressed distinct pursuits, including selling quilts to non-Amish consumers. It took a certain type of person to flourish in the boundary zone between Amish society and the world.

INSIDER ACCESS

As described in the previous chapter, outsiders to the community often sought a connection within an Amish settlement to help them gain access to desirable quilts. For David Pottinger, the plastics CEO turned Indiana country merchant, his essential relationship was with Amos and Bertha Bontrager, an Amish couple who lived near the northern Indiana crossroads locally called Honeyville. Bertha was, as Pottinger described her, a "broker" for quiltmaking services in the community. She knew who could piece, mark, or bind quilts, and she arranged these services for non-Amish who wanted assistance

in making new quilts. After meeting the Bontragers in 1974 on the recommendation of a friend, Pottinger forged a friendship with the couple that helped him build his collection of Indiana quilts. The Bontragers were willing to help him buy quilts from their coreligionists. On his business trips to Indiana, which occurred about every two weeks, Pottinger began to meet regularly with the couple. They typically shared a meal at the Bontragers' home and then visited a short list of Amish families Bertha had lined up, each eager to sell their quilts. "Bertha's and Amos's introduction was universal," Pottinger remembered, "No matter where I went, I was welcome. And [the families] also wanted to sell." Bertha did not take a commission for assisting Pottinger in finding old quilts; rather, she viewed her role as a service to her friends, enabling them to sell their quilts to a buyer willing to pay whatever they asked without bargaining over price.[1]

Pottinger characterized Bertha as "a very unusual Amish woman," noting that despite the steadfastness of her conservative faith, she had a "kind of worldly view of what was possible . . . and she pushed the envelope a little bit."[2] At this point in the early 1970s, it was much less common than it is today for Amish families—especially Amish women—to run their own businesses catering to outsiders.[3] For this reason alone, Bertha would have seemed unusual in her willingness to interface with non-Amish in such a public way. Pottinger's characterization of Bertha as "worldly" echoes the description other quilt collectors and dealers used to describe the Amish intermediaries who assisted them in buying quilts from Amish families.

Jonathan Holstein similarly described Hannah Stoltzfoos as "worldly." One of the earliest quilt entrepreneurs in Lancaster County, she was likely the first Old Order member to sell new Amish-made quilts to outsiders. Once Stoltzfoos knew that outsiders, typically urban dealers and collectors, were interested in old Amish quilts, she became a conduit to help members of her faith sell their quilts without needing to negotiate with buyers directly. In the very early 1970s, when Jonathan Holstein and Gail van der Hoof began asking around about these solid-colored, graphic quilts with their amazingly intricate quilting stitches, it is no surprise that they made the acquaintance of Stoltzfoos.[4]

Upon learning that Jonathan Holstein and Gail van der Hoof were searching for old quilts, Stoltzfoos put the word out to people in the community that she would sell their family quilts. As Holstein remembers it, when Stoltzfoos had good quilts to sell, she would use a pay phone to call him and van der Hoof in New York, and they would plan a trip over the following weekend to see what she had, rarely turning anything down. Upon Holstein's request, Stoltzfoos brought the couple into an Amish home during a "quilting" so they could observe women working on a quilt and learn more about the process. She later remembered that she had a good relationship with the couple, that they were people she trusted, unlike other outsiders who came in search of quilts. This relationship of trust benefited both parties.[5]

Stoltzfoos also recalled a good working relationship with the George Schoellkopf Gallery in New York City. Similar to the way her relationship worked with Holstein and van der Hoof, she periodically called Schoellkopf to describe what old quilts she had

available, and he would have her send some to his gallery for his review. As Stoltzfoos remembered in a 2004 interview, he often bought what she sent, but he occasionally returned quilts.[6]

In contrast to these relationships that Stoltzfoos considered mutually beneficial, she recalled how some outsiders tried to take advantage of her. She generally did not keep any old quilts that she was selling on display in her shop because she recognized their value and the risk that might entail. Once a couple came into her shop and asked to see some old quilts. She brought out a few, including one she had helped to make as a teenager and another that was in shambles. The couple chose to buy the tattered quilt for $35. After the sale, the man showed Stoltzfoos a book featuring photos of old Amish quilts.[7] Meanwhile, the woman stood at the door with the tattered quilt and Stoltzfoos's old quilt both nearby. Telling the man it was time to go, she reached for the valuable quilt that she did not purchase as she began to make her exit. Pointing out that she had the wrong quilt, Stoltzfoos didn't let her get far. The woman quickly threw the quilt down and ran out without even taking the quilt she had rightfully purchased. Stoltzfoos made sure the man left with the quilt. She never saw them again. She felt that it definitely was a set-up: the man's job was to distract her while the woman walked out with the quilt.[8]

THE AMISH QUILT DEALER

David Riehl of Churchtown, Pennsylvania, was another Amish entrepreneur who became actively involved in the quilt trade. In 1981, after seeing more and more outsiders looking for old quilts come through the Amish enclave in Lancaster County where his family lived, Riehl decided there must be money in quilts. He began to learn through the grapevine of the Amish community which of his coreligionists had quilts they were willing to sell. He also began to read the handful of books published about Amish quilts in an effort to learn what made some more desirable than others. He sought out enough quilts—paying $150 and $200 apiece—to fill a suitcase and went to the Lancaster train station to catch a train to New York City. On this first trip in 1981, he hailed a cab to Christie's, the famed auction house. The friendly receptionist, who happened to come from Lancaster County herself, suggested he try to sell his quilts to an Upper East Side antique dealer rather than to the auction house. And with that advice Riehl, like the quilts he carried with him, transitioned out of his own world and into that of Madison Avenue galleries that sold Amish quilts as works of art.[9]

Riehl, like most Amish men of his generation, grew up on a farm and considered agriculture the ideal vocation for an Amish man and his family. As his son Benuel explained, "See, seventy-five years ago everybody farmed, whether they were farmers or not." Farmland in Lancaster County, which sold at $300 to $400 an acre when Riehl was a teenager in the 1940s, surged to $4,500 an acre by the early 1980s. In the 1960s, many Amish families divided their farms in two, allowing subsequent generations to continue the agrarian life. But with encroaching development and rising population—

both in the Amish community and in Lancaster County at large—fewer Amish families could afford the increasingly scarce and expensive farmland. Amish men, including David Riehl, struggled to make ends meet and were never able to purchase their own acreage. During the 1960s and 70s, many men in Riehl's generation began to work off the farm, finding employment in small factories or on construction crews. With the mid-1970s recession, fewer of these jobs were available in Lancaster County, and some Amish men looked for alternatives to both farm and factory work to earn their livings. Beginning in the late 1970s, entrepreneurship blossomed among Lancaster's Amish community as members of the church started small businesses and cottage industries catering to both Amish and non-Amish people. Rather than opening a storefront selling dry goods or establishing an industry constructing furniture or sheds—typical enterprises in Lancaster County—David Riehl started an informal business buying quilts from Amish neighbors and selling them to dealers with urban galleries.[10]

Urban dealers did not know what to make of this Amish man who ventured far from rural Lancaster County to sell quilts in big cities. Some dealers relished his visits; one begged him to stop at her shop first so she could have first pick from his suitcases. Another dealer was frustrated with his tactics; if she didn't buy what he offered, he would stand outside the front door of her shop and try to sell directly to her customers.[11] It may have been great publicity to have a real live Amish man standing in front of your shop, but if he was stealing your business, that was crossing a line.

One of Riehl's earliest customers was the Philadelphia antiques dealer M. Finkel and Daughter. Amy Finkel began specializing in quilts soon after she joined her father's antiques business in the mid-1970s. David Riehl often rode the train or hired a driver to bring him to Finkel's shop on Philadelphia's Antique Row (East Pine Street). "We were buddies," recalled Finkel, recounting one Halloween when her young daughters borrowed Riehl's daughters' clothes to dress up as Amish girls. Over several years, Riehl would periodically take Finkel to Amish homes in Lancaster County. "He would always say, 'It's just down the road'—twenty miles later—'down the road!'" Finkel remembered. "David would say [to their Amish host], 'I've brought these people, and they're here to see your quilts.' And the lady would open up her blanket chest and take out a quilt, and we would start a negotiation and buy it." But upon hearing similar accounts from fellow dealers working with Riehl, she suspected that he was perhaps "too crafty" about such sales and often wondered if the quilts in the chest were in fact made by the lady's grandmother or if they were placed there to give the dealers the special Amish-flavored experience they were seeking. "Now did we mind?" Finkel asked herself; "Probably not." She and others still left Amish country with desirable quilts to sell at city shops.[12]

Although many members of the Amish community were quite eager to sell their old quilts because they would rather have the money than worry about someone breaking into their house in search of quilts, some were initially reluctant to sell to Riehl. According to Benuel Riehl, Amish people did not perceive his father's business venture as "a cultural threat"—as pushing against guidelines set forth in the *Ordnung*—rather, they were suspicious about whether he was actually able to pay top dollar for their quilts.

To counter these doubts, Riehl had to play tough. On one occasion he approached an Amish family with a particularly striking, pristine Double-Nine Patch quilt to sell. They seemed unwilling to commit, skeptical that Riehl could actually pay what non-Amish pickers offered. Riehl went to the bank and took out a good faith loan for three thousand dollars in one hundred dollar bills, much more than he could actually afford. He returned to the Amish family's home and laid out thirty one hundred dollar bills on the table, asking if they would prefer to keep the quilt or to receive the cash. "I knew if I could buy that quilt from him for that kind of money, I would be the quilt dealer to sell to," he recalled. With this bold move, Riehl established his reputation as able to pay top dollar, which quickly spread throughout the community.[13]

With this same quilt, Riehl was able to secure his reputation among New York dealers. He took it to Joel and Kate Kopp at America Hurrah, one of the top galleries. Stuffed in his suitcases were also some lesser-quality quilts, which the Kopps declined. Riehl then explained that he had done something "really crazy," admitting he had purchased a quilt for three thousand dollars. Intrigued, the Kopps asked to see it and were swept away. When they asked how much it would cost them, Riehl "didn't blink" and asked for four thousand dollars. He made the sale, proving that he could find desirable quilts in Amish homes and had the "chutzpah" to make the deal, as the Orthodox Jews he was occasionally mistaken for in New York might have said.[14]

Riehl began to play in bigger leagues. He described his tactics as "applied psychology," an apt description for the delicate negotiations necessary to deal with both his practical Amish neighbors and shrewd urban dealers. As Riehl observed in an interview with a journalist, "buying from a Pennsylvania Dutchman—an Amishman—and taking it to New York, to a New York Upper East Side Jew, you better have something good and you must be pretty sharp."[15] Riehl needed to establish himself publicly as the guy to sell to in Lancaster County and as the guy who could bring the best stuff to New York. In 1987 he attended a well-publicized local Amish family's estate auction where a mint condition Center Diamond quilt would be sold. The competition was fierce, since many local antiques dealers attended in hopes of buying the quilt. "When I went to the auction," Riehl recalled to a reporter, "there was no way in the world I felt I would come home with the quilt."[16] But he wanted the quilt, or more accurately, he wanted to be able to sell the quilt to America Hurrah, his best New York customer. During the auction, the price continued to climb as bidders dropped out, leaving only a collector and another dealer competing for the quilt. At that point, Riehl impulsively jumped into the fray. "He didn't have the money in his checking account," his son recalls. Bidding much more than the auctioneers anticipated the quilt would bring, Riehl took the quilt home for $6,900, twice as much as pickers generally paid for quilts at that point and a record in Lancaster County. "He bought it and went to the bank," securing another good faith loan, recalled his son. Riehl knew he was taking a risk but was confident that he would at least make back the money.[17] He considered keeping the quilt off the market, allowing its value to increase. He even told a reporter that his "intention is to take a trip to Europe and sell it there. It would be a big thrill." Eventually, he sold the quilt in New

York, not making a substantial profit. "It was almost too risky for him to do it again," noted his son.[18]

Perhaps in an effort to avoid this sort of risk, in the 1990s Riehl developed a more exclusive relationship with dealer David Wheatcroft, then based in Massachusetts. Wheatcroft had started off in the late 1970s as a picker, knocking on doors in Amish settlements across the United States. By the time he and Riehl became well acquainted, Wheatcroft sold folk art to clients out of his gallery rather than knocking on doors.[19] When Riehl sold to New York dealers, he had to hire a driver to haul him and his suitcases full of quilts—and usually at least one family member—to the city. Wheatcroft, on the other hand, came to him on a regular basis. They became close personal friends, and Riehl no longer had to use his "applied psychology," or what dealer Finkel referred to as his "craftiness," in order to make a sale. Wheatcroft was up front about how much he could pay. Their relationship also allowed Riehl to diversify, since Wheatcroft also wanted frakturs (Pennsylvania German illuminated manuscripts) and furniture made by Amish craftsman Henry Lapp. With fewer desirable quilts left in Amish homes after two decades of intense picking, this gave Riehl a new outlet.[20]

With Riehl's help, in 1992 David Wheatcroft established a new record for the most paid for a quilt in Lancaster County, breaking the auction price Riehl had established in 1987. Riehl had gotten wind that at an upcoming estate sale at the Kauffman fruit farm in Bird-in-Hand, Pennsylvania, a very special quilt would be for sale. John E. Kauffman had received the quilt from his grandmother prior to his 1934 marriage, and it had been lying under the eaves in his attic since 1948. His wife "never really liked the quilt," and the couple had all but forgotten it. Aside from a few moth holes, the quilt appeared as it did when Kauffman was a young man.[21] Its distinguishing feature was the combination of three patterns—a "nine patch in split bars," Wheatcroft called it. At the estate sale, Wheatcroft bid animatedly against another dealer, raising the price far above the $5,000 Riehl had estimated for the piece. This time Riehl did not have to put up the money himself. Instead, Wheatcroft used his money, paying Riehl a commission for notifying him about the quilt. "That is why David Wheatcroft and Dad had a good relationship," recalls Benuel Riehl. "They could do things like that knowing that one wouldn't cross the other." When the *Lancaster New Era* reported on this $17,300 sale, they only mentioned Wheatcroft, the appropriate credit since most Amish prefer to stay "under the radar." Yet Emma Riehl, David's widow, keeps the newspaper clipping announcing the record-setting quilt in a scrapbook. David Riehl no doubt had a sense of pride about his accomplishment despite his indoctrinated Amish humility. Eventually, Wheatcroft sold this quilt to Doug Tompkins, where it joined other quilts in the Esprit fashion company's collection.[22]

Riehl's son perceived his father's business venture as primarily a way to "make a dollar." Upon learning about the growing market for old quilts, David Riehl knew that his own position in the Amish community, coupled with his ability to socialize with anyone, made him the perfect person to begin this venture. While financial needs certainly inspired his business, it also filled other needs. Riehl did not fit the traditional

Amish mold; by nature he was neither a farmer nor a factory worker. He was curious about the outside world, and his business allowed him opportunities to travel and meet people he normally would not meet. From time to time he brought his family with him to New York City on his business trips to go sight-seeing. "It wasn't strictly business; it was also pleasure," the younger Riehl recalled. Once, upon hearing that Mary Tyler Moore liked Amish quilts, Riehl waited outside the Broadway theater where she was performing in an unsuccessful effort to make a sale to this celebrity.[23] As he continued buying and selling quilts over the years, Riehl also developed an aesthetic appreciation for them that was largely absent from Amish culture by the 1980s and 90s. Like the young art enthusiasts attracted to Amish quilts in the 1970s, Riehl began to see in these old bedcovers a simple beauty, even calling them works of art.[24]

Although he was an insider to the Amish community, Riehl was very much an outsider to the art world in general and to the distinct marketplace of Amish quilts in particular. He did not consider how other local dealers might react to his dealing practices. One Lancaster dealer recalled that in the early 1980s Riehl asked her who she sold to in New York. She did not tell him, but instead she offered to buy his quilts herself.[25] Although Riehl seemed to have few qualms about going straight to New York City's most reputable dealers rather than selling up the so-called chain, he was not going to let those top dealers take advantage of him. Early on, a New York dealer had offered him a regular finders' fee of $50 for each quilt he brought, a common practice for pickers who work for a dealer. But Riehl already knew by that point that more substantial profits were possible, and he was not about to start working for someone else.[26]

LIMINAL FIGURES

Bertha Bontrager, David Riehl, and Hannah Stoltzfoos exemplify that while New York sophisticates may have initiated the formation of the Amish quilt market, some Amish individuals were willing participants with insider knowledge of the community that helped shape the market. They knew who had quilts to sell, and they could benefit economically through these connections. But the intentional separation of the Amish community from "the world" limited their knowledge of art and the art market. Unlike local non-Amish dealers such as Patricia Herr or Fran Woods, who lived in Lancaster County yet understood the world of art and museums, these Amish individuals were on less solid footing outside their community. They had not acquired the "modern eye" shared by those accustomed to looking at works of modernist art and design; they were accustomed to doing business with people who were known and trusted in the community, not necessarily with strangers from big cities. Like the quilts they sold, they became liminal figures, existing in a state between two worlds—not exclusively Amish, yet not fully of "the world."

David Riehl was out of his element when he took the train to New York and showed up at Christie's auction house with a suitcase full of quilts. But his Amish kindred were initially doubtful that he could pay top dollar and apprehensive about an Amish man

who walked so confidently in New York. Stoltzfoos—considered "adventuresome" by Holstein and likely "worldly" by peers within her own community during the 1970s—additionally had to step outside an Amish woman's typical roles to make sales.[27] Yet as intermediaries, they helped negotiate quilts' value within their communities. Once Amish people trusted Riehl and Stoltzfoos to help them get good prices for their quilts, community members preferred to deal with coreligionists rather than outsiders.

CHAPTER **8**

A GOOD AMISH
QUILT FOLDED
LIKE MONEY

To be successful in the quilt trade as a dealer or consumer required a mastery of connoisseurship, or at least an ability to assert specialized knowledge, even if one did not possess it. The goal of connoisseurship, as Charles Montgomery, the antiques dealer, scholar, and curator who attempted to make a science of the practice explained, "is to determine the date and place of manufacture, the author, if possible; and where within the range of its fellows the object stands in terms of its condition, excellence of execution, and success as a work of art."[1] In short, connoisseurship is the ability to evaluate objects. When it came to Amish quilts during the peak years of the market, dealers, collectors, and appraisers determined monetary value based on some of Montgomery's fourteen points of connoisseurship such as overall appearance, color, analysis of materials, techniques employed, date, and geographic attribution. They also employed criteria more specific to the medium of quilts, such as pattern.

Some connoisseurs developed almost scientific means of weighting a quilt's qualities, proclaiming that certain proportions of fabrics or colors had a direct correlation with monetary value. Yet evaluation was not a pure science. As Montgomery acknowledged, one of the important questions a connoisseur must ask is "Does it sing to me?" This query gauged the unquantifiable characteristics that made some quilts particularly desirable.[2] Or, as dealer David Wheatcroft observed, "A good Amish quilt folded like money." He likened the soft folds of an old quilt to a worn dollar bill; yet his evocative observation also suggested old quilts' monetary potential.[3] The collectable type of Amish quilt indeed had distinct characteristics that were understood and recognized by the cultural brokers who shaped quilts' monetary worth, while quilts that did not share these qualities were disregarded and ignored.[4] Furthermore, those individuals with a monetary stake in the Amish quilt trade promulgated the idea that "classic" Amish quilts were no longer being made, that they were a thing of the past rather than the manifestation of a living, thriving community.[5]

THE CRITERIA

Dealers and collectors sought out certain quilt patterns associated with Lancaster County, the best-known Amish community (and not coincidentally the one closest to East Coast urban dealers) and elevated them above Amish bedcovers made elsewhere.

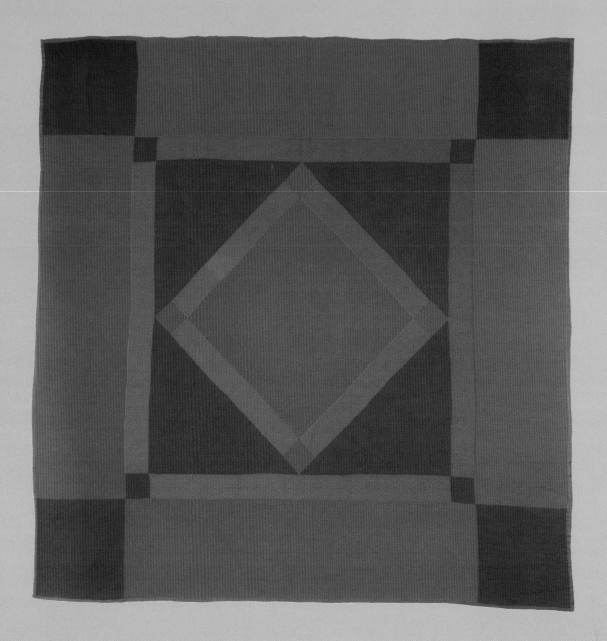

Figure 8.1. Center Diamond,
unknown Amish maker, c. 1930.
Lancaster County, Pennsylvania.
72 x 72 in. Note the corner blocks:
the small red and purple squares
in the inner borders framing the
central diamond and the central
square and the purple squares in
the outer corners.

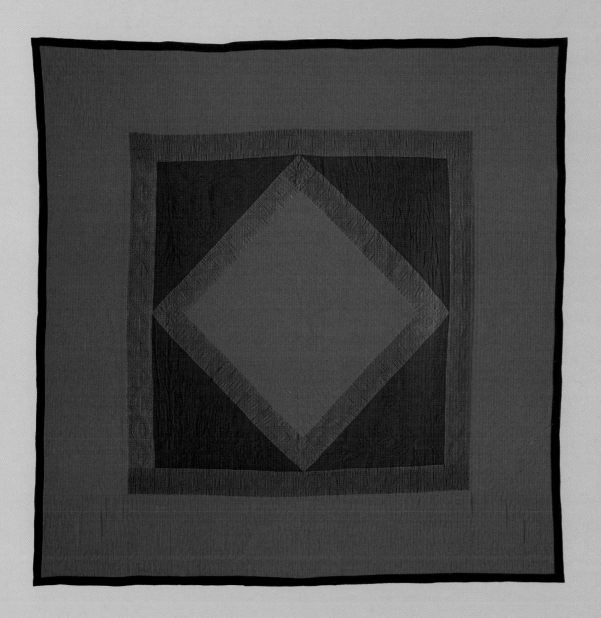

Figure 8.2. Center Diamond,
unknown Amish maker, c. 1920.
Lancaster County, Pennsylvania.
The variation is without corner (From the collections of the Heritage
blocks. Center of Lancaster County)

The most desirable Lancaster County Amish quilts had a central focus rather than repeated blocks.[6] These patterns in particular—Center Diamond, Center Square, Bars, and Sunshine and Shadow, as they became known after Jonathan Holstein gave them these descriptive names in *The Pieced Quilt* (1973)—bore the most resemblance to the color field, minimalist, and op art paintings to which New Yorkers liked to compare them.[7] Amish quiltmakers in the Midwest more often used repeated block patterns. Some collectors held the midwestern variety in high regard as well, yet many connoisseurs considered Lancaster County quilts as the best.[8]

One New York dealer theorized that the further an Amish quilt was made from Pennsylvania, the weaker its visual effect.[9] George Delagrange, a picker and dealer in Ohio, saw through this East Coast bias, observing that "an awful lot of Ohio quilts in the early years became Pennsylvania quilts as soon as they left Ohio," noting that their prices increased with this rechristening.[10] Dealer Amy Finkel commented that in comparison to Lancaster examples, "the Ohio quilts are less intense and don't look uniquely Amish. They could have been made by any American."[11] This telling observation suggests a significant aspect of the connoisseurship of Amish quilts: the more distinctly Amish (i.e., less like *any* American could have made it), the better.

Some collectors—particularly dealers with access to midwestern Amish settlements—argued that the best midwestern quilts compared to the best of Lancaster quilts.[12] During the 1970s, non-Pennsylvania Amish quilts tended to be lumped together as "Midwestern," and dealers made few efforts to distinguish them. But by the early 1980s collectors, including David Pottinger in northern Indiana, began to articulate the regional characteristics that did in fact exist among quilts from various midwestern settlements. In addition to building a collection of Indiana Amish quilts, Pottinger began buying Illinois Amish quilts, which sometimes featured rich wool fabrics in unexpected and original designs not made in other regions. Don Walters, a folk art dealer based in Indiana, theorized that "the farther away from Pennsylvania you go, the more creative the quilts."[13] Eventually some collectors developed regional specializations—some preferring the maverick Illinois type, others the intricate piecing and dynamic colors on Ohio examples, while others remained loyal to the "intensely focused" Lancaster ones.[14]

Among connoisseurs, certain patterns developed cachet. The ultimate Lancaster County quilt was the Center Diamond, with its intensely focused center. And the best Diamond was one with a red center, preferably without "corner blocks," the term used to describe the squares of fabric some quiltmakers used in the outer or inner borders (figs. 8.1–8.2). Among Ohio quilts, the most desirable patterns were Ocean Waves and Tumbling Blocks, two designs that accentuate the visual interaction of small bits of fabrics by creating optical illusions (figs. 8.3–8.4). Collectors also coveted crazy quilts and other scrappy quilts from Illinois, featuring a nonstandard arrangement of haphazard fabric pieces (figs. 8.5–8.6).[15] Dealers sought out these particular patterns, knowing that the patterns' reputations created a ready-made market.

Fabric became another criterion dealers used to gauge desirability and value. Throughout the first half of the twentieth century, most quiltmakers in midwestern Amish settlements primarily used cotton fabrics to construct their quilts, just as they usually wore cotton clothing.[16] Cotton quilts—unlike wool ones—were easier to care for because they were washable. In contrast, the "old dark quilts" of Lancaster County were most often made from dress wools and fabrics woven with wool blends and mixtures.[17] Due to its molecular structure, wool absorbs dye in a more saturated way than other fibers, resulting in cloth that reflects light differently than cotton or synthetic fabrics. Although it is difficult to accurately determine fiber content with the naked eye, dealers knew the "look" and "hand" of wools and wool mixtures that were good showcases for the deep, bold colors of Lancaster quilts. Wool quilts were particularly desirable among collectors. According to a 1982 price guide, "If an all-wool quilt and an all-cotton quilt of comparable design, craftsmanship, and color were matched, the wool quilt would probably sell for roughly 25 percent more."[18]

These same dealers could also recognize undesirable fabrics, and while they could not always articulate accurately the less-attractive quality, they lumped such lesser cloths under the category of "crepe." Technically, crepe is a catch-all term for fabrics with a nubby or grainy surface, typically created with crepe yarns spun with a very high twist, or with a crepe weave, an irregular interlacing pattern of warp and weft resulting in a crinkled surface (see fig. 8.7). By the late 1970s, dealers used the term crepe, or "creep" as Amish women pronounced it, as a pejorative for fabrics that did not hang right, feel right, hold up right, or just plain look right.[19]

In the early days of the Amish quilt market, some dealers avoided crepes at all costs. Madison Avenue dealer George Schoellkopf said in 1973, "I hate this fabric. . . . I think it's so awful."[20] One quilt authority of the 1970s even referred with distaste to the "crepe period" of Amish quilts in which the pieces "often lack the mellowness of the woolen examples."[21] This writer did not understand that many crepes were in fact woven from wool; she probably intended to disparage manufactured fibers like rayon and acetate or early synthetic fibers like nylon. Without the aid of a microscope, fabrics woven from these fibers sometimes bore a close resemblance to wool, but others looked notably artificial when compared to wool fabrics and did not hold up well in quilts.[22] Esprit's curator, Julie Silber, called rayon crepes "TROUBLE" because they "do not hold color well, and fade very easily."[23] A "crepe period," however, is difficult to define, since rayon crepe came onto the consumer market in 1926. Its availability and use in Amish quilts coincided with that of 100-percent wool goods, which were widely available on the consumer market until the mid-1940s.[24]

In the late 1970s, quilts with crepe or rayon fabrics sold for less than those of all wool or cotton. As Joel Kopp of America Hurrah noted in 1979, "When [rayon crepes] sell now, they go for 50 to 60 percent less than the same quilt made of natural fibers."[25] In 1986 a knowledgeable dealer explained how to evaluate quilts' prices based on their proportional composition of crepe. According to these guidelines, some patterns could "tolerate" crepe more than others. For example, in a Double Nine Patch from Lancaster

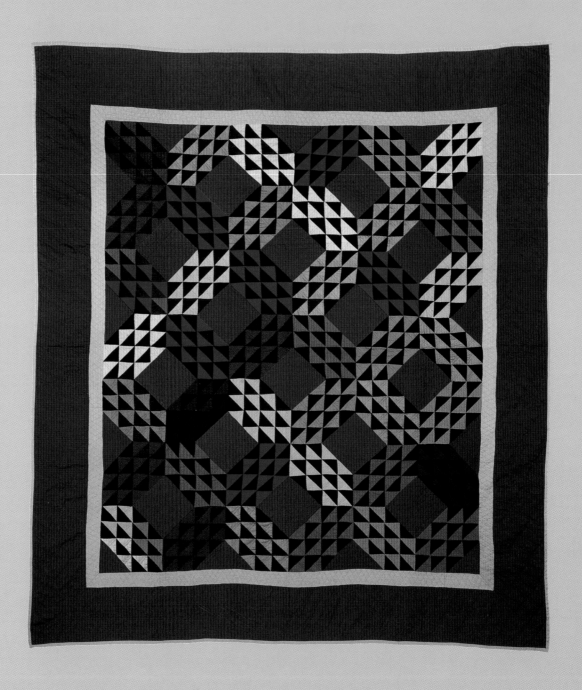

Figure 8.3. Ocean Waves, unknown
Amish maker, dated 1924. Holmes
County, Ohio. 84 x 75 in. (© Faith and Stephen Brown)

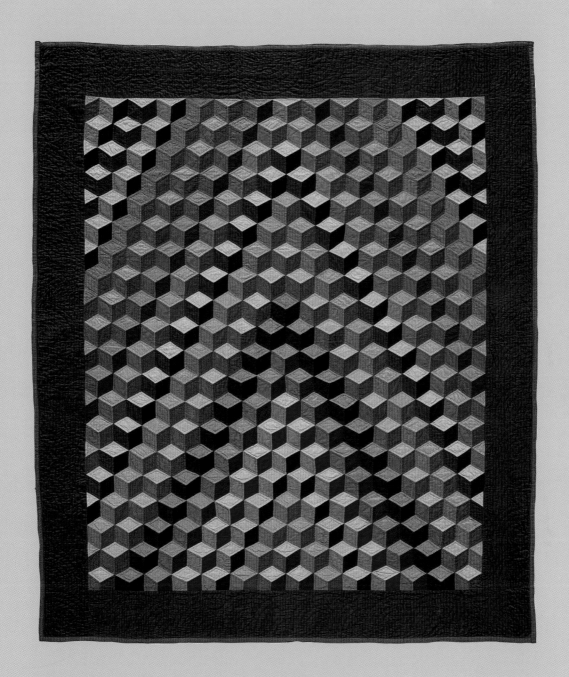

Figure 8.4. Tumbling Blocks,
unknown Amish maker, c. 1935.
Holmes County, Ohio. 78 x 68 in. (© Faith and Stephen Brown)

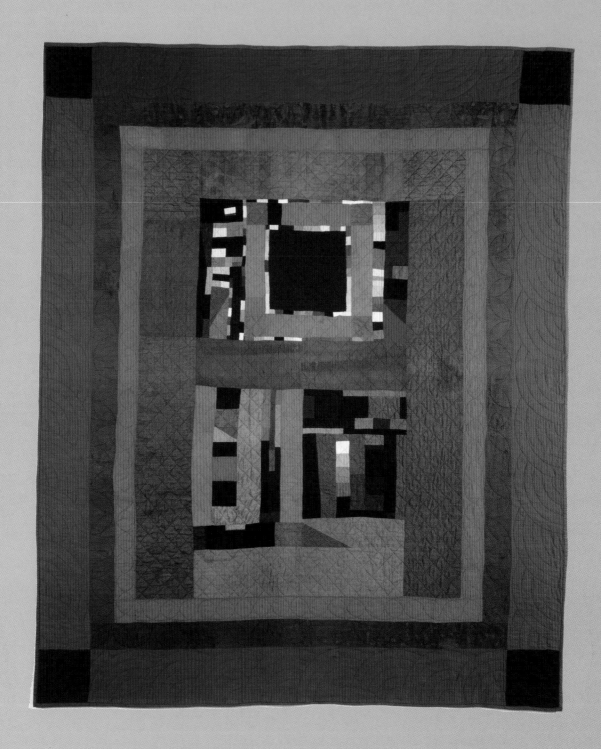

Figure 8.5. Scrap quilt, Elizabeth
Kauffman Hershberger, c. 1900.
Arthur, Illinois. Wool and cotton.
65 x 79 in. (Collection of Illinois State Museum,
1998.152.35)

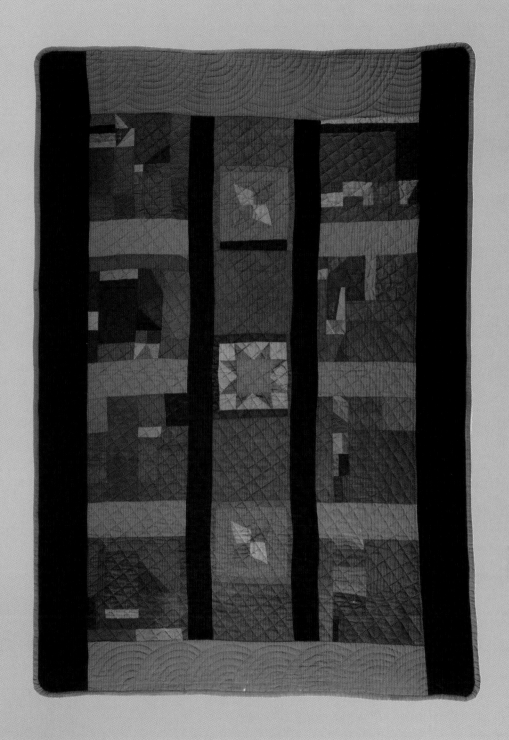

Figure 8.6. Scrap quilt,
Lucy Yoder Mast, c. 1900.
Arthur, Illinois. Wool with cotton
back and binding. 46 x 64 in.

(Collection of Illinois State Museum,
2001.43.152.35)

County, rayon crepe resulted in no appreciable price difference unless it appeared in its wide outer borders. The dealer explained that because this pattern was very popular among collectors and fairly unusual among Lancaster examples, crepe in its repeated blocks was fairly unobtrusive. On the other hand, dealers considered crepe in a Sunshine and Shadow quilt a significant deterrent, because this was such an abundantly available pattern. A Sunshine and Shadow quilt in all wool fabrics could retail for $6,000 to $8,000 in urban galleries. But wide-border fabrics pieced from crepes would decrease such a pattern to $1,000 to $2,000 on the New York market. If the quilt only had a small portion of crepe, it would retail for $2,000 to $3,000. Lancaster County patterns with expanses of crepe fabric in the wide borders or center field would be hurt the most. "A Bars or Diamond with rayon or cotton crepe can be worth as much as 75 percent less than a wool one," a dealer explained.[26]

To collectors and dealers, the most desirable fabric weaves in Lancaster County Amish quilts were thin dress wools ("worsted" wools used to make suiting, in contrast to fuzzier "woolen" cloths), often in a twill weave. As David Riehl, the Amish entrepreneur who brought quilts to New York City pointed out, "It must be wool and a certain kind of wool."[27] Some wool fabrics, such as the one Amish women commonly called "Henrietta cloth," had an iridescent glow attributable to warp and weft yarns of contrasting colors, often spun from different fibers (usually wool and silk or wool and cotton, see fig. 8.8). Lancaster County's Amish quiltmakers also used wool "batistes," a fine plain weave cloth they used to make dresses, which Holstein felt resulted in the "most intensely colored surfaces" (fig. 8.9).[28] Such wool and wool mixed fabrics indeed had a rich intensity that connoisseurs preferred over glossier, slicker fabrics woven with manufactured rayon or acetate fibers.[29] The earthiness of the wool quilts contrasted with the sheen common to many early 100 percent rayon fabrics, which first became available on the consumer market in the late 1920s.[30] Most Amish quilts from Ohio, Indiana, and other midwestern settlements were made from cotton fabrics in a variety of different weaves. Cotton does not absorb light the same way wool does. But some cotton fabrics had their own desirable qualities— cotton sateen, for example, was woven with a satin float weave that reflected light in dazzling ways (fig. 8.10).

Figure 8.7. Detail of rayon crepe, Center Diamond, unknown Amish maker, c. 1940. Lancaster County, Pennsylvania.

(International Quilt Study Center & Museum, University of Nebraska–Lincoln, 2003.003.0126)

Figure 8.8. Detail of twill Henrietta cloth, Center Diamond, unknown Amish maker, dated 1914. Lancaster County, Pennsylvania.

Figure 8.9. Detail, Bars, unknown Amish maker, inscribed "SL," c. 1890–1910. Lancaster County, Pennsylvania. Rust fabric is two-toned twill Henrietta cloth, while green binding is plain weave wool batiste. See figure 3.9 for full quilt.

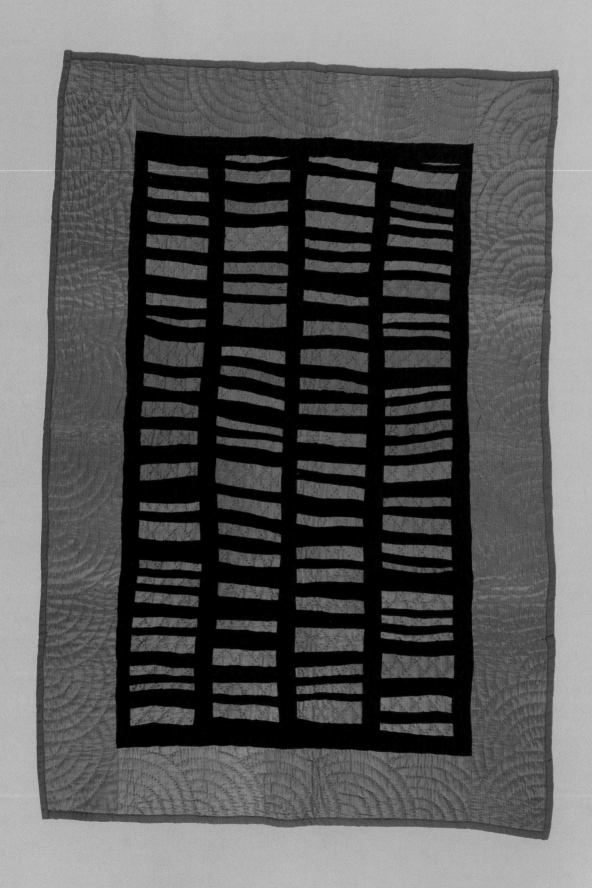

Another fiber that was problematic to the quilt market was polyester. Beginning in 1953, Dacron—du Pont's trademarked polyester fiber—was manufactured into various retail fabrics, including cotton/polyester blends that would soon be adopted by Amish for use in their clothing and their quilts.[31] For Amish women, who were responsible for laundering and ironing their family's clothing in homes without electricity, this easy-care fabric had great appeal. As had long been their practice, they used many of the same fabrics in their quilts that they used in their clothing. While Amish women celebrated the ability to wash these quilts—something likely to ruin wool quilts—collectors in the 1970s and 80s disdained the switch to synthetic fabrics. Although some polyester blends could be mistaken for the cotton and wool they were intended to resemble, many looked and felt distinctly synthetic. They were often slicker or crisper to the touch.[32]

In addition to polyester blend fabrics, quiltmakers also began using polyester batting for the middle layer of quilts. Polyester batting, available by 1960, had a different feel to a trained hand than thin cotton batting, and this knowledge could be used to determine if a quilt had been made after this product's introduction.[33] Quilts with polyester batting also did not require as many intricate quilting stitches because the web-spun fiber would hold its form much better than cotton. Quilts filled with polyester batting were puffier, contrasting with quilts filled with cotton, which were flatter and thus hung more easily on walls.

"CLASSIC" QUILTS

A quilt's age was important, but unlike the rule with most antiques, older was not simply better and thus more valuable. Because many collectors and dealers in the 1970s were more interested in the aesthetic value of these quilts than in the documentation regarding their age, much of the knowledge about dates was simply speculative.[34] In a 1979 interview, a Philadelphia dealer compared two hypothetical quilts pieced in the same pattern—one dated 1880 and one dated 1910. "If they are both in the same condition, the one that is most pleasing optically brings the higher price," he said, suggesting that aesthetics could trump age.[35]

More important than how *old* a quilt was, was how *new* it was. Starting with the earliest writings on the subject, authors articulated a "classic era" for Amish quiltmaking. The first book focusing on Amish quilts, Robert Bishop and Elizabeth Safanda's *Gallery of Amish Quilts* (1976), offered the range 1870 to 1935. These authors did not provide any evidence for these dates in their text; only 7 of the 156 quilts pictured had quilted or embroidered dates, while the authors listed the balance with estimated dates.[36] Similar dating schemes for the "classic era" proliferated in subsequent publications, with the end date usually around 1930 or 1940.[37] As one dealer recalled, "In dealing, the 1940s was a real cut-off point. You didn't offer anything to anybody [with a date] after that."[38] Such rules resulted in unethical behavior. One quilt now in the Indiana State Museum's collection has visible prick holes where quilting stitches, once reading "Dec. 1957," are now removed. The museum's catalogue record gives 1910 as

Figure 8.10. Chinese Coins, unknown Amish maker, c. 1920–1940. Midwestern United States. Cotton sateen. 47 x 32 in.

(International Quilt Study Center & Museum, University of Nebraska–Lincoln, 2000.007.0025)

its estimated date. Someone, perhaps the Amish individual who owned the quilt or a dealer who bought it, deliberately removed this date, knowing that it would fetch a better price if it were regarded as older.[39]

Many Amish quilts are in fact quite difficult to date. Amish quiltmakers usually pieced their quilts with solid colored fabrics. Unlike printed fabrics with motifs that changed with the prevailing fashion trends, these plain fabrics are much more challenging to date accurately. Quilts with dates marked with quilting or embroidery stitches helped budding quilt experts learn how to better estimate dates.[40] Yet in the 1970s exhibition curators and writers on the subject estimated dates as early as 1850, despite little supporting evidence.[41] These early so-called experts were probably similarly careless in assigning front-end dates, for new research has since uncovered classic-looking examples made well past the classic period's 1940 cut-off date.[42]

By defining "classic" Amish quilts, dealers constructed what an Amish quilt was and was not, a definition that often did not correspond to reality. The idea of "classic" makes clear that what is made now is *not* classic and is either atypical, sub-par, nontraditional, or merely forgettable. To make the most of the market for "antique" Amish quilts (if quilts made thirty-five years earlier are truly antique, given the 1940 cut-off), dealers needed to persuade consumers that new Amish quilts were inferior to the classics. Some called Amish quiltmaking a "dead art." One curator labeled Amish quiltmaking as "largely moribund today, its days of glorious accomplishment past."[43] Dealer and collector Phyllis Haders lamented, "Within only a few generations this unique form of expression has peaked and faded away. For those of us who cannot directly share the Amish experience, these quilts remain unique works of art, symbolizing a lost era of creative skill and aesthetic sensitivity."[44] It benefited those who made their living selling and writing about Amish quilts to portray the craft as a dead art, rather than an ever-evolving one, because it elevated the value of "classic" quilts.

In the 1980s, some Amish quilt experts began to define these objects more and more narrowly, making declarative statements about hard-and-fast rules they believed governed the quiltmakers' design processes. To connoisseurs, Amish-made quilts with printed fabrics, prominent use of white, or appliquéd motifs did not look distinctly Amish, so they disregarded them. "Printed fabric was never used: it would have broken the simple and intense rhythms of the pieced geometry and disturbed the pure color of the top," wrote one such authority.[45] This expert projected his own art world values as well as his notions about Amish simplicity and primitiveness onto the Amish quiltmaker, presuming that she would make design choices using the same criteria he would. Yet Amish quiltmakers probably gave no thought to "rhythms" and "pure color" when making quilts and chose for the most part to use the same fabrics they used to make their clothing, using the patterns they liked best. Other expert claims were even more arbitrary: "Orange-red and yellow are heretical colors," dealer George Schoellkopf told the *New York Times*, emphasizing with an air of authority what he may have perceived as a theological attribute of Amish quiltmaking. While perhaps no quilts with these

colors appeared in his 1981 gallery exhibit, many Amish quilts in fact do feature fabrics in those hues.[46]

Dealer Roderick Kiracofe realized how much pickers in the field were shaping perceptions of what Amish quilts should look like. He recalled that while visiting David Pottinger in northern Indiana he tried his own hand at door-knocking in the Amish community. In one home, the family pulled out a blue-and-white quilt unlike any Amish quilt Kiracofe had ever seen, calling it a "summer quilt" (see fig. 2.2 for an example). Upon seeing this quilt pieced with white fabric—breaking one of the supposed rules of Amish quiltmaking—Kiracofe realized how much of what he had seen in books and exhibitions had been "shaped by the dealers and collectors who went in there [and decided that] 'We like those and not those.' "[47] Dealer Joseph Sarah agreed, noting that "die hard collectors" were not interested in blue-and-white Amish quilts from the early twentieth century: "It is difficult as a dealer to sell to someone and convince them that this is indeed an Amish quilt."[48] Curator Stacey Epstein rejected such a quilt, commenting, in eliminating it from Robert and Ardis James's private collection, "Too much *white*—has non-Amish feel."[49] For this curator and others, it was not enough for a quilt to be made by an Amish person; it had to look and feel distinctly "Amish," based on complex criteria about what made a good Amish quilt.

"FAKE" AMISH QUILTS

As in art markets ranging from old master paintings to African masks, accompanying the buildup of this market was the proliferation of fakes—or, more accurately, quilts that were purported to be something they were not. In the field, where many pickers and dealers paid little attention to provenance, fraudulent practices (or at least suspicions of fraud) ran rampant. Fakes included both falsified dates and falsified (i.e., non-Amish) makers.

With the right materials in hand—fabrics from old clothing worked well—a contemporary Amish woman could easily produce a quilt that looked old. Amish businesses catering to tourists visiting their settlements sold these new quilts, but if they ended up in the hands of an unscrupulous dealer, they might be rechristened as old.[50] Amish women making new quilts from old fabric did not necessarily try to misrepresent them; collector Patricia Herr noted that when she encountered such quilts, all she had to do was ask the quiltmaker the right question—as simple as "When did you make this?"—to learn whether it was an old or new quilt.[51] In contrast, Darwin Bearley, a collector and dealer from Ohio, told of an Amish woman encouraging him to misrepresent a quilt: "I was offered a crib quilt made recently by an Amish woman in her 80s. Because it was made entirely of old fabrics, she suggested I might sell it as old."[52]

Whether Amish entrepreneurs deliberately deceived their consumers is debatable, but unscrupulous dealers no doubt had such intentions. Dealers were known to alter embroidered or quilted dates or to add ones not originally there.[53] In some instances, pickers and dealers assigned dates without asking their Amish sources for details

about a quilt's origin. More blatantly, one Mifflin County, Pennsylvania, dealer bought quilts made in the 1960s and 70s from Amish families and told her customer that they were made fifty to seventy years earlier, drastically altering not only their dates but also their value.[54]

Crib quilts proved to be particularly susceptible to faking by both Amish and non-Amish quiltmakers. These small quilts required much less fabric and fewer laborious quilting stitches to assemble than full-size quilts. Many pickers who bought directly from Amish homes regularly purchased old clothing and scraps of fabrics left from dressmaking. David Wheatcroft explained that such fabrics came in handy when he needed to make repairs to old quilts. But he also noted that these abundantly available scraps of old fabric could just as easily be used to make fake quilts.[55] In the late 1970s an *American Art & Antiques* article warned that real Amish crib quilts "are extremely rare, and expensive, and therefore, so are the fakes," listing some of the factors a potential buyer should look for.[56] Dealers Thomas Woodard and Blanche Greenstein observed in an 1978 issue of *Antique Collecting* that several "'artists' have been reproducing good replicas of the dark, richly colored geometric quilts, sometimes even using old fabrics in worn condition for authenticity." They advised, "If you don't ask about the age, you may not be told it's brand new. If it is brand new, the price should be considerably lower. Watch out!"[57]

Among dealers, rumors flew about untrustworthy pickers who sold fakes. Several dealers were convinced that one picker's girlfriend was producing many of the supposedly Amish crib quilts he was selling because they looked too good to be true and appeared on the market at a point when crib quilts were widely understood to be scarce and expensive. These quilts, executed in patterns and colors that appealed to collectors, could easily pass for Amish, but East Coast dealers who had bought and sold thousands of Amish quilts were suspicious. They noted telltale signs such as binding stitched on in a particular way and repeated use of a specific color palette. "The real pity of it is that this girl could have gotten an MFA with these things. They're beautiful," said one dealer. If the dealers' suspicions were correct, they were not in fact Amish-made quilts. With this picker's supposedly fraudulent quilts now spread throughout private and public collections, it will be difficult to ever know for certain whether they are Amish-made, or Amish-inspired.[58]

In the 1980s, collectors and dealers began to seek out information about quilts' makers and subsequent owners, valuing this information about provenance because it suggested authenticity in the face of a market potentially flooded with fakes. In the early days of interest in Amish quilts, few pickers had bothered to collect such information. Pickers were not overly concerned with a quilt's history because, as one collector observed, they knew they were "selling art objects, they are not selling them as history. . . . They are just looking for the best object they can afford."[59] As one dealer summed it up in the late 1970s, "If a quilt is ugly, it doesn't matter if it is signed and dated and comes with a history."[60] Provenance was more important in the upper echelons of the

Figure 8.11. Baskets, Susanna Yoder, c. 1920–1930. Topeka, Indiana. 39 x 33 in.

- -

(From the collection of the Indiana State Museum and Historic Sites, 71.989.001.0430)

- -

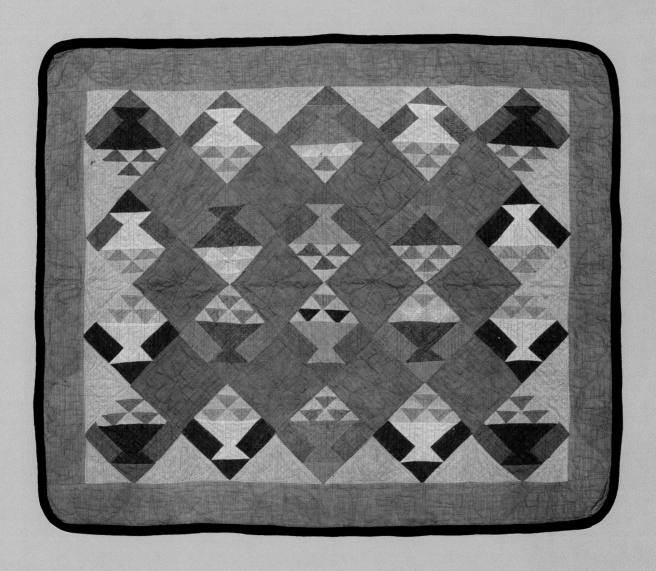

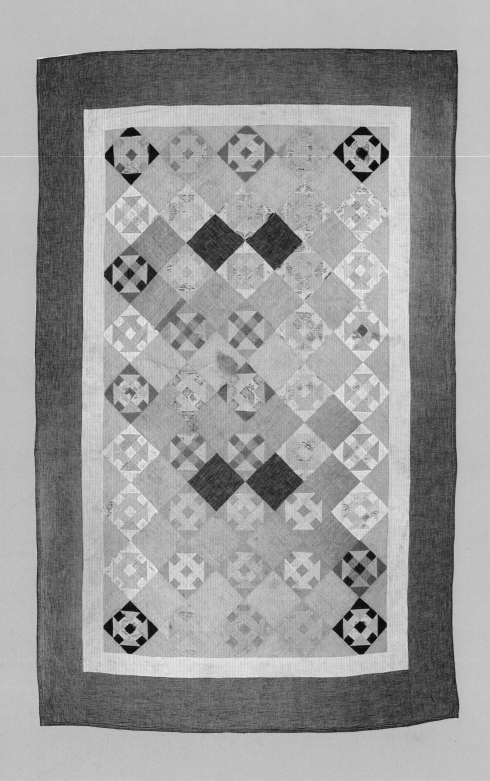

quilt market, but it mattered less to pickers rapidly acquiring quilts in the field and to individuals who wanted to hang a visually striking quilt above their couch.[61]

But the escalating prices in the 1980s, coupled with the proliferation of fakes on the market, made this information more necessary. Some unethical pickers and dealers easily found a fix for quilts they bought without documented history: they could fabricate an Amish-sounding name. David Wheatcroft recalled an occasion where a dealer paired common Amish first names with common Amish last names, adding the invention to quilts' provenance to provide an authentic-sounding history to quilts he sold at auction.[62]

BUT DOES IT SING?

Despite the various criteria used to evaluate Amish quilts, the emotional aspect—the question of whether a quilt "sang"—sometimes proved more important. David Pottinger, the plastics manufacturer turned quilt collector, said he "fell in love with this quilt," a crib-sized bedcover in a Baskets pattern (fig. 8.11). The quilt was a scrapbook of the soft chambray fabrics favored by the Indiana Amish. Chambray fabric is woven with a dyed warp thread (often blue) and a white weft, creating a muted color. The quiltmaker used scraps in an orderly way, creating simple geometric baskets out of browns and tans. In typical Indiana fashion, she set these basket blocks diagonally (on point) with alternating setting blocks. These unpieced setting blocks form a secondary pattern—a blue square set on point like a diamond that jumps from the background to the foreground. But unlike many of the quilts in Pottinger's collection, this one was from an unknown maker. "I bought this from a dealer," he said, "and I very seldom bought from dealers—he wouldn't tell me where most of them came from." Fifteen years later, he saw an advertisement for a quilt for sale along with a youth-sized bed. The quilt was quite tattered, worn through to the backing, with bits of cotton batting hanging loose. It featured many muted chambrays in shades of blue, pink, brown, and purple, and Pottinger recognized it as the work of the same hand that made his old favorite, the anonymous Baskets crib quilt (fig. 8.12).[63]

"When I ran onto this rag fifteen years later," he recalled, "the lady said, 'What will you give me for it?' And I said, 'I will give you anything you want. I have to have that quilt.'"[64] With this purchase he learned that Susanna Yoder had made the two quilts, elevating the value of each in his mind. Yet there was more to this transaction than documenting its maker and handing over an undisclosed sum of money. That Pottinger had an emotional response to these quilts is evident in the way he speaks about them years later. Here emotions proved to be the most powerful criterion for evaluation as a tattered "rag" of quilt became something to be bought at all costs.

Pottinger had an evolving relationship with the Indiana Amish and their quilts. Like his contemporaries who collected Amish quilts, he considered quilts "graphic objects" and preferred to see them from twenty feet away.[65] But unlike a majority of his fellow collectors, he had a more intimate understanding of quilts' original context

Figure 8.12. Hole in the Barn Door, Susanna Yoder, c. 1890. Topeka, Indiana, 68 x 42 in.

(From the collection of the Indiana State Museum and Historic Sites, 71.989.001.0456)

within Amish homes, having purchased them directly from families with whom he became acquainted. His insider knowledge did not alter the ways in which he displayed his quilts like art objects. Rather, it changed the quilts' emotional value. Pottinger's quilts functioned as souvenirs, connecting him to his experiences living among the Amish.[66] In 1986 Pottinger described what his collection of quilts now meant to him: "What it represents to me are memories, memories of acquiring those quilts and [of] the families I lived with, sat with, and talked with. Those quilts are the souvenirs of my memories and my change in life."[67] No connoisseur has developed the scientific formula to evaluate these qualities.

CHAPTER **9**

DESIGNED TO SELL

The Amish have always considered themselves farmers. Since the

inception of the Amish in the seventeenth century, farming has not only been their traditional livelihood but has also been considered a religious mandate set forth in the Old Testament. Moreover, the Amish have considered agriculture—with parents and children working side by side—as a means of keeping family close and passing on the church's values, limiting children's interaction with the outside world while instilling the ethic of hard work and personal responsibility.[1] Farming remained the ideal vocation during the second half of the twentieth century, but rising prices for agricultural land coupled with increasing Amish population challenged it as a way of life. In larger Amish settlements near expanding suburbs, the value of farmland rose as developers purchased it to build houses and establish commercial districts. With Amish population growing rapidly due to high birth rates and because most Amish children join the church as adults, land could not be secured for all young families to farm.[2]

By the 1970s, these demographic, economic, and geographic realities left Amish communities with important decisions to make. Families could migrate away from established settlements in search of affordable farmland, they could further subdivide existing farms, they could seek nonagricultural employment working for non-Amish businesses, or they could start their own businesses.[3] In Lancaster County, Pennsylvania, eastern Ohio, and many smaller settlements, family businesses emerged as the favored choice. These businesses, usually established adjacent to the home, allowed fathers and mothers to be close to their children, to set their own hours, and to intersperse other domestic tasks into their workday. Children—particularly those over fourteen who were no longer in school—worked in family businesses just as they had on farms. In this way, small businesses enabled families to control their work environment and continue their long-standing emphasis on working closely as a family.[4]

The growth of small businesses among Lancaster County Amish in the 1970s coincided with intense outsider interest in the religious group's "old dark quilts." By the early 1980s few desirable old quilts were available directly from Amish homes because most families had sold them to pickers who came knocking at their doors. Consumers could still buy them from city galleries and antiques dealers, but they cost as much as $10,000. These quilts had become art objects. Yet just as "Amish" had signified a certain cachet to collectors of old quilts, it similarly added value to new quilts for sale within

Amish communities and commissioned by non-Amish businesses. These enterprises capitalized on outsider interest in the religious group and their old quilts, establishing new quilts as an important commodity within Amish settlements—essentially a newfangled cash crop. Home-based quilt businesses were one of the ways Old Order Amish adapted to changing economic, demographic, and geographic circumstances, maintaining what outsiders considered an old-fashioned tradition of crafting quilts, but doing so through sophisticated processes of design, production, marketing, and distribution. With the commodity potential of new quilts, Amish businesses crafted quilts designed to sell.

QUILT BUSINESSES

Many Amish settlements have become home to quilt businesses, particularly those that have attracted even a modest number of tourists. Lancaster County, one of the oldest and best-known Amish communities, has had both the earliest and the highest concentration of such enterprises. In turn, this geographic area has become synonymous with quilts, identified in the media as a "Quilt Capital."[5] Businesses have started in other Amish settlements large and small across North America. Some of these were Amish owned and operated, while non-Amish entrepreneurs managed others. Some specialized in retailing quilts, while others existed as home-based cottage industries that wholesaled or consigned quilts to retail outlets. Fashion companies, home furnishing businesses, and studio art quilters employed Amish women to hand quilt their products and fiber art.[6] Businesses targeted a variety of consumers, with those located in Amish settlements geared toward tourists, and others targeting interior designers and corporate art consultants.

Before they began concerning themselves with outsider fashions and consumer taste, some Amish seamstresses sewed for coreligionists, earning money to supplement farm income. Since early in the twentieth century, Amish women had engaged in quilt-making in exchange for money, usually as a service to friends and family who wanted to give quilts to their children but did not want to complete all the steps in the quilt-making process themselves.[7] Some women had established reputations within their communities for having a particular talent, such as fine quilting stitches, innovative quilt marking skills, or an ability to apply a decorative binding. As experts, they hired themselves out to perform these specialized tasks.[8] For example, in the early twentieth century, an Amish man hired a widow neighbor with especially good quilting stitches to quilt the tops pieced by his wife.[9] More common was the practice of hiring out a quilt's piecing. Many women did not have time to piece, but they could buy a quilt top and then host a daylong quilting frolic where friends and neighbors efficiently stitched the three layers of a bedcover together.[10] Non-Amish individuals also hired Amish quilters to complete the intricate quilting stitches needed to turn a pieced or appliquéd quilt top into a finished quilt.[11]

The first formal quilt enterprise in Lancaster County was likely started in 1959 by Emma Good, an Old Order Mennonite living in New Holland.[12] Although Good had sold quilts informally for some years, the impetus to start a business occurred when Philadelphia fabric salesman Bill Greenberg, who "had long admired the color, design, and quality" of the quilts made by his Amish customers in Lancaster County, hired several of them to make quilts, intending to sell them in New York City and Philadelphia. Emma Witmer, Good's daughter, recalled that her mother helped in the production of these quilts in the late 1950s. When Greenberg failed to sell most of them, he sold the remaining twenty-two quilts to Good. At her husband's urging, she posted a sign at their home advertising quilts. After successfully selling them, she employed Amish and Mennonite neighbor women to produce more. Good's quilts were often appliqué designs executed in the popular 1960s colors of brown and avocado, very different from the pieced Amish quilts art enthusiasts sought out in the 1970s.[13]

Hannah Stoltzfoos was likely the first Old Order Amish woman to begin selling new quilts to outsiders in Lancaster County.[14] In 1972, Emma Good gave Stoltzfoos twenty new quilts from her inventory to sell on consignment. She easily sold these and continued growing her business in subsequent years. In the mid-1970s interest in quilts was on the rise, perhaps stemming from the American Bicentennial, feminist appreciation of traditional women's arts, and recent museum exhibitions and books highlighting quilts. In 1976 Stoltzfoos sold 500 new quilts. In these early years, Stoltzfoos sold quilts made by other local women, but eventually she took more control of the product by designing the quilts and farming out the work. Soon consumers began to commission quilts according to their own taste, even supplying Stoltzfoos with swatches from carpets and drapes so that quilts matched their decor. Stoltzfoos initially sold old Amish quilts as well, but her business in coordinating the production and retailing of new quilts long outlasted the 1970s rush to buy old ones.[15]

As Amish quiltmakers realized that outsiders to their community were willing to pay for their handiwork, they capitalized on the entrepreneurial atmosphere of Amish society in the 1970s and 80s. As in other facets of Amish culture, change was slow; but making quilts to sell to outsiders spread within settlements, becoming conventional and acceptable rather than unusual. Dozens of other similar shops had sprung up in Lancaster County by the 1990s, employing thousands of Amish women in the production of quilts.

Many quilt enterprises started small. In the mid-1980s Katie Stoltzfus and her daughters began making quilts to sell through local retailers catering to tourists visiting Lancaster County. When Katie was left with an inventory of ten or twelve quilts one year, her husband suggested that she put a sign at the end of their lane advertising quilts for sale. Within half an hour of the sign going up, her first customer knocked at her door. She displayed those first quilts in her parlor, draping them over couches and chairs. All the quilts sold. In subsequent years the business she called Country Lane Quilts grew, and the family built an addition to their home featuring a basement showroom and an office and sewing room above.[16]

Quiltmakers who did not run their own retail businesses could sell or consign quilts to the numerous shops in larger Amish settlements that specialized in retailing quilts to tourists. Located since 1979 in Intercourse, Pennsylvania—the heart of Lancaster County's tourist district—the Old Country Store has stocked hundreds of consigned Amish-made quilts. One of its competitors was neighboring Nancy's Corner, which bought quilts from more than three hundred local quilters and retailed them to the county's thousands of consuming tourists.[17]

Another business model grew directly out of the trade in antique Amish quilts. In the mid-1970s, Susan and George Delagrange had begun buying old quilts from Amish families in Ohio, selling them to out-of-town dealers and interior designers. In the 1970s, Amish quilts were abundant and could be bought cheaply in Ohio's settlements. But as the market for "old dark quilts" continued to expand through the 1970s and into the 1980s, the supply of old quilts could not meet demand. A limited number of quilts in desirable colors and patterns existed. Those lucky enough to own one soon realized that this was a hard piece of art to care for. Unlike the paintings many collectors thought they resembled, quilts hung on walls in sunlit apartments or bank branches could quickly fade from light damage. Used on a bed, regular wear and tear could spoil an Amish quilt worth thousands of dollars. The old quilts were irreplaceable, the Delagranges thought, but new quilts were a "viable alternative" that could give consumers "an opportunity to have them as art without both the expense and the possibility of damage or loss." The Delagranges established Amish Design in 1980, hiring Amish women to make quilts and targeting interior designers and art consultants who placed quilts in corporate art collections as their primary clientele.[18]

The market for new quilts grew out of interest in the old dark quilts, but the resulting products were much more diverse—made with new patterns, new materials, and new techniques. Most quilts made for the consumer market looked significantly different from those Amish women had made for their families earlier in the twentieth century. By the 1970s Amish women were themselves less interested in the dark colors and old patterns, regarding them as "old-fashioned."[19] Amish quiltmaking, itself a relatively young tradition, had always been a fluid practice, with patterns, fabrics, and color preferences changing according to Amish fashions.[20] Though staunchly traditional in many respects, the Amish—like the rest of society—have always adopted new fashions, consumer products, and technologies; they just do so at their own pace.

The fashion trends of the dominant American culture also influenced how these new quilts looked. Many consumers searching for new Amish quilts were less interested in the aesthetics of the old dark quilts than in buying a quilt to match their own interior decorating scheme. The growing mainstream quilt industry, spurred by what is known as the "Quilt Revival" of the late twentieth century, supplied contemporary quiltmakers with fabric, patterns, battings, and tools to produce handcrafted quilts.

With these products widely available, Amish quiltmakers and entrepreneurs used the same suppliers as non-Amish quiltmakers for their quiltmaking needs, resulting in quilts that looked more "mainstream," rather than distinctly Amish.[21]

When produced for retail shops, most Amish-made quilts featured contemporary designs that changed with interior decorating fashions. As Rachel Pellman, manager of the Old Country Store in Intercourse, Pennsylvania, during the 1980s, recalled, "If you went to the local wallpaper store and looked at the wallpaper books, you could pretty much tell what colors were going to be popular in quiltmaking."[22] Amish quilt designers learned how to stay on top of these trends by reading new "how-to" quilt books, following industry publications, and attending trade shows.[23] One Amish businesswoman reported, "We have to keep up with what colors are fashionable so we can make the changes from one year to the next." Retailers also needed to have a diverse inventory on hand to satisfy the varying tastes of consumers; "You get all kinds of people. So we try to do all kinds of quilts. Hopefully we do a quilt for everybody," said another businesswoman. Many tourists visiting Amish settlements wanted a quilt that was Amish made, but preferred other styles than the old dark quilts. To these consumers, a quilt's Amish origins signified quality, regardless of its aesthetics. And Amish businesswomen were happy to "give them whatever they want."[24]

Consequently, many shops offered custom services; customers brought in swatches of curtains and rugs to commission quilts to match their décor.[25] As one observer—and admirer of the old dark quilts—commented in 1988, "Surprising as it seems to those of us who love a classic Amish color scheme of black and purple with a touch of wild pink, most quilt buyers are looking for something in pastel blue and white or shades of brown to match the bedroom wallpaper."[26] Although one Amish entrepreneur called custom orders a "hassle" due to the difficulties in matching colors, these businesswomen had no qualms with adapting their quiltmaking practices to suit consumer taste.[27]

One new pattern that took off among consumers had its origins in Lancaster County. In 1983, *Brides* magazine came to Lancaster to profile an old home renovation for a newly married couple. The magazine decided it needed a custom-made quilt to take center stage in the bedroom and sought out the assistance of the Old Country Store, one of the largest fabric and quilt retail shops in the County. The manager, Rachel Pellman, and her colleague, Craig Heisey, created the pattern.[28] "We thought it should have hearts to represent love, and maybe distelfink birds or something like that to represent the Lancaster area," recalled Pellman, referring to two symbols frequently found on Pennsylvania German decorative arts of the eighteenth and nineteenth centuries. Similar motifs appeared on old Amish quilts but were usually hidden in the quilting stitches rather than prominently featured in the pattern. The pattern Pellman and Heisey designed required appliqué, the technique of sewing one piece of fabric onto a background fabric, allowing figurative elements to be more prominent.[29]

The "Country Bride" quilt (fig. 9.1), as it soon was called, featured overlapping hearts, undulating vines of tulips, and a pair of lovebirds. In contrast to Pennsylvania German painted furniture, slip-decorated pottery, and fraktur, which often featured

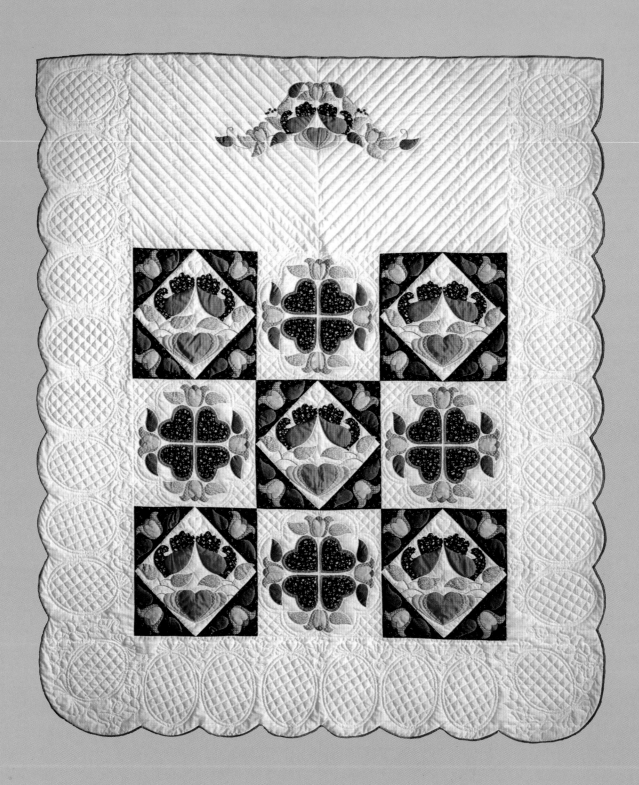

this imagery in red, green, and yellow, the Country Bride quilt was in rose and blue, staple colors of early 1980s home decorating. The appliquéd motifs were set on a white background, which showcased the intricate quilting stitches echoing some of the figurative elements. The edge of the quilt featured gentle scallops rather than a straight binding.

After the quilt appeared in the June/July 1983 issue of *Brides*, the Old Country Store began receiving frequent requests from quiltmakers for its pattern. Initially, Pellman's staff sold photocopies of the pattern for a few dollars before realizing that consumer demand warranted publishing the pattern and an accompanying how-to book. The staff at the Old Country Store followed up with a whole series of Country Bride patterns, including Country Lily, Country Love, and Country Songbird.[30] The design fit perfectly with the American Country aesthetic popular throughout the 1980s. And when the dominant interior design colors switched to salmon and green in the 1990s, quilters easily could adapt the Country Bride series of patterns to follow.[31]

In addition to those who wanted to reproduce the romantic quilt themselves, many consumers wanted to buy Country Bride quilts and began asking for them at Lancaster County's many quilt retail shops. Amish entrepreneurs who consigned quilts to shops like the Old Country Store or operated their own quilt retail stores decided they needed to adopt the new trend. They bought Country Bride patterns and farmed out work to women with appliqué skills, a rarity among Amish women who predominantly made quilt tops with the techniques of piecing and embroidery. Some creative quiltmakers adapted the pattern, making slight variations in the layout or changing the colors. Emma Witmer recalled that when she showed her variation of the Country Bride pattern to its co-designer, Rachel Pellman did not even recognize it.[32] The success of the Country Bride quilt and its related Country spin-offs ushered in many romantic appliqué patterns that have remained popular among consumers coming to buy quilts in Lancaster County.

The Country Bride phenomenon reveals the process through which trendy patterns spread through Amish cottage industries. Other popular patterns have included Dahlia, Bargello, Autumn Splendor, and Star Spin (figs 9.2–9.3).[33] Just as with old quilts, conformity within the community predominated rather than individualism. If a certain pattern sold well, then every Amish quilt entrepreneur wanted to make that quilt. This reflected good business sense, but it was also indicative of Amish culture's emphasis on submitting to the will of the community rather than the individual. Innovators have experimented with novel practices (including quilt patterns), pushing the community from its edges by adopting new ways of doing things; but most Amish have been hesitant to initiate change until others have tested the boundaries of tradition.[34]

In 2003, in an unusual act of individualism, Amish quiltmaker Mary Beiler copyrighted a version of a Bargello pattern she called "Light in the Valley" (fig. 9.4).[35] Beiler's friend had adapted the design from an old needlepoint pillow. Beiler encouraged her to copyright the pattern, suspecting it would be a good seller. She thought copyright protection would ensure that "Light in the Valley" would not spread through the Amish

Figure 9.1. Country Bride.

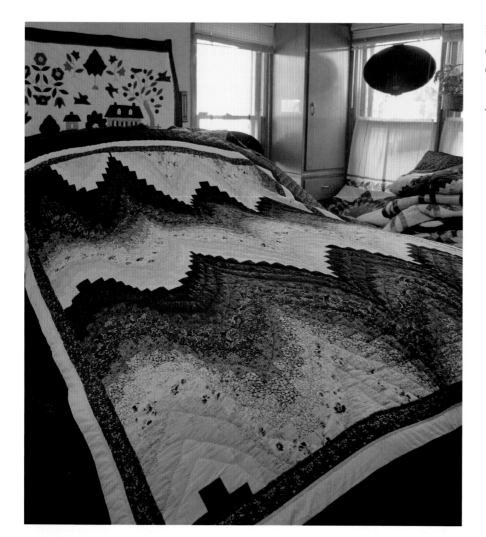

Figure 9.2. Bargello style quilt, designed by Emma Witmer, Witmer Quilts, 2012.

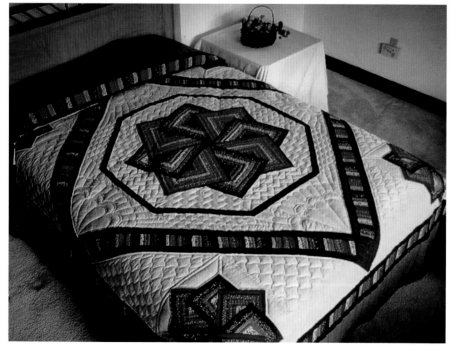

Figure 9.3. Star Spin, 2010.

(Image courtesy of Amish Country Quilts.)

Figure 9.4. Light in the Valley, detail, 2012. Amish woman Mary Beiler copyrighted this design in 2003. Since that time, the Lancaster County–based online retailer, Almost Amish, has purchased the copyright from Beiler.

(Image and design ©Almost Amish, www.almost-amish.com)

quilt industry like so many other popular patterns. Her friend, wary of such legal action since it went against the historic Amish practice of using oral agreements based on trust rather than legal documents, suggested that Beiler use her own name to file for copyright. Perhaps copyright was ironically one of the few ways of creating a truly individual quilt, though it clearly went against the faith's tenet of humility and was enforceable by lawsuit, an excommunicable action under Amish *Ordnung* (the locally prescribed guidelines governing Amish life).[36]

The materials Amish quiltmakers used to make popular patterns like Bargello and Country Bride differed from those used to make the old dark quilts. Commercial quiltmakers purchased fabrics specifically for quiltmaking rather than using leftovers from making clothing. Printed fabrics, which Amish refrained from wearing owing to long-standing prohibitions against ornate designs, regularly appeared in quilts for the consumer market. Many of the old quilts predated cotton/polyester blend fabric, which did not become widely available until the mid-1950s.[37] Since the 1970s, Amish quiltmakers have regularly used this easy-care fabric for most of the quilts they made for the consumer market. They have used polyester batting for quilts' inner layer rather than cotton batting or flannel sheets, two materials commonly used to make quilts during the first half of the twentieth century.[38]

Beginning during the 1990s, some consumers sought out quilts made with all-natural fibers. This was largely an aesthetic preference, since 100% cotton quilts have a

softer look and feel. But these consumers likely also considered natural fibers as more authentic, adhering to imagined perceptions of an old-fashioned Amish quiltmaking tradition. Although many Amish quiltmakers have continued to prefer synthetic blends and polyester batting because they are easier to use and care for, Amish quilt retailers have acquiesced to this consumer demand and have stocked at least a selection of quilts made from 100% cotton.[39]

In addition to stocking quilts in trendy patterns, many Amish shops kept a small section of quilts in dark, solid-colored fabrics, using patterns commonly found on antique quilts such as Sunshine and Shadow, Nine Patch, and Center Diamond. While these quilts featured colors and patterns common to the old dark quilts, quiltmakers typically executed them in one of two ways that resulted in an appearance distinctly different from the old ones they meant to replicate.

First, small quilts intended for walls predominated. Amish women often called these "wall-hangers."[40] Some of these quilts could easily be mistaken for antique crib quilts, like the wall-hanger Susan Gingerich consigned to the Helping Hands Quilt Shop in Berlin, Ohio, which passed through the hands of dealers and collectors until it ended up in a museum collection (fig. 9.5).[41] But many wall-hangers looked too neat, too precise, and featured patterns more commonly found on old full-size quilts (like Bars or Center Diamond) rather than those more typical of crib-sized quilts (fig. 9.6).

Second, quiltmakers rescaled the old patterns to fit the large beds standard in the late twentieth century. For example, old Lancaster County Amish quilts in center medallion formats typically were nearly square, with dimensions ranging from 70 to 80 inches.[42] This size of quilt could barely cover the top of a contemporary full-size mattress, let alone a queen or king size. Collectors usually hung the old quilts on walls rather than using them on their beds. But businesses produced ones with dimensions around 95 by 110 inches, designed to fit contemporary beds. These quilts featured designs with enlarged central motifs and wider outer borders that could hang over the edge, covering thick mattresses and box springs. Sometimes designers included an additional allowance of fabric so the quilt could be folded over pillows without disrupting the symmetrical design (fig. 9.7). This new scale created new proportions, altering the feel of old patterns like Center Diamond or Bars and resulting in quilts without what collectors and dealers referred to as "perfect proportions."[43] Consumers who loved the aesthetics of the old quilts, choosing to hang them on walls for dramatic effect, did not like these adaptations.[44]

Some Amish quilt entrepreneurs not only used old patterns and colors to make quilts for the consumer market; they also used old fabrics. Many Amish women had treasure troves of scrap fabric left over from generations of making clothing and quilts; many also owned old clothing constructed from these same wools and cottons. Noting the prices collectors paid for old wool quilts, some Amish women used their scraps and old clothes to make new quilts, usually crib-sized wall-hangers, which did not require as much yardage as a bed-sized quilt.[45] In 1988 a writer in the Amish publication *Die Botschaft* observed of one such quilt: "Looks like it could be close to one hundred years

Figure 9.5. Susan Gingerich, Nine Patch, c. 1997. Wayne County, Ohio. 35 x 40 in. Gingerich consigned this "wall-hanger" to a quilt shop; after it sold, it was later mistaken for an antique crib quilt.

(International Quilt Study Center & Museum, University of Nebraska–Lincoln, 2000.007.0014)

Figure 9.6. Amish quilt shop, New Holland, Pennsylvania, 2008. Note the Center Diamond "wall-hanger," a scaled-down version of this ubiquitous pattern.

Figure 9.7. Intercourse, Pennsylvania, quilt shop. The Star quilt at left has an additional fabric allowance to fold over pillows without disrupting the symmetry of the design.

(© Peter Finger/CORBIS)

old. Brown, grey, off red . . . something that not everyone would want to put on their bed. But just what the quilt buyers want. It had to be filled in with all cotton, even using cotton thread."[46] The Amish writer's observations reveal not only that this old style of quilt had fallen out of favor within Amish homes but also that some Amish individuals had become quite aware of specific characteristics—all cotton thread, for example— that made quilts desirable to outsiders. These new quilts made with old materials and 100% natural fibers, unlike those pieced from new contemporary fabrics, could easily be mistaken for valuable antiques. Some were in fact sold on the antiques market, either by unscrupulous dealers passing them off as old or as objects with unknown provenance.[47] New quilts made from old fabrics affected the entire Amish quilt market. According to one dealer's observation, they lessened the value of genuine antiques by increasing the supply of quilts circulating in the market.[48]

Non-Amish businesses like George and Susan Delagrange's Amish Design also made quilts explicitly intended to replicate the old ones.[49] They wanted to produce an affordable substitute for the expensive old Amish quilts and revive what they perceived as the declining state of Amish quiltmaking. Contemporary Amish preferences for tech- niques, materials, and colors no longer conformed to the criteria antiques dealers and quilt collectors used to evaluate the old quilts.[50] The Delagranges hired Amish women to make quilts for the consumer market, instructing them in how to make a product that met their standards and would appeal to urban consumers seeking quilts as part of interior design schemes.

Susan Delagrange designed the quilts, drawing inspiration directly from antique ones. As a dealer and connoisseur of the old quilts, Susan knew how to design quilts that would appeal to their target clients—interior designers and corporate art collectors who liked to hang quilts on walls like paintings. She provided the employee responsible for piecing each quilt a sketch on graph paper with notations indicating which fabric to use where (fig. 9.8).[51] Some quilts were straight reproductions of old ones (fig. 9.9). Other designs attempted to replicate elements of many older quilts that emerged from the use of small scraps of fabric left over from dressmaking. Late twentieth-century Amish quilt enthusiasts appreciated these seemingly random color choices and unex- pected symmetries. For example, Susan designed a Baskets quilt so that the red and green baskets alternated in an asymmetrical fashion. On another design Susan care- fully laid out the seemingly "random" placement of the blocks so that it would appear like a scrap quilt pieced from assorted leftovers (fig. 9.10). In her sketch for a Chinese Coins quilt, a pattern typically made with scraps of fabric in various sizes left over from dressmaking, Susan instructed her piecer in how to achieve the haphazard, scrappy feel: the strips of fabric should be cut in half-inch increments ranging from one-half inch to three inches.[52]

The Delagranges also controlled the color palette. They chose muted jewel tones, deep purples and blues, rusty reds and browns, mustard, gray, and forest green—hues found on old dark quilts. By the 1970s, these colors were out of fashion among many Amish quiltmakers, save for the most conservative groups.[53] But the Delagranges limited

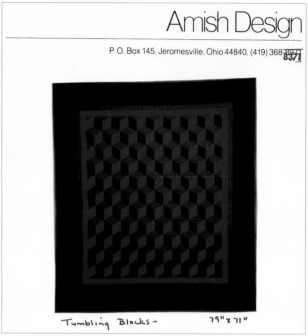

the palette to these colors in an effort to create a product that felt "Amish" to their art enthusiast clients familiar with the dark quilts.

Rather than have Amish quiltmakers use the materials they had grown accustomed to by the early 1980s, the Delagranges supplied them with fabrics. To their clientele, the synthetic blend fabrics Amish women had been using to make quilts since the 1960s and 70s were undesirable because they did not provide the soft feel or saturated color of those made earlier in the twentieth century.[54] Amish Design mail-ordered 100% cotton, solid-colored fabrics, including cotton sateen, a lush iridescent fabric that had been a favorite of midwestern Amish quiltmakers early in the twentieth century. Moreover, because the puffy polyester batting Amish quilters preferred did not result in the flat, smooth effect collectors liked when they hung quilts on the wall, the Delagranges supplied them with thin cotton flannel to use instead of batting.[55] Their Amish employees complained about the 100% cotton materials, which they found much more difficult to stitch through compared with polyester batting and synthetic blend fabrics.[56] But the end product, tailored to a specific market segment, looked and felt suitably "Amish," even if the Amish women had little control over the design and materials.

"AUTHENTIC" AMISH DESIGN?

What then, was authentically Amish about quilts designed expressly for the consumer market? One might be tempted to call Amish Design's quilts authentic because they relied on the old patterns and colors, but these design decisions simply filled a niche market and resulted in idealized versions of Amish quilts. That did not stop quilts

Figure 9.8. **(top left)** Amish Design sketch and fabric swatches for Ocean Waves quilt by Susan Delagrange.

(George and Susan Delagrange Collection)

Figure 9.9. **(top right)** Amish Design promotional materials, c. 1982.

(George and Susan Delagrange Collection)

29-22

5"

2"

2"

5"

8-4

1. Rust 5 Slate blue
2. Navy 6 Light brown 5" rust bind
3 Bright blue 7 Dark brown muslin back
4 Black

Figure 9.10. Amish Design sketch
for Double Nine Patch quilt by
Susan Delagrange. (George and Susan Delagrange Collection)

produced and sold by the Delagranges' company from ending up in museums, inter-mingled with the old Amish quilts that inspired their design. Although the Delagranges purposely labeled the quilts they sold so that future consumers would not mistake them for antique ones, the stitched-on labels could be—and were—easily removed.[57]

One might also be tempted to call Hannah Stoltzfoos's quilts authentic because she—an Amish woman—designed the quilts. But she also relied on published patterns and followed contemporary design trends, aiming to make quilts tailored to her custom-ers' taste. Many of these customers sought quilts that aligned with home décor trends rather than with any imagined ideal of "Amish design."

As the next chapter explores, Amish quiltmakers contributed to the labor neces-sary to produce the goods sold by both types of businesses. If the identity of the maker signified authenticity in consumers' minds, then both businesses produced authentic Amish quilts. Yet as we shall see, the production and marketing processes complicated the notion of maker's identity: how much did an Amish woman need to contribute to the process in order to call a quilt "Amish"?

CHAPTER **10**

HOMESPUN

EFFICIENCY

As businesses, the industries producing and distributing Amish quilts needed to determine the most cost-effective and efficient means of making and selling quilts. When it came to making quilts—cutting fabric, piecing or appliquéing, marking, quilting, and binding—efficiency dictated a method that contrasted with that employed by an earlier generation of Amish women who crafted quilts for their own family members. And while earlier in the twentieth century some Amish women informally sold their quiltmaking services, the era of making quilts for the consumer market necessitated more sophisticated means of distribution at both the wholesale and retail level. In short, quilt businesses formalized both production and distribution systems in order to shift quiltmaking from a domestic craft to a viable business model. This formalization, however, had its consequences as the role of Amish women within their families and communities also changed.

PRODUCING QUILTS

Most Amish-made quilts for the consumer market were constructed using a process akin to the preindustrial putting-out system, in which individual women worked at home on distinct steps of the quiltmaking process rather than completing a quilt from start to finish.[1] This method of production employed thousands of quiltmakers in cottage industries, allowing them to work part-time and fit quiltmaking around other domestic tasks.[2] An individual, usually the Amish or non-Amish owner of the business selling quilts, coordinated the individual workers and steps in the quiltmaking process. In Lancaster County's thriving quilt market during the late 1980s, a peak period for buying quilts, dozens of businesses employed hundreds of subcontractors, selling thousands of quilts per year.[3]

The mode of production contrasted with the typical way Amish women made quilts for their families' use, in which one woman may have completed the steps herself or invited relatives and friends for a quilting frolic to help finish the time-consuming quilting stitches.[4] At a frolic, many hands made quick work of the laborious quilting process. And the event doubled as a social occasion, with sisters and cousins chatting while they sat around a quilting frame rocking short, sharp needles through a quilt's layers. Shared meals, often prepared by teenage girls who had not yet refined their quilting skills, were

part of the daylong affair. Amish women remembered efficiently completing quilts by sharing the labor in this socially productive way.[5]

Quilt businesses opted to use the putting-out system rather than communal quilting frolics or a factory production setting because it seemed more efficient and resulted in higher quality products. Subcontractors working in their homes used their own equipment, including sewing machines, thimbles, and quilting frames, entailing fewer overhead costs for businesses. With quiltmakers specializing in specific steps, quilts were more uniform. This was particularly true when it came to quilting. When a quilt was stitched together at a frolic, one might find a variety of sizes and qualities of quilting stitches at various points on the quilt owing to the many hands contributing. According to one Amish entrepreneur, quilting stitches, like handwriting, have a distinct, recognizable style. Stitching from multiple hands on a single quilt produces a less uniform product. Entrepreneurs determined that a variety of quilting stitches resulted in an inferior quilt, although, ironically, multiple hands likely quilted many of the old quilts that collectors loved.[6]

A relatively small number of designers—some Amish, some non-Amish—determined the visual aspects of Amish-made quilts. In most quilt businesses, the employees doing piecework in their homes were not part of the creative process. Rather, a designer—often the business owner herself—instructed employees in what to make, whether it was a popular pattern like Country Bride, a quilt commissioned to match bedroom drapes, or one intended to look like an "old dark quilt."[7] There were exceptions to this generalization, however, since quiltmakers who demonstrated particular design skills were given some creative license.[8]

The job of Hannah Stoltzfoos—as well as of many other quilt entrepreneurs who operated their businesses in similar fashion—involved coordination: making sure the various steps in the process were fulfilled. Stoltzfoos acquired supplies from local and mail order sources, stocking her home workspace with an inventory of popular fabrics. She designed the quilts, choosing patterns and colors. One individual employee cut the fabric required for the design, another pieced the quilt, another marked it, another quilted it, and still another bound the edges to finish the piece. Businesswomen like Stoltzfoos coordinated the transportation of the quilt-in-process using UPS, horse and buggy, hired driver, or bicycle.[9] One owner described this process in 1987: "You don't take one quilt over to a neighbor to have it marked, you get a whole box full. Then there's twelve quilt tops that have to be bagged in separate bags and ready for the quilters."[10] Barbara Beiler of Strasburg, Pennsylvania, who had subcontractors quilting for her in Amish communities in Maryland and Missouri, explained, "We love the UPS man. He saves us a lot of trips to the post office."[11] Non-Amish business owners like the Delagranges handled transportation more directly. With no restrictions on driving cars, they picked up quilts and transported them to the next step themselves.[12]

Businesses operating on this model varied in size. Many started small, like Naomi Fisher's business, which in 1980 employed twelve to fifteen women quilting and five women piecing. Chris and Katie Stoltzfus's Country Lane Quilts also started small, with

Katie and her daughters initially doing most of the work in the mid-1980s. By 2008 she employed around two hundred women who specialized in piecing, quilting, or appliqué.[13]

Quiltmakers producing quilts to consign or wholesale to retail shops engaged in a similar process of specialization. This mode was sometimes less formal due to the absence of a controlling business owner coordinating the process. Family members frequently worked together on these quilts, with mothers, daughters, and sisters contributing to the various steps. One elderly Lancaster Amish woman stitched bindings onto quilts that her younger relative wholesaled to local quilt shops. Another elderly couple collaborated on quilts they sold; the husband cut and pieced the tops, they hired someone to mark the quilting designs, and then the wife quilted.[14]

Entrepreneurs who coordinated quilt production sometimes found dealing with a large network of home-based employees frustrating. One mused, "Every once in a while I'm tempted to piece a quilt, quilt it and sell it and not bother with anybody."[15] After coordinating subcontractors for many years, Ronks, Pennsylvania, quilt shop owner Marian Stoltzfus decided it was too much hassle and opted to sell locally made quilts on consignment from her home-based shop.[16] Another Lancaster County quilt shop owner made the same decision, telling scholar Beth Graybill, "It's just easier this way, fewer people to deal with," explaining that part of her decision stemmed from her inability to price the quilts she sold high enough to pay her subcontractors a decent rate.[17]

Most businesses paid their subcontractors a piece rate. Piecing—machine stitching fabric together to form a quilt's decorative top layer—usually was compensated with a flat rate per quilt. In 1980, Lancaster County Amish businesswoman Naomi Fisher paid her piecers $35 to $40, depending on the size of the quilt and number of fabric patches.[18] During 1981 and 1982, Amish Design paid slightly more, ranging from $40 to $60 per quilt depending on a pattern's complexity.[19] This rate continued to rise throughout the 1980s and 90s.

Many businesses paid quilters by the yard of thread used. This encouraged finer quilting stitches, which used more thread. Naomi Fisher supplied her quilters with thread, which came 250 yards to a spool. Her quilters used from 250 to 450 yards of thread per quilt. Most quilters interspersed quilting—a time-consuming task—with many other domestic activities, making it difficult to calculate an hourly wage. One particularly diligent quilter, Miriam Stoltzfus, estimated that she quilted eight hours a day and could complete a queen-size quilt in three weeks, if she "sticks to it." Using Fisher's and Stoltzfus's estimates, we can calculate an approximate hourly rate quilters earned. In the early 1980s, quilters netted an estimated 25 to 30 cents a yard, resulting in $75 to $135 per queen-size quilt, breaking down to an hourly wage of $.63 to $1.13 per hour. In 1987, Lancaster quilters earned 35 to 40 cents per yard, resulting in $87 to $180 per quilt, or $.73 to $1.50 an hour. In 1991, Missouri quilters charged as much as 50 cents a yard, bringing in $125 to $225 per quilt or $1.04 to $1.88 an hour. In the mid-2000s, some young Lancaster County Amish women who quilted during evenings after completing other tasks estimated that they earned $2.00 an hour.[20]

During the mid-1980s when the market for new quilts boomed in Lancaster County, a local journalist identified a "Quilters War," in which quilt shop owners lured away the best quilters from their competitors by offering a few more cents per yard.[21] Outraged businesswomen feared that they were in danger of pricing their quilts out of the market due to the increasing rates quilters demanded. "I just wish the ladies would realize it's better to work for a little less than have nothing to do at all. What I'm concerned about is that these quilts are going to be overpriced and nobody is going to buy them. . . . No use any of us getting greedy," one said.[22] In 1989 another quilter wrote in a column in an Amish newspaper: "We hear now again of paying 45 to 50 cents a yard for quilting. Where will it all stop? We need to be careful that we not price ourselves right out of the market."[23] These quilters earned far below the minimum wage, and bargaining for a few cents more per yard might boost one's hourly rate from $1.20 to a mere $1.31.

SELLING QUILTS

The retail price of a quilt depended on the amount of work that went into it. A sign hanging in an Amish-owned quilt shop in Strasburg, Pennsylvania, in 1992 read: "If you think our prices are high, go home and make a quilt then tell us what you'd charge."[24] Finer quilting stitches in intricate designs fetched more money than bigger stitches or less dense designs. Appliqué, a process requiring miniscule hand stitching, brought a higher price than pieced quilts, which were usually stitched with a sewing machine.[25] In 1980, one could purchase a pieced bed-sized quilt from a small Amish shop for as little as $150. In 1987, quilts ranged in price from $400 to $600. By 1992, many quilts were in the $600 to $800 range, with complex appliqué patterns going for as much as $1,600.[26] With so many Amish women regarding quiltmaking as a viable means of earning income amid their ongoing domestic tasks, the supply of new quilts began to flood the market by the early 1990s, and prices on many began to drop.[27]

Some quilt businesses—both Amish and non-Amish operated—retailed quilts consigned or sold to them by other makers. These shops provided an outlet for Amish quiltmakers to sell quilts without owning and operating their own retail businesses.[28] The Old Country Store in Intercourse, Pennsylvania, retailed consigned quilts, with prices set by the consignor. During the 1980s, Rachel Pellman worked as the manager of the store, one small part of the complex of shops, museums, and visitor center called The People's Place, owned by Mennonite entrepreneurs Merle and Phyllis Good.[29] "The store sort of prided itself on being a place where you could walk in and buy any quilt off the rack and it was going to be a high quality piece of work," Pellman recalled. "Local craftspeople would bring quilts in, and I would look at them and determine whether or not they met our quality standards." She remembered that sometimes she had to reject consignors' quilts due to quality issues, but she gave them feedback, explaining a way to alter techniques or materials in order "to make the next one acceptable."[30]

Shops selling wholesaled quilts or quilts on consignment were a place where non-Amish quiltmakers could also sell their quilts. When retail shops consigned or bought

quilts, they may not have known how many individuals worked on a given piece or even if the makers were Amish. This proved to be a liability, since rumors of quilts produced overseas and sent to Lancaster to sell abounded. Some shops stopped accepting finished quilts on consignment or wholesale, preferring to control the process and know exactly who did the work.[31]

During the peak market in the late-1980s, retail shops became wholesalers in their own right. Out-of-town quilt dealers frequented these shops, buying quilts for resale in shops across the United States and around the world. As one non-Amish quilt retailer observed of these nonlocal buyers, "The people found out they might be able to get a round trip ticket here, buy a motel room, spend a week in Amish Country, and pick out what they wanted for less than they could buy a quilt out there."[32] In the early 1980s, a California dealer bought quilts in Lancaster County for $300 apiece and took them home to resell for $1,000 or more.[33] This not only was a more economical means of supplying quilt shops distant from Amish settlements with inventory, but it also gave the quilts the added cachet of being "bought in the field"—in the heart of Amish country. Some Amish entrepreneurs grew bitter about the discrepancy in prices between quilts sold at their local shops and those sold in urban areas. In 1985 one complained, "I am ready to get out of the quilt business, because some of the buyers take our Amish-made quilts to big cities and triple their money."[34]

Quilts that did not meet the quality standards of retail shops often ended up at public auction, or what locals in Lancaster County often called "mud sales" because of the wet spring weather often accompanying the events. Wholesalers also sold quilts at these sales, with some of the profit often going toward a worthy cause, like the local volunteer fire company or a health clinic (figs. 10.1–10.2). In the mid-1980s the Gordonville Fire Company Auction in Lancaster County sold around three hundred quilts at its annual auction. This auction attracted local and out-of-town quilt entrepreneurs, eager to buy quilts for cheaper prices than those offered at retail shops. Other local Amish quiltmakers and entrepreneurs attended in order to see what quilts sold well. With hundreds sold in a day, these auctions sometimes resulted in a flooded market, with quiltmakers and auction organizers complaining about the low prices. Since the early 1990s, the New Holland Quilt and Craft Auction has occurred every two months, selling quilts and quilt tops. Quilt retail shop owners and wholesalers have attended, buying finished quilts and quilt tops at bargain basement prices to supplement their inventories.[35]

In recent years, Amish quiltmakers have gained another outlet for selling their quilts: the Internet. Non-Amish businesses have operated websites, functioning on a model similar to retail stores selling or consigning quilts. While Amish businesses have not owned their own websites or computers since Amish church districts banned computer ownership in the mid-1980s, they have benefited from access to this technology and to the non-Amish entrepreneurs who enable them to sell goods online. Just as Internet marketing has expanded the consumer base for all sorts of businesses, it has been a boon for Amish entrepreneurs selling a variety of products. One such business,

Figure 10.1. Quilts on display at the Gap Fire Company mudsale, Spring 2011.

(Photograph by Nao Nomura)

Figure 10.2. Quilt at auction at mudsale, Spring 2011.

(Photograph by Nao Nomura)

the "Authentic Amish Store" has the tagline "helping the Amish and the 'outsider' to come together through the internet," and the stated goal of helping "the farmers sell Amish quilts and Amish crafts . . . without offending the church or their religion."[36] This technology has certainly helped Amish quiltmakers market their old-fashioned craft of quiltmaking to a larger audience than is possible by hanging a "Quilts for Sale" sign at the end of the lane. Internet sales of Amish quilts show the paradoxical nature of contemporary Amish quilt businesses: Amish quiltmakers maintain the "old-fashioned" tradition of crafting quilts through entirely modern (and worldly) processes, including the act of online shopping.[37]

CHANGING AMISH LIFESTYLES

In a society in which women have historically played important but always subordinate roles, quilt businesses have influenced Amish life in much more than just economic ways. Although businesses selling Amish quilts were quick to market them as traditional objects crafted just as they had been one hundred years earlier, much about Amish life has changed since women in the church began making quilts in the late nineteenth century. The growth of Amish-run businesses within numerous Amish settlements is, according to scholar Donald Kraybill, "the most profound and consequential change" to the Amish lifestyle since their arrival in North America in the eighteenth century.[38] Quilt businesses, which capitalized on outsider interest in a traditional craft, have been a key part of this transformation, particularly in their impact on women. Amish women either managing the production and retailing of quilts or laboring on piecework provided Amish families with new forms of female-generated income, and this in turn contributed to new patterns of gender relations within individual families and Amish society as a whole.

Prior to the 1960s, when the majority of Amish families still farmed, wives contributed to the economic livelihood of the family by milking, collecting eggs, tending vegetable gardens and lawns, in addition to household tasks such as child care, cooking, food preservation, and sewing. Amish men acknowledged the importance of women's work on the farm and in the household.[39] Farm income—earned through the collective work of parents and their children—was the norm within Amish communities.

But during the past thirty or so years, fewer and fewer Amish families have earned their primary income from farming, with many husbands finding work outside the home in non-farm industries such as machine shops and mobile work crews like construction or masonry. In the Lancaster County settlement in 2009, almost all women, married or unmarried, worked for pay in some capacity, either running their own businesses or, more often, doing piecework at home, usually in addition to traditional domestic tasks.[40] Whereas farm income was shared income earned through shared labor, husbands and wives now both contributed in distinct ways to family livelihoods.[41] Scholars have only begun to study how these changing employment patterns have affected gender relations within Amish society.[42]

For the thousands of Amish women who fitted steps in the quiltmaking process—piecing, quilting, marking, or binding—around ongoing domestic tasks, there was little disruption to the prevailing division of labor emphasizing traditional gender roles. But these women gained income—even if it was only a modest amount—that was theirs to spend or save. Some women felt more control over money from quiltmaking than they did over income their husbands brought in from non-farm labor.[43] One of Amish Design's employees chose to buy a cow with the money she brought in quilting, and expressed satisfaction in her ability to do so.[44] Scholar Beth Graybill suggests that contributing to family income was a means of reestablishing "the rough gender parity of the family farm": earning income allowed women to reassert their role as producers within the post-farming context of Amish culture.[45]

In contrast to women who engaged in piecework, female entrepreneurs who owned quilt businesses had less time for other domestic tasks yet contributed a more significant amount of money to their families' incomes and resources to their community at large. Women have helped finance trips to visit family members in distant states or winter vacations to the Amish settlement in Pinecraft, Florida.[46] One Amish woman surmised, "A woman's income could never buy a farm. But it helps."[47] Some of the larger quilt businesses even provided the family's primary income rather than what Amish call a "sideline," or supplemental income. Some entrepreneurs became so successful that they employed husbands, serving as a true family enterprise much as farming did in the past. Such businesses also employed children, who often waited on customers at a home-based shop in addition to helping with other domestic tasks.[48] When a woman's business was especially successful, her children and community members began to turn to her for leadership in a way that had historically been reserved for Amish men. One woman's children came to her rather than their father when they needed money. Another female entrepreneur gave community members loans to start their own businesses.[49]

Like women in mainstream society who began working outside the home in greater numbers during the last decades of the twentieth century, Amish businesswomen have also struggled with the balance between home and work. Home-based quilt shops sometimes pulled mothers away from children in ways that farming did not. One entrepreneur expressed the ambivalence: "Who comes first—your children or your customers? Well, of course the customers come first, but they shouldn't, or should they? When a woman has her children waiting on her, she's torn between the two."[50] Reflecting on years in business, another quilt shop owner asked herself, "Did I put too much into the business and not enough into the family?"[51]

Another unanticipated outcome of the growth of Amish quilt businesses has been continued quiltmaking. During the mid-twentieth century, many Amish families began buying store-bought bedspreads to give to their children rather than homemade quilts. "It was the time of bedspreads," recalled one Amish woman.[52] A fifty-dollar comforter or chenille spread often seemed a better option than a handcrafted quilt labored over for many hours. When outsiders became interested first in old Amish quilts and then in

new ones intended for sale, Amish women were inspired to make more, selling many but also keeping some for home use. Some outside observers have considered Amish quilts made for the consumer market or differing from the old dark variety as a degradation of tradition.[53] Rather, it has prompted women to once again make quilts for their own children, exhibit newfound creativity by using a variety of fabrics and patterns, supplement—if not supplant—their families' incomes, and keep the practice of Amish quiltmaking alive.

CHAPTER **11**

THE

AMISH BRAND

In 2009, well past the peak of the Amish quilt market, the satirical newspaper *The Onion* published a short article under the headline, "Amish Woman Knew She Had Quilt Sale the Moment She Laid Eyes on Chicago Couple." Datelined Lancaster, Pennsylvania, the fake news story quotes the protagonist, Mary Stolzfus: "One look and it was 'Choo choo! Here comes the money train, right on schedule.'" The proprietor ordered her daughters to "put on a little dog and pony show," singing in German and otherwise "performing Amishness" to the outsiders. Stolzfus goes on to say, "Give 'em a little 'no electricity' this, and some 'butter churn' that, and cha-ching, you've got enough barn-raising money to last you a month."[1] While a news parody provides no evidence of actual events or practices and plays upon stereotypes rather than nuance, this article suggests that by the twenty-first century, the notion of an Amish woman marketing quilts by performing her own culture was a joke that readers should get. As with most *Onion* articles, readers understood the satire because it contained a grain of truth. Amish businesses—as well as non-Amish businesses—have successfully marketed quilts by promoting stereotypical aspects of Amish culture. In reality, as well as in *The Onion*, quilts' perceived Amish origins—stitched by kerosene lantern light by women sitting around a quilting frame using age-old patterns—were a significant selling point for new Amish quilts made for the consumer market.

Just as Mary Stolzfus's fictional shop did, real Amish and non-Amish enterprises marketed quilts by banking on consumer fascination with the religious group and a growing understanding that when it came to quilts, Amish ones were best. This "branding" originated with the 1970s art and fashion world's obsession with "old dark quilts," but it morphed into a catchall category for various styles of quilts made by small Amish businesses targeting tourists visiting "Amish Country," by boutique quilt producers like Ohio-based Amish Design, by mail order companies, including Lands' End, and by multinational corporations outsourcing quilt production to offshore factories. Many of the quilts marketed with the "Amish" brand bore little resemblance to the ones that hung on gallery and museum walls. Although it was not a brand in the legal sense, consumers understood "Amish" as they did other trusted brand names; to consumers, "Amish" signified quality, authenticity, and tradition. By emphasizing quilts' Amish origins in advertising materials, providing tourists visiting home-based shops with a taste of Amish life, and highlighting stereotypes of Amish culture—kerosene lighting,

traditional home-cooked meals, horse and buggy travel—diverse businesses marketed with the Amish brand.

BEFORE THERE WERE AMISH QUILTS

The businesses that created a thriving industry and market for new Amish quilts had a precedent in similar enterprises where "outsider" groups adapted and marketed crafts to sell to consumers and in earlier industries aimed at reviving craft traditions as a means of economic empowerment. Products of ethnically, culturally, or religiously based industries like Shaker chairs and Navajo blankets likewise used identity affiliation as a branding technique. Amish entrepreneurs likely were not drawing inspiration from earlier businesses, but a certain subset of consumers had long valued buying products from family businesses, from groups outside of the dominant American culture (frequently as part of tourism), or as a means of keeping old-fashioned traditions alive.

As early as 1790 the Shakers—a communally organized religious group—had established industries targeted at consumers outside their faith as a means of sustaining their communal existence. The first such industry was likely the propagation of seeds for sale, an endeavor followed by craft industries producing various wooden vessels, including iconic Shaker oval boxes. By the late nineteenth century, Shakers also crafted furniture and clothing for the outside market. These industries relied on "Shaker" as a brand; they linked religious identity with quality, referring to their products as "Genuine Hand-Made Shaker Cloaks" and "Genuine Shaker Chairs." In the late nineteenth century, one Shaker trustee applied an ornamental trademark to furniture so that consumers would know that they were purchasing genuine Shaker products rather than the growing number of imitations. Shakers developed products desirable to a consuming public as an economic means of maintaining boundaries from the outside world, prefiguring Amish cottage industries developed in the late twentieth century.[2]

Iroquois women beaded whimsies, Navajo women wove blankets, and Pueblo women turned pots to sell to tourists, collectors, and other urban consumers beginning in the late nineteenth century. The traders and ethnologists who initially bought these crafts helped establish a consumer market for Indian-made objects and encouraged cultural production among these artisans, who increasingly tailored crafts for the growing market.[3] Anglo traders often played a key role not only in marketing but also in design. For example, traders supplied Navajo weavers with patterns popular with collectors and discouraged them from using chemically dyed wools in favor of natural dyes, which collectors deemed more "traditional."[4] The vital aspect of these products was their Indian origins, which served as a brand name.[5]

Some twentieth-century cottage industries had goals beyond making products to sell; their founders envisioned craft making as a means for revitalizing communities and preserving traditions. In Appalachia during the 1920s and 30s, northerners with both philanthropic and financial motives established programs intended to revive and preserve Appalachian traditional crafts by teaching local people craft making skills and

by marketing the resulting products to middle-class consumers.[6] Art historian Glenn Adamson has called such paternalistic projects "craft missionary work" because they aimed to teach the "simple folk" of Appalachia skills that would bring "proprietary, prosperity, and Christianity to the backwards population of the Southern Highlands."[7] The women who founded guilds and settlement schools taught locals to make handicrafts that appealed to urban consumers. They established artistic standards and implemented savvy marketing techniques, instructing artisans, "You don't have to make it like you like it—you have to make it like the person who buys it likes it."[8] The baskets, pottery, coverlets, furniture, and other objects designed by educated, middle-class women and crafted by Appalachian artisans found an eager market of consumers who valued them as authentic products made by true American "folk."[9] Here, "Appalachian" served as the brand name.

These consumer sentiments reemerged in the 1960s with a new Appalachian craft revival, this time led by young Americans working as part of Volunteers in Service to America (VISTA, designed as a domestic Peace Corps) and Appalachian Volunteers (AVs), both groups funded through the Johnson administration's War on Poverty. Among the many projects these volunteers—predominantly white middle-class college students—helped to establish were craft guilds and cooperatives that marketed products, including quilts, to consumers outside Appalachia.[10] Through connections with influential politicians and tastemakers, quilting cooperatives, including Grassroots Quilting Co-op, Cabin Creek Quilters, and Mountain Artisans, found markets outside of Appalachia eager for their quilts. These enterprises often received product development advice from outsiders such as fashion designer Dorothy Weatherford, who assisted Mountain Artisans, helping design quilts that appealed to urban consumer taste and were marketed with the "Appalachian brand."[11]

MARKETING "AMISHNESS"

Like Shaker, Navajo, and Appalachian craft enterprises before them, Amish quilt businesses recognized that their identity was part of the appeal. Consumers perceived these religious and ethnic associations as seals of authenticity, guarantees that the products were well-crafted from old-fashioned designs and were contemporary heirs to long-standing traditions. A quilt's genuine Amish origins signaled to consumers that what they were buying was the real deal, an alternative to a mass-produced, store-bought bedspread and a substitute for the quilts their own grandmothers never made them.

Businesses that retailed quilts or other crafts had a particular appeal to tourists because visitors perceived Amish merchandise—whether or not it was actually Amish-made—as being of high quality and value.[12] A 1993 survey of two hundred visitors to Lancaster County, Pennsylvania, regarding the public perception of Amish products revealed that a high percentage of tourists considered Amish products higher in value, artisanship, quality, and uniqueness than non-Amish products.[13] Another survey, directed at tourists visiting Shipshewana, Indiana, in 2000, similarly found a majority

of respondents willing to pay more for Amish-made products because they were "quality and homemade."[14]

These perceptions, rooted in late-twentieth century nostalgia for an imagined past, viewed cheap plastic and imported goods as artificial. In contrast, Amish products seemed more "authentic," even if this perception stemmed from idealized notions of Amish culture. Perceived incorrectly by outsiders as immune to the pressures of consumer society, the Amish seemed to make things with more integrity because they lived with more integrity.[15]

Amish and non-Amish businesses alike promoted the "Amishness" of quilts as a selling point. By associating quilts with simplicity, tradition, and fine craftsmanship, retailers attracted consumers eager to buy what they considered an authentically old-fashioned product imbued with the qualities of Amish life they most admired. More than with other Amish products like gazebos, pedigreed dogs, or heirloom tomatoes, the Amish brand was a vital attribute when it came to quilts.[16] Whether marketing to tourists visiting family-owned shops, to interior designers buying quilts to hang in office spaces, or to millions of middle-class Americans through mail order catalogs, businesses capitalized on the Amish identity of the makers who labored away on quilts.

SELF-PROMOTION

Tourists have been making trips to see the Amish in Lancaster County since the 1940s when the Pennsylvania Turnpike opened. Beginning in the 1950s and 60s tourists ventured to Amish settlements in Ohio and Indiana.[17] A few Amish families participated in the early tourism industry, hosting meals in their homes, selling ice cream from their farms, or welcoming tourists to furniture or carriage shops that catered to their core-ligionists. Non-Amish entrepreneurs who published travel guides, led tours through Amish country, or booked meals in Amish homes usually mediated these encounters. But this changed as Amish entrepreneurs started their own businesses catering to tourists. Donald Kraybill explains that with the growth of small roadside stands and other shops selling goods targeted to tourists in the 1980s, the Amish "bypassed the tourist industry."[18] More accurately, they joined the tourist industry. Their new businesses were part of an ongoing process, which Kraybill calls "cultural bargaining," by which the Amish have negotiated their relationship to the outside world. Amish culture has slowly changed over the years; gradually, the cultural fences separating the Amish from mainstream society have shifted to the point where Amish-run businesses catering to tourists became a culturally viable and economically important option.[19]

Although the Amish emphasis on humility has made some Amish businesses hesitant to promote the "Amishness" of their products or businesses by referring to their shops as "Amish owned" or using stereotypical Amish imagery in advertising, many quilt entrepreneurs have willingly promoted their shops as Amish.[20] They found that "Amish" served as an essential descriptor when it came to marketing quilts, significantly raising their value. As early as 1980, Amish-owned businesses promoted "Hand-

made Quilts Made by the Amish."[21] Throughout the 1990s, Amish-owned quilt shops continued to market their businesses using the Amish brand in advertisements in free newspapers targeted to tourists. Ads announcing "Buy Right off an Amish Farm" and "Visit Our Farm for Quality Amish Quilts and Crafts" encouraged visitors not only to buy a quilt but to experience a real Amish setting.[22] Other Amish quilt businesses clued in potential consumers to the Amish brand in less overt ways, using the key tagline "No Sunday Sales," references to farmhouses, or the terms "locally handcrafted" or "Plain People" as implicit means of marketing with the Amish brand.[23] These proprietors had good reason to identify themselves as Amish, for growing competition from non-Amish enterprises selling quilts—sometimes imported ones—were a threat to their businesses. Amish entrepreneurs knew that when it came to quilts, customers were willing to pay extra for ones guaranteed to be Amish-made.[24]

Consumers visiting quilt retailers in Lancaster County sought not only quilts but a tourist experience in which they could glimpse authentic Amish life. If they merely wanted quilts, there were easier ways to buy them. They wanted to see a real Amish home, watch a real Amish woman quilt, and perhaps even buy a real Amish quilt. Amish entrepreneurs operating retail outlets recognized that the experience was part of their product, and some endeavored to provide tourists with the imagined "Amishness"—the authenticity—they sought. The tourism industry was complicit in providing visitors with this experience. For example, tour buses bypassed a particular Amish quilt shop because it was located in a less rural area rather than on a "real Amish farm," whereas another farm-based business greeted busloads of tourists daily during peak tourist season because "people like to get out on the farm."[25]

One Amish businesswoman performed "Amishness" by staging a "live quilting" for the bus tours that regularly visited her rural quilt shop located on her family's farmstead. She stationed herself at a small quilting frame with a pre-printed quilt depicting a bucolic Amish scene with buggy and barn. When tour buses arrived at a prearranged time, she was in the midst of quilting. "Tourists like to find me at it," she explained. Such a quilt top—referred to as "cheater cloth" by quiltmakers and the quilt industry because it gives the appearance of piecing or appliqué without any of the effort—was the antithesis of a hand-stitched quilt in a non-figured pattern that potential customers may have imagined. Yet such staging helped create an experience these visitors would perceive as authentic. Once the tour group entered the shop, she made a show of lighting the kerosene lanterns hanging overhead, allowing the tourists to experience a bit of electricity-free Amish life.[26] Other proprietors also promoted their businesses with "live quilting": the 1994 brochure for Zook's Handmade Quilts and Crafts in Strasburg, Pennsylvania, read, "The Zook women, in fact, can often be found quilting in the shop."[27]

Consumers regarded experiences like those in this shop as authentic because of elements like the quilting frame and kerosene lanterns, the setting in which they imagined Amish quilts were made. A *New York Times* reporter cited one shop's "homey trappings," including a woman stirring soup in an adjacent kitchen, as evidence of the authenticity of the quilts.[28] The domestic setting suggested that quiltmaking was a regu-

lar activity in an Amish household, a perception that emphasized quilts' origins within a traditional, hardworking society and downplayed the reality that these were commercially produced commodities.

Visits to quilt shops adjacent to Amish homes were one of a few means through which tourists could glimpse a real Amish home and interact with Amish people.[29] Businesswoman Rebecca Esh recalled that her customers gawked at her living space when they came into her home-based shop.[30] One consumer who has bought quilts in Ohio's Amish country commented that in addition to shopping for quilts, "we love to chat with the Amish ladies."[31] Many became repeat customers in part because they valued building a relationship with Amish entrepreneurs. One businesswoman recalled that a couple from New York bought as many as a dozen quilts from her over the years. She theorized that her repeat customers kept coming not just for the quality quilts but also for what she called the "personal touch": one-on-one attention. This entrepreneur recognized that part of the appeal of buying quilts in her shop was that she prioritized "special time with [her] customers."[32] Describing her favorite Ohio quilt shop, a repeat customer commented that it "feels the most 'authentic' in that the people working the store are Sarah (the owner) or her daughters."[33] To consumers like this, the Amish brand signified not only quality quilts but a certain type of shopping experience: buying quilts directly from Amish women in an Amish environment. Tourists in turn purchased quilts or other objects crafted using quiltmaking techniques, such as potholders or pillows, as souvenirs of their experience.[34]

ROMANTICIZING THE AMISH

When non-Amish businesses marketed and retailed Amish quilts, they too emphasized the Amish origins of their products. But these businesses could not rely on tourists' intrigue with experiencing real Amish people in a real Amish setting. Retailers had to convince consumers that what they sold was authentically Amish despite the absence of a genuine Amish setting. One non-Amish proprietor of a shop in Adamstown, Pennsylvania, recalled a customer begging, "Please tell me an Amish woman made it."[35] Some businesses guaranteed it. Mercer & Bratt Amish Quilts mail order materials read: "The Mercer & Bratt label, sewn onto the back of each quilt, is our guarantee that your quilt is completely authentic: made by Amish people in their own tradition (and in their own living rooms)." Almost Amish, an Internet retailer, will supply upon request a Certificate of Authenticity with their products that are Amish-made.[36]

Non-Amish businesses accentuated to the point of romanticizing aspects of their quilts they hoped consumers would identify as quintessentially Amish: craftsmanship, authenticity, and simplicity. The Old Country Store's 1979 "Quiltalog" advertised a Sunshine and Shadow quilt, emphasizing that "both the pattern and people have about them a simplicity, a starkness, a strength." In its 1984 brochure, Country Quilt Shoppe of Middlebury, Indiana stated, "The product of painstaking attention to minute details, each quilt reflects the values treasured by the Amish—simple beauty, unity and utility."

Handmade Amish Quilts, a Peterborough, New Hampshire, mail order company based far from Amish settlements, hired Amish women across North America to make its products. With nostalgic language, the catalog promoted its quilts as made in a different world, far removed from modern society: "In a land of quiet and rare simplicity, beyond the hurry and confusion of cities and highways, live the Amish. . . . Untouched by technology, they live and farm as their ancestors did 300 years ago. All-but-forgotten skills flourish here, best seen, perhaps, in the hand-made quilts for which the Amish have become famous."[37] Ironically, one of the main reasons Amish participated in businesses making new quilts was that they no longer farmed as their ancestors did, and they worked in cottage industries as a way of replacing farm income.

With the success of the Amish brand of quilts, corporations selling home furnishings also wanted a piece of the market. Lands' End, the mail order retailer, commissioned a series of Amish-made quilts that it sold in its catalogs during the late 1980s and early 1990s. In 1989 Amish women, along with a few non-Amish quilters, completed one hundred limited edition king-size quilts that Lands' End sold in their catalog for $800 apiece. The company celebrated the quilts as preindustrial goods rather than as products of complex design, production, marketing, and distribution processes. Lands' End, which employed both Amish and non-Amish women to make its 1989 Christmas Quilt, acknowledged only the Amish contributions in an effort to accentuate the product's old-world origins. Its Holiday Catalog read: "We all agreed that the quilt looked beautiful. The colors we chose worked well. But the best thing of all about our quilt was the people who were making it." "The people" referred to were Amish quiltmakers from Holmes and Wayne Counties in Ohio, not the non-Amish Lands' End employees who designed the quilt, the non-Amish seamstresses who also pieced and quilted, or Deb Murphy, the local entrepreneur who coordinated the process. The promotional photo appearing in the Lands' End catalog appeared to be an older Amish woman, presumably Sara Yoder, who ran the successful Lone Star Quilt Shop, described as "the Driving Force Behind the Lands' End Quilt." In fact, Yoder, like most Old Order Amish, refused to have her photograph or that of her daughter taken, so Murphy's non-Amish mother and daughter stood in, wearing the Yoder family's garb and posing in the Yoder house. Rather than picture any of the non-Amish seamstresses who helped and who had no prohibition against photography, Lands' End opted to highlight the "Amish brand," even if it was simply playing dress-up.[38]

By obscuring non-Amish contributions, Lands' End marketed its limited edition quilts as products of an earlier time. The catalog text emphasized that the product was stitched by the light of kerosene lanterns, delivered by horse-drawn buggy, and quilted as a form of entertainment. The key to the Christmas Quilt's promotion was the identity of its makers—or at least those Lands' End chose to promote: the Amish ones. The quilt's appearance—a popular contemporary pattern featuring a striking star on a light-colored ground—was less important to the product's branding than the Amish women involved in its production. Lands' End knew that a quilt's genuine Amish

origins signaled to consumers that what they were buying was of high craftsmanship and authentic design.

Both consumers and entrepreneurs understood the Amish brand as a selling point for goods made or sold in Amish communities. In order to survive economically in a period when farmland was often too expensive for many families to purchase, home-based industries catering to outsiders provided a welcome alternative to both farming and working outside the home. The increased interaction with the outside world that many small businesses have necessitated has significantly changed the way the Amish and outsiders have related to one another.[39] This interaction has been a two-way street. Non-Amish consumers wanted Amish-made goods, especially quilts, and often asserted their preferences as consumers to influence product design. Amish businesses went against the grain of their espoused tenet of humility to promote the "Amishness" of their products, recognizing that their religious affiliation might help make a sale. Non-Amish businesses also capitalized on perceptions of "Amishness," romanticizing Amish traditions so they too could make a sale.

Alongside its inventory of quilts and other patchwork objects, Riehl's Quilts and Crafts sold what they labeled an "Amish Flashlight": a kitchen match glued to a small pocket-sized piece of wood. The irony of the product is that Amish have no need for such a tool, since battery-powered flashlights fit perfectly into the accepted practice of using technologies that do not require access to the high-wire electrical grid.[40] But the proprietors recognized that the product would sell because of its perceived association with Amish culture even if they intended it as a joke. The flashlight reminded consumers that the Amish lived a distinct lifestyle, keeping modernity at an arm's distance. The quilts Riehl's sold functioned in a similar way. Handmade quilts—no longer a staple in every Amish home since many preferred to use store-bought bedspreads—symbolized Amish tradition to consumers, even if they were based on popular published patterns and featured trendy printed fabrics. The Amish did not need quilts or Amish flashlights in their own homes, but they were happy to sell them, reinforcing perceptions of "Amishness" in order to earn a living.

CHAPTER **12**

OUTSOURCING
AUTHENTICITY

The term "Amish" functioned like a brand name, adding value to quilts by signifying quality and authenticity, but unlike a trademark, whose owner can legally prevent unauthorized use of the name, "Amish" was free for anyone to use, no matter what product they sold. When it came to selling quilts, "Amish" turned into an adjective that at times had nothing to do with who made the product. In an age of globalization, "Amish" unexpectedly became a descriptor for products made far from Amish country, in Chinese factories and Thai refugee camps. As businesses making Amish quilts to sell to consumers found success, enterprises seeking a piece of this market found a new, low-cost labor force—non-Amish needleworkers both in the United States and abroad—a reality that eventually undercut consumers' ideals of authenticity and shifted the monetary value of all quilts downward.

The process that I have just described is called "outsourcing," a term used to describe contemporary practices in the manufacturing or information technology fields of obtaining goods or services by contract from outside sources. Amish and Mennonite businesses outsourced quiltmaking labor to Hmong seamstresses; multinational corporations outsourced production to overseas factories; and Hmong seamstresses in the United States outsourced needlework to impoverished families in Thai refugee camps and villages. The end results were a flooded market for so-called Amish quilts not made by Amish quiltmakers, declining quality and prices for many of these quilts, and consumer mistrust of the Amish brand.

HMONG NEEDLEWORK

By the early 1980s, quilts made by the Amish had found a market niche. The design repertoire of Amish quiltmakers had expanded as appliqué patterns such as "The Country Bride" attracted consumers seeking quilts in Amish communities. Demand was high, and not enough Amish seamstresses were skilled at the hand stitching required for intricate appliqué quilts. Luckily for Amish quilt businesses, the Hmong, new residents to the Lancaster County area, had the necessary sewing skills, experience selling their own textile arts, and a knack for learning and adapting others' cultural practices.

The Hmong are a minority ethnic group, historically based in the areas of present-day China, Vietnam, and Laos, with a tradition of fine needlework skills. Hmong women

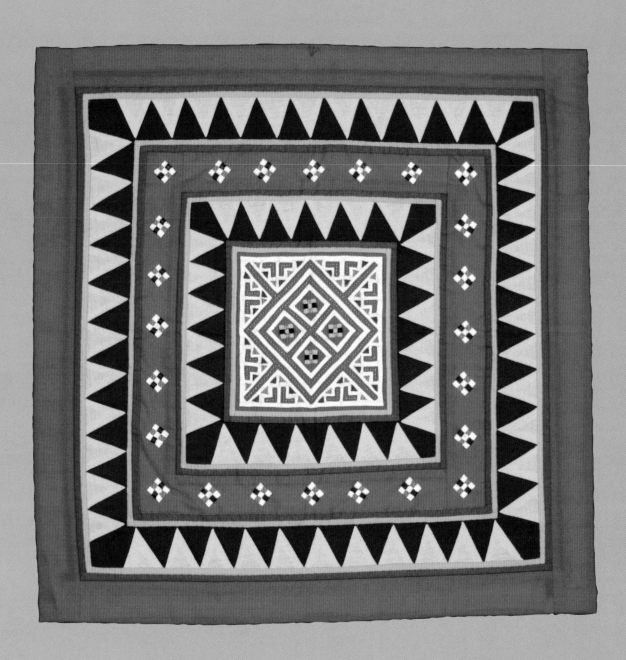

Figure 12.1. Hmong *paj ntaub*
(flower cloth), by Nang Vue.
Lansing, Michigan. Cotton/
polyester, reverse appliqué,
appliqué, and embroidery.
17.75 x 17.75 in.

(Courtesy of Michigan State University
Museum, 5842.7.4)

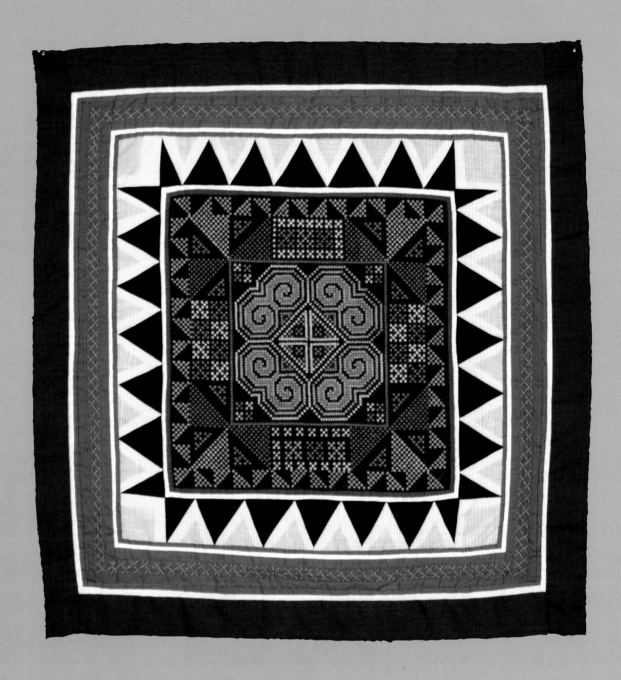

Figure 12.2. Hmong *paj ntaub* (flower cloth), by Mai Vue. Lansing, Michigan. Cotton/polyester, monk's cloth, cross-stitch, appliqué, and embroidery. 16.38 x 15.75 in. (Courtesy of Michigan State University Museum, 5842.17.2)

Figure 12.3. Hmong in traditional dress, Bac Ha Market, Vietnam, 2010.

(Image licensed by Attribution-NonCommercial 2.0 Generic Creative Commons license. Photograph by flickr.com user avlxyz)

had long decorated ceremonial clothing, baby carriers, and funeral accouterments with embroidery, appliqué, and batik, three textile practices collectively known among Hmong clans as *paj ntaub* (pronounced "pa ndau" and translated as "flower cloth"). While practices among various Hmong clans differed, they shared precise geometric forms, fine detailed stitching, and bold coloring (figs. 12.1–12.3). Traditionally, young girls learned *paj ntaub* techniques from watching their mothers, developing appliqué

and embroidery skills along with abilities of manipulating symmetry, proportion, and color.[1]

Hmong refugees began immigrating to the United States in 1975, following the end of the Vietnam War. As part of U.S. involvement in Southeast Asia in the years leading up to and during the Vietnam War, the United States had provided financial and logistical support to what has become known as a "CIA Secret Army" consisting of Hmong and other minority groups from the highlands of Laos who fought against the regions' communist armies, including the North Vietnamese. When the communist government declared victory in Laos in 1975, just as the U.S. military left the region, the Lao People's Democratic Republic began to target Hmong people, rounding them up into concentration camps because they had fought on the side of the Americans. Many Hmong attempted to escape Laos by crossing the Mekong River into refugee camps in Thailand. Many died trying. From these camps, Hmong refugees awaited asylum, with tens of thousands resettling in the United States during the late 1970s and 80s. Other refugees found asylum in Canada and Western Europe, although many have continued to live in Thai camps.[2]

In the refugee camps, Hmong came to rely on their traditional textile art as a primary source of income. They were accustomed to outsider interest in *paj ntaub*, having sold it to French colonials in the 1940s and to American governmental advisors and missionaries working in Laos during the 1950s and 60s. During the 1960s, prior to the mass exodus of Hmong refugees from Laos into Thailand following the Vietnam War, a few nonprofit and Thai government-sponsored agencies began marketing various arts made by hill tribes including the Hmong. With the establishment of refugee camps in the 1970s, aid agencies and missionary groups cultivated craft production among Hmong refugees in hopes that outsider interest in *paj ntaub* might provide families with a modest supplemental income. Aid groups then brought *paj ntaub* to urban markets in Thailand and exported pieces across the globe.[3]

Christian and Missionary Alliance (CAMA), an international aid organization, established Camacraft in 1976, tasked with developing "self-help" projects that refugees could work on to earn income while living in Thai camps. A few entrepreneurial Hmong had made their own efforts at selling textile pieces to camp workers and the occasional Thai tourist. But the American founders of Camacraft were convinced that Hmong seamstresses needed assistance with product development, and they advised them to craft objects familiar to Westerners like aprons, potholders, coasters, and Christmas ornaments. Some Hmong women had already begun making bedcovers by stitching together squares of *paj ntaub*, separated by strips of cloth much like an American-style quilt. Camacraft encouraged production of this form, instituting standardized sizes it hoped would appeal to Western consumers. Camacraft marketers also dictated what colors and fabrics Hmong women should use in these pieces, suggesting color palettes they thought would be pleasing. Hmong women of different clans living in the camps learned from one another and integrated new techniques and designs, priding themselves on being able to quickly adopt new techniques and styles. In a practice that

parallels the way Amish women chose quilt patterns to make for the consumer market, designs that sold well soon spread among the Hmong seamstresses working in refugee camps.[4]

Church organizations sponsored many of the first Hmong refugees to the United States. In 1978 the Mennonite Central Committee—the relief, service, development, and peace agency of the Mennonite and Brethren in Christ denominations—began resettling Hmong refugees in the United States and Canada, with thirty families finding new homes in and near Lancaster County. Other Hmong families resettled in nearby Philadelphia. Sizeable Hmong communities were established near Minneapolis, Minnesota, and Fresno, California, with smaller pockets in Michigan, Rhode Island, Washington, Wisconsin, and elsewhere. As Hmong immigrant communities grew, with individuals becoming naturalized U.S. citizens, kin remaining in refugee camps were also able to emigrate.[5]

With poor English language skills and little transferable work experience or education, Hmong immigrants faced a difficult adjustment to life in the United States. Making *paj ntaub* to sell naturally emerged as a viable means for Hmong women to contribute to their families' meager incomes, a practice they could fit in around other domestic responsibilities within their patriarchal society.[6] Hmong immigrant communities in Minnesota, Washington, Rhode Island, Michigan, and California quickly organized cooperatives and associations, often with the guidance of women volunteers from sponsoring church or aid agencies, that helped build consumer markets for *paj ntaub*. But those living in southeastern Pennsylvania soon realized that a thriving market for handcrafted textiles already existed. Rather than shoehorn their own *paj ntaub* tradition into the established marketplace, some seamstresses decided to adapt their skills to fit the booming market for quilts.[7]

As Hmong women in the Lancaster area recount, in the early 1980s one seamstress learned, perhaps from an Amish or Mennonite friend met through a local church sponsorship, how to construct the types of quilts local shops sold. When she started earning money for her fine appliqué skills, friends and relatives wanted to learn the practice too.[8] Amish businesses had no qualms about hiring these newcomers to the community. As one quilt businesswoman said, "We're all God's creatures. I'll take a chance with anyone."[9] The reverse appliqué technique Hmong women used to make *paj ntaub* was easily adaptable to the new sorts of appliqué quilts sold in Lancaster County's many quilt shops (fig. 12.4). Hmong women in fact found making quilts easier than *paj ntaub*, since the technique was less intricate.[10]

As Hmong women's reputation for fine appliqué work spread among Lancaster County quilt shops, these seamstresses found more and more work available to them as part of the complex putting-out system crafting thousands of quilts for the consumer market.[11] By one estimate, Hmong women living in southeastern Pennsylvania and their relatives in Asia did 99 percent of the appliqué work sold in Lancaster County shops by 1987.[12] When scholar Sally Peterson remarked to an Amish proprietor of a Lancaster quilt shop that she could not tell the difference between the work by Amish

Figure 12.4. Appliqué quilt top by Thor Yer, 1993. This Hmong quiltmaker used an appliqué pattern popular among Amish quilt shops.

(Courtesy of Michigan State University Museum, 7538.1)

and Hmong seamstresses, the businesswoman responded that the Hmong work was much better. Hmong quiltmakers also were faster stitchers than their Amish and Mennonite counterparts. Peterson found that some particularly skilled Hmong women strived to finish quilts from start to finish—including cutting, piecing, appliquéing, and quilting—within a week, a pace most Amish women did not attempt. Like their Amish counterparts, most Hmong quiltmakers earned far below the minimum wage, but they preferred sewing to factory work, the alternative employment for many. Hmong quiltmakers liked working at home, the flexibility of fitting quiltmaking around other activities, and involving both children and grandparents in the activity.[13] According to some estimates, by the late 1980s nearly all Hmong women in the Lancaster County area worked on quilts for the consumer market.[14]

Making quilts paid better than making *paj ntaub*, and Hmong women considered quilts less laborious than their traditional needlework. Furthermore, with the already thriving market for Amish quilts, Hmong seamstresses had little economic incentive to establish a local market for *paj ntaub*. In 1989 a journalist reported that one Hmong woman earned $250 a day marking quilting designs on appliqué quilts at $25 apiece. In contrast, another woman stitched *paj ntaub*, rather than quilts, spending a week working on an intricate wall hanging she hoped to sell for $25.[15] For this reason, many southeastern Pennsylvania Hmong seamstresses had all but abandoned working on *paj*

Figure 12.5. Installation of *We Try to Be Strong: 28 Years of Hmong Textiles in Philadelphia.* At right, Pang Xiong Sirirathasuk Sikoun's piece *I am the Rose of Sharon, the Lily of the Valley,* and at left, *paj ntaub* pieces made for the consumer market by Hmong living in Pennsylvania and in Laos.

(Photograph by Will Brown of work by Pang Xiong Sirirathasuk Sikoun. Used courtesy of the artists and the Philadelphia Folklore Project)

ntaub in favor of more lucrative quiltmaking, even teaching daughters to make Country Bride and Double Wedding Ring quilts rather than create their elaborately decorated ceremonial clothing.[16]

THE TENSION

On the surface, Hmong quiltmaking practices appear to be a heartwarming example of adapting one's skills to new surroundings and creating culturally hybrid quilts. Yet an ongoing tension existed. While Amish and Mennonite businesses were eager to employ Hmong seamstresses to do skilled appliqué work, they often were not so quick to acknowledge Hmong contributions to their customers. Businesses selling quilts in Lancaster County recognized that the Amish identity of the quiltmakers was a huge part of the appeal to consumers shopping for quilts. Amish origins signified authenticity even if this was only an imagined construct. While conducting fieldwork in the late 1980s, Sally Peterson found that quilt retailers did not deny the Hmong contributions to quilts; rather, as she describes, it was "omission and anonymity that create[d] the ambiguity of identity, allowing a tacit deception, and the assumption of authenticity to continue." Most stores labeled Hmong-appliquéd quilts as "Amish Made," even if Amish women only contributed the quilting. Other labels read "Made Locally," a true statement, yet still a means of disguising Hmong contributions.[17]

While many casual customers shopping for quilts in Lancaster County may have not been aware of the collaboration between Amish and Hmong quiltmakers, it has not been a secret. Journalists and scholars have written about the process at length, although many of the articles explicating the relationship between these two ethnic groups have been targeted at specialized audiences like folk art or textile enthusiasts.[18] Yet most tourists visiting the Amish—a primary consumer base for Amish quilts— no doubt had trouble imagining that quilts sold here could be made by anyone else. Authentic quilts in Lancaster County were Amish quilts, no questions asked.

In the late 1980s, Hmong quiltmakers were caught between wanting credit for their contributions to the popular appliqué quilts sold at quilts shops and fears that such acknowledgement might backfire, because it could jeopardize their relationship with the local quilt businesses. In addition to seeking public acknowledgment as a source of ethnic pride, some Hmong women wanted to be "free agents": to be able to negotiate pay rates on their own terms and sell directly to customers rather than through Amish or Mennonite businesses who profited from their fine needlework skills. These Hmong women wanted to band together to strategize about how they could be treated better within Lancaster's quilt industry. But many other Hmong seamstresses did not want to risk losing this important source of income. According to some Hmong quiltmakers, Amish and Mennonite businesses warned them against starting their own businesses selling quilts, implying that it would somehow be illegal.[19]

Frustrated with the situation, an entrepreneurial Hmong quiltmaker decided to disregard these warnings, opening her own retail outlet to sell both quilts and *paj ntaub*.

In 1990, Lo Mao Moua established Pennsylvania Hmong Crafts in Intercourse, Pennsylvania, the center of Amish-focused tourism to Lancaster County. Moua and her sister in Wisconsin appliquéd many of the quilt tops and then contracted with Amish and Mennonite women for the quilting. Here the tables were turned; a Hmong entrepreneur now hired Amish women. Moua told a journalist: "I tell my customers the truth. The quilt top is done by me; the quilting is done by Amish. Sometimes they already know. Sometimes they don't care."[20] Like other quilt retailers, Moua also sold smaller quilted items like wall hangings, placemats, and pot holders. Moua also stocked *paj ntaub* made by elderly women in Pennsylvania, immigrants resettled in other communities, or Hmong still living in Thailand. Sometimes she integrated *paj ntaub* blocks into quilts. She discovered that running a retail outlet had its own challenges, including overhead costs. Paying rent in Intercourse dictated that Moua needed to charge more for her quilts while earning less profit. In 1997 she closed her shop, deciding to run her quilt business from her home as many Amish seamstresses did. She continued to sell quilts at craft shows on the East Coast.[21]

Other women, including Pang Xiong Sirirathasuk, similarly stopped working directly for Amish quilt businesses in favor of selling or consigning completed quilts to retailers or at craft shows where she could keep all of the profit.[22] She also wanted to publicize Hmong contributions to the popular quilts sold in Lancaster County. She even exhibited an Amish-style Rose of Sharon wall hanging in a Philadelphia gallery (fig. 12.5). The exhibit label read: "Many times we made things and Amish people never said so. I just want people to know that I made this."[23]

Even more than Amish women, Hmong women were accustomed to adapting traditions. Many Hmong quiltmakers became adept not only at using fine stitches to appliqué the motifs of Country Bride quilts but also at creatively modifying popular patterns with individual touches or inventing their own patterns. Lo Mao Moua added pieced corner elements to the Country Bride pattern to create what she called "Country Bride Combination." Houa Yang copyrighted her Grape Galore pattern, a stylized wreath of grapes.[24] Some quiltmakers even combined aspects of *paj ntaub* with patterns Amish quiltmakers used to make their "old dark quilts"; Tong Lor used purple squares of intricate *paj ntaub* reverse appliqué to form the central motif of her Center Diamond quilt, flanking it with rich red and blue fabrics in this favorite Amish design of the early twentieth century. Quiltmaking may not have been Hmong women's traditional textile art, but neither was it an Amish tradition before they adopted it during the nineteenth century. Quiltmakers from both cultures found ways to adapt the practice of making quilts into both a personal expression and a saleable commodity. Unfortunately, many consumers visiting Amish country perceived a hierarchy of authenticity; Amish quiltmakers made authentic quilts, they thought, while Hmong made inexpensive knockoffs. As Lo Mao Moua, proprietor of Pennsylvania Hmong Crafts, later told a journalist, "Because I am Asian, they think I sell cheap imports."[25]

In the late 1980s, during the same years when the Amish quilt industry was employ-
ing Amish and Hmong women alike in the thriving business of making quilts to sell
to consumers, large home textiles corporations also discovered quilts. Throughout the
1980s, prices for both antique quilts and new ones produced in cottage industries had
continued to rise. By the end of the decade, a prized antique Amish quilt could sell for
as much as $15,000, while new quilts sold in Amish shops for as much as $1,500. With
these prices, few consumers could afford quilts, and those who could were reluctant to
actually use them as bedcoverings. To many American consumers, lovingly handmade
quilts had become a luxury, despite all they symbolized about frugality and simplicity.

Observing this trend, in 1988 American Pacific Enterprises and its chief rival,
Arch Associates, both big players in the home textiles industry, identified a potentially
lucrative market in quilts made with overseas labor. According to a home furnishings
trade journalist, companies that began mass-producing quilts in the late 1980s "brought
quilts into the affordable price range by taking American designs and fabrics overseas
to be made into reasonably priced, handcrafted quilts."[26] These corporations had an
abundance of design resources available to them, thanks to the hundreds of coffee table
books full of images of historic American quilts that had been published since the early
1970s.[27] And among the many styles of quilts produced in factories in China, India,
Hong Kong, and elsewhere were ones described in marketing materials as "Amish
quilts."

Arch and American Pacific's designers intended for these quilts marketed as
"Amish" to look like old dark quilts. Arch's "Amish Star" from its Heirloom Collec-
tion line, for example, was based on a nearly identical quilt published on the cover
of *A Treasury of Amish Quilts* (1990), a coffee table book filled with striking images of
Amish quilts owned by private collectors (figs. 12.6–12.7). Arch's "Amish Star" featured
a royal blue background with green inner border and sawtooth binding, whereas the
original had a black background with blue border and binding. The hues of the solid-
colored forty-five-degree diamonds comprising the pattern traditionally called Broken
Star appear nearly identical. Arch's designers carefully matched the quilting motifs,
reproducing the undulating feathers, wreaths, and parallel lines of the original. Like the
Amish-made Broken Star, Arch's "Amish Star" was machine pieced and hand quilted,
although the quilting on the Chinese-made reproduction was not as fine as that on the
Amish one. Arch claimed superior craftsmanship in its marketing materials, citing "7
stitches to the inch," and "proudly sewn by one woman" as two of its quality standards.[28]

Other manufacturers made quilts that resembled old Amish quilts, but they chose
not to market them as "Amish" (figs 12.8 and 12.9). Judi Boisson American Country
outsourced labor from Hong Kong and retailed its quilts at upscale stores like Barneys
New York and Neiman Marcus. It marketed quilts inspired by Amish originals without
explicitly calling them Amish. Judi Boisson was a longtime quilt and folk art dealer,
with storefronts in midtown Manhattan and in the Hamptons, and had bought and

sold many Amish quilts throughout the 1980s.[29] Members of Boisson's elite consumer base may have been familiar with "classic Amish quilts" and recognized the inspiration for some of her designs in the old quilts collectors had hung on walls since the 1970s. Boisson's quilts competed most directly with the antique market itself and with quilt businesses like Amish Design or Mercer & Bratt, who contracted with Amish women to make quilts using the old patterns and colors.

Corporations outsourcing quilts could produce a greater volume of product and sell it for much lower prices than an Amish cottage industry could. American Pacific Enterprises contracted with a Chinese manufacturer employing around 20,000 workers. In its Shanghai factory, employees worked in teams of three or four to machine piece, hand appliqué, and hand quilt American Pacific's bedcovers. With this mode of production, factory workers crafted quilts using the same techniques as women working in businesses in Amish settlements. Each quilt took around fifty hours to complete.[30] Unlike machine-produced bedding, hand making quilts, even in a factory setting, was a labor-intensive process. When American Pacific began making handmade quilts in China, the company's president, Jared Block, "had real reservations about whether this was a good idea," owing to the amount of labor involved.[31] While Block perceived handmade quilts as having limited production capacity, even in factories, the reality was that American Pacific produced 100,000 quilts a month in China, an amount that far outstripped even the biggest cottage industries in Amish country.[32] With low labor costs and high production volume, American Pacific could easily price its quilts far below those made by Amish businesses. These large corporations also had much wider distribution, wholesaling quilts to major American department stores and mail order catalogs, including Federated Department Stores, Macy's, Dillard's, L.L. Bean, Domestications, and Spiegel. As a result, mass-marketed quilts accounted for $200 million in sales in 1991, according to industry estimates.[33]

Businesses producing factory-made quilts not only competed with Amish enterprises by selling quilts that mimicked old quilts with dark colors, they made many quilts similar to the contemporary styles marketed by Amish quilt businesses to tourists visiting Lancaster County or Holmes County. These quilts did not look distinctly Amish but were generically "old-fashioned" in feel, using traditional patterns like Double Wedding Ring, Fans, and Trip Around the World that had long been popular among Amish and non-Amish quiltmakers alike. While Amish proprietors sold quilts for anywhere from $500 to $1,500 in the late 1980s and early 1990s, similar outsourced quilts usually sold in the $100 to $300 range. George Delagrange of Amish Design, the business that hired Amish women to make quilts in the old patterns and colors, recalled that "with 'Amish' quilts made offshore in Haiti and other places . . . if someone wanted something big and graphic and cheap, we couldn't compete. They were selling them for half of what it cost us to have one made."[34] Factory-made quilts, with their lower prices, began to pull down the prices of Amish-made quilts by decreasing demand at the higher price points. Furthermore, these cheaper prices lessened what consumers were willing to pay for any quilt.

Figure 12.6. Broken Star, unknown Amish maker, c. 1930. Holmes County, Ohio. 80 x 76 in. This quilt, which appeared on the cover of *A Treasury of Amish Quilts* (Intercourse, PA: Good Books, 1990), presumably inspired Arch Quilts' "Amish Star."

(© Faith and Stephen Brown)

THE HEIRLOOM COLLECTION

Amish Star

Fabric face and back: 100% Cotton
Fill: 100% Polyester
Made in China with domestic U.S. and imported fabric

Handmade
Patchwork
Quilt

Figure 12.7. Packaging materials for Arch Quilts' "Amish Star." Arch Quilts' "Heirloom Collection," c. 1992.

- -

(From the collection of Diane Tepfer.)

- -

Manufacturers and retailers anticipated that factory-made quilts would appeal to consumers not only because they were inexpensive but because they felt like authentic pieces of "Americana," a category of collectible objects associated with the American past. Trade journalists regularly used Americana to describe the sort of quilts made in foreign factories and targeted at American consumers who liked to own objects associated with old-fashioned American traditions.[35] Mass-produced Americana did not necessarily correspond to actual traditions of the past, but it reflected consumers' nostalgia-fueled imagined ideals of a simpler time.[36] In describing how her company drew on "renewed interest in Americana," Lands' End product manager said: "People perceive a very high intrinsic value in hand-crafted, folk-oriented goods, [quilts] bring back memories of when they were kids and their grandmother had them."[37] Marketers drew on nostalgia for the American past while emphasizing that this was an affordable type of Americana, in contrast to more expensive antiques. American Pacific's president acknowledged, "Buying a quilt is the same as buying a print of a master's painting—you can't afford to have the Mona Lisa, but you can afford to have a good quality print."[38] Yet many of the marketing tactics manufacturers and retailers used promoted factory-made quilts as authentic—the Mona Lisa rather than the print. And companies like American Pacific encouraged retailers and marketers to exploit the idea of authenticity. American Pacific's vice president for marketing suggested that if retailers touted outsourced quilts as true pieces of Americana, consumers would respond.[39]

Terms like "heirloom-quality," "remarkable workmanship," "simplicity of yesterday," and "Americana" indeed peppered advertising copy. In text accompanying order information for a $99 pastel "Rainbow Fans" quilt, mail order retailer Domestications encouraged customers to "pass these quilts down through the generations!"[40] Such marketing tactics seemed to work; according to one industry executive, "Quilts are selling because it's one of those things like having an instant ancestor."[41] For late-twenti-

eth-century Americans who did not own quilts made by their great-grandmothers, an imported factory-made quilt could connect them to an imagined past.

Lands' End took a different and arguably more honest marketing approach, emphasizing that its imported, factory-made quilts were a practical substitute for precious heirlooms. In its May 1992 "Coming Home" catalog, the mail order retailer touted "Art you can live with. Handcrafted quilts at $129 and $139 [for] a twin." The catalog copy emphasized that unlike antique quilts, which cost "six-figures" and were too valuable to put on a bed, these quilts were machine washable and dryable. Yet they shared antiques' "traditional patterns" and "authentic ginghams and calicos," making them "as much like collectors' quilts as we could make them." Lands' End successfully articulated the best

aspects of quilts made with outsourced labor: the low price and practicality coupled with the trappings of tradition.[42]

Other companies entered the quilt market at even lower price points, manufacturing quilts by using shortcuts such as printed quilt designs ("cheater cloth") rather than pieced or appliquéd designs. Home fashions company Perfect Fit specialized in these bottom rungs of the market, manufacturing quilts that retailed between $17.99 and $30 in 1991.[43] In 1993 Perfect Fit partnered with the Museum of American Folk Art to produce a series of printed quilts based on ones in its collection, including quilts marketed as "Amish Diamond" and "Amish Wedding Ring." These started at $30 for a twin size, with prices increasing for larger quilts. As products licensed by an esteemed institution specializing in Americana, retailers could market these quilts as both "Amish" and as "actual reproductions" of museum pieces.[44] Consumers who may never have considered purchasing either an antique or a new Amish-made quilt—especially at early 1990s prices—could buy these affordable reproductions, perceiving that the quilts came with a seal of authenticity bestowed by their connection to both the Amish and the American Folk Art Museum.

With more and more manufacturers entering the quilt business, corporations competed by lowering prices, often at the expense of quality. The factory-made quilt industry developed cheaper means of creating quilts so that soon many were no longer mass-produced by hand-quilters in Chinese factories but were entirely machine-made, with preprinted patchwork designs and machine quilting rather than the painstaking hand quilting and appliqué seen on many factory quilts. Some retailers and manufacturers began to worry that the "perceived value of hand-made products will be lessened."[45] If businesses outsourcing quilts to overseas factories fretted about this, Amish quilt businesses experienced it firsthand, forced to lower prices during the 1990s in order to compete with the factories flooding the market with inexpensive and cheaply made quilts.[46]

MADE WITH LOVE?

Amish quilts had been selling since the 1970s because consumers and collectors perceived them as authentic; in other words, they thought these quilts were made with love. But as quilts sold by Amish businesses dropped in price and sometimes in quality, consumers increasingly had trouble distinguishing them from the factory-made quilts abundantly available from department stores and mail order catalogs. To the sophisticated quilt enthusiasts who loved the old dark quilts, both varieties seemed more like kitsch than authentic pieces of design and craftsmanship. To them, quilts had become something cheap, both in price and quality.[47] Factory-made quilts also lowered the more nebulous emotional value of all quilts. When a quilt was labeled "Made in China," many consumers no longer perceived that it was made with love. Yet many of the customers who wanted quilts to be based on traditional, authentic American designs were not willing to pay American quiltmakers' prices if they could buy outsourced ones at a local

department store for hundreds of dollars less. But a distinct subset of consumers—quiltmakers and quilt enthusiasts who wanted to preserve the craft of making American quilts—grew particularly frustrated and vocal about the influx of foreign-made quilts.

In 1991 the Smithsonian Institution partnered with American Pacific, licensing four historic quilts in the National Museum of American History for reproduction in American Pacific's Chinese factory. Mail order catalogs and department stores retailed these reproductions of nineteenth-century quilts to American consumers. While American Pacific and its competitors had been outsourcing quilts to overseas factories for several years at this point, those frustrated with how the practice undermined the value of all quilts had previously had nowhere to target their ire. With the availability of the Smithsonian's reproduction line in January 1992, a protest against outsourced quilts began, targeting the Smithsonian for selling out its national treasures. As a government-funded museum and self-proclaimed "Nation's Attic," the Smithsonian became a scapegoat for Americans' reactions to various contemporary issues: the commercialization of American heritage, disillusionment toward government entities, and anxieties surrounding increasing globalization. But the Smithsonian Quilt Controversy, as it soon became known, was ultimately about quilts as objects that were distinct from other consumer goods. As then-senator Albert Gore observed: "There is great irony and insensitivity in the Smithsonian's decision to have Chinese workers reproduce classic American quilts that will be sold here."[48]

To follow Gore's logic, there was little irony in manufacturing clothes, cars, televisions, and other mass-produced products in overseas factories. But quilts? That was something different. In his mind, and that of his Tennessee constituents who wrote him angry letters, quilts were no ordinary commodities; they were imbued with authenticity that stemmed from the creative act of an American woman. As one protestor wrote to a textile arts magazine: "When someone makes a quilt, it is like breathing life into fiber and material. A little bit of the quilter goes into a quilt. How can the Chinese women who make the Smithsonian copies know of American women's thoughts or fears when they produce an 'Ocean Waves' or 'Kansas Troubles' quilt?"[49] In essence, the factory-made copy did not have the *aura* of the original.[50] Many Americans who had come to understand quilts as special—as quintessentially American objects and bearers of women's history—shared this reaction. To the most ardent protestors, who wrote angry letters, signed petitions, renounced their Smithsonian memberships, or marched on the National Mall wrapped in quilts, no one could make a better or a more authentic quilt than an American quiltmaker. And to many, an Amish woman was the ultimate American quiltmaker.

THE BACKLASH

Although some consumers were content with quilts that looked like old Amish quilts even if made by factory workers in China or Haiti, others continued to go to Amish country in search of the real deal. They wanted a quilt that was actually Amish made,

and they assumed that anything they purchased from a quilt shop in Lancaster County would fit the bill. Surely buying a quilt in a quaint, kerosene-lit, rural shop on an Amish farm rather from JCPenney or mail-ordered from Domestications would provide not only a more authentic experience but also an authentic quilt. But unlike consumers who knowingly purchased outsourced quilts, these buyers were sometimes fooled into thinking what they bought was Amish-made, because Amish had outsourced some of the labor to Hmong women since the early 1980s.

During the 1990s and 2000s, inexpensive factory-made quilts and an apparent decline in consumer demand had brought down the prices of quilts sold in Lancaster County's quilt shops.[51] By the early 2000s some Hmong working in Lancaster County's quilt industry had become disappointed with the decreasing profits earned through quiltmaking. If consumers no longer sought out Amish quilts in great numbers, Hmong seamstresses could no longer consider stitching away on "Amish quilts" as a viable income. Some Hmong women began to outsource quilts themselves in hopes of earning more profit.

Hmong quiltmakers in Pennsylvania sent patterns and fabric for quilts to relatives and friends still living in Asia, then resold the finished products to wholesalers and auction houses in Lancaster County.[52] In contrast to quilts made in Lancaster by either Hmong or Amish women, which cost around $400 to make, in Thailand quilts could be made for as low as $65 to $80.[53] The practice of American Hmong outsourcing needlework from Hmong living in Thailand was not novel. Entrepreneurial quiltmakers like Pang Xiong Sirirathasuk from Upper Darby, Pennsylvania, had made buying trips to Thai refugee camps where she bought *paj ntaub* to sell to American consumers since the 1980s. Sirirathasuk had tutored Hmong seamstresses living in refugee camps in how to best make products to appeal to Americans and earn them the most profit. She also taught these women to assemble *paj ntaub* into American-style quilts.[54]

But outsourced Hmong needlework sold not as *paj ntaub* but as locally made Amish quilts were something else. As the Allentown, Pennsylvania, *Morning Call* reported in 2006, no one knows for sure how many of these foreign-made quilts have been sold in Amish country. Rather than end up in shops like Hannah's Quilts or Witmer Quilts, many of them were sold at the New Holland Quilt and Craft Auction, held every two months in Lancaster County. Here quilts were sold on consignment, and buyers—mostly quilt shop owners seeking a cheap means to supplement their inventories—had no way of knowing if quilts were made locally or overseas.[55] The auction's manager told the *Morning Call* journalist that the flooded auction and the resulting prices—as low as $60 for an intricately appliquéd quilt top—were causing tensions between Hmong and Amish, both trying to survive in the quilt industry. Amish entrepreneurs blamed local Hmong quiltmakers for inundating the market with too many quilts, not necessarily aware that many of these were in fact made overseas. Other auctions, like the annual Gordonville Fire Company sale, which raised money to support the community's volunteer fire company, began limiting the number of quilts individuals could submit to seventeen because some Hmong women were consigning what the auction

deemed excessive numbers of quilts. Some Amish and Mennonite quilt entrepreneurs felt like Hmong quiltmakers were "trying to take over a historical thing that's associated with Amish and Mennonites," despite the reality that most Amish and Mennonite quilt businesses had begun only twenty to thirty years earlier.[56]

Backlash occurred at some of the quilt shops in Lancaster that had, in the past, accepted quilts on consignment. With knowledge of the influx of foreign-made quilts growing among entrepreneurs, businesses wanted more control over their product and began to commission more quilts on contract rather than accept undocumented consignments or wholesaled quilts. While it meant more work for quilt shop proprietors, it was a means of guaranteeing that quilts were, indeed, locally made.[57]

When the *Morning Call* published a series of articles investigating outsourced quilts flooding the market in Lancaster, many readers responded with outrage. One called these quilts "counterfeit"; another proposed an "industry standardized label to identify the real German-Amish-Mennonite quilt," because he did not want his "quilt money subsidizing slave like labor kapos overseas." Ironically, he did not identify quilts as American, but as German, an attribution that overlooked the American origins of Amish and Mennonite quiltmaking traditions. His sentiment, however, was tinged with an "America first" mentality similar to that which protestors had voiced against the Smithsonian over a decade earlier. Peter Seibert, the director of the recently established Lancaster Quilt and Textile Museum, fielded these comments in an online forum. He responded to the idea of standardized labels by stating: "A good idea, but there is no central authority that could make that determination. Labels can be removed and many of the quilts pass through multiple hands along the way. The real solution will be for buyers to demand authentic quilts."[58]

Organizers of the Kutztown Folk Festival, an annual celebration of Pennsylvania German culture featuring a highly anticipated juried quilt show and auction, debuted certificates of authenticity in 2006. Rather than verify Amish or even Pennsylvania German origins, organizers wanted these labels to guarantee that quilts were made in the United States, in reaction to the *Morning Call*'s exposé. Despite certificates of authenticity, quilts sold at the 2006 auction brought much lower prices than in previous years. The festival's director had anticipated that the newspaper's revelations might have such an outcome.[59]

Once again, the imagined ideal of authenticity seemed to be at the forefront of how to value quilts. What was an "authentic quilt"? One *Morning Call* reader wrote in a letter to the editor, "I'm shocked! My vision of sweet Amish women sitting in a quaint living room having a quilting bee has been destroyed." The reader considered Amish quilts authentic only if they conformed to her imagined ideal of how they were made.[60] Peter Seibert, director of a museum that collected old dark quilts in simple graphic patterns, complicated the issue in the newspaper's online forum, questioning exactly what made an "authentic" Amish quilt. Seibert pointed out that Amish living in midwestern settlements quilted some of the quilts sold in Lancaster County. He asked, "Is that an authentic Lancaster quilt?" And he described quilts Amish made for their

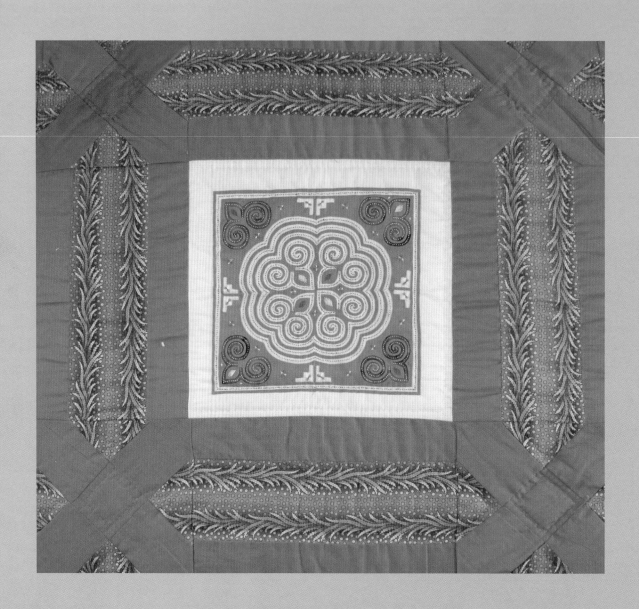

own use as undesirable to consumers: "Most people would never own them. They incorporate fabric markers, crocheting, quilting, shiny modern fabrics, etc. This is not the country aesthetic that we associate with their quilts."[61] But as Seibert implied, perhaps these quilts, undesirable to consumers yet made entirely by Amish makers according to Amish taste for use in Amish homes, were in fact the most authentic Amish quilts. If so, it seemed consumers would rather own ones made in Thailand or purchased from a mail order catalog that at least conformed to their imagined ideals of what an authentic Amish quilt should look like.

"HARMONY A-HMONG THE CULTURES"

George Delagrange and David Wheatcroft, successful Amish quilt dealers during the peak years of the market for old dark quilts, have been quick to blame the influx of outsourced quilts for the demise of the market in antique Amish quilts and new quilts like the ones Delagrange's Amish Design sold.[62] Certainly, foreign-made quilts flooding the market hurt their businesses, but not necessarily because consumers could simply buy quilts for lower prices. Imported and outsourced quilts—as well as lower quality quilts sold by some Amish proprietors—influenced consumers' ideas about the value of Amish quilts in general. Quilts, available for $99 or even $19, now equated with kitsch in the minds of some potential consumers. The flooded market for inexpensive quilts—whether Amish made, Hmong-made, or factory-made—had reduced not only the monetary but also the emotional value of quilts, which consumers perceived as made with love in the spirit of age-old traditions. People had bought Amish quilts not simply based on price or aesthetics. They bought them because quilts were comforting, reminded them of the past (even if it was an imaginary past), and allowed them to feel transported to what they perceived as the simpler world of the Amish. In the age of outsourcing, these intangible aspects of quilts were harder to identify.

Out of the conflict and controversy over Hmong contributions to quiltmaking in Lancaster County, one particular entrepreneur attempted to find harmony. Old Order Mennonite quilt proprietor Emma Witmer began to sell what she called "Harmony A-Hmong the Cultures" quilts in the 1990s (fig. 12.10). Similar to the hybrid quilts described above designed by Lo Mao Moua and Tong Lor that combined elements of *paj ntaub* with Amish quiltmaking styles, these quilts celebrated Hmong needlework, acknowledging both the seamstresses' skills and the beauty of traditional Hmong designs. But unlike the aforementioned quilts, "Harmony A-Hmong the Cultures" quilts were sold in the oldest quilt shop in Lancaster County.[63] These bed-sized quilts, which Witmer describes as a combination of Amish and Hmong styles, featured squares of *paj ntaub* stitched by Hmong women in Thai refugee camps and sent to stateside relatives. Witmer began acquiring these embroidered and reverse appliquéd squares from some of her local Hmong seamstresses in 1995. They convinced her that by purchasing these squares, which take refugee women 6 to 8 weeks to make, she would be helping Hmong living in Thai camps, a prospect that suited Witmer's religiously driven ethic of service.

Figure 12.10. "Harmony a-Hmong the Cultures" quilt, Garden Maze.

(Designed by Emma Witmer, 2012)

Witmer designed the quilts in a commonly used setting for a repeated block quilt, with neutral-colored sashing separating the *paj ntaub* blocks. Unlike many Lancaster quilt entrepreneurs, Witmer had long been quick to acknowledge Hmong contributions to the quilts she sold, saying without hesitation that Hmong women did all of the appliqué work. She valued her "Harmony" quilts not only for their fine needlework and great composition but because they represented the union of two cultural practices, each in a constant state of adaptation, rather than of unchanging tradition. The customers that have bought Witmer's "Harmony" quilts were not the art collectors who loved old dark quilts or the casual tourists looking for souvenirs; these were consumers who valued really quality needlework, no matter what the ethnicity of the maker. [64]

CONCLUSION

Individuals have used various criteria to bestow Amish quilts with value. An elderly Amish woman valued an "old dark quilt" not necessarily because she liked the way it looked but because her mother had helped make it, giving it to her as a gift when she left home and was married. Some enthusiasts with a taste for abstract paintings have valued Amish quilts aesthetically as art objects, hanging them on walls and admiring their graphics and colors. Dealers and collectors valued quilts monetarily, recognizing that buying and selling quilts necessitated negotiating price; but as connoisseurs, they also had an emotional interest in what made a great quilt. Tourists visiting Amish country valued souvenir quilts they purchased for emotional reasons, as reminders of a vacation to a simpler time and place. A Hmong seamstress living in a Thai refugee camp and a young Amish mother both valued Amish quilts as potential sources of income. And multinational corporations valued Amish quilts as the inspiration for consumer products, mass-produced in overseas factories and sold to Americans eager to own their own bit of "Amishness." Despite these distinctions, however, ultimately, the criteria all translated into monetary value, the kind of value that seemed to matter most. Amish quilts, especially the old dark ones, but also new ones made for the consumer market, have made a lot of money for a lot of people. Many collectors considered old quilts like any other art they might purchase—not just as beautiful objects to own but as investments. It is no coincidence that very successful entrepreneurs and businessmen owned many of the most prominent Amish quilt collections.

Jonathan Holstein takes great pride in claiming that he discovered Amish quilts. But that did not keep Holstein and his wife, Gail van der Hoof, from selling more than twenty of their best quilts to Doug Tompkins for around $10,000 each in 1986. These were some of the same quilts that the couple had bought during the early 1970s in Lancaster County, paying from $23 to $290 apiece.[1] In May 1973, for example, Holstein and van der Hoof paid a picker $250—then a significant price—for a distinctive Baskets quilt made by Mary Lapp.[2] When Tompkins and Julie Silber (Esprit's curator) visited Holstein and van der Hoof in New York City thirteen years later to look at their quilts, this Baskets quilt was among those that Tompkins wanted to purchase. The parties negotiated over the price of this particular quilt, with Holstein and van der Hoof asking $10,500, and Tompkins offering $10,000. This $500 sticking point was twice as much as Holstein and van der Hoof had originally paid their picker back in 1973. The final price—$10,000—was forty times what the couple had originally paid.[3] After additional haggling over the value of certain patterns and fabrics, Holstein and van der Hoof sold 23 quilts to Tompkins, shipping them from New York to San Francisco.[4]

With more than one hundred Amish quilts remaining in Holstein's private collection (among a total of more than four hundred quilts), he negotiated a deal in 2003

with a growing academic center based at the University of Nebraska-Lincoln (UNL). Appraised at $2.2 million, Holstein's collection of quilts, quilt-related items, and archives was welcomed by UNL's International Quilt Study Center (IQSC) as "one of the most historically important collections in existence." The deal was negotiated as part donation, part sale, with IQSC benefactors and notable quilt collectors Robert and Ardis James donating funds to assist with the purchase. With this arrangement, Holstein received monetary compensation along with a significant tax deduction for the donated portion of his valuable collection.[5]

As a lifelong businessman, David Pottinger, the onetime plastics manufacturer who built prominent collections of quilts made by the Amish in Indiana and Illinois, knew how to make money off his collection. Beginning with a book contract he negotiated with New York's E. P. Dutton and the Museum of American Folk Art in 1983, Pottinger increased the profile, and in turn the monetary value, of quilts in his collection.[6] Along the way, he was able to make a good deal of money. He toured exhibitions of his quilts throughout the 1980s, receiving loan fees for the service, including $3,500 from the Smithsonian National Museum of American Art's Renwick Gallery in 1987.[7]

Pottinger considered it important for the states of Indiana and Illinois to own large groups of quilts made by the Amish communities within their borders. Yet he was not interested in donating the remarkable collections of these objects he had accumulated over the course of many years. Rather, he sold them. He convinced the Indiana State Museum of the historical and cultural value of the more than five hundred Indiana Amish quilts in his collection. The Lilly Endowment donated $400,000 to make this purchase, and the museum's volunteer society raised the additional $250,000. While Pottinger generally paid whatever amount an Amish family asked for a quilt, this was generally less than the estimated $1000 per quilt he received as a result of his deal with the Indiana State Museum.[8]

In the late 1990s, David Pottinger approached the Illinois State Museum to see if they would be interested in acquiring his collection of over 160 Amish quilts from that state. The Museum recognized the collection's importance and solicited a donation from Illinois Power, the gas and electricity provider. The first lady of Illinois, Lura Lynn Ryan, headed a campaign to raise the rest of the money needed to purchase Pottinger's collection.[9]

QUILT REPATRIATION

By the early 1990s, Doug Tompkins, the president and CEO of Esprit, had traded his role as a producer of fashion for one as a preserver of land. His involvement in the "deep ecology" movement, which demanded systemic changes to human values while critiquing industrialization and consumer culture, led him to abandon his ownership of Esprit as he sold off his stock to his wife Susie. With his fortune, he bought South American acreage in order to protect it from development. By 1995 he was the second-largest private landowner in Chile.[10]

As part of their divorce settlement, the Tompkinses split the Esprit quilt collection, about three hundred quilts, with Doug keeping the most desirable Lancaster County examples. He wanted these quilts to go back to Lancaster County "to the place and the people from which they came."[11] To Tompkins, this goal was in line with his current beliefs about preservation: the quilts, like the great wilderness of Patagonia, should be safeguarded for future generations. In 1994 Esprit's curator, Julie Silber, began to inquire about the feasibility of bringing the quilts back to Lancaster. Tompkins envisioned a nonprofit center, operated with Amish blessing, that would house, interpret, and display quilts and related materials and maintain an archives and library about Amish life. Tompkins wanted to fund the startup costs of such a project and imagined that it would be self-sustaining once it was up and running.

As anyone familiar with Amish culture might have guessed, Tompkins' proposal met with some resistance from the Amish. David Luthy, an Amish man living in Ontario who maintains a low-profile library and archive on Amish life, wrote Silber: "If Doug wants the Amish to bless his project, I don't think they ever will. How can we give our blessings to something which attracts more people to study us when tourism is already choking many of our settlements including the one in Lancaster County. . . . Why not keep it in California?"[12]

When Silber contacted Patricia Herr, an Amish quilt dealer and collector based in Lancaster, her immediate reaction was that "this [will make] no sense to an Amish person." Herr obliged, however, and put Silber and Tompkins in touch with some leaders of the local Amish community. These Amish men responded positively; they would be happy to have the quilts repatriated because they could sell them to raise money for the Clinic for Special Children, a community hospital founded by Harvard-trained pediatrician Dr. Holmes Morton in 1990 to treat rare genetic diseases that had become far too common among the Amish population.[13] The Amish were not naïve; they had witnessed local estate auctions selling old quilts for as high as $17,300. Community leaders were also accustomed to organizing fundraisers to earn money for causes such as the Clinic. They would welcome the donation of such highly valued goods which would no doubt raise much needed money to help children in the community.[14]

Despite the worthiness of the cause, this was not what Tompkins had in mind. He continued to devote most of his resources to the preservation of land in Chile. He deeded the quilts in his portion of Esprit's collection to one of his nonprofit foundations, the Conservation Land Trust, now with the intention of selling the collection to raise money for his deep ecology pursuits rather than donating the quilts back to Amish country. Julie Silber hoped to keep at least a portion of the quilts together as a group, preferring not to split up the eighty-two quilts that had been exhibited in 1990 at San Francisco's de Young Museum and published in *Amish: The Art of the Quilt* (1990).[15] Joel and Kate Kopp of America Hurrah appraised this group of quilts at $1.37 million. Silber first approached the International Quilt Study Center at the University of Nebraska-Lincoln to see if it was interested in purchasing this group of quilts. The asking price was $1 million, and Tompkins seemed unwilling to negotiate. After efforts at making a

sale stalled with IQSC, Tompkins and his foundation grew impatient and contemplated putting the quilts up on the auction block at Sotheby's.[16]

In 2002 Silber, still insistent that these eighty-two quilts stay together, perceiving their value as a group as greater than if they were sold individually at auction, again contacted Patricia Herr, who served on the board of the Heritage Center Museum of Lancaster County, to see if this local institution could acquire the quilts. The small museum, which collected and exhibited decorative arts from the greater Lancaster County region, did not have a budget or necessary benefactors to make such a substantial purchase, and Herr was not optimistic at the prospect of finding that kind of money. But as she began to ask a few wealthy Lancastrians and talked to Peter Seibert, the CEO of the Heritage Center, her mood began to change. As Herr describes it, the prevailing attitude was "Bring these things back, we've got to save them!" The museum's board agreed and quickly secured a loan for $1 million. They began a fundraising campaign with an "adopt a quilt" program in which donors could earmark funds for acquisition of a specific quilt. While the Amish played no part in the process, many other Lancaster locals saw these quilts as valuable because of their origins in the county as many as one hundred years earlier. In less than a year's time, the museum had raised the money to pay off the loan.[17]

In 2004 the Heritage Center Museum opened its branch, the Lancaster Quilt and Textile Museum, in a turn-of-the-century beaux-arts bank building in Lancaster's historic center. On permanent exhibition was a selection of the eighty-two quilts that had hung on the walls of Esprit's corporate headquarters in San Francisco. The museum periodically rotated this group of quilts in order to protect the light-sensitive textiles and provide visitors with a fresh exhibition. Lancaster's mayor called the museum's opening the beginning of "downtown revitalization." Local stores and restaurants viewed the museum as a potential boon for business; many decided to open on Sundays to capitalize on the anticipated crowds at the museum. These quilts now had a new potential value as agents of economic renewal.[18] The museum also provided business to some of Lancaster County's quilt entrepreneurs. Hannah Stoltzfoos and Emma Witmer both stocked quilts in the museum's gift shop, including reproductions of some in the museum's collection.[19]

Yet the Lancaster Quilt and Textile proved not to be the economic boon Lancastrians had predicted. In 2011 both the Lancaster Quilt and Textile Museum and its parent organization, the Heritage Center Museum, closed their doors, no longer able to function as a museum open to the public. The organization began a fundraising campaign to ensure the care of its museum collections, including the eighty-two prized quilts once owned by Esprit. In September 2012, it announced the transfer of its collections to Lancaster County's Historical Society.[20] Like many cultural institutions, the Heritage Center and Quilt and Textile Museum had faced hardships brought on by the economic crisis. Yet even before the recession's onset, the quilts had not attracted the crowds it had hoped. The Amish themselves have remained a top tourist pull for Lancaster County, competing only with the outlet malls that draw consumers away from the farmsteads

and villages. But the quilt museum located in the city of Lancaster perhaps seemed too far removed from the authentic country life of the pastoral imagination. Within Lancaster County, the celebration of Amish quilts as art objects—the aestheticizing of old bedcovers—felt out of place, since tourists longed for beds covered in quilts, not quilts hanging on walls like paintings.

MUSEUM VALUE

How did museums value the expensive quilts they acquired? Private collectors like Holstein and Pottinger took pride in the collections they assembled and relished knowing that their vision has been preserved and validated by the institutions that now owned the quilts. The museums reciprocated, acknowledging the collectors by calling the quilts collectively "Jonathan Holstein Collection" at the International Quilt Study Center & Museum and "David Pottinger Collection of Amish Quilts" at the Indiana State Museum. Docents at the Lancaster Quilt & Textile Museum told visitors about Esprit and Doug Tompkins, just as they highlighted the features of Bars and Center Diamond quilts.[21] The repositories that owned these collections valued the quilts collectively, considering their use in exhibition, research, and education as greater than could be achieved by individual quilts.[22] When quilts were not on exhibit, these institutions kept them stored in acid-free boxes, wrapped in tissue paper.

Few Amish quilts that differed from the "old dark" or "classic" variety have made their way into museum collections. Private collectors assembling groups of Amish quilts preferred these quilts, and since museums usually acquire from private collectors, only such examples typically end up in institutional collections. Fortunately, there are a few exceptions. Indiana State Museum's David Pottinger Collection of Amish Quilts includes several tattered everyday quilts that received frequent use and laundering, some quilts made from lighter colored and printed fabrics, and examples of utilitarian knotted comforters, appliqué quilts, and other Amish-made quilts that do not fit the criteria celebrated by connoisseurs. The International Quilt Study Center & Museum also owns a few Amish quilts that were made in the second half of the twentieth century, after the so-called "classic era."[23] These include quilts made for the consumer market during the 1970s, 80s, and 90s, crafted to look like old dark quilts. IQSC&M also owns quilts that dealer and collector records purported were made during the early twentieth century. Only through fiber microscopy and fieldwork in Amish settlements did IQSC&M learn that these quilts were in fact made during the 1960s through 1990s. But even with this realization, curators determined that the quilts were still valuable to its educational mission, in large part because they challenged widely held assumptions about the dates and styles of Amish quilts.[24] Few, if any, Amish-made quilts in the commercially popular styles like Country Bride or Bargello are owned by museums. Institutions have yet to find value in commercially produced Amish quilts that do not look like old quilts. Without the inclusion of such quilts in museum collections, "Amish quilts" will remain

defined by connoisseurs of old quilts rather than by the quiltmakers and consumers who have kept Amish quiltmaking a living, thriving practice.

IN SEARCH OF THE AUTHENTIC AMISH QUILT

At the end of this story, are we any closer to articulating what makes an authentic Amish quilt? Returning to a question asked in this book's introduction, what makes an Amish quilt Amish? Is it the maker? Is it the style? Is it the age? Is it the brand? Is it the way the quilt is used? What, indeed, is Amish about an Amish quilt? To me, a quilt used and loved in a contemporary Amish home—perhaps embellished with fabric paint, fringe, or sequins—is just as authentically Amish as an old dark Center Diamond or as a light-colored Country Bride quilt sold by Hannah's Quilts. Neither the Amish nor the quilts they have made and used have ever been static and unchanging. Maybe Jonathan Holstein would not bother to hang a contemporary Amish creation on a gallery wall today, but that does not make the continued cultural production of Amish quilts any less significant.

The coincidence of old Amish quilts resembling mid-twentieth-century abstract art did not set the story of Amish quilts in motion. Nor did Robert Hughes's proclamation that quilts like the one Rebecca Fisher Stoltzfus made in 1904 (see fig. 3.16) are America's "first abstract art" conclude it. At least a few Amish women in the nineteenth century began making quilts for reasons we'll never quite know. Since then, many thousands more have taken up the practice of stitching quilts to make gifts for family members, to earn extra money, or to craft something beautiful and expressive. And this story is not complete. Although "experts" have called Amish quiltmaking a dying art for decades now, it has remained a living, changing art.

By examining the role of Amish quilts within multiple contexts—including Amish communities, the art world, the marketplace, and globalization—we can see that these objects have not had static meanings or values. But this is also true of all objects of material culture. Amish quilts are distinct objects because they were made within a defined cultural system, and they have garnished attention due to how they look, the particular people who have made them, and what they symbolically represent. But in other ways, Amish quilts are not distinct. As with all objects, we use our worldview, our past experiences, our familiarity with other objects, and our imagination to craft meaning and value. We do this by creating, discovering, buying, selling, using, displaying, preserving, discarding, and reusing. We find value in objects. And in turn objects give value to our lives.

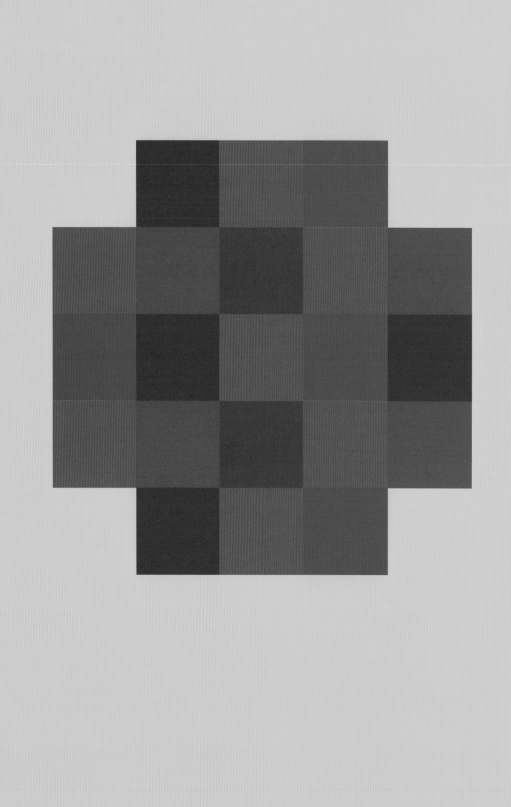

Notes

INTRODUCTION

1. Bender, *Plain and Simple*, 1.
2. Bender, *Plain and Simple*, xi.
3. Bender, *Plain and Simple*, 1, 15, 27–30, 83, 137–41; Weaver-Zercher, "Pursuing Paradise," 97–101.
4. Sara Miller, interview by author, May 10, 2002, IQSCM files, Archives and Special Collections, University of Nebraska–Lincoln. Also see Smucker, Crews, and Welters, *Amish Crib Quilts*.
5. Kraybill, *Riddle*, 44.
6. Kraybill, Johnson-Weiner, Nolt, *The Amish*, 185; Nolt and Meyers, *Plain Diversity*, 1–14. For the most up-to-date information, see *Amish Studies*, Young Center for Anabaptist and Pietist Studies, Elizabethtown College, http://www2.etown.edu/amishstudies/FAQ.asp.
7. Nolt and Meyers, *Plain Diversity*, 7; see also "Organization," *Amish Studies*, Young Center for Anabaptist and Pietist Studies, Elizabethtown College, http://www2.etown.edu/amishstudies/Organization.asp.
8. Nolt and Meyers, *Plain Diversity*, 9, 47. On shunning and excommunication, see Kraybill, *Riddle*, 137–41.
9. Kraybill, *Riddle*, 113–14, 202–26.
10. Hostetler, *Amish Society*, 74–86.
11. Kraybill and Nolt, *Amish Enterprise*, 22–35.
12. David Weaver-Zercher describes how Americans in the late twentieth century came to view the Amish as a "saving remnant" that showed mainstream society how much it had "strayed" from a purer, even "Edenic" state while providing a model for a more authentic way of life. See *Imagination*, 185–89.
13. Kraybill, "Introduction: The Struggle to be Separate," 9; Swank, "From Dumb Dutch to Folk Heroes," 61–63; Weaver-Zercher, *Imagination*, 24–26, 52–60.
14. Weaver-Zercher, *Imagination*, 53–55, 91–104.
15. Weaver-Zercher, *Imagination*, 104–14.
16. In a 2000 survey of visitors to Shipshewana, Indiana, Thomas J. Meyers found that when asked to "free-associate the word *Amish* and other words that came to mind," tourists' top four responses were "a simple life" (36%), "hardworking" (12%), "a peaceful, tranquil life" (12%), and "old-fashioned" (8%). See Meyers, "Amish Tourism," 115–16.
17. See Weaver-Zercher, *Imagination*, 63–78; and Walbert, *Garden Spot*, 48–59.
18. Kraybill, *Riddle*; Nolt and Meyers, *Plain Diversity*, 2–3; Weaver-Zercher, *Imagination*, 185–89. I am particularly grateful to Nao Nomura for sharing insights into contemporary Amish life gleaned while living with an Amish family for most of a year during a Fulbright Fellowship. Her forthcoming work will elucidate how Amish individuals forge personal identities while reinforcing community boundaries through participation in consumer culture.
19. Brandt and Gallagher, "Tourism and the Old Order Amish," 73–74; Kraybill, *Riddle*, 287; Luthy, "Origin and Growth of Amish Tourism"; Walbert, *Garden Spot*, 67–100; Weaver-Zercher, *Imagination*, 82–104. For a recent study of the rhetoric of Amish tourism, see Trollinger, *Selling the Amish*.
20. Kraybill, *Riddle*, 290–91.
21. See J. Baylor Roberts, "Pennsylvania Dutch—In a Land of Milk and Honey," *National Geographic*, July 1938; Elmer C. Stauffer, "In the Pennsylvania Dutch Country," *National Geographic*, July 1941; Richard Gehman, "Amish Folk: Plainest of Pennsylvania's Plain People," *National Geographic*, August 1965.
22. Douglas Lee and Jerry Irwin, "The Plain People of Pennsylvania," *National Geographic*, April 1984, 493, 503, 506, 511–12.
23. Macleish, "Rediscovering the Simple Life," 86.
24. Foster, "Amish Society: A Relic of the Past," 33–37; Schumacher, *Small Is Beautiful*.
25. Downing, "Witnessing the Amish"; Weaver-Zercher, *Imagination*, 154–59; Peter Weir, *Witness* (Paramount Pictures, 1985).
26. Bender, *Plain and Simple*, xii. Beth E. Graybill refers to Bender's *Plain and Simple* as part of a genre she calls "Redemptive Pilgrimages," in which outsiders write about and reflect on their encounters with the Amish in an idealized manner ("Amish Women, Business Sense," 41–42).
27. Weaver-Zercher, "Pursuing Paradise," 99.
28. For a useful description of the choices Amish quiltmakers made when making quilts, see Cunningham, "All in the Details," 39–48.
29. Brackman, *Clues in the Calico*, 165–67. Also see Brackman, *Encyclopedia of Pieced Quilt Patterns*; and Brackman, *Encyclopedia of Appliqué*.
30. Because batting is not visible on a quilt in good condition, it is difficult to know with certainty what a batting is made from. Amish women tended to use commercially available fabrics and in general did not raise cotton or sheep for wool. Brackman, *Clues in the Calico*, 53–54; Granick, *The Amish Quilt*, 48; Pumphery, "The Stearns & Foster Company, 1846–1900."
31. ISM DPC, 71.989.01.420. When referring to specific quilts in museum collections, I use the object's accession number as a reference; see the bibliography for museum abbreviations. Sara Miller, interview.

CHAPTER 1. MADE IN AMERICA

1. See Keyser, "Beds," 12–18.
2. On quilts as both products of industrialization and reactions against it, see Hanson, "Introduction," in Hanson and Crews, eds., *American Quilts*, 1–9.
3. Brackman, *Clues*, 15–16; Holstein, "Aesthetics of Amish Quilts," 80.
4. On the Colonial Revival and quilts, see Gunn, "Perfecting the Past," 228–33.
5. Gunn, "From Myth to Maturity," 196.
6. Berlo, "Acts of Pride," 9–11; Gunn, "From Myth to Maturity," 195–98. Examples of early quilt historians who promulgated this and other myths include Webster, *Quilts*, and Finley, *Old Patchwork Quilts*.
7. Gunn, "Myth to Maturity," 195–98.
8. Studies include Garoutte, "Early Colonial Quilts," 18–27; Keller, "Quilts of Lancaster County"; Prendergast, "Fabric Furnishings"; and Seaman, "Bed Coverings," 9–32.
9. Mohanty, "Woven Documents," 58–59.
10. Brackman, *Clues*, 13–15; Keller, "Quilts of Lancaster County," 276–77.
11. Brackman, *Clues*, 13.

12. Berlo, "Acts of Pride," 10–11; Garoutte, "Early Colonial Quilts," 18–27; Holstein, "Aesthetics of Amish Quilts," 80; Lasansky, "Myth and Reality in Craft Tradition," 115. For an example of the myth at work, see Finley, *Old Patchwork Quilts*, 33.

13. Lasansky, "Myth and Reality," 115. Lasansky points out the geographic differences at work here; in New Mexico in the late nineteenth and early twentieth centuries—the frontier—women had much less access to factory-made cloth and did regularly recycle clothing and reuse feed sacking.

14. Berlo, "Acts of Pride," 10–11. Holstein notes that the backs of quilts are also typically made from one piece of new fabric rather than pieced together from scraps ("Aesthetics of Amish Quilts," 81).

15. Maines, "Paradigms of Scarcity and Abundance," 84; e.g., see IQSC&M #2002.006.0001.

16. Brackman, *Clues*, 16–17; Ordoñez, "Technology Reflected," 146–51. On quiltmaking as a product of industrialization and abundance, see Maines, "Paradigms of Scarcity and Abundance," 84–88. For a helpful and accessible overview of processes that spurred increased quilt-making in the mid-nineteenth century, see R. Shaw, *American Quilts*, 37–43.

17. For a concise overview of the development and dissemination of sewing machines, see Loscalzo, "Sewing Machine," 175–83.

18. Brackman, *Patterns of Progress*, 11, 21–23; Loscalzo, "Sewing Machine," 180.

19. Granick, *Amish Quilt*, 45.

20. Brackman, *Clues*, 18.

21. Brackman, "American Adaptation," 23–24.

22. See Granick, *Amish Quilt*, 29–32, 106–7; Keller, "Quilts of Lancaster County." I have identified only seven dated Amish examples made prior to 1880. An oft-cited 1849–dated example (sometimes listed as 1840) first appeared in Granick; based on my discussion with Granick and her husband, David Wheatcroft, this quilt has a weak provenance originating with a dealer. They do not currently know this quilt's whereabouts. This potential early example needs more analysis before credibly declaring it the earliest known dated Amish quilt. References to it can be found in Granick, *Amish Quilt*, 30, and "Icons of Faith," 16; and Holstein, "Aesthetics of Amish Quilts," 82, and "Plain Art," 22. For a complete list of identified dated Amish quilts, see Smucker, "From Rags to Riches."

 Prior to domestic production of quilts, wealthy British, Europeans, and colonial Americans purchased professionally made quilts, sometimes importing them from India. See Osler, *Traditional British Quilts*, 81–92.

23. Bishop and Safanda, *Gallery*, 22; Pellman and Pellman, *World*, 10, 26.

24. Herr, "Quilts within the Amish Culture," 48. Notably, British scholar Dorothy Osler has recently made the most systematic effort at establishing a link between Welsh quilts and Amish quilts. By examining census records, land deeds, migration patterns, cultural affinities, and stylistic similarities of the quilts made by members of these two groups, she has argued that an accumulation of evidence from these diverse sources supports the assertion that the "visual links between Amish and Welsh quilts are not accidental" (*Welsh Connection*, 133). She most strongly makes this case for Amish quilts made in Lancaster County, Pennsylvania, and in Arthur, Illinois, a daughter community of the Somerset County, Pennsylvania, Amish settlement, which was in close proximity to a Welsh community. Also see Osler, "Spatial Distribution"; Jenkins, *Making Welsh Quilts*.

25. Bishop and Safanda, *Gallery*, 15, 24–25; Holstein, "Aesthetics of Amish Quilts," 98; Pellman and Pellman, *World*, 11.

26. Although there are several early dated whole cloth quilts with Amish attributions, there are also a number of early dated repeated block pieced quilts. Whole cloth examples include one in IQSC&M dated 1868 (2005.055.0001), one at ISM DPC dated 1869 (71.989.001.0423), and two more at IQSC&M dated 1897 and 1898 (2005.0018.0022 and 2003.003.0119). I have identified more than thirty pieced quilts in the date range of 1871 through 1900, suggesting that pieced quilts were more common than whole cloth ones during these early decades of Amish quiltmaking.

27. Keller, "Quilts of Lancaster County," 100–101, 171–72, 270. Keller refutes a commonly held assumption that Pennsylvania German—including Amish—quiltmakers learned and/or adapted the craft from their "English neighbors." See, for example, Bishop and Safanda, *Gallery*, 15; Granick, "Amish Quilts of Lancaster County," 27; Herr, *Amish Quilts of Lancaster County*, 18; Pellman and Pellman, *World*, 40.

28. Patricia Keller plans to further her analysis to assess data specific to Amish households with quilts.

29. Schlabach, *Peace, Faith, Nation*, 22–23.

30. For examples of the theory of Amish quilts originating in eastern Pennsylvania and spreading west, see Bishop and Safanda, *Gallery*, 15; Holstein, "Aesthetics of Amish Quilts," 98.

31. For descriptions of economic hardships Amish settlers faced on the frontier, see Luthy, *Settlements That Failed*; Schlabach, *Peace, Faith, Nation*, 38–46.

32. Luthy, *Amish Settlements*, 9–10, 16–18.

33. Schlabach, *Peace, Faith, Nation*, 39–40; P. Yoder, *Tradition & Transition*, 264. Ricky Clark discusses the similarities among quilts made by various Germanic groups in Ohio, suggesting a related Germanic aesthetic among Amish, Zoarites, Moravians, Brethren, and Swiss Mennonites. See "Germanic Aesthetics," 33.

34. Elsewhere I have published a list of Amish-made quilts with inscribed dates that I have identified in public collections and publications. Of these, only two date to the late 1860s, 5 to the 1870s, 18 to the 1880s, 19 to the 1890s, 26 to the 1900s, 49 to the 1910s, 66 to the 1920s. See Smucker, "From Rags to Riches," 391–407.

35. See statistics in Kraybill, "Struggle," 9; P. Yoder, *Tradition and Transition*, 262–63. Compare this number to the most recent Amish population figures: in 2011 there were an estimated 261,150 Amish (including children) in North America. For current statistics, see "Amish Population Change 2009–2011," Young Center for Anabaptist and Pietist Studies, Elizabethtown College, http://www2.etown.edu/amishstudies/PDF/Statistics/ Population_Change_2009_2011.pdf. On nineteenth-century Amish migration patterns, see Luthy, *Settlements That Failed*; Schlabach, *Peace, Faith, Nation*, 38–46; P. Yoder, *Tradition and Transition*, 264–65. For data on when settlements were established see Luthy, *Amish Settlements*.

36. Kraybill, "Struggle," 9.

37. Schlabach, *Peace, Faith, Nation*, 215–19; P. Yoder, *Tradition and Transition*, 153–70.

38. On the Nebraska Amish schism, see Hostetler, *Amish Society*, 290–92. On quilts made in this community, see Good, *Quilts from Two Valleys*; Granick, *Amish Quilt*, 87–101; Nomura and Smucker, "From Fibers to Fieldwork," 123–55.

 Another example of intentionally conservative quiltmaking has occurred among the group known as the "Swiss Amish," centered in eastern Indiana. They arrived in the Midwest directly from Europe during the 1830s to 1850s, a hundred years after the primary wave of Amish migration to North America. They speak a distinct Swiss dialect rather than the Pennsylvania German spoken by most Amish. The Swiss Amish are not an affiliation of the Old Order Amish. Swiss Amish have tended to hold tighter to tradition and have been more reluctant than Old Order groups to embrace any sort of compromise or adaptation. Swiss Amish quilts traditionally have been plain whole cloth quilts (that is, not using any pieced pattern), a practice that seems to echo these more conservative leanings.

On the Swiss Amish, see Nolt and Meyers, *Plain Diversity,* 101–20. On quilts made by this group, see Granick, *Amish Quilt,* 122–23.

39. As Kraybill notes, it is unclear if ownership of telephones helped provoke the division or only factored into the outcome (*Riddle,* 191). For more on the telephone in Amish life, see Umble, *Holding the Line.*

40. For more on how change and fashion function within Amish culture, see Huntington, "Dove at the Window," 218; and Kraybill, *Riddle,* 69–70, 293–318. On "cultural fences," see 297–98. On quiltmaking as an expression of "nonconformity to the world and its fashions," see Keller, "Quilts of Lancaster County," 324–25.

41. See Kraybill, *Riddle,* 298–99, Amish bishop quoted on 297.

42. Hostetler, *Amish Society,* 39; Kraybill, *Riddle,* 8. Jakob Ammann was the Swiss Anabaptist leader who led the conservative faction in the 1693 schism between Swiss and Alsatian Anabaptists, resulting in the Amish church. For a brief overview of the history of the Amish, see the introduction; for further reading, see Nolt, *History of the Amish.*

43. Amish history is full of schisms that have resulted in distinct Amish denominations that may be more or less conservative than the average Old Order Amish church district. Conservative groups with clear rules limiting quiltmaking patterns and colors include the Swartzentruber Amish of eastern Ohio; the Nebraska (White Topper) Amish of central Pennsylvania; the Troyer Amish, scattered across New York, Pennsylvania, and Michigan; and the Swiss Amish in Indiana and their daughter settlements elsewhere.

44. Holstein sees the motivations prompting Amish women to make quilts as being little different than those prompting other Americans to do so. See his nuanced yet speculative discussion on this point in "Aesthetics of Amish Quilts," 84. Patricia Keller makes similar points in her analysis of why rural Lancaster County, Pennsylvania, women adopted the out-of-fashion craft of quiltmaking once their traditional domestic practice of spinning and other steps in fiber processing was no longer economically viable due to industrialization. She argues that quiltmaking in some ways replaced these outmoded acts and symbolically maintained women's productive role within the home ("Quilts of Lancaster County," 282–305).

45. On Old Order Amish efforts at defining themselves by holding tight to old and out-of-fashion practices, see Juhnke, *Vision, Doctrine, War,* 45–46.

CHAPTER 2. AMISH QUILTS, AMISH VALUES

1. A preliminary, abbreviated version of this chapter appears in Smucker, Shaw, and Cunningham, *Amish Abstractions.* Wingard is quoted in Wagler, *Mighty Whirlwind,* 111; see also Detweiler, *Hammer Rings Hope,* 42–45; "Olen J. Wingard," *Swiss Anabaptist Genealogical Association,* http://saga.ncweb.com/TNG71/getperson.php?personID=I34828&tree=johns.

2. Kraybill, *Riddle,* 154–58; Olshan, "Homespun Bureaucracy," 212.

3. Detweiler, *Hammer Rings Hope,* 45; Wagler, *Mighty Whirlwind,* 194–216.

4. ISM DPC 71.989.001.0371. This quilt is also pictured in McLary, *Amish Style.* Another quilt attributed to Lancaster County was sent to Indiana in a "relief box" for tornado victims. See Pellman and Pellman, *World of Amish Quilts,* 29.

5. Abbie Gertrude Enders Huntington discusses giving away quilts for relief, quoting an Amish woman who helped make quilts intended for this purpose: "I think this will cheer up some poor family that doesn't have a real home. It's nice and bright and warm" ("Dove at the Window," 691).

6. Kraybill, *Riddle,* 29.

7. Kraybill calls the persistence question, "How is a tradition-laden group thriving in the midst of modern life?" the big riddle that his seminal book aims to solve. His answer: "Their dual strategy of *resistance* and *negotiation* has worked, for they have indeed flourished" (*Riddle,* 316–17).

8. Kraybill, *Riddle,* 302–5.

9. For more on this process of innovation and change, see Huntington, "Dove at the Window," 218.

10. In his study of the tensions between asceticism and consumer culture within contemporary Amish society in northern Indiana, Bruce Tharp discusses how desire for products emerges among individuals. He cites the prevalence of shopping at Wal-Mart, interaction with outsiders in the workplace, home shopping parties (like Tupperware and Pampered Chef), and advertising flyers as some of the means through which the Amish learn about new products ("Ascetical Value," 192–97).

11. For contemporary Amish perspectives on how change functioned within their community, see Tharp, "Ascetical Value" 177–88. Also see Huntington, "Dove at the Window," 204, 209, 217; Kraybill, *Riddle,* 298–305.

12. Berlo and Crews, *Wild by Design,* 100; Holland Cotter, "Quilts That Hew to Discipline Even as They Dazzle," *New York Times,* July 9, 1999; R. Shaw, Introduction to *Amish Quilts 1880 to 1940,* 9; "Diversity within Tradition: Amish Quilts at the Met," *Antiques and the Arts Online,* Dec. 2, 2003, http://antiquesandthearts.com/GH-2003-12-02-12-27-29p1.htm.

13. Peterson, "Discourse and Display," 462.

14. See Hostetler, *Amish Society,* 148–9; Kraybill, *Riddle,* 50, 148; Lasansky, *Good Start,* 30–33; Swank, "Proxemic Patterns," 40–42.

15. Quilting is not necessarily an easier skill than piecing, just a significantly different skill. Good piecing requires a solid grasp of geometry and color sense. Quilting, on the other hand, requires the ability to use a needle, thimble, and thread and can more easily be picked up for a short stint. Many Amish women interviewed by Rachel Pellman recalled hiring out the piecing and then holding quilting frolics to complete the bedcoverings. See Mary Beiler, interview by Rachel Pellman, Jan. 12, 2005, LQTM; Mary Esh, interview by Rachel Pellman, Oct. 13, 2004, LQTM; Sadie Esh, interview by Rachel Pellman, Feb. 27, 2004, LQTM; Mary Glick, interview by Rachel Pellman, Apr. 8, 2004, LQTM; Lydia Huyard, interview by Rachel Pellman, Mar. 29, 2005, LQTM. Also see C. Hornberger, "Amish Quilter," 33; Lasansky, *Good Start,* 34. A division of labor also occurred among some Amish (Black Topper) in Big Valley, Pennsylvania. Barbara C. Peachey really liked to piece quilts for her grandchildren, which other family members quilted (Mifflin County Mennonite Historical Society Quilt Exhibition, October 2008).

16. Rebecca Esh, interview by Rachel Pellman, Jan. 6, 2005, LQTM; Elizabeth Zook, interview by Rachel Pellman, July 27, 2006, LQTM.

17. Mary King and Lizzie Zook, interview by Rachel Pellman, Aug. 14, 2006, LQTM; "Malinda F. Stoltzfus," *Swiss Anabaptist Genealogical Association,* Hostetler Database, http://saga.ncweb.com/TNG71/getperson.php?personID=I86342&tree=Hostetler.

18. See Granick, *Amish Quilt,* 168–72; Lasansky, *Good Start,* 34. Miriam Hostetler, conversation with the author, May 5, 2004.

19. Stoltzfoos recalled that it was not common to hire out quilting services. Hannah Stoltzfoos, interview by Rachel Pellman, Feb. 2, 2004, LQTM.

20. See Granick's interviews with Amish women, Eve Wheatcroft Granick Collection on Quilts, MS 327 B2, Archives and Special Collections, University of Nebraska–Lincoln Libraries.

21. Mary Beiler, interview.

22. See Lasansky, *Good Start,* 32–34; Swank, "Proxemic Patterns," 42.

23. Mary Beiler, interview.

24. Harding, "Quilts: America's Folklore," 64–65; Lipsett, *Remember Me.*

25. Lipsett, *Remember Me,* 23. For examples of turn-of-the-century friendship quilts with embroidered names, see Kiracofe and Fox, *Going West!*

26. First published in Haders, *Sunshine and Shadow,* the quilt is now owned by IQSC&M. Also see friendship quilts published in Pellman and Pellman, *World,* 106–8.

27. On motivations for migration, see Nolt and Meyers, *Plain Diversity,* 32–34.

28. ISM DPC 71.989.001.0403 and 71.989.001.0404; "Lewis Edward Harshberger," *Swiss Anabaptist Genealogical Association, Hostetler Database,* http://saga.ncweb.com/TNG71/getperson.php?personID=I29042&tree=Hostetler. Martha Helmuth's 1956 quilt features friendship blocks from friends in Indiana, Kentucky, Michigan, Ohio, Iowa, Pennsylvania, Kansas, and Virginia. See quilt and corresponding materials at Heritage Historical Library, Aylmer, Ontario.

29. Other spool friendship quilts include one made for John Hershberger and Fannie Nisley in the Mennonite Historical Library, Amish and Mennonite Museum Collection, Goshen College, and one pictured in Pellman and Pellman, *World,* 106–7.

30. ISM DPC 71.989.001.0233; Granick, *Amish Quilt,* 155.

31. ISM DPC, 71.989.001.0220.

32. Hostetler, *Amish Society,* 249–51.

33. ISM DPC, 71.989.001.0319. A String Star quilt was given to Albert J. Lehman's daughter when her home burned around 1920. See ISM DPC 71.989.001.0273.

34. Aaron and Mary King, interview by Rachel Pellman, Jan. 26, 2006, LQTM; Kraybill, *Riddle,* 157–8; "Christian Aid Ministries," *Anabaptists,* www.anabaptists.org/places/cam/; Sara Miller, interview by author, May 10, 2002, IQSC&M files, Archives and Special Collections, University of Nebraska-Lincoln.

35. Mennonite Central Committee began selling Mennonite- and Amish-made quilts at its annual regional relief sales beginning in the 1960s, around the same time the Gordonville Fire Company's Spring Auction was established. See Klimuska, "Men Raise Barns," 7–8; Klimuska, "Aprons Aside," 38–40; Klimuska, "300 New Quilts at Auction," 33; Kraybill, *Riddle,* 157–58; Legeret and Legeret, *Quilts Amish,* 9; Jacques Legeret to author, March 31, 2009; Parrish, "Imports"; Griselda Shelly, "Relief Sales," *Global Anabaptist Mennonite Encyclopedia Online,* 1989, www.gameo.org/encyclopedia/contents/R459ME.html/?searchterm=relief%20sale; Smith, "Women's Mission to Stitch."

36. ISM DPC, 71.989.01.285, 71.989.01.286, 71.989.001.0991, and 71.989.001.0231; Pottinger, *Quilts from the Indiana Amish,* 23.

37. ISM DPC, 71.989.01.336; McLary, *Amish Style,* 84.

38. Granick, *Amish Quilt,* 76; Herr, "Quilts within the Amish Culture," 59.

39. *The Lancaster County Quilt Harvest* was one of many local, regional, and state quilt documentation projects that collected data on quilted bedcoverings during the 1980s and 90s. The Lancaster project documented approximately 1,600 quilts made or used in Lancaster County prior to 1942. Sponsored by the Heritage Center Museum of Lancaster County and directed by Patricia Keller, the project field workers documented local quilts during 1988 and 1989. When possible, they recorded family histories of the quilts. See Herr, *Quilting Traditions,* 4–5; Keller, "Quilts of Lancaster County," 36, 165.

40. Mary Esh, interview; Sadie Esh, interview; Annie Glick and Mary Esh, interview by Rachel Pellman, Feb. 13, 2004, LQTM; Daniel Lapp and Orpha Lapp, interview by Rachel Pellman, Nov. 19, 2004, LQTM; Leah Lapp, interview by Rachel Pellman, Apr. 12, 2005, LQTM; Edna Petersheim, interview by Rachel Pellman, Sept. 29, 2004, LQTM; Moses Smucker and Susie Smucker, interview by Rachel Pellman, Mar. 26, 2004, LQTM; Arie Stoltzfus, interview by Rachel Pellman, Mar. 3, 2004, LQTM; Fannie Stoltzfus, interview by Rachel Pellman, Feb. 4, 2004, LQTM.

41. Patricia Herr notes that all known Lancaster County Amish Baskets quilts were likely made by Mary Stoltzfus Lapp (1875–1955),

her sister Barbara Stoltzfus Glick (1879–1949), or Sarah Stoltzfus (1923–2005). See Herr, *Quilting Traditions,* 58, 60; Herr, "Quilts within the Amish Culture," 59, 61; Sarah Stoltzfus and Emma Stoltzfus, interview by Rachel Pellman, Oct. 27, 2004, LQTM. Additional information from files/interviews conducted by Patricia Keller, Lancaster Quilt Harvest.

42. Sadie Esh, interview; Glick and Esh, interview.

43. Brackman, *Pieced Quilt Patterns.* In Eve Wheatcroft Granick's summaries of interviews with elderly quiltmakers, several women recalled that they adapted patterns from *Farmer's Guide, Farmer's Wife,* and other published sources. See *The Amish Quilt,* 173. Aside from this reference, most authors writing about Amish quilts have ignored the possibility that Amish women used commercial patterns, preferring to imagine their quiltmaking practices untainted by the commercial world. This changed with Janice Tauer Wass's observations about the significant influence of commercially available patterns on Illinois Amish quiltmakers (*Illinois Amish Quilt,* 29–32).

44. Quilt scholars have called this era the "twentieth century's first quilt revival" because of the outpouring of quilts made by American women and the many commercially available products that fueled the popular craft (e.g., Benberry, "First Quilt Revival"; Gunn, "Perfecting the Past," 228–86).

A number of commercially published patterns owned by Amish women are now in ISM DPC and the Illinois Amish Quilt Collection, Illinois State Museum. For an inventory of patterns in the Illinois collection, see Wass, *Illinois Amish Quilts,* 156–58. A Kansas Amish woman recalled using the patterns published by the *Kansas City Star* (published from 1928 through 1960 and syndicated in *Weekly Kansas City Star* and *Weekly Star Farmer*); see Barbara Chupp, interview by Eve Wheatcroft Granick, Mar. 19, 1984, MS 327 B2, EWG UNL; Brackman, *Encyclopedia of Applique,* 182. As part of the Ohio Quilt Research Project, Ricky Clark found that Amish in Ohio also used published patterns ("Germanic Aesthetics," 42). A worn copy of a Ladies Art Company catalog, c. 1950, once owned by an Amish woman, Mrs. Noah Hostetler, is now in the collection of George and Susan Delagrange. The author thanks Connie Chunn for her assistance in dating Ladies Art Company materials. Chunn freely shares her research on the quilt pattern company at her website, http://ladiesartcompany.com.

45. ISM DPC 71.989.001.0315, by Anna Christner Miller, c. 1931–33. A whole cloth quilt is assembled from yardage of only one fabric rather than pieced in a pattern; Amish often have called this a "plain quilt." On the Wilkinson Quilt Company, see Goldman, "Wilkinson Quilt Company," 131–61. The business operated from 1908 through 1943; known catalogs were published in the 1910s, 1920s, and 1930s.

46. Barbara Brackman, *Pieced Quilt Patterns,* 4–6; 524–25; Kiracofe, *American Quilt,* 226–27; Stearns & Foster Company, *Catalogue,* 6; Waldvogel, "Mountain Mist Patterns," 95–138.

47. Miriam Stoltzfus, interview by Rachel Pellman, Jan. 18, 2006, LQTM. Stoltzfus grew up in the Old Order Amish church, but in 1968 as an adult joined the less strict Beachy Amish church. Katie Zook of Leola, Pennsylvania, remembered the appliqué quilt her mother made her in the late 1930s. Other hand-appliquéd quilts include Pots of Flowers, IQSC&M, Ardis and Robert James Collection, 1997.007.0558; Tulip, Dr. and Mrs. Donald and Patricia Herr, c. 1938–42 (see image in Herr, *Amish Quilts of Lancaster County*); Pots of Tulips, Lizzie Hochstetler Harshberger, 71.989.01.405; Tulips, Lizzie Hochstetler Harshberger, 71.989.01.409, dated 1932, both in ISM DPC; and Illinois quiltmaker Sally Briskey Stutzman's c. 1940 Potted Star Flower quilt, using a visible running stitch rather than a hidden appliqué stitch, Illinois State Museum, 1998.152.16. See Wass, *Illinois Amish Quilts,* 146–47. Machine appliquéd examples include Pot of Flowers by Mary J. Christner, dated 1937, ISM DPC,

71.989.001.0248; North Carolina Lily, c. 1920–40, 2000.007.0074; and Baskets, c. 1920–1940, 2000.007.0088, both in IQSC&M, Sara Miller Collection. A particularly unusual example is by Cora Etta Hershberger, c. 1932, and features an appliqué design on one side of the quilt and a pieced Irish Chain on the other side. The appliqué stitching is of poor quality. Reversible quilts are not uncommon. My first reaction upon seeing this quilt was that she wanted to be able to hide her worldly appliqué pattern, but perhaps she was unhappy with the results of her appliqué attempt because her stitches were large and visible and the figures were clunky. See ISM DPC, 71.989.01.407. On Amish appliqué, also see Joseph Sarah to Ardis James and Robert James, June 29, 1990, IQSC&M, administrative file, 1997.007.0558; Herr, *Amish Quilts of Lancaster County.*

48. Joe Sarah to Ardis James, Jan. 25, 1989, IQSC&M, administrative file, 1997.007.0337; Pellman and Pellman, *World,* 122. Another Amish woman recalled that in the 1940s her mother shopped for fabric remnants—a small amount of fabric left on a bolt and sold at a reduced price—when she needed something special for a particular quilt. Katie Stoltzfus, interview by Rachel Pellman, Oct. 19, 2004, LQTM. Another quiltmaker acquired fabric scraps from a local garment factory, including some with printed designs. She used these leftovers to make Lone Star quilts for her eight children during the 1950s and 1960s. Katie Fisher, interview by Rachel Pellman, Mar. 22, 2004, LQTM. Another Amish woman recalled buying remnants because they were cheaper. Barbara Beiler, interview by Rachel Pellman, Feb. 4, 2004, LQTM.

49. On feed and flour sacks as "dual-use packaging," see Strasser, *Waste and Want,* 211–15. Strasser describes how manufacturers encouraged reuse of bags by including instructions for how best to remove the label and promoting a variety of potential uses for the cotton fabric from these bags. Some manufacturers sold their products in bags made from fabric printed with cheery designs. These bags made their way into many American quilts and likely appear on the backs of some Amish quilts. Amish women interviewed by Rachel Pellman and Eve Granick recalled using feed sacks to make clothing, bedding, towels, and quilts. See Granick, *Amish Quilt,* 172–73; Huyard, interview; Mary Lapp, interview by Rachel Pellman, Feb. 19, 2004, LQTM; Leroy Smucker and Elizabeth Smucker, interview by Rachel Pellman, Mar. 10, 2005, LQTM; Mary Yutzy Nissley, "Fabric Notebook," 1933, MS 327 B2, EWG UNL. Also see Elizabeth Miller's well-documented quilt pieced from feed sacks in the collection of the Heritage Historical Library, Aylmer, Ontario. See Luthy, "Only Thread and Time"; ISM DPC, 71.989.001.0456.

50. Susanna Miller Raber, Double Wedding Ring, ISM DPC, 79.989.01.0444.

51. See Granick, *Amish Quilt,* 169–70, 173–74; Herr, *Amish Quilts of Lancaster County,* 24; Herr, "Quilts within the Amish Culture," 56; Katie Stoltzfus, interview; David Wheatcroft and Eve Granick, interview by author, Westborough, MA, Sept. 19, 2008, digital recording in author's possession. For examples of quilts with printed fabrics for backs, see Berlo and Crews, *Wild by Design,* 100–101; Herr, *Amish Quilts of Lancaster County,* 42, 64, 70, 80, 82, 110, 130, 162, 172, 186.

52. Jonathan Holstein, "Amish Quilts for Esprit Collection, Julie Silber, Curator," 1986, SPEC MS 305, B3F9, JHP UNL; Zebrowski, "Any Amish Quilts," 128.

53. Granick, *Amish Quilt,* 172, 180–4.

54. Unnamed Amish woman quoted in Herr, "Quilts within the Amish Culture," 56.

55. Fabric swatches, IQSC&M, Jonathan Holstein Collection. Another collection is in the Eve Wheatcroft Granick Collection on Quilts,

Archives and Special Collection, University of Nebraska-Lincoln. Examples of Amish wedding dress fabric collections are also highlighted in Frye, *Handmade Legacy,* 19; Granick, *Amish Quilt,* 53. I also learned about this practice from Wheatcroft and Granick, interview.

56. Mary Yutzy Nissley, "Fabric Notebook," 1933–1960, MS 327 B2, EWG UNL; Granick, *Amish Quilt,* 53. In Granick's papers, this notebook is unattributed. Using the children's and husband's names as identified on the fabric swatches, Granick's notes from interviews with Amish women, and a genealogy database, I was able to determine that Nissley assembled the notebook. See "Mary Yutzy," *Swiss Anabaptist Genealogical Association, Hostetler Database,* http://saga.ncweb.com/TNG71/getperson.php?personID= I47024&tree=Hostetler; Mrs. Andy Nissley, interview by Eve Wheatcroft Granick, MS 327 B2, Eve Wheatcroft Granick, Collection on Quilts, Archives & Special Collections, University of Nebraska-Lincoln Libraries.

57. ISM DPC, 71.989.001.0379. Scholar Susan Stewart refers to objects' ability to substitute for experiences or memories as metonym (*On Longing,* 135–56).

58. Tharp, "Ascetical Value," 247.

59. See ISM DPC, 71.989.01.258; Miriam Stoltzfus, interview.

60. ISM DPC, 71.989.01.323. Upon her mother's death, Mrs. Andy Miller discovered a number of quilts stored away in a chest. She contacted David Pottinger to see if he was interested in buying the quilts prior to the family sale.

61. Benuel Riehl, interview with the author, May 13, 2008. Quilts were valued this high in the collecting market based in New York City during the mid- to late 1980s.

62. Wheatcroft and Granick, interview.

63. ISM DPC, 71.989.001.0236.

64. Quoted in Karen Heller, "The Fancy Quilts of the Plain People," *Philadelphia Inquirer Magazine,* Jan. 25, 1987, 22.

65. Barbara Beiler, interview.

66. See interviews with Amish quiltmakers conducted by Rachel Pellman between 2004 and 2006, LQTM, and objects in ISM DPC.

67. David Pottinger and Faye Peterson, interview by author, Goshen, IN, May 22, 2008, digital recording in author's possession.

68. Pottinger and Peterson, interview.

CHAPTER 3. OFF OF BEDS AND ONTO WALLS

1. Jonathan Holstein, interview by author, Cazenovia, NY, Nov. 9, 2007, digital recording in author's possession.

2. Carol Brock, "The Quilting Party," *New York Sunday News,* Mar. 18, 1973; Holstein, *Abstract Design in American Quilts: A Biography of an Exhibition,* 16 (referred hereafter to as *Biography of an Exhibition*); Nash, "Gail van der Hoof," 142–43. Although Gail van der Hoof's (1943–2004) contributions likely equal Holstein's, she left less of a written record. As a frequently published writer, Holstein's voice often overshadows van der Hoof's. The couple married in 1973 and divorced in 1991.

3. "New York School" is the commonly used term for the avant-garde artists working in New York during the postwar era when American artists for the first time gained international prominence. Many of these artists worked in the style called "abstract expressionism."

4. Colgan, "Collecting Quilts," 51; Holstein, *Biography of an Exhibition,* 15, 17–18, 20; Holstein, *Pieced Quilt,* 113; Holstein, interview. "Op Art," *The Concise Oxford Dictionary of Art Terms,* Oxford Art Online, www.oxfordartonline.com. A journalist for *Time* coined the term "op art" in 1964.

5. Holstein, interview; Holstein, *Biography of an Exhibition*, 20–21. Although $12 sounds like very little money today, when converted to 2009 prices using the Consumer Price Index it equals about $74.

6. Holstein, interview.

7. Holstein, interview. Although this particular quilt has been exhibited and published with frequency, no book or exhibition has referred to the initials "S.L." subtly quilted in one corner. I discovered theses initials when examining the quilt at the IQSC&M (see fig. 8.9). As it is one of the best-known Amish quilts, it is unfortunate that this slim bit of information about the quilt's provenance has been neglected in favor of treating it solely as an art object. Publications of this quilt include Ducey, *The Collector's Eye*; Holstein, *Abstract Design*; Holstein, *American Pieced Quilts*; Holstein, *Biography of an Exhibition*; Lipman and Winchester, *Flowering*.

8. Holstein, interview. See IQSC&M, Jonathan Holstein Collection, 2004.004.0014.

9. Holstein, interview.

10. Holstein, *Abstract Design*, 10.

11. Holstein uses some of this language in his catalog essay for *Abstract Design*. On Holstein's adoption of Greenberg's ideas, see Peterson, "Discourse and Display," 474. Also see Auther, "Decorative," 339–64.

12. Holstein, *Biography of an Exhibition*, 20, 27; Holstein, *Pieced Quilt*, 8.

13. Auther, "Fiber Art," 21; Gordon, "Intimacy and Objects," 244.

14. Holstein, *Pieced Quilt*, 8; Holstein, *Biography of an Exhibition*, 34.

15. Holstein, *Biography of an Exhibition*, 27–31; Holstein, "The Whitney and After", 82.

16. Holstein, *Biography of an Exhibition*, 36, 39.

17. Holstein, *Biography of an Exhibition*, 44.

18. Holstein, *Biography of an Exhibition*, 43; Hilton Kramer, "Art: Quilts Find a Place at the Whitney," *New York Times*, July 3, 1971, 22. Kramer served as *NYT* art critic from 1965 through 1982, at which time he resigned from the *Times* to found the neoconservative journal of arts and culture, *The New Criterion*. Additional reviews include John Gruen, "Sophisticated Primitives"; Janet Malcolm, "On and Off the Avenue: About the House," *New Yorker*, Sept. 4, 1971, 59–62; David Shapiro, "American Quilts," *Craft Horizons* (Dec. 1971): 42–45, 72; Elisabeth Stevens, "Lounging and Looking in Fun City," *Wall Street Journal*, July 26, 1971.

19. Stevens, "Lounging and Looking."

20. Janet Malcolm, "On and Off the Avenue: About the House," *New Yorker*, Sept. 2, 1974, 68.

21. Anthony Julius, "Minister of Culture," *New York Times*, Dec. 31, 2006, Sunday Book Review, 22; Kramer, "Quilts Find a Place," 22.

22. Holstein, *Abstract Design*; Holstein, *Biography of an Exhibition*, 35–36, 54–55.

23. Greenstein went on to become one of the most prominent quilt dealers in New York City. Thomas Woodard and Blanche Greenstein, interview by Marsha MacDowell, Oct. 28, 2003, Quilt Treasures, Project of the Alliance for American Quilts and Michigan State University Museum, and MATRIX: Center for Humane, Arts, and Social Sciences Online, www.allianceforamericanquilts.org/treasures/main.php?id=15.

24. Examples include "The Joy of Quilting," *Newsweek*, Jan. 10, 1972; "Craze for Quilts," *Life*, May 5, 1972; Sarah Booth Conroy, "Modern Art Expressed in Quilting," *Washington Post Service*, 1972 [printed in local and regional newspapers on various dates]; "Comeback of the Quilt," *Reader's Digest*, March 1974.

25. Holstein, *Biography of an Exhibition*, 57, 59, 216–17.

26. Holstein, interview.

27. Holstein, *Pieced Quilt*, plates 38–39. Quilt expert Barbara Brackman has studied published sources of quilt patterns to determine when pattern names were first published. As she notes, "pattern names,

like all vocabulary, change over time. The right name for a pattern is what you call it." Many names originated during the late twentieth century's "quilt revival," including Sunshine and Shadow, which Holstein was the first to mention in print in *The Pieced Quilt* (1973). His book is also the first published mention of Center Square and Center Diamond, both patterns common to Lancaster County Amish. The Amish used to call quilt patterns by local names in their Pennsylvania German dialect but now usually use the names from published sources (Holstein, interview). See Brackman, *Pieced Quilt Patterns*, 4, 286. On Lancaster County Amish use of pattern names, see Rachel Pellman's interviews with Amish quiltmakers, archived at the Lancaster Quilt and Textile Museum, Lancaster, PA.

28. Holstein, *Pieced Quilt*, cover.

29. Holstein, *Biography of an Exhibition*, 90.

30. Holstein, *Pieced Quilt*, 114.

31. Alloway, *Systemic Painting*; Gruen, "Sophisticated Primitives," 60, Holstein, *Pieced Quilt*, 115; Hunter and Jacobus, *Modern Art*, 320.

32. Holstein, *Pieced Quilt*, 115.

33. Quoted in Jean Lipman, *Provocative Parallels*, 144.

34. Halle, *Inside Culture*, 128–31.

35. Holstein, *Pieced Quilt*, 116.

36. Rohrer, "My Experience with Quilts (A Bias)." Also see Rohrer's paintings in Rosenberg, *Warren Rohrer* and Stein, *Warren Rohrer*, including the work, *Amish 5* in the latter.

37. Patricia T. Herr, interview by author, Lancaster, PA, October 23, 2007, digital recording in author's possession.

38. Art museums hosting exhibitions of Amish quilts include the Brandywine River Museum (1976); Institute of Contemporary Art, University of Pennsylvania (1976); University of Louisville Fine Arts Department (1979); Henry Art Gallery, University of Washington (1981); Georgia Museum of Art (1981); University of Michigan Museum of Art (1982); Nassau County Museum of Fine Art (1985); Smithsonian American Art Museum's Renwick Gallery (1987, 2000); Midwest Museum of Art (1989); Minneapolis Institute of Arts (1989); Allentown Art Museum (1989); Speed Art Museum (1992); Spencer Museum of Art, University of Kansas (2002); Sheldon Art Gallery, University of Nebraska-Lincoln (2005); Denver Art Museum (2005); de Young Museum (1990, 2009–10).

39. Smith, "Downsizing in a Burst of Glory," *New York Times*, May 12, 2011.

40. Hughes, *American Visions*, 43–44.

Chapter 4. Folk Art and Women's Work

1. Auther, *String, Felt, Thread*, xi, xxi, 128, 201 n. 69. See Museum of Contemporary Crafts, *Fabric Collage*. The quilts on display at the 1965 Museum of Contemporary Crafts exhibit were loaned by the Newark Museum, the Museum of the City of New York, and the Brooklyn Museum. Based on the pattern names in the exhibition checklist, all of the exhibited quilts were likely pieced rather than appliqué. Also see Rhode Island School of Design Museum of Art, *Mountain Artisans*.

2. "Cooper's Bedroom," *Vogue*, Feb. 1970. Photographs of Vanderbilt's quilt-covered space have been republished in Goodman, *World of Gloria Vanderbilt*. Not coincidentally, Vanderbilt was raised in part by her aunt, Gertrude Vanderbilt Whitney, who founded the Whitney Studio Club, precursor to the Whitney Museum of American Art, which hosted the first exhibit of American folk art in 1924. See Rumford, "Uncommon Art," 15.

3. See *The Concise Oxford Dictionary of Art Terms*, Oxford Art Online, s.v. "folk art." www.oxfordartonline.com (accessed Nov. 7, 2008).

4. Rumford, "Uncommon Art," 14–15; Stillinger, "From Attics," 52–53; Vlach, "Holger Cahill," 151–52.

5. Eaton, *Material World*, 168–70.

6. Cahill and Wellman, "American Design," 15; Christensen, *Index of American Design*; "Pennsylvania Dutch Furnishings for your Country Home," *House and Garden* (Dec 1942): 56; Tuttle, "Picturing."

7. Initially called the Museum of Early American Folk Art, it changed its name to the Museum of American Folk Art in 1966, and to American Folk Art Museum in 2001. These names reflect the museum's changing scope, since it no longer limited its collecting to "early" antique pieces or American pieces. In the last several years, the museum has fallen on particularly hard times, having sold its building in favor of exhibiting in a smaller location and placing much of its collection in storage. See Ardery, *Temptation*, 174; Brody, "Building of a Label," 257–76; Fine, *Everyday Genius*, 41, 253; Robin Pogrebin, "With Help From Friends, Folk Art Museum Will Stay Open," *New York Times*, Sept. 21, 2011.

8. Auther, "Fiber Art," 24. On this "pastoral" understanding of craft in the 1960s, see Adamson, *Thinking Through Craft*, 106, 121–26. For more on the craft revival of the 1960s and 70s, see Auther, *String, Felt, Thread*, 25–28.

9. Adamson, *Thinking Through Craft*, 5, 150–58; Auther, "Fiber Art," 18, 21, 27.

10. Adamson, *Thinking Through Craft*, 150–51; Auther, *String, Felt, Thread*, 93–162; Mainardi, "Quilts," 1, 18–23.

11. Ardery, *Temptation*, 101–73; Deloria, "Counterculture Indians," 159–88; Lewis, *Mountain Artisans*, vii.

12. Agnew, *Back From the Land*; Berlo, "Acts of Pride," 7: Jacob, *New Pioneers*.

13. Among other rural areas, this occurred in both Amish country and Appalachia. See Bender, *Plain and Simple*; Lewis, *Mountain Artisans*. On the relationship of craft and the pastoral within countercultural back-to-the-land movements, see Adamson, "Craft Paradigms," 89–98.

14. Reich, *Greening of America*, 256.

15. T. Miller, *60s Communes*, 120.

16. Ardery, *Temptation*, 51–54; Barker, *Handcraft Revival*, 66–109; Lewis, *Mountain Artisans*; Rita Reif, "If Only Liberace Would Quilt the Roof of His Car," *New York Times*, June 25, 1971, 41.

17. Callahan, "Helping the Peoples," 23; Livingston, "Reflections," 54.

18. Gary Hunt quoted in Scheper-Hughes, "Anatomy of a Quilt," 94.

19. Callahan, "Helping the Peoples," 26; Livingston, "Reflections," 54.

20. Callahan, "Helping the Peoples," 27; Livingston, "Reflections," 54; Rita Reif, "Quilting Co-op Tastes Success, Finds it Sweet," *New York Times*, Apr. 18, 1969, 47.

21. Beardsley, "Freedom Quilting Bee," 182.

22. The Rockefeller family has had a long interest in preserving American art, antiques, and folk art. John D. Rockefeller, Jr. and his wife Abby Aldrich Rockefeller founded Colonial Williamsburg in 1927. Abby Aldrich Rockefeller was instrumental in founding the Museum of Modern Art (MOMA) in 1929. Her collection of folk art is housed in the museum named after her, now part of the Colonial Williamsburg complex.

23. Lewis, *Mountain Artisans*, 48, 60, 69; Museum of Art, Rhode Island School of Design, *Mountain Artisans*, 15, 17.

24. Lewis, *Mountain Artisans*, 58, 75, 82; Museum of Art, Rhode Island School of Design, *Mountain Artisans*.

25. Curry, "Time Line," 195–99; Metcalf, "Politics of the Past," 28–30; Murray, "Beyond American Folk Art," 58; Rumford, "Uncommon Art," 13–53. Some of the first exhibits highlighting "folk art" were the Whitney Studio Club's (the precursor of the Whitney Museum) *Early American Art* (1924) and the Newark Museum's *American Primitives: An Exhibit of the Paintings of Nineteenth-Century Folk Artists* (1930).

26. Rumford, "Uncommon Art," 14–21.

27. Curry, "Slouching Towards Abstraction," 64; Metcalf, "Politics of the Past," 30.

28. Lipman and Winchester, *Flowering*, 8.

29. Curry, "Rose-Colored Glasses," 24–41; Curry, "Slouching," 62; Holstein, interview; Holstein, *Biography of an Exhibition*, 92; Lipman, *American Primitive Painting*; Winchester, "Antiques for the Avant Garde," 64–73.

30. Lipman and Winchester, *Flowering*, 6, 274. "Stripe painters" is a contemporary term used synonymously with "color field painters." See examples by Noland and Newman in figs. 3.8 and 3.10 above.

31. I use "anonymous" reluctantly. When an unsigned quilt was in an Amish home, the quilt was not anonymous. It only became anonymous when it was detached from its cultural origins.

32. Brody, "Building of a Label," 259–60; Murray, "Beyond American Folk Art."

33. For example, see Rita Reif, "Amish Quilts Abound; Vibrant Color and Wit Mark Patchworks," *New York Times*, July 14, 1974.

34. Examples of such folk art collectors include Abby Aldrich Rockefeller's collection now at the museum named for her at Colonial Williamsburg, Herbert Hemphill Jr.'s collection now at the Smithsonian American Art Museum, and Ralph Esmerian's collection at the American Folk Art Museum.

35. Winterthur Museum, *Beyond Necessity Guide*, unpaginated.

36. Ames, *Beyond Necessity*, 11; Winterthur Museum, *Beyond Necessity Guide*.

37. Swank, Introduction to Quimby and Swank, *Perspectives on American Folk Art*, 2.

38. Ames, *Beyond Necessity*, 16, 19, 21.

39. Mainardi, "Quilts," 1. See also Ames, *Beyond Necessity*, 63–64; Berlo, "Acts of Pride," 6–7.

40. Mainardi, "Quilts," 1, 22.

41. Holstein, interview.

42. Swank, Introduction, 1–12.

43. Ardery, *Temptation*, 210–14; Murray, "Beyond American Folk Art"; Swank, Introduction, 6–7. Winterthur invited Holstein to participate in a multimedia presentation on a variety of approaches to looking at folk art. Sandra Mackenzie to Jonathan Holstein, Feb. 16, 1977, SPEC MS 305, B2F7, JHP UNL.

44. Broude and Garrard, "Feminism and Art," 10. For an extensive discussion of feminist interpretations of the divide between art and craft, see Auther, *String, Felt, Thread*, 93–162.

45. Shapiro, "Geometry and Flowers," 26.

46. Mainardi, "Quilts," 21, 22.

47. Chicago, *The Dinner Party*; Robinson, *The Artist and The Quilt*. On needlework and feminist art, see Berlo, "Acts of Pride," 7–8; Bernick, "Stands Up Like a Man," 141; Broude and Garrard, "Feminism and Art," 24.

48. Julie Silber, interview by author, Albion, CA, Aug. 16, 2008, digital recording in author's possession.

49. Holstein, *Abstract Design*; Ferrero, Reuther, and Silber, "A Legacy of Hearts and Hands, Project Proposal," 1984, SPEC MS 305, B3F3, JHP UNL; Frye, *Handmade Legacy*; Stewart McBride, "Quilts: Biographies Written Stitch by Stitch," *Christian Science Monitor*, Apr. 22, 1981; Silber, interview.

50. Cooper and Buferd, *Quilters: Women and the Domestic Art*, 15–18.

51. Related to the newfound interest in the artistic merits of quilts was a renewed interest in making quilts. Quilt collecting, quilt exhibits, and quiltmaking are all part of what quilt scholars now call the "quilt revival" of the late twentieth century. Three major stimuli for the quilt revival were *Abstract Design in American Quilts*, feminist interest in quilts, and the American Bicentennial. See Berlo, "Acts of Pride," 6–8; Laury, "The 1970s," 52–55.

52. Hall-Patton, "Jean Ray Laury," 65–66, 74; Laury, *Appliqué Stitchery;* Laury, *Quilts & Coverlets;* Laury, "The 1970s," 54.

53. Berlo, "Acts of Pride," 6–7; Hall-Patton, "Quilting Between the Revivals."

Chapter 5. The Fashion for Quilts

1. Hughes and Silber, *Amish: the Art of the Quilt,* 23–24.

2. Marilynn Johnson [Bordes] to author, July 11, 2008.

3. Marilynn Johnson Bordes, *Great Quilts;* Rita Reif, "Antiques: Quality Quilts," *New York Times,* June 8, 1974; Jonathan Holstein to Marilynn Johnson, July 18, 1973, SPEC MS 305, B1F11, JHP UNL; Jonathan Holstein to Marilynn Johnson Bordes, Aug. 11, 1973, SPEC MS 305, B1F12, JHP UNL. The Metropolitan paid Holstein and van der Hoof $1500 for one quilt and $325 for another. The museum may have also purchased additional Amish quilts from the couple.

4. Bordes, *Great Quilts,* 1–2.

5. Bordes, *Great Quilts,* Plate 11. The second quilt Bordes identified as an Amish example was later attributed to a Quaker maker. See Amy Finkel, interview by author, Philadelphia, PA, May 15, 2008, digital recording in author's possession; *Pennsylvania Quilts.*

6. Finkel, interview; *Pennsylvania Quilts.*

7. Victoria Donahue, "Amish Quilts and Abstract Art Blended at ICA," *Philadelphia Inquirer,* Aug 8, 1976, 11–D; Institute for Contemporary Arts, invitation to *Made in Pennsylvania,* June 9, 1976, SPEC MS 305, B8F8 JHP UNL.

8. Holstein, interview.

9. "Craze for Quilts," 75.

10. "Craze for Quilts," 75–77. For more on the Freedom Quilting Bee see Callahan, *Freedom Quilting Bee.*

11. Sarah Booth Conroy, "Modern Art Expressed in Quilting," *Washington Post Wire Service,* published at various dates in late 1972 and 1973; "Craft Comeback," 114; Holstein, interview.

12. Holstein, interview.

13. Mrs. Stanley R. Smith to Jonathan Holstein, Jan. 15, 1972, SPEC MS 305, B1F7, JHP UNL; Abby S. Riley to Whitney Museum, Jan. 24, 1972, SPEC MS 305, B1F7, JHP UNL; Jonathan Holstein to Abby S. Riley, Feb. 5, 1972, SPEC MS 305, B1F7, JHP UNL; Mrs. Donald Judkins to Jonathan Holstein, Jan. 14, 1972, SPEC MS 305, B1F7, JHP UNL; Mrs M. P. Hall to Whitney Museum, Jan. 13, 1972, SPEC MS 305, B1F7, JHP UNL.

14. Holstein, interview; Holstein, *Biography of an Exhibition,* 48, 56–57.

15. Holstein, interview; Holstein, *Biography of an Exhibition,* 48, 56–57.

16. Rachel Newman, interview by Marsha MacDowell, Oct. 27, 2003, Quilt Treasures, Project of the Alliance for American Quilts and Michigan State University Museum, and MATRIX: Center for Humane, Arts, and Social Sciences Online.

17. Phyllis Haders advertisement, *Antiques and the Arts Weekly,* Dec. 1978, 32. For more on dealers and their marketing tactics, see chapter 6.

18. "Living With Art," *House and Garden,* Oct. 1978, 142.

19. Dan Shaw, "Mapping Out a Place for Everything," *New York Times,* May 27, 2007.

20. D. P. Hornberger, "Country Contemporary," 21, 24–25.

21. See Emmerling, *American Country;* Emmerling, *Collecting American Country.*

22. Bowermaster, "Take This Park and Love It," *New York Times Magazine,* Sept. 3, 1995, 26; Humes, *Eco Barons,* 19–20, 24–25, 31–32; Kile, "Free Spirit in the West," 56–61; Solis-Cohen, "Heritage Center Museum," 11–A; Tompkins, Afterword to *Amish;* Martha Sherrill Dailey, "Doug & Susie Tompkins: Concept Galore," *Washington Post,* Oct. 18, 1987, G8.

23. Tompkins, Afterword, 204.

24. Kile, "Free Spirit in the West," 57–8; Silber, Foreword to *Amish,* 6–7; Tompkins, "A Very Warm Welcome!" 2.

25. Tompkins, "A Very Warm Welcome!" 2; Tompkins, Afterword, 204; Martorella, *Corporate Art,* 34–5.

26. Silber, *The Esprit Quilt Collection;* Silber, interview.

27. Quoted in Kile, "Free Spirit in the West," 58.

28. Perhaps most famously, Pablo Picasso and his cohort began collecting and drawing inspiration from African art around 1910. For an interpretation of the relationship between early modern artists like Picasso and the "primitive" or "tribal," see Clifford, "Histories of the Tribal," 189–214. Also see Hutchinson, *Indian Craze,* 31. Previous to his interest in quilts, Tompkins collected what he referred to as "tribal arts." See Doug Tompkins, "Notes of a Collector," March 16, 1990, de Young Museum Research Files.

29. Silber, Introduction to *Amish Quilts of Lancaster County,* 11.

30. M. H. de Young Memorial Museum, "Amish: The Art of the Quilt," Acoustiguide Working Script, June 3, 1990 (audio tour script), de Young Museum Research Files.

31. On Tompkins' design of Esprit's headquarters, see Humes, *Eco Barons,* 36; catalog quotation, Tompkins, "A Very Warm Welcome!" 2.

32. Kile, "Free Spirit in the West," 56–60; Silber, *The Esprit Quilt Collection,* 35.

33. Singal, "Towards a Definition of American Modernism," 21.

34. Joan Kron, "Breaking the Rules," *Wall Street Journal,* June 11, 1985, 26; see also Bowermaster, "Take This Park," 26; Humes, *Eco Barons,* 36; Silber, interview.

35. Quoted in Dailey, "Doug & Susie Tompkins," G9.

36. Quoted in "Esprit de Corp. Company History," *Funding Universe,* www.fundinguniverse.com/company-histories/Esprit-de-Corp-Company-History.html.

37. Kron, "Breaking the Rules," 1.

38. Silber, interview.

39. Bowermaster, "Take this Park," 24; Humes, *Eco Barons,* 45; Tompkins, *Comprehensive Design Principle;* Susan C. Faludi, "Feuding Esprit Founders Reach Accord: Doug Tompkins Will Relinquish Post," *Wall Street Journal,* June 4, 1990, C16; Graydon, "Buying Sanctuary," 30.

40. Bowermaster, "Take This Park," 25; Graydon, "Buying Sanctuary," 34; Humes, *Eco Barons,* 54; conversation with Julie Silber, October 2009.

41. Silber, interview.

42. Silber, interview; Hughes and Silber, *Amish: The Art of the Quilt;* Hughes, *Shock of the New.* See the acknowledgments following Hughes's essay in *Amish: the Art of the Quilt,* 36.

43. Hughes and Silber, *Amish: The Art of the Quilt,* 14–15.

Chapter 6. From Rags to Riches

1. Pottinger and Peterson, interview.

2. Appadurai, "Commodities," 16; Kopytoff, "Cultural Biography," 65. Amish families knew pickers as "quilt men."

3. Appadurai, "Commodities," 15.

4. Holstein, interview.

5. Tina Hondras, "Quilts Express Amish Artistry," *Lancaster New Era,* July 23, 1973; Rita Reif, "Amish Quilts Abound; Vibrant Color and Wit Mark Patchworks," *New York Times,* July 14, 1973.

6. Linda Gruber, interview by author, Mar. 31, 2008, Wynnewood, PA, digital recording in author's possession.

7. Pamela Ackerman to Jonathan Holstein, Feb. 11, 1974, SPEC MS 305, B2F1, JHP UNL; Clara Elford, "Amish Quilt Data," June 19, 1985, SPEC MS 305, B5F7, JHP UNL; Jean Herve Donnard to Jonathan Holstein, Oct. 13, 1971, SPEC MS 305, B1F4, JHP UNL; Jonathan Holstein, "American Quilts," Jan. 5, 1973, SPEC MS 305, B1F12, JHP UNL; Jonathan Holstein, "Consignment of Quilts to Temple Beth-El, Great Next, N.Y.," Apr. 23, 1974, SPEC MS 305, B1F12, JHP UNL; Jonathan Holstein to Margot Johnson, Mar. 20, 1974, SPEC MS 305, B2F1, JHP UNL; Jonathan Holstein to Marilynn

Johnson, July 18, 1973, SPEC MS 305, B1F11, JHP UNL; Jonathan Holstein to Mary Kahlenberg, May 13, 1974, SPEC MS 305, B2F1, JHP UNL; Holstein, *Biography of an Exhibition*, 64–85.

8. Holstein, interview.

9. Herr, interview.

10. Kraybill, *Riddle*, 218–19.

11. Holstein, interview; Herr, interview.

12. Holstein, interview.

13. Colgan, "Collecting Quilts," 52.

14. Holstein, interview. Holstein, *Biography of an Exhibition*, 97.

15. Berman, "Collecting Children's Quilts," 43; Woodard and Greenstein, interview; Wheatcroft and Granick, interview.

16. Fran Woods quoted in Klimuska, "Old Amish Quilts," 11; Holstein, *Biography of an Exhibition*, 8–9, 86–87.

17. Gruber, interview.

18. Gruber, interview. Linda Gruber, "Quilts Etc. For Jon & Gail Inc.," 1973, SPEC MS 305, B1F12, JHP UNL; Linda Gruber to Jonathan Holstein and Gail Van der Hoof, Aug. 1973, SPEC MS 305, B1F12, JHP UNL; Tina Hondras, "Quilts Express Amish Artistry," *Lancaster New Era*, July 23, 1973.

19. Gruber, interview; Katie Stoltzfus, interview by Rachel Pellman, Oct. 19, 2004, LQTM.

20. Leroy Smucker and Elizabeth Smucker, interview.

21. Eli Miller, "Haven, Kansas," *The Budget*, Feb. 16, 1983, A3.

22. Pottinger and Peterson, interview.

23. Michael Oruch, interview by author, New York, NY, Nov. 8, 2008, digital recording in author's possession.

24. Wheatcroft and Granick, interview.

25. Xenia Cord, interview by author, May 9, 2008, Kokomo, IN, digital recording in author's possession; Rebecca Haarer, interview by author, May 13, 2008, Shipshewana, IN, digital recording in author's possession; Pottinger and Peterson, interview.

26. Rhea Goodman advertisement, *The Budget*, Apr. 26, 1973, 5. The June 7, 1973, *Budget* included the ads for the chicken house and nursing cow.

27. On *The Budget* as a means of creating "imagined community," see Nolt, "Inscribing Community," 183.

28. Michael Oruch noted that Amish families were often familiar with his name when he met them because they had seen it printed so many times in *The Budget*. Oruch, interview.

29. Darwin Bearley, classified advertisement, *The Budget*, national edition, Aug. 4, 1982; Darwin Bearley, classified advertisement, *The Budget*, national edition, Mar. 2, 1983; Barbara S. Janos, classified advertisement, *The Budget*, national edition, Aug. 14, 1985; Barbara S. Janos, classified advertisement, *The Budget*, national edition, Mar. 2, 1983; David Wheatcroft, classified advertisement, *The Budget*, national edition, Mar. 2, 1983.

30. Oruch, interview; Wheatcroft and Granick, interview. Granick featured this quilt prominently in *Amish Quilt*, 6. Other Arthur crazy quilts, likely made by friends or relatives of this quiltmaker, are in the Smithsonian American Art Museum's Renwick Gallery, the Illinois State Museum, and the Faith and Stephen Brown Collection. See Smucker, Shaw, and Cunningham, *Amish Abstractions*, 114; Wass, *Illinois Amish Quilts*, 60–63.

31. Granick, *Amish Quilt*, 87; Klimuska, "Old Amish Quilts," 14; Stoltzfoos, conversation with author, June 14, 2008. Other interviewees recalled rumors of stolen quilts, and rumors likely outnumbered actual occurrences. Herr, interview; Holstein, interview.

32. Kraybill, *Riddle*, 119–20.

33. Hannah Stoltzfoos, conversation.

34. Fannie Beiler, interview by Rachel Pellman, Mar. 7, 2007, Lancaster Quilt and Textile Museum; Hornberger, "Amish Quilter," 33; Klimuska, "Old Amish Quilts," 14; Stoltzfoos, conversation.

35. Stoltzfoos, conversation.

36. Schulman, *The Seventies*, 16–17.

37. Unnamed picker quoted in Kile, "On the Road," 76.

38. "The Meetin' Place," *Quilter's Newsletter Magazine*, Jan. 1975, 17. Bryce Hamilton, telephone conversation, Nov. 21, 2012. Hamilton has continued his relationships with Amish families he met in the 1970s; in his current business he hires Amish women to craft quilts that he sells at consignment shops and at festivals, including Sisters Outdoor Quilt Show in Oregon and the Kutztown Folk Festival in Pennsylvania.

39. Kile, "On the Road," 79; Roderick Kiracofe, interview by author, San Francisco, CA, Aug. 14, 2008, digital recording in author's possession; Silber, interview.

40. Kile, "On the Road," 76.

41. Kate Kopp, telephone interview by author, Mar. 8, 2009, digital recording in author's possession; Pottinger and Peterson, interview; van der Hoof quoted in Colgan, "Collecting Quilts," 52; Wheatcroft and Granick, interview.

42. Finkel, interview.

43. Wheatcroft and Granick, interview.

44. Pottinger, *Quilts from the Indiana Amish*, 1, 5; Pottinger and Peterson, interview.

45. Pottinger and Peterson, interview.

46. ISM DPC, 71.989.001.0223 and 71.989.001.0219.

47. ISM DPC; Pottinger and Peterson, interview.

48. Emmerling, *American Country*, 26; Pottinger, *Quilts from the Indiana Amish*, 11; Margaret Sheridan, "Amish Quilts: Folk Art with a Warm Feeling," *Chicago Tribune*, Nov. 9, 1986, M2.

49. Quoted in Emmerling, *American Country*, 27; quoted in Greene, "Taking a Dream," 99.

50. Haarer, interview; Herr, interview; Pottinger and Peterson, interview.

51. Haarer, interview.

52. Stoltzfoos, conversation.

53. Finkel, interview.

54. Woodard and Greenstein, interview. Initially they called their shop "Thomas K. Woodard." See The Alliance For American Quilts, Michigan State University Museum, and MATRIX: Center for Humane Arts, Letters, and Social Sciences Online, "Quilt Treasures Presents: Woodard and Greenstein," *The Alliance for American Quilts, Quilt Treasures*, www.allianceforamericanquilts.org/treasures/timeline.php?id=15.

55. Kopp, interview; "The Best Hurrah," *New York Magazine*, Feb. 14, 1972, 63.

56. Kindig, "Darwin Bearley," 32.

57. Woodard and Greenstein, interview.

58. Silber, interview; Smith, "Joel Kopp."

59. Wheatcroft and Granick, interview.

60. Michael Kile to Jonathan Holstein, Jan. 9, 1981, SPEC MS 305, B2F11, JHP UNL; Kiracofe, interview; "Kiracofe and Kile," *The Clarion*, Summer/Fall 1980.

61. Nancy Druckman, interview by author, Oct. 28, 2008, New York, NY, digital recording in author's possession.

62. Caldwell, "Year in Review 1987–88," 127; Druckman, interview; Jenkins, *Appraisal Book*, 280.

63. Jenkins, *Appraisal Book*, 278.

64. Bernard Levy quoted in Caldwell, "Bernard & S. Dean Levy," 106–7.

65. With only images from the auction catalog to compare, I may be overlooking differences between these two quilts that account for the price difference. The catalog lists the lesser-priced quilt as wool and cotton, while the more expensive one is listed as wool. This fiber

content may account for some of the difference. See discussion of fiber in chapter 8. Christie's New York, *Fine American Furniture, Silver, Folk Art and Decorative Arts, Friday, January 20 and Saturday, January 21, 1989* (New York: Christie's, 1989), 63; Christie's New York, *Fine American Furniture, Silver, Folk Art and Decorative Arts, New York, Saturday, June 2, 1990* (New York: Christie's, 1990), 81.

66. Druckman, interview.

67. For examples, see Sotheby's, *Important Americana, New York, January 28, 28, and 31, 1987* (New York: Sotheby's, 1987), lot 1126; Christie's, *Highly Important American Furniture, Silver, Folk Art and Decorative Arts, New York, Friday, January 19 and Saturday, January 20, 1990* (New York: Christie's New York, 1990), lot 533a; Sotheby's, *The American Folk Art Collection of Don and Faye Walters, Saturday, October 25, 1986* (New York: Sotheby's, 1986), lot 79.

68. Quoted in Colgan, "Collecting Quilts," 51–52.

69. Rita Reif, "Offbeat Settings Enhance Winter Show," *New York Times*, Feb. 10, 1991, sec. 2, 34; Woodard and Greenstein, interview.

Chapter 7. Amish Intermediaries

1. Pottinger and Peterson, interview. Also see Pottinger, *Quilts from the Indiana Amish*, 1–9.

2. Pottinger and Peterson, interview.

3. For more on the development of Amish businesses and the role women have played in them, see chapters 9, 10, and 11.

4. Holstein, interview; Hannah Stoltzfoos, interview; Hannah Stoltzfoos, conversation with author.

5. Holstein, interview; Hannah Stoltzfoos, interview; Stoltzfoos, conversation.

6. Hannah Stoltzfoos, interview.

7. In addition to Holstein, *The Pieced Quilt* (1973), two other books, both published in 1976, focused on Amish quilts. See Haders, *Sunshine and Shadow*; Bishop and Safanda, *Gallery*.

8. Stoltzfoos, conversation.

9. Riehl, interview; Klimuska, "Swanky," 19–20; Heller, "Fancy Quilts," 18, 20.

10. Kraybill and Nolt, *Amish Enterprise*, 22–31; Riehl, interview. For more on the growth of entrepreneurship in Amish settlements, see chapter 9.

11. Herr, interview; Riehl, interview.

12. Finkel, interview.

13. Heller, "Fancy Quilts," 22; Jonas and Sarah King, interview; Klimuska, "Swanky," 21–22; Riehl, interview.

14. Klimuska, "Swanky," 22; Riehl, interview.

15. Riehl quoted in Klimuska, "Swanky," 19; Riehl quoted in Heller, "Fancy Quilts," 22.

16. Quoted in Ed Klimuska, "Dealer Pays Record $6900 for Amish Quilt at Auction Here," *Lancaster New Era*, Feb. 25, 1987.

17. Riehl, interview. Although some Amish people attempt to avoid debt, Amish have long turned to commercial lenders. Local banks in Lancaster County have had exceptionally good relations with Amish borrowers. Bankers often know Amish families and consider them trustworthy. See Adam Davidson, "Amish Banking Unscathed by Economic Woes," *Morning Edition* (National Public Radio, Dec. 12, 2008); Kraybill and Nolt, *Amish Enterprise*, 46–47.

18. Klimuska, "Collectors Pay Thousands," 4; Klimuska, "Dealer Pays Record"; Riehl, interview.

19. Herr, interview; Riehl, interview; Wheatcroft and Granick, interview.

20. Riehl, interview; Wheatcroft and Granick, interview.

21. Reba Ranck, interview by Rachel Pellman, Jan. 25, 2006, LQTM.

22. "Amish Quilt Sold for Record $17,300 Here," *Lancaster New Era*, May 1, 1992; Ranck, interview; Riehl, interview; Emma Riehl,

conversation with author, Churchtown, PA, May 13, 2008; Silber, interview; Wheatcroft and Granick, interview.

23. Wheatcroft and Granick, interview.

24. Riehl, interview.

25. Herr, interview.

26. Heller, "Fancy Quilts," 22; Klimuska, "Swanky," 21.

27. Holstein, interview.

Chapter 8. A Good Amish Quilt Folded Like Money

1. Charles Montgomery was a leading scholar of the American decorative arts whose notes on connoisseurship first appeared as "Some Remarks on the Practice and Science of Connoisseurship," in *American Walpole Society Notebook* (1961): 7–20. Republished with an introduction by the editor as "The Connoisseurship of Artifacts," in *Material Culture Studies in America*, ed. Thomas J. Schlereth (Nashville, TN: American Association for State and Local History, 1982), 143–52. Quotation on page 145 of the reprinted version.

2. Montgomery, "Connoisseurship," 145.

3. David Wheatcroft, conversation with author, Sept. 19, 2008.

4. For example, Bars and Center Diamond quilts were favored over other Lancaster County patterns. Amish quilts that looked too much like mainstream American quilts in color and pattern were disregarded in favor of more "Amish-looking" quilts. See Howard Becker's discussion of the relationship of shared aesthetic standards to value in *Art Worlds*, 131–35.

5. I use the term "classic" just as dealers, collectors, and curators have. It refers to the type of quilts favored by these enthusiasts, featuring dark, rich colors, intricate quilting, and relatively simple geometric patterns. See Nomura and Smucker, "From Fibers to Fieldwork," 124–25.

6. See the introduction for a more detailed description of these differences.

7. Holstein, *Pieced Quilt*, 99–101; Holstein, interview.

8. Holstein, interview; Kopp, interview; Pottinger and Peterson, interview; Smith, "Joel Kopp."

9. David M. S. Pettigrew quoted in Zebrowski, "Any Amish Quilts," 119.

10. Susan Delagrange and George Delagrange, interview by author, Jeromesville, OH, Oct. 3, 2008, digital recording in author's possession.

11. Quoted in Heller, "Fancy Quilts," 22.

12. Zebrowski, "Any Amish Quilts," 119.

13. Quoted in Zebrowski, "Any Amish Quilts," 119.

14. Smith, "Joel Kopp."

15. Herr, interview; Holstein, interview; Silber, interview.

16. A notable exception to this is quilts made in the Amish settlement near Arthur, Illinois. Here quiltmakers primarily used fine dress wools to make most late nineteenth-century quilts and then transitioned to various cotton cloths in the twentieth century (Wass, *Illinois Amish Quilts*, 8).

17. A fabric blend features two or more fibers (e.g., wool and rayon) spun together to form a yarn, which is then woven to make the fabric. A fabric mixture features a warp yarn of one fiber and a weft yarn of another fiber.

18. Bishop, Secord, and Reiter Weissman, *Quilts, Coverlets*, plate 107.

19. Manufacturers can also apply finishes to cloth to create a crepe. See Granick, *Amish Quilt*, 183; Kadolph and Langford, *Textiles*, 397, 405; Kindig, "Darwin Bearley," 32.

20. Quoted in Tina Hondras, "Quilts Express Amish Artistry," *Lancaster New Era*, July 23, 1973; Zebrowski, "Any Amish Quilts," 128.

21. Ada Robacker, "Quilts of Quality," *Antique Collecting*, Jan. 1978, 17.

22. Berlo and Crews, *Wild by Design*, 100; Granick, *Amish Quilt*, 183; Nomura and Smucker, "From Fibers to Fieldwork," 127.

23. Julie Silber to Jonathan Holstein and Gail van der Hoof, Apr. 1986, SPEC MS 305, B3F11, JHP UNL.

24. For detailed discussion of when manufacturers introduced various manufactured and synthetic fibers to the consumer market, see Nomura and Smucker, "Fibers to Fieldwork," 128–32.

25. Quoted in Zebrowski, "Any Amish Quilts," 128.

26. Silber to Holstein and van der Hoof, [April 1986]; David Wheatcroft qtd. in same.

27. Quoted in Heller, "Fancy Quilts," 20.

28. Granick, Amish Quilt, 184; Holstein, "Aesthetics of Amish Quilts," 86.

29. These fibers are regenerated from naturally occurring cellulose polymers; thus they are called "manufactured" rather than "synthetic."

30. Nomura and Smucker, "Fibers to Fieldwork," 129–30.

31. Granick, Amish Quilt, 186, 47–48; Hawley, "Commercialization," 112; Nomura and Smucker, "Fibers to Fieldwork," 130–31, 147.

32. Mrs. John Byler, interview by Eve Wheatcroft Granick, Mar. 8, 198?, MS 327 B2, Eve Wheatcroft Granick, Collection on Quilts, Archives & Special Collections, University of Nebraska-Lincoln Libraries; Nomura and Smucker, "Fibers to Fieldwork," 127, 132–36, 148–49; Amish Quilts: 17 March–12 May 1985, Nassau County Museum of Fine Art, Roslyn Harbor, New York (Roslyn Harbor, NY: Nassau County Museum of Fine Art, 1985).

33. Holstein, interview; International Quilt Study Center & Museum, "Quilt Explorer – Timeline," http://explorer.quiltstudy.org/timeline.html; Zebrowski, "Any Amish Quilts," 128.

34. Holstein, interview; Pottinger and Peterson, interview; Wheatcroft and Granick, interview; Zebrowski, "Any Amish Quilts," 21.

35. James Glazer quoted in Zebrowski, "Any Amish Quilts," 121.

36. Bishop and Safanda, Gallery. For more on the "classic era," see Nomura and Smucker, "Fibers to Fieldwork," 124–26.

37. For examples, see Granick, Amish Quilt, 9; Haders, "Quilts: The Art of the Amish," 113; Klimuska, "Collectors Pay," 3; Peck, American Quilts & Coverlets, 84; R. Shaw, Quilts, 174; Tanenhaus, "Pennsylvania German Quilts," 60; Zebrowski, "Any Amish Quilts," 121.

38. Kiracofe, interview.

39. ISM DPC, 71.989.01.346.

40. Dating practices differed among Amish settlements. Indiana Amish quiltmakers frequently dated quilts in the stitches, as evidenced by the many dated quilts in the David Pottinger Collection at the Indiana State Museum, Indianapolis. Darwin Bearley, collector of Ohio quilts, believes that Ohio Amish makers dated their quilts more frequently than those in other states. Many fewer Lancaster County quiltmakers added such inscriptions, although some do exist. Only 3 of 82 Lancaster County quilts in Esprit's core collection had stitched dates. Of the UNL International Quilt Study Center & Museum's 330 Amish quilts, only 21 are dated. See Smucker, "From Rags to Riches," Appendix, for a list of dated Amish quilts that I have identified. See Bearley, "A Thirty Year Collection," 157; Hughes and Silber, Amish: the Art of the Quilt; Peck, American Quilts & Coverlets, 86.

41. Granick discusses a quilt attributed to Mifflin County, Pennsylvania, dated 1849 (printed 1840 elsewhere). Wheatcroft and Granick purchased this quilt from a dealer, and it has no known family history to validate the date or confirm that it is Amish-made. The next-earliest-known dated quilt is from 1869 (Granick, Amish Quilt, 30; Wheatcroft and Granick, interview). Authors dating quilts to 1850 include Bishop and Safanda, Gallery, 64; and Haders, Sunshine and Shadow, 26.

42. For more on the "classic era," and examples of more recently made quilts with pre-1940 dates, see Nomura and Smucker, "Fibers to Fieldwork."

43. R. Shaw, Quilts, 174.

44. Haders, "Quilts: The Art of the Amish," 116. In 2006, Darwin Bearley commented that after 1950 "it's as if somebody simply turned off a creative engine" ("A Thirty Year Collection," 158).

45. R. Shaw, Quilts, 174. Some Amish quiltmakers used printed fabrics on the tops of quilts. Many Amish quilts are backed with printed fabric. See chapter 2.

46. Schoellkopf quoted in Rita Reif, "Quilts Star in New Exhibits," New York Times, June 21, 1981, D27. For published examples of Amish quilts using these colors see Granick, Amish Quilt, 28, 34, 40, 78, 84, 86, 121, 131, 138; Pellman and Pellman, Treasury, 43, 45, 47, 56, 61, 69, 78, 92, 97, 109.

47. Kiracofe, interview.

48. Joseph Sarah, interview by author, Columbus, OH, Oct. 3, 2008, digital recording in author's possession.

49. Stacey Epstein, "Amish quilt inventory," nd, IQSC&M, object file, 1997.007.0509.

50. For more on Amish quilt businesses and recycling old fabrics into new quilts that looked old, see chapter 9.

51. Herr, interview.

52. Kindig, "Darwin Bearley," 32. Also see Rita Reif, "How to Avoid a Phony Powder Horn," New York Times, Apr. 10, 1988, 110.

53. Holstein, Biography of an Exhibition, 117.

54. Nomura and Smucker, "Fibers to Fieldwork," 138–42.

55. Wheatcroft and Granick, interview.

56. Zebrowski, "Any Amish Quilts," 129.

57. "Thos. K. Woodard," 31.

58. Wheatcroft and Granick, interview; Oruch, interview.

59. Pottinger and Peterson, interview.

60. Blanche Greenstein quoted in Zebrowski, "Any Amish Quilts," 128.

61. Pottinger and Peterson, interview.

62. Wheatcroft and Granick, interview.

63. Pottinger and Peterson, interview; Pottinger, Quilts from the Indiana Amish, 70; ISM DPC, 71.989.001.0456.

64. Pottinger and Peterson, interview.

65. Nancy Adams, "Quilt Fancier," Chicago Tribune, Dec. 18, 1983, L4.

66. See Stewart, On Longing, 134–36.

67. Pottinger quoted in Margaret Sheridan, "Amish Quilts: Folk Art with a Warm Feeling," Chicago Tribune, Nov. 9, 1986, M2.

CHAPTER 9. DESIGNED TO SELL

1. Kraybill and Nolt, Amish Enterprise, 20–22. For an Amish explanation of farming as the ideal way of life, see 1001 Questions and Answers on the Christian Life, 139–40.

2. The Amish population in Lancaster County doubled about every twenty years from 1940 forward (Kraybill and Nolt, Amish Enterprise, 22–25). Currently around 85 percent of children in Amish families join the church and remain Amish as adults. Amish families currently average five or more children. See "Amish Population Trends 2012, One Year Highlights," Amish Studies, Young Center for Anabaptist and Pietist Studies, Elizabethtown College, http://www2.etown.edu/amishstudies/Population_Trends_2012.asp. Also see Luthy, Amish Settlements; Meyers, "Population Growth," 308–21; Meyers, "To Remain in the Faith," 378–95.

3. Kraybill and Nolt outline these choices in detail as well as alternatives, including the use of artificial birth control and allowing higher education, in Amish Enterprise, 26–29.

4. Kraybill and Nolt, Amish Enterprise, 26–29, 210–12. In Elkhart and LaGrange Counties in Indiana and Geauga County in Ohio, factory work became the predominant alternative to farming during the late twentieth century. See Kraybill and Nolt, Amish Enterprise, 231–33; Meyers, "Lunch Pails and Factories," 165–81; Nolt and Meyers, Plain Diversity, 85–90.

5. See Klimuska, *Lancaster County*; Smucker, "Destination Amish Quilt Country."

6. Some artists self-label as "studio quilt artists," a term that describes their three-layer quilt format and the process of creating work in a studio with the intention of exhibiting in galleries alongside other studio artists. See James, "Beyond Tradition," *American Craft*, 16–22. Nancy Crow is a prominent studio quilt artist who has employed Amish women to quilt her art works. Denyse Schmidt hires Amish women to complete her "couture quilts." See Denyse Schmidt, "Amish Ladies," *Denyse Schmidt Quilts,* http://www.dsquilts.com/quilts.asp?PageID=45. Accessed October 14, 2009.

7. On the Amish practice of giving quilts to children before they left their parents' homes, see chapter 2.

8. Quiltmaking involves several distinct steps, including piecing, marking, quilting, and binding. Piecing entails sewing pieces of fabric together to form a geometric design. Once the quilt top is pieced, a quilt marker uses chalk or pencil to mark a decorative pattern on the fabric. Quilting is stitching, following the marked design, to hold together a quilt's three layers. Finally, a quiltmaker applies binding, often a thin strip of fabric, to the front and back edges of the quilt.

9. Hannah Stoltzfoos, interview.

10. See interviews with Amish women by Rachel Pellman, LQTM. ISM DPC has examples of quilts where women were hired to complete some of the quiltmaking steps. This practice likely occurred in other Amish communities as well.

11. For examples, see interviews by Rachel Pellman of Mary Beiler, Lydia Huyard, and Smucker and Smucker.

12. Old Order Mennonites separated from the Mennonite Church during the last quarter of the nineteenth century. Old Order Mennonites share much in common with Old Order Amish, including limited use of modern conveniences, plain dress, and a conservative Anabaptist theology. See Wenger, "Old Order Mennonites." I distinguish between formal and informal sales of quilts because Amish and Old Order Mennonite women had long engaged in quilt-making in exchange for money (as discussed above) without the formal trappings of a business or space reserved for retail activities.

13. For accounts of this business's origins, see Emma Witmer, interview by Heather Gibson, Oct. 20, 2003, Alliance for American Quilts, Quilters' S.O.S. — Save Our Stories, www.allianceforamericanquilts.org/qsos/interview.php?pbd=qsos-a0a2y2–a; and Patricia T. Herr, "Quilts within the Amish Culture," 60. Herr and colleague Patricia Keller interviewed Bill Greenberg in 1992. The author confirmed some of these details during conversations with Emma Witmer, July 30, 2008, New Holland, PA, and Hannah Stoltzfoos, June 14, 2008, Witmer, PA.

14. Patricia Herr discusses an undated postcard, c. 1950–60, depicting Amish man Mose B. Stoltzfoos's "Ice Cream Farm," with quilts hanging outdoors as if for sale. Herr suggests that this enterprise may have been the first Lancaster County retail outlet for Amish quilts, but no additional information has confirmed this. See Herr, "Quilts within the Amish Culture," 59–60, 62.

15. Hannah Stoltzfoos, interview; Stoltzfoos, conversation with author. For more on Hannah Stoltzfoos's role in selling old quilts, see chapter 7. For origins of her business, see Herr, "Quilts within the Amish Culture," 60–61.

16. Katie Stoltzfus, conversation with author, July 30, 2008; Stoltzfus, *Country Lane Quilts,* vi.

17. Roger Mummert, "A Cozy Amish Craft," *New York Times,* Feb. 9, 1992; Ruth, "Merle Good and Phyllis Pellman Good," 234; The Old Country Store, "Quiltalog," 1979, Heritage Historical Library, Aylmer, Ontario.

18. Susan and George Delagrange, "Amish Design Business Binder," 1980, Susan and George Delagrange Collection; Delagrange and Delagrange, interview; Susan Delagrange to Sandra Mitchell, April

3, 1990, IQSC&M, administrative file, 1997.007.0510. Other similar businesses include First Edition Quilts, Mercer & Bratt Quilts, and Amish Country Collection. See Elaine Mercer, interview; Marilyn Hoffman, "A Flair for the Simple," *Christian Science Monitor,* Jan. 8, 1988, sec. Home and Family, 21.

19. Barbara Beiler, interview; Brackman, "New Amish Quilts," 46; David Riehl quoted in Heller, "Fancy Quilts," 22; Mary Yoder, interview by Rachel Pellman, Mar. 28, 2006, Lancaster Quilt and Textile Museum.

20. Evidence in the form of extant quilts and probate records suggests that Amish women did not begin making quilts in earnest until around 1880. For a detailed discussion of the origins of Amish quiltmaking and how change and fashion function within the church, see chapter 1.

21. Barbara Brackman makes this point regarding the availability of goods in "New Amish Quilts," 54.

22. Rachel Pellman, interview by Janneken Smucker, Apr. 4, 2008, Alliance for American Quilts, Quilters' S.O.S. — Save Our Stories, http://www.allianceforamericanquilts.org/qsos/interview.php?pbd=qsos-a0a7z7–a.

23. Stoltzfoos, conversation. Witmer, conversation. Graybill recounts how one of her informants regularly attends craft and fabric trade shows in New York City to get ideas ("Amish Women," 181).

24. Unnamed Amish quiltmaker quoted in Klimuska, "Tourist Business," 35, 37; Amish informant quoted in Graybill, "Amish Women," 150.

25. Klimuska, "New Quilts," 30–1; Klimuska, "Tourist Business," 37; Stoltzfoos, conversation.

26. Brackman, "New Amish Quilts," 46.

27. Quoted in Klimuska, "New Quilts," 31.

28. Heisey was a graphic designer for People's Place, the Intercourse, PA, complex of visitors' center and retail shops that included The Old Country Store.

29. Pellman, interview; "Do-it-Yourselves: Renovating a Home of Your Own," *Brides,* July 1983.

30. Benner and Pellman, *Country Lily Quilt*; Benner and Pellman, *Country Paradise Quilt*; Benner and Pellman, *Country Bride Quilt Collection*; Benner and Pellman, *Country Love Quilt*; Heisey and Pellman, *Country Bride Quilt.*

31. Pellman, interview. On "American Country," see Emmerling, *American Country.*

32. Witmer, interview. Hmong seamstresses living in the Lancaster County area did possess the necessary appliqué skills, and many of them began to participate in the quiltmaking industry; see chapter 12.

33. Dahlia has been a longstanding favorite, prominently featured in Amish quilt shop brochures from 1979 through 2008. The Old Country Store, "Quiltalog"; Mrs. Levi S. Fisher, "Handmade Quilts," nd [c. 1975–1980], Heritage Historical Library, Aylmer, Ontario; "Country Quilt Shoppe," 1984, Heritage Historical Library, Aylmer, Ontario; "Zook's Handmade Quilts and Crafts," 1994, Heritage Historical Library, Aylmer, Ontario; "Smuckers Quilts," 2008, author's possession; Carol Fish, "My Life and Quilted Times," *Penn Dutch Traveler,* March 6, 1995, 1, 10. Bargello quilts, inspired by needlepoint designs of the same name, were a popular fad among many quiltmakers in the 1990s. Amish women have continued to make them. See Doheny, *Bargello Tapestry Quilts.*

34. For more on how change occurs within Amish society, see Kraybill, *Riddle,* 295–311; Huntington, "Dove at the Window," 209, 217–18, 229. On Amish fashion, see L. Stoltzfus, *Traces of Wisdom,* 134–35.

35. Mary Beiler, interview; "Amish Quilts and Crafts," www.amishquiltsandcrafts.com/quilts.html.

36. Kraybill, *Riddle,* 115. On Amish attitudes toward the law, see Kraybill and Nolt, *Amish Enterprise,* 159–61; Kraybill, *Amish and the State.*

Copyrighting a quilt pattern, especially one based on an historic source like a needlepoint pillow proved tricky. Online discussion forums filled with non-Amish quilters debated whether they could reproduce the design if they did not plan to sell it; see "Light in the Valley," *Quilting Board — The Quilter's Message Board,* June 15, 2009, www.quiltingboard.com/posts/list/30/21382.page. At least one young Amish woman executed the striking pattern in a quilt she made for her own use (Anna Smucker Stoltzfus, conversation with author, Aug. 18, 2009). At some point after the copyright of this design, Almost Amish, an internet proprietor of Amish-style (and many Amish-made) quilts, bought the copyright to this design. According to Almost Amish's website, for this particular design they "source 100% Amish artisan labor to piece, quilt, and bind." See http://store.almost-amish.com/servlet/-strse-Quilt-Shop-cln-Bed-Quilts-cln-Light-in-the-Valley-Copyrighted/Categories.

37. Nomura and Smucker, "From Fibers to Fieldwork," 130, 146–47.

38. Although her methodology is unclear, Linda Boynton found in her early 1980s study of changes to Amish quiltmaking practices that "most of the quilts made and sold to tourists are made of printed cotton and polyester blends. Although some cotton filling [batting] is still used, polyester filling is used most frequently" ("Recent Changes," 41). Also see Susie Esh, "Quilts and Things," *Penn Dutch Traveler,* June 15, 1992, 9; Mrs. Levi S. Fisher, "Handmade Quilts"; Klimuska, "New Quilts," 28; Tepper and Tepper, "Naomi Fisher," 69.

39. Weiner-Johnson, "Selling the Past," 20; Witmer, conversation with author.

40. Brackman, "New Amish Quilts," 46.

41. See IQSC&M, Sara Miller Collection, 2000.007.0014. The author identified this quilt as a contemporary wall-hanger rather than an antique crib quilt during fieldwork in Wayne County, Ohio, August 2005. Some proprietors advertised these products specifically: Hand Made Quilts and Crafts touted its "All Wool Wallhangings in Stock"; see advertisement in *Penn Dutch Traveler,* June 15, 1992.

42. Granick, *Amish Quilt,* 78. For dimensions on a number of Amish quilts, see the International Quilt Study Center & Museum's online collection database at http://quiltstudy.org.

43. For example, Jonathan Holstein wrote of Amish quilts, "The proportions and relations of their various parts are often almost impossibly correct, not just in one quilt, but in one after another" ("Aesthetics of Amish Quilts," 120).

44. Several quilt shop owners noted that these "old-fashioned" quilts currently do not sell well; one said that they were only popular among her European and Japanese customers (Katie Stoltzfus, conversation; Stoltzfoos, conversation; Witmer, conversation).

45. Rachel Fisher, interview by Eve Wheatcroft Granick, Nov. 1983; Fox, "Old Quilts and New," 30; Mary Glick, interview; Granick, *Amish Quilt,* 173–74; Handmade Quilts and Crafts advertisement, *Penn Dutch Traveler,* June 15, 1992; Herr, interview; Mummert, "A Cozy Amish Craft"; Nomura and Smucker, "Fibers to Fieldwork," 142.

46. A.C.B., "New Wimington, PA," *Die Botschaft,* Jan. 6, 1988, 2.

47. Such instances are quite hard to document. Numerous informants had heard of such occurrences, but once a quilt entered the commercial market, it was difficult to know its precise origins (Herr, interview; Holstein, interview; Leah N. Yoder Hostetler, conversation with author, July 13, 2004, Mifflin County, PA; Oruch, interview; Silber, interview; Wheatcroft and Granick, interview). Also see Zebrowski, "Any Amish Quilts," 128–29. At least two newly made quilts passed off as old are now in the collections of the IQSC&M; see objects 2000.007.0014 and 2003.010.0005.

48. Wheatcroft and Granick, interview.

49. I have examined quilts produced and retailed by Amish Design now in IQSC&M, comparing them alongside older quilts not made for the retail market. As someone quite familiar with the patterns, tech-

niques, and fabrics of old Amish quilts, I can confidently say that many of these quilts made in the 1980s could easily pass for ones made fifty years earlier. Amish Design stitched a label to each of its quilts, but these were no longer affixed to those in IQSC&M's collection.

50. For an elaborated discussion of the criteria for desirable Amish quilts, see chapter 8.

51. Amish Design's piecers used the sketch to complete the quilt top and then returned the sketch along with their work to the Delagranges. George and Susan Delagrange generously allowed me to borrow these design materials for research purposes.

52. Susan and George Delagrange, "Binder."

53. Conservative groups that continued to primarily use the dark colors in their quilts in the late twentieth century include the Swartzentruber Amish of eastern Ohio, the Nebraska (White Topper) Amish of central Pennsylvania, and the Troyer Amish, scattered across New York, Pennsylvania, and Michigan. Many of Amish Design's quiltmakers were Swartzentruber Amish; although they continued to use dark colors, they used synthetic fabrics and polyester batting. Susan and George Delagrange, "Binder"; Delagrange and Delagrange, interview.

54. For a detailed discussion of collectors' taste for old Amish quilts, including fabric and fiber preferences, see chapter 8.

55. Susan and George Delagrange, "Binder."

56. Mary E. Slabaugh to George & Susan Delagrange, Jan. 22, 1982, Susan and George Delagrange Collection; Susan and George Delagrange, "Binder"; Delagrange and Delagrange, interview.

57. Delagrange and Delagrange, interview. Collectors Robert and Ardis James purchased quilts produced by Amish Design from antiques dealer Sandra Mitchell and later donated them to IQSC&M. Amish Design quilts from IQSC&M include objects 1997.007.0359E, 1997.007.0501, 1997.007.0502, 1997.007.0503, 1997.007.0504, 1997.007.0506, 1997.007.0507, 1997.007.0508, 1997.007.0509, 1997.007.0510, 1997.007.0511, 1997.007.0512, 1997.007.0513, 1997.007.0514, 1997.007.0515, 1997.007.0548, 1997.007.0577, 1997.007.0583, 1997.007.0587, 2009.039.0007, 2009.039.0019, 2009.039.0020.

Chapter 10. Homespun Efficiency

1. Nearly all Amish quiltmakers have been women rather than men. Although some retired men have begun to help their wives with steps such as cutting fabric, piecing, and quilt marking, Graybill found that men have not quilted ("Amish Women," 152–54).

2. Sam Smucker, conversation with author, July 30, 2008; Katie Stoltzfus, conversation; Witmer, conversation. See Carol Fish, "My Life and Quilted Times," *Penn Dutch Traveler,* Mar. 6, 1995, 1, 10; Sandra Gottlieb, "Mrs. Beiler's Modern Management," *Wall Street Journal,* Oct. 22, 1985. See also Klimuska, "New Quilts"; "It's War!" 32–33; and "How One Woman," 40–41, in *Lancaster County.*

3. Since many of these businesses are Amish owned and operated and some choose not to advertise, it is difficult to estimate exactly how many there were at any given time. In 1987 journalist Ed Klimuska noted the challenge of estimating how many quilts were made in Lancaster County's quilt cottage industries: "Nobody counts; nobody knows. Certainly thousands a year" ("New Quilts," 28). While it is even more difficult to estimate either current and past numbers of women participating in Amish quilt businesses, I believe that since the 1980s thousands of Amish women have helped make quilts for the consumer market. Beth Graybill's work supports this rough estimate, largely because she demonstrates that Amish women's entrepreneurship has been undercounted in the past. Around 116,000 adult (baptized) Amish live in North America. An estimated 12,000 adult Amish (of which more than half are women) live in Lancaster

County, home to the second-largest Amish settlement. Some businesses have employed as many as 200 women making quilts, although not all of these quiltmakers were from the Lancaster settlement, nor were they all Amish. One Amish informant assured Graybill that "most every woman is doing something on the side. . . . It is expected of you." Another informant told her that farmwives and young mothers married to day laborers almost all do some quilting for pay. See Graybill, "Amish Women, Business Sense," 61, 130–32; Young Center for Anabaptist and Pietist Studies, Elizabethtown College, "Amish Studies," http://www2.etown.edu/amishstudies/FAQ.asp. In his 1987 newspaper series on Lancaster's quilt industry, Ed Klimuska estimated that "countless" women worked in these businesses, although one of his headlines read, "New Quilts: They Sell by Thousands, Make Work for Hundreds," 28.

4. As discussed in chapter 2, Amish women have long specialized in specific aspects of the quiltmaking process, such as marking quilting patterns or piecing particularly intricate patterns. Specialization itself is not a new part of quiltmaking.

5. Rachel Pellman's interviews with Lancaster County Amish women reveal that quilting frolics were memorable occasions filled with friends, conversation, and food. See Interviews with Amish Women, Lancaster Quilt and Textile Museum.

6. Kraybill and Nolt, *Amish Enterprise*, 39; The Old Country Store, "10 Important Questions to Consider Before You Buy a Quilt," 2008; Sam Smucker, conversation with author, July 30, 2008, New Holland, PA. In her 1992 column in the free tourist newspaper, *Penn Dutch Traveler*, Amish businesswoman Susie Esh wrote, "I am not a piecer, I'm a quilter" ("Quilts and Things," April 1992, 11).

7. This has been the process at Hannah's Quilts, Country Lane Quilts, Amish Design, and other businesses.

8. Conversation with Katie Stoltzfus. Susan and George Delagrange of Amish Design trusted one particular woman with quilts that required an intuitive design sense, calling her "the greatest colorist we had ever known" (Delagrange and Delagrange, interview).

9. Fish, "My Life and Quilted Times," 10; Klimuska, "How One Woman," 41; Klimuska, "New Quilts," 29. In Lancaster County, Old Order Amish have a prohibition against riding bicycles, but this is not true in all settlements. See Kraybill, *Riddle*, 24, 213.

10. Bird-in-Hand, Pennsylvania quilt shop owner quoted in Klimuska, "New Quilts," 31.

11. Quoted in Gottlieb, "Mrs. Beiler's," 33.

12. Delagrange and Delagrange, interview.

13. Katie Stoltzfus, conversation.

14. Mary Esh, interview; Graybill, "Amish Women," 119; Huyard, interview.

15. Weaverland Valley, PA, quilt shop owner quoted in Klimuska, "How One Woman," 41.

16. Marian Stoltzfus, conversation with author, June 14, 2008.

17. Graybill, "Amish Women," 118.

18. Tepper and Tepper, "Naomi Fisher," 69.

19. Susan and George Delagrange, "Binder."

20. Speed, quality of stitches, and intricacy of quilting designs all affect how many yards of thread a quilter could stitch in an hour. See Graybill, "Amish Women," 118; Hawley, "Commercialization," 111; Klimuska, "It's War," 32; Miriam Stoltzfus, interview; Tepper and Tepper, "Naomi Fisher," 69. In a 1985 publication, Linda Boynton estimated that Lancaster Amish quiltmakers earned an estimated 60 cents an hour on quilts consigned to shops ("Recent Changes," 42). During the 1980s and 90s, quilt businesses placed classified advertisements seeking quilters in *The Budget*, a national newspaper with circulation in all Amish settlements. Some of these ads listed the rate per yard of thread. See, for example, Handmade Amish

Quilts, "Wanted Quilters," *The Budget*, June 13, 1990; Jean Horst, "Quilting," *The Budget*, Feb. 3, 1988; Joseph J. Yoder, "Quilters Wanted (prefer Amish)," *The Budget*, Nov. 4, 1987. Rather than paying by the yard, from 1981–82 Amish Design paid its quilters a piece rate of $60 to $80 per quilt depending on its size, likely resulting in a similarly low hourly wage. Graybill notes that as contractual workers, quilters are exempt from the Fair Labor Standards Act ("Amish Women," 118).

21. Klimuska, "It's War!" 32.

22. Quilt shop owner quoted in Klimuska, "It's War!" 32.

23. "Notice," *Die Botschaft*, Feb. 22, 1989, 5. This sentiment was not new in the late 1980s. Businesswoman Naomi Fisher observed in 1980 that her quilters, mostly older women whose husbands had retired from farming, were "not really paid adequately for their time. If I charged the amount of money that their handiwork is worth, I'd be pricing myself right out of the market." See Tepper and Tepper, "Naomi Fisher," 69–70.

24. Roger Mummert, "A Cozy Amish Craft," *New York Times*, Feb. 9, 1992.

25. Brackman, "New Amish Quilts," 46; Susie Esh, "Quilts and Things," *Penn Dutch Traveler*, June 15, 1992, 10; Mummert, "A Cozy Amish Craft," 25.

26. Brackman, "New Amish Quilts," 46; Mrs. Levi S. Fisher, "Handmade Quilts"; Klimuska, "New Quilts," 28; Mummert, "A Cozy Amish Craft," 25.

27. In Lancaster County quilt shops today, bed-size quilts range in price from $500 to $900.

28. Fish, "My Life and Quilted Times," 1, 10. Fish, a non-Amish quilt entrepreneur, periodically wrote brief articles about running her retail shop, Amish Country Traditions, in *Penn Dutch Traveler*. Fisher's Handmade Quilts in Bird-in-Hand currently operates on the consignment model, although under its original management Fisher sold quilts on consignment in addition to employing about five piecers and twelve quilters working on her own designs. See Tepper and Tepper, "Naomi Fisher," 69.

29. Established in 1976, People's Place aimed to present accurate information to tourists about the Amish and Mennonite religions. Since the late 1970s People's Place had retail components, including galleries selling work by local artisans and a bookstore. For its history, see Ruth, "Merle Good and Phyllis Pellman Good," 233–35.

30. Pellman, interview; Phyllis Pellman Good, telephone interview by author, Feb. 27, 2009, digital recording in author's possession. Also see Mummert, "A Cozy Amish Craft," 25; The Old Country Store, "Quiltalog"; Ruth, "Merle Good and Phyllis Pellman Good," 234; Shirer, "Lancaster County Celebrates Quilts," 25–26. While the Old Country Store did not exclusively sell Amish-made quilts, Good Enterprises, People's Place's parent company, promoted the Amish brand by publishing numerous books featuring Amish quilts since 1981 and by exhibiting antique Amish quilts in the adjacent People's Place Quilt Museum, which opened in 1988.

31. For example, see Parrish, "Way of Life" and "Imports." For more on this controversy and the relationship of Amish quilts to globalization, see chapter 12.

32. Nan Oberholtzer quoted in Klimuska, "New Quilts," 30.

33. Klimuska, "New Quilts," 30.

34. Mrs. W. Troyer, "Clymer, NY," *The Budget*, Nov. 13, 1985.

35. "Amish Quilts Sold for Bargain Prices at Twice-Yearly Auction," *Lancaster Intelligencer Journal*, Oct. 21, 1985; Atlee J. Hochstetler, "West Union, Ohio," *The Budget*, June 28, 1989; Hometowne Auction LLC, "Hometowne Quilt Auction," www.hometownequiltauction.com/index.php; Klimuska, "300 New Quilts," 33; Parrish, "Imports." Also see Graybill's description of attending the annual Gordonville auction in "Amish Women," 261–66.

36. "About Us," http://authenticamishstore.com/about_us.html, accessed Mar. 22, 2012.

37. Kraybill and Nolt, *Amish Enterprise*, 120–21. Websites selling Amish-made quilts include "Almost Amish," www.almost-amish.com; "Amish Loft Quilts," www.amishloft.com/amishloft/quilts_main.html; "myFarmstand," www.myfarmstand.com; "AmishQuilter," www.amishquilter.com; "Amish Country Quilts," www.amishcountrylanes.com/Pages/AboutUs.shtml.

38. Kraybill, *Riddle*, 259.

39. For studies of Lancaster County Amish women's productivity on family farms, see Erickson and Klein, "Women's Roles," 282–96; Jellison, "Chosen Women," 102–18; Reschly and Jellison, "Production Patterns," 134–62. Also see Olshan and Schmidt, "Feminist Conundrum," 220–21.

40. Graybill, "Amish Women," 248.

41. Kraybill, *Riddle*, 261; Kraybill and Nolt, *Amish Enterprise*, 208–10.

42. Graybill, "Amish Women." I am grateful to Graybill for pointing me toward an earlier, qualitative study of Amish businesswomen: Ann Stoltzfus Taylor, "Demographic and Developmental Profile of Newly-emerging Entrepreneurs among Married Women in the Old-Order Amish Society of Lancaster County, Pennsylvania," EdD diss., Temple University, 1995.

43. Kraybill and Nolt, *Amish Enterprise*, 208–9; Tepper and Tepper, "Naomi Fisher," 68. On "pin money" and other money earned domestically by women, see Zelizer, *Social Meaning of Money*, 61–63.

44. Delagrange and Delagrange, interview.

45. Graybill, "Amish Women," 241.

46. Graybill, "Amish Women," 127.

47. Amish informant quoted in Graybill, "Amish Women," 216.

48. Graybill, "Amish Women," 129, 138; Kraybill and Nolt, *Amish Enterprise*, 209–12, 264n5. When I visited Smuckers Quilts in July 2008, Sam Smucker was tending the retail shop.

49. Graybill, "Amish Women," 158, 217–18.

50. Amish informant quoted in Graybill, "Amish Women," 139.

51. Quoted in Kraybill and Nolt, *Amish Enterprise*, 209.

52. Mary Beiler, interview.

53. For examples of this "degradation" theory, see Haders, "Quilts: The Art of the Amish," 113; Joyce, "Fame Don't Make the Sun Any Cooler," 227–30; R. Shaw, *Quilts: A Living Tradition*, 174–75.

CHAPTER 11. THE AMISH BRAND

1. "Amish Woman Knew She Had Quilt Sale the Moment She Laid Eyes on Chicago Couple," *The Onion*, Sept. 15, 2009.

2. On Shaker use of trademark, see Edward D. Andrews, *The Community Industries of the Shakers,* New York State Museum Handbooks 15 (Albany: New York State Museum, 1933), 243. I am grateful to Susan Strasser for pointing me to this source.

3. See Dilworth, *Imagining Indians*, 81–88, 125–72; Gordon, "Whimsey," 61–76; Hutchinson, *Indian Craze*, 11–50; Kladzyk, "Sacred Hoop," 102–5, 108, 110–11; M'Closkey, *Swept Under*.

4. Hutchinson, *Indian Craze*, 32–33. M'Closkey questions the extent of influence Anglo dealers exerted over Navajo weavers (*Swept Under*, 141–68).

5. See Bsumek, *Indian-Made;* Dilworth, "Handmade by an American Indian."

6. Adamson, *Thinking Through Craft,* 111–14, Barker, *Handcraft Revival;* J. Becker, "Selling Tradition," 129–34; J. Becker, *Selling Tradition.*

7. Adamson, *Thinking Through Craft,* 111–12.

8. Isadora Williams quoted in J. Becker, *Selling Tradition,* 76–77. Also see 73–92.

9. J. Becker, "Selling Tradition," 381–82. Cuesta Benberry notes that weaving was much more common among these Southern Highlands industries, but a few quilt cottage industries also were established. See Benberry, "Quilt Cottage Industries," 85–87.

10. Ardery, *Temptation,* 52–58.

11. For examples, see Ardery, *Temptation,* 58–60; Lewis, *Mountain Artisans,* 47–58. On the role of such enterprises in establishing an art market for quilts, see chapter 4.

12. Hawley, "Maintaining Business," 321–22; Kraybill and Nolt, *Amish Enterprise,* 52, 247–48; Smucker, "Destination," 200.

13. Kraybill and Nolt, *Amish Enterprise,* 195, 247–48. The authors directed the survey.

14. Meyers, "Amish Tourism," 123.

15. On nostalgia, see Stewart, *On Longing,* 23–24. On Amish participation in consumer culture, see Tharp, "Ascetical Value," and Nao Nomura's forthcoming dissertation on Amish consumer culture from the University of Tokyo.

16. The Amish brand was probably an important aspect of some of these other products, but phrases like "Amish gazebo," or "Amish tomatoes" have not been as ubiquitous as "Amish quilt."

17. Luthy, "Origin and Growth," 119, 122–23, 126–27. Also see the introduction for additional background on the growth of Amish-focused tourism.

18. Kraybill, *Riddle,* 290; Weaver-Zercher, *Imagination,* 92–97.

19. Kraybill, *Riddle,* 295–302; Kraybill and Nolt, *Amish Enterprise,* 34–35. For more on how change has occurred within Amish culture, see chapter 1.

20. Kraybill and Nolt argue that few Amish businesses directly promote their businesses using the keyword "Amish" (*Amish Enterprise,* 154, 196). Also see Walbert, *Garden Spot,* 86. According to Kraybill and Nolt, some Lancaster County Amish entrepreneurs prefer the term "Pennsylvania Dutch" over "Amish" when referring to their products because it does not directly point to the religious group but couches it in the larger milieu of a traditional-minded region.

21. Mrs. Levi S. Fisher, "Handmade Quilts," nd [c. 1974–80], Heritage Historical Library, Aylmer, Ontario.

22. For example, Chris and Katie Stoltzfus, "Country Lane Quilts," *Intercourse News,* Winter 1994; "Smuckers Quilts," *Penn Dutch Traveler,* Mar. 6, 1995; "Lovina's Stitchery," *Penn Dutch Traveler,* Mar. 6, 1995; Omar and Katherine Stoltzfus, "Country Barn Crafts," *Intercourse News,* Winter 1993.

23. For example, see Marian Stoltzfus, "Stoltzfus Quilts & Crafts," *Intercourse News,* Winter 1993, 3. Stoltzfus advertised quilts sold "In Our Farmhouse Location."

24. For more on imported quilts, see chapter 12.

25. Amish informants quoted in Graybill, "Amish Women," 128, 134.

26. Graybill, "Amish Women," 105–6, 108. To protect her Amish informants' identities, Graybill usually used pseudonyms.

27. See MacCannell, "Staged Authenticity."

28. Roger Mummert, "A Cozy Amish Craft," *New York Times*, Feb. 19, 1992.

29. Donald Kraybill refers to shops catering to tourists as "a symbolic and literal middle ground . . . where tourist and Amish can safely interact at a polite distance." See *Riddle,* 290–91.

30. Rebecca Esh, interview.

31. Ginny Culver to author, Sept. 17, 2007.

32. Graybill, "Amish Women," 133.

33. Cynthia Prescott to author, Oct. 10, 2007.

34. In addition to these quilted items, other related goods include appliance covers, placemats, beach bags, and vests, all of which, as Beth E. Graybill notes, are not traditionally Amish in design or function ("Amish Women," 181). But we should remember that quilts were also not part of Amish culture until around 1870.

35. Mary Hartman quoted in Klimuska, "Collectors Pay Thousands," 5.

36. Almost Amish, www.almost-amish.com.

37. Handmade Amish Quilts, "Handmade Amish Quilts," 1990, Heritage Historical Library, Aylmer, Ontario.

38. *Lands' End Holiday Catalog*; Grace Schantz, "Lands' End Christmas Catalogue Spotlights Holiday Quilts Made by Local Seamstresses," *Daily Record* (Wooster, Ohio), Nov. 7, 1989, A6. The article about the commissioned quilts in the local Wooster paper featured a photograph of four of the non-Amish contributors. On the Amish prohibition against photography, see Kraybill, *Riddle*, 41.

39. Kraybill and Nolt, *Amish Enterprise*, 3–4; Olshan, "Cottage Industries," 136, 140–42.

40. Kraybill, *Riddle*, 206–7.

CHAPTER 12. OUTSOURCING AUTHENTICITY

1. See Linch and Schmude, "Hmong Needle Treasures," 18–19; MacDowell, "Old Techniques," 26–27; Peterson, "Cool Heart," 35–38.

2. See Crystal, "Hmong Traditions," 10–13; Donnelly, *Changing Lives*; Peterson, "Cool Heart," 39; Quincy, *Hmong*, 213–24. On involvement of Hmong in the extended conflict in Southeast Asia, see Hamilton-Merritt, *Tragic Mountains*.

3. Peterson, "From the Heart," 331–37.

4. MacDowell, "Old Techniques," 27; Peterson, "From the Heart," 335–39.

5. Elmer Neufeld, "Mennonite Central Committee United States," *Global Anabaptist Mennonite Encyclopedia Online*, 1987, www.gameo.org/encyclopedia/contents/M4659.html/?searchterm=mcc; Parrish, "A Way of Life"; Quincy, *Hmong*, 219.

6. On the gender hierarchy within Hmong culture, see Donnelly, *Changing Lives*, 28–33.

7. Donnelly, *Changing Lives*, 88–112; Henry, "Hmong and Pennsylvania German Textiles," 43; Linch and Schmude, "Hmong Needle Treasures," 19; MacDowell, "Old Techniques," 28; Elaine Markoutas, "A Proud People Carry on Folk Art of the Life that Was," *Chicago Tribune*, Dec. 12, 1982; Parrish, "Way of Life"; Peterson, "From the Heart," 392–400, 411–12, 417; Peterson, "Cool Heart," 42–43.

There is some discrepancy as to whether Hmong in southeastern Pennsylvania attempted to establish a cooperative in the early 1980s. Sally Peterson, who presented a detailed exploration of *paj ntaub* marketing in her dissertation, was based in Pennsylvania for her field work. She discussed cooperatives in other geographic locations but stated that "none of the Pennsylvania Hmong have established a retail outlet such as those in the larger communities of California and Minnesota" ("Cool Heart," 42). A likely explanation for the lack of an established cooperative in southeastern Pennsylvania is that many Hmong women soon found relatively lucrative work in the existing industry of making quilts and did not need to sell *paj ntaub*. In contrast, Jean Henry, a program coordinator for an English as a Second Language program for refugees, wrote that one of her Hmong informants in Pennsylvania participated in a cooperative selling *paj ntaub* in 1982. See Henry, "Hmong and Pennsylvania German Textiles," 44. Hmong quiltmaker Lo Mao Moua recalled a grant-funded project called "Pennsylvania Hmong Craft" that was a short-lived enterprise marketing *paj ntaub*. Lo Mao Moua, interview by Heather Gibson, July 23, 2007, Alliance for American Quilts, Quilters' S.O.S. — Save Our Stories, www.allianceforamericanquilts.org/qsos/interview.php?pbd=qsos-a0a2w9–a.

8. Parrish, "Way of Life"; Peterson, "From the Heart," 412. Although Michigan has a much smaller Amish population than southeastern Pennsylvania, Hmong women there also found work in the mid-1980s collaborating with Amish quiltmakers. See MacDowell, "Old Techniques," 28–29.

9. Quoted in Peterson, "From the Heart," 414–15.

10. Carol Morello, "Hmongs are at Home with Country Quilts," *Philadelphia Inquirer*, Mar. 5, 1989, 20–A. Peterson, "From the Heart," 412, 414; Houa Yang, interview by Heather Gibson, Aug. 22, 2003, Alliance for American Quilts, Quilters' S.O.S. — Save Our Stories, www.allianceforamericanquilts.org/qsos/interview.php?pbd=qsos-a0a2w2–a.

11. For a discussion of the putting-out system commonly used by businesses marketing Amish quilts, see chapter 10.

12. Philadelphia Folklore Project, "We Try To Be Strong: 28 Years of Hmong Textiles in Philadelphia," www.folkloreproject.org/programs/exhibits/hmong/index.php.

13. Peterson, "From the Heart," 414.

14. Morello, "Country Quilts," 20–A; Peterson, "From the Heart," 411; Patricia Dane Rogers, "New Twist to Amish Quilts," *Washington Post*, Mar. 19, 1992, sec. Washington Home, 24.

15. Morello, "Country Quilts," 20–A.

16. Gibson, "Embroidered History," 46; Henry, "Hmong and Pennsylvania German Textiles," 46; Morello, "Country Quilts," 20–A; Peterson, "From the Heart," 416, 418; Peterson, "Cool Heart," 43.

17. Peterson, "From the Heart," 417.

18. Much of my initial knowledge of Hmong contributions to quiltmaking in Lancaster County comes from these sources. See Faubion, "Amish and the Hmong"; Folsom, "Personal Perspective"; Henry, "Hmong and Pennsylvania German Textiles"; Linch and Schmude, "Hmong Needle Treasures"; MacDowell, "Old Techniques"; Peterson, "Cool Heart." Articles aimed at a general audience published in widely circulating newspapers include Morello, "Country Quilts"; Carol Morello, "Laotian Quilters in Pa.," *Washington Post*, Mar. 30, 1989; Rogers, "New Twist"; and the more recent multipart exposé by Kathleen Parrish in the Allentown, PA *Morning Call*.

19. Peterson, "From the Heart," 415.

20. Quoted in Parrish, "Prosperity."

21. Moua, interview; Parrish, "Prosperity."

22. Faubion, "Amish and the Hmong," 34.

23. Philadelphia Folklore Project, *We Try To Be Strong: 28 Years of Hmong Textiles in Philadelphia*.

24. Yang, interview; Moua, interview.

25. Quoted in Parrish, "Prosperity."

26. Donna Boyle Schwartz, "Blockbusters: A Big Hit in Quilts, American Pacific is Expanding its Role in Related Home Textiles," *HFD*, June 1, 1992, 28. *HFD* was a trade journal that covered the home textiles industry. The initials were shorthand for Home Furnishings Daily (despite its weekly issues in the late 1980s and early 90s). Currently the periodical is called *HFN*, short for Home Furnishings News.

27. Sharon K. Bernard, "Piecing it Together," *HFD*, Oct. 28, 1991, 44.

28. Pellman and Pellman, *Treasury*. In March 2009 I analyzed a c. 1992 Arch "Amish Star" purchased by Diane Tepfer, Washington, DC, complete with its packaging. I am grateful to Ms. Tepfer for sharing her quilt and recollections with me. For information about an identical Arch quilt, see "Ebay Quilt Scammers," *Hart Cottage Quilts*, 2009, http://hartcottagequilts.com/quiltscams (accessed Dec. 16, 2009). I viewed the Broken Star quilt pictured on the cover of *Treasury* when it was on exhibit at the de Young Museum in 2009 as part of *Amish Abstractions: Quilts from the Collection of Faith and Stephen Brown*. See Smucker, Shaw, and Cunningham, *Amish Abstractions*, 94.

"Quilting stitches per inch" is a measurement quilt enthusiasts began touting at some point during the 1980s. Seven stitches is a relatively good standard, particularly when using polyester batting, as Arch did with its Heirloom Collection. Amish quilters are renowned for their small stitches, often accomplishing 10–14 stitches per inch.

29. Sharyn K. Bernard, "Young Boisson's Quilts Get Warm Reception," *HFD*, Dec. 10, 1990. Boisson, *American Home Collection*; Klimuska, "Swanky," 19–20.

30. Jura Koncius, "The Quilts That Struck a Nerve," *Washington Post*, Mar. 19, 1992, sec. Washington Home, 24; Jura Koncius, "Museum Quilts for the Home," *Washington Post*, Dec. 26, 1991, sec. Washington Home, 5.

31. Jared Block quoted in Janet Grady Sullivan, "Quilt Makes a Comeback," *HFD*, June 4, 1990, 35.

32. Schwartz, "Blockbusters," 36.

33. Sam Adler, "Americans Go Crazy for Quilts," *HFD*, June 8, 1992, 66.

34. Delagrange and Delagrange, interview.

35. Sharyn K. Bernard, "Americana Quilts Get Warm Reception," *HFD*, May 6, 1991; Bernard, "Piecing It Together," 43; Schwartz, "Blockbusters," 28; Karla Wattman, "Perfect Fit," *HFD*, Oct. 4, 1993, 94; Wattman, "Queuing up for Quilts," *HFD*, Aug. 30, 1993, 33.

36. Susan Stewart defines nostalgia as the "longing for an imagined past" (*On Longing*, 23).

37. Anita Iodice quoted in Janet Grady Sullivan, "Bitten by the Quilting Bee," *HFD*, July 29, 1991.

38. Quoted in Schwartz, "Blockbusters," 28.

39. Bernard, "Piecing," 44.

40. Examples in the Smithsonian Institution Archives, Product Development & Licensing Records include marketing and advertising materials from Domestications, Chambers, The Linen Source, and American Pacific Enterprises.

41. Jura Koncius, "The Power, The Glory, The Quilts," *Washington Post*, Mar. 11, 1993, sec. Washington Home, 20.

42. Most retailers' advertising copy stated that quilts were imported, although not necessarily where they were made. The Smithsonian Institution received complaints from quilt enthusiasts regarding retailers' advertisements for its reproduction line of quilts that did not explicitly state that the product was imported (see below for more on this controversy).

43. Sullivan, "Bitten," 42.

44. Wattman, "Perfect Fit," 94; and "Patchwork's Progress," *HFD*, Jan.17, 1994, 42.

45. Adler, "Americans Go Crazy," 68. Also see Wattman, "Patchwork's Progress."

46. Organizers of the Kutztown Folk Festival, an annual Pennsylvania tradition capped off with a quilt auction selling quilts made by both Amish and non-Amish, blamed imported quilts on its poor sales in 1992. See Aminah Franklin, "Quilters Feel Impact of Foreign Competition," *Morning Call* (Allentown, PA), July 22, 1992, A1.

47. Delagrange and Delagrange, interview; Wheatcroft and Granick, interview.

48. Gore quoted in Koncius, "Quilts That Struck a Nerve," 10.

49. Judith Griggs, "It's Not Just the Money [Letter to Editor]," *Threads*, Sept. 1993.

50. Benjamin, "Work of Art."

51. The cheap labor and low prices of factory-made quilts likely influenced the decrease in consumer demand for Amish-made quilts. Of course, it is difficult to pinpoint causes for the decreasing interest in quilts in general during these years. Interviewees offered various other hypotheses, including the influx of imported quilts on the consumer market, a change in home architecture (fewer big walls to hang quilts), the early 1990s recession, damage to quilts from exposure to too much light, and simply a change in fashion. Delagrange and Delagrange, interview; Druckman, interview; Finkel, interview; Silber, interview; Wheatcroft and Granick, interview.

52. Parrish, "Prosperity"; Philadelphia Folklore Project, *We Try To Be Strong: 28 Years of Hmong Textiles in Philadelphia*.

53. Parrish, "Imports."

54. Peterson, "From the Heart," 324–26.

55. Parrish, "Imports"; Hometowne Auction LLC, "Hometowne Quilt Auction," www.hometownequiltauction.com/index.php.

56. Parrish, "Imports." Todd Reinhart quoted in same.

57. Parrish, "Imports"; Barbara Garrett, conversation with author, Nov. 12, 2009.

58. "Transcript of Chat With Peter Seibert," *themorningcall.com*, Apr. 26, 2009, www.mcall.com/news/local/all-quilt=seibert-transcript,0,4037315.story (accessed May 8, 2009). These comments were posted by readers Joan Gullett and Roland Nachtigall Jr.

59. Ron Devlin, "Needlework Meets with Reserved Pocketbooks," *Morning Call* (Allentown, PA), July 9, 2006, B1.

60. Jacqueline Leonardi Alburtis, "Shocked to Learn Quilts Aren't Made By Amish," *Morning Call* (Allentown, PA), Apr. 25, 2006, A8.

61. "Transcript of Chat With Peter Seibert."

62. Delagrange and Delagrange, interview; Wheatcroft and Granick, interview.

63. For more on Emma Witmer's shop, see chapter 9.

64. Parrish, "How a Hill Tribe"; Witmer, interview; Emma Witmer, conversation with author, June 30, 2008, New Holland, PA.

Conclusion

1. Jonathan Holstein and Gail van der Hoof, "Logbook," 1973, Jonathan Holstein Collection; Linda Gruber, "Quilts Etc. For Jon & Gail Inc.," 1973, SPEC MS 305, B1F12, JHP UNL.

2. For more on Mary Lapp's Baskets quilts, see chapter 2.

3. Holstein and van der Hoof, "Logbook"; Julie Silber, "DRT likes," April 1986, SPEC MS 305, B4F6, JHP UNL; Julie Silber to Jonathan Holstein and Gail van der Hoof, Mar. 28, 1986, SPEC MS 305, B3F11, JHP UNL; Julie Silber to Jonathan Holstein and Gail van der Hoof, April 1986, SPEC MS 305, B3F11, JHP UNL.

4. Silber to Holstein and van der Hoof, April 1986; Silber, "DRT likes"; Jonathan Holstein, "Amish Quilts for Esprit Collection, Julie Silber, Curator," 1986, SPEC MS 305, B3F9, JHP UNL.

5. Carolyn Ducey, "Valuable Quilts Donated to Center," *Scarlet*, May 8, 2003, http://www.unl.edu/scarlet/v13n16/v13n16features.html; "Groundbreaking $2.2 Million Collection Donated to Quilt Center," *UNL News Releases*, May 5, 2003, http://www.unl.edu/ucomm/ucomm/2003/0503/050503anews.html.

6. Pottinger and Peterson, interview; Pottinger, *Quilts from the Indiana Amish*.

7. National Museum of American Art, "Exhibition Prospectus," Feb. 9, 1987, Smithsonian Renwick Gallery Exhibition Files. Exhibits of Pottinger's quilts include those hosted by the Craft and Folk Art Museum, Los Angeles (1984), the Chicago Public Library Cultural Center (1986), and the Smithsonian's Renwick Gallery (1987). Among other sites, they were also exhibited in Zurich, Switzerland.

8. Sally Falk, "Donors Sought to Keep Amish Quilt Collection," *Indianapolis Star*, June 21, 1987; Bernick, "A Quilt Is an Art Object," 138; Kathryn McClary, interview by author, Indianapolis, IN, May 28, 2008, digital recording in author's possession.

9. Wass, *Illinois Amish Quilts*, vi. Although I have been unable to determine the total price for this collection, based on how much Pottinger received from Indiana, he likely reaped in at least $200,000 from the Illinois transaction.

10. Ion Bowermaster, "Take This Park and Love It," *New York Times Magazine*, Sept. 3, 1995, 24. Alan Drengson, "Deep Ecology Movement," *Foundation for Deep Ecology*, http://www.deepecology.org/movement.htm; Susan C. Faludi, "Feuding Esprit Founders Reach Accord: Doug Tompkins Will Relinquish Post," *Wall Street Journal*, June 4, 1990, C16; Graydon, "Buying Sanctuary," 30.

11. Silber, interview; Julie Silber to David Luthy, Jan. 26, 1994, Heritage Historical Library, Aylmer, ON; Lita Solis-Cohen, "Heritage Center Museum Buys 82 Amish Quilts," *Maine Antique Digest,* Aug. 2002, 11–A.

12. David Luthy to Julie Silber, Feb. 3, 1994, Heritage Historical Library, Aylmer, ON.

13. Herr, interview. On hereditary diseases among the Amish, Holmes Morton, and the Clinic for Special Children, see Hostetler, *Amish Society,* 328–31; Kraybill, *Riddle,* 105–6.

14. Both the local Lancaster newspapers and *The Budget* often reported on high prices paid for quilts at public auction. For example, see "Amish Quilt Sold For Record $17,300 Here," *Lancaster New Era,* May 1, 1992; Christ F. Glick, "Gap, PA," *The Budget,* Feb. 12, 1997; Ed Klimuska, "Dealer Pays Record $6900 for Amish Quilt at Auction Here," *Lancaster New Era,* Feb. 25, 1987; Samuel S. Lapp, "Gordonville, PA, Melita Fellowship," *The Budget,* May 13, 1992; Mrs. Clarence Martin, "Akron, PA," *The Budget,* May 13, 1992. On community fundraisers known as benefit auctions, see Kraybill, *Riddle,* 156.

15. Hughes and Silber, *Amish: The Art of the Quilt,* (Alfred A. Knopf, 1990); Silber, interview; Solis-Cohen, "Heritage Center Museum Buys 82 Amish Quilts."

16. Silber, interview; Solis-Cohen, "Heritage Center Museum Buys 82 Amish Quilts," 11–A.
 Susie Tompkins relinquished her remaining shares of Esprit in 1996, with a group of investors taking ownership of the fashion company. Susie continued to acquire quilts with the assistance of Silber, although she found Amish quilts too "severe" and "masculine," preferring quilts she described as folksier and Silber characterized as "maverick." Susie's quilts continued to hang in the corporate headquarters after her departure from the company. The collection was taken down and put into storage in 2002 when the San Francisco corporate headquarters closed. Esprit continues today as a brand name owned by Esprit Holdings Limited, based in Hong Kong and Germany. "ESPRIT, company," *Esprit,* www.esprit.com/index .php?command=Display&navi_id=15 (accessed April 16, 2010); Constance C. R. White, "Patterns," *New York Times,* Feb. 4, 1997, B7.

17. Herr, interview; Silber, interview; Solis-Cohen, "Heritage Center Museum Buys 82 Amish Quilts," 11–A.

18. Martha Raffaele, "Quilt Museum Celebrates Fabric of Amish History," *Associated Press State & Local Wire,* Apr. 1, 2004; John M. Spidaliere, "Sunday Service," *Lancaster New Era,* Mar. 3, 2004, A-1.

19. Herr, interview; Susan Jurgelski, "It's Hip to Buy Squares," *Lancaster New Era,* Mar. 25, 2004, A-6.

20. Sharron V. Nelson, "The Heritage Center of Lancaster County Declares 2012 a Year of Transition," Heritage Center of Lancaster County, http://mim.io/e406f1 (accessed June 12, 2012); Heritage Center of Lancaster County, "Lancaster County Heritage Quilt Fund Established," http://quiltandtextilemuseum.com/qt/ ?primary=lancaster-quilts-textiles (accessed June 12, 2012); Heritage Center of Lancaster County, "Heritage Center Museum Collections to Transfer to LancasterHistory.org," http://lancasterheritage.com/?p=616 (accessed Dec. 27, 2012).

21. I received a docent-guided tour to the Lancaster Quilt and Textile Museum in October 2009.

22. Ducey, "Valuable Quilts"; McClary, interview. Collections at IQSC&M support a graduate program in textiles; students study quilts as part of their coursework. I earned my MA in Textile History from this program at the University of Nebraska-Lincoln.

23. For a discussion of how connoisseurs defined the "classic era," see chapter 8.

24. See Nomura and Smucker, "From Fibers to Fieldwork," 123–55.

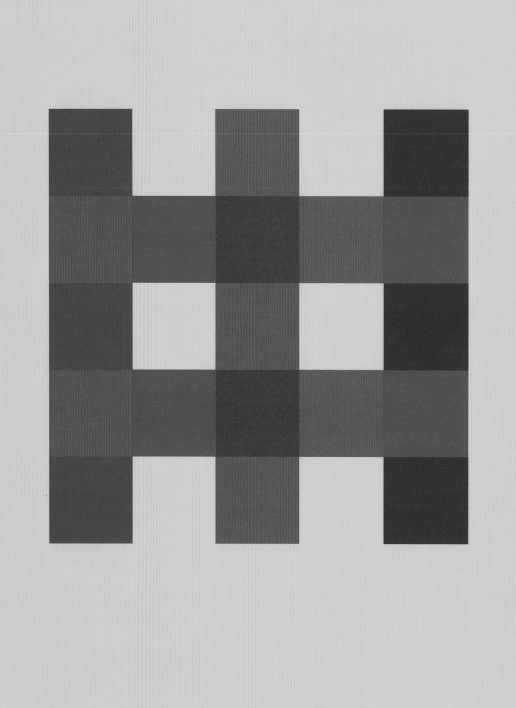

Bibliography

ARCHIVAL, MANUSCRIPT, AND OBJECT COLLECTIONS

Amish Design Collection, George and Susan Delagrange, Jeromesville, OH.

De Young Museum Textile Department Research Files, San Francisco, CA.

Eve Wheatcroft Granick Collection on Quilts, University of Nebraska-Lincoln, Archives and Special Collections Library (EWG UNL).

Heritage Historical Library, Collection on Quilts, Aylmer, ON.

Indiana State Museum, David Pottinger Collection of Amish Quilts, Indianapolis, IN (ISM DPC).

International Quilt Study Center & Museum (IQSC&M), Jonathan Holstein Collection, University of Nebraska-Lincoln.

International Quilt Study Center & Museum (IQSC&M), Ardis and Robert James Collection, University of Nebraska-Lincoln.

International Quilt Study Center & Museum (IQSC&M), Sara Miller Collection, University of Nebraska-Lincoln.

International Quilt Study Center & Museum (IQSC&M), Henry and Jill Barber Collection, University of Nebraska-Lincoln.

Jonathan Holstein Papers, University of Nebraska-Lincoln, Archives and Special Collections Library (JHP UNL).

Lancaster Quilt and Textile Museum, Heritage Center of Lancaster County, Lancaster, PA. (LQTM).

Smithsonian Institution Archives, Office of Product Development and Licensing Records (SIA PDL).

Smithsonian Institution, National Museum of American History, Division of Home and Community Life, Esther deLashmutt Collection on the Smithsonian Quilt Controversy (NMAH).

Smithsonian Institution, Smithsonian American Art Museum, Renwick Gallery Exhibition Files.

INTERVIEWS

Conducted by Author

Brown, Faith, and Stephen Brown. Tiburon, CA, August 18, 2008.

Cord, Xenia. Kokomo, IN, May 9, 2008.

Cunningham, Joe. San Francisco, CA, August 18, 2008.

Delagrange, Susan, and George Delagrange. Jeromesville, OH, October 3, 2008.

Druckman, Nancy. New York, NY, October 28, 2008.

Finkel, Amy. Philadelphia, PA, May 15, 2008.

Good, Phyllis Pellman. Telephone interview, February 27, 2009.

Haarer, Rebecca. Shipshewana, IN, May 13, 2008.

Havig, Bettina. Columbus, OH, October 5, 2008.

Herr, Patricia T. Lancaster, PA, October 23, 2007.

Holstein, Jonathan. Cazenovia, NY, November 9, 2007.

Kiracofe, Roderick. San Francisco, CA, August 14, 2008.

Kopp, Kate. Telephone interview. March 18, 2009.

McLary, Kathleen. Indianapolis, IN, May 28, 2008.

Mercer, Elaine. Belleville, PA, October 18, 2008.

Miller, Sara. Kalona, IA, May 10, 2002. Archives and Special Collections, University of Nebraska-Lincoln.

Oruch, Michael. New York, NY, November 8, 2008.

Pellman, Rachel. Lancaster, PA, April 4, 2008. Alliance for American Quilts, Quilters' S.O.S.— Save Our Stories, http://www.allianceforamericanquilts.org/qsos/interview.php?pbd=qsos-a0a7z7–a.

Polemis, Michael. Telephone interview. August 7, 2008.

Pottinger, David, and Faye Peterson. Goshen, IN, May 22, 2008.

Riehl, Benuel. Narvon, PA, May 13, 2008.

Sarah, Joseph. Columbus, OH, October 3, 2008.

Silber, Julie. Albion, CA, August 16, 2008.

Wheatcroft, David, and Eve Granick. Westborough, MA, September 19, 2008.

Conducted by Other Interviewers

Beiler, Barbara. Interview by Rachel Pellman, February 4, 2004. LQTM.

Beiler, Fannie. Interview by Rachel Pellman, March 7, 2007. LQTM.

Beiler, Mary. Interview by Rachel Pellman, January 12, 2005. LQTM.

Brown, Joyce. Interview by Eve Wheatcroft Granick, n.d. EWG UNL.

Byler, Mrs. John. Interview by Eve Wheatcroft Granick, March 8, 1984. EWG UNL.

Chupp, Barbara. Interview by Eve Wheatcroft Granick, March 19, 1984. EWG UNL.

Esh, Katie. Interview by Rachel Pellman, January 29, 2004. LQTM.

Esh, Mary. Interview by Rachel Pellman, October 13, 2004. LQTM.

Esh, Rebecca. Interview by Rachel Pellman, January 6, 2005. LQTM.

Esh, Sadie. Interview by Rachel Pellman, February 27, 2004. LQTM.

Fisher, Katie. Interview by Rachel Pellman, March 22, 2004. LQTM.

Fisher, Rachel. Interview by Eve Wheatcroft Granick, November 1983. EWG UNL.

Gingerich, Lovina. Interview by Eve Wheatcroft Granick, March 19, 1984. EWG UNL.

Glick, Annie, and Mary Esh. Interview by Rachel Pellman, February 13, 2004. LQTM.

Glick, Mary. Interview by Rachel Pellman, April 8, 2004. LQTM.

Huyard, Lydia. Interview by Rachel Pellman, March 29, 2005. LQTM.

Kauffman, Suvilla. Interview by Rachel Pellman, February 3, 2004. LQTM.

King, Aaron and Mary. Interview by Rachel Pellman, January 26, 2006. LQTM.

King, Jonas and Sarah. Interview by Rachel Pellman, January 22, 2004. LQTM.

King, Malinda F. Interview by Rachel Pellman, February 26, 2004. LQTM.

King, Mary. Interview by Rachel Pellman, May 7, 2004. LQTM.

King, Mary, and Lizzie Zook. Interview by Rachel Pellman, August 14, 2006. LQTM.

King, Mary S. Interview by Rachel Pellman, March 22, 2004. LQTM.

Kurtz, Mrs. Joe E. Interview by Eve Wheatcroft Granick, March 8, 1984. EWG UNL.

Lapp, Daniel, and Orpha Lapp. Interview by Rachel Pellman, November 19, 2004. LQTM.

Lapp, Leah. Interview by Rachel Pellman, April 12, 2005. LQTM.

Lapp, Mary. Interview by Rachel Pellman, February 19, 2004. LQTM.

Lapp, Mattie, and Malinda Lapp. Interview by Rachel Pellman, February 10, 2004. LQTM.

Lapp, Rachel. Interview by Rachel Pellman, January 14, 2004. LQTM.

Miller, Fanny. Interview by Eve Wheatcroft Granick, March 22, 1984. EWG UNL.

Miller, Lizzie. Interview by Eve Wheatcroft Granick, 1984. EWG UNL.

Miller, Maude. Interview by Eve Wheatcroft Granick, March 1984. EWG UNL.

Miller, Mrs. John. Interview by Eve Wheatcroft Granick. 1984. EWG UNL.

Miller, Sara. Interview by Eve Wheatcroft Granick, March 18, 1984. EWG UNL.

Miller, Sylvia. Interview by Eve Wheatcroft Granick. 1984. EWG UNL.

Moua, Lo Mao. Interview by Heather Gibson, July 23, 2007. Alliance for American Quilts, Quilters' S.O.S.—Save Our Stories. http://www.allianceforamericanquilts.org/qsos/interview.php?pbd=qsos-a0a2w9–a.

Newman, Rachel. Interview by Marsha MacDowell, October 27, 2003. Quilt Treasures, Project of the Alliance for American Quilts and Michigan State University Museum, and MATRIX: Center for Humane, Arts, and Social Sciences Online.

Nissley, Mrs. Andy. Interview by Eve Wheatcroft Granick. 1984. EWG UNL.

Petersheim, Edna. Interview by Rachel Pellman, September 29, 2004. LQTM.

Ranck, Reba. Interview by Rachel Pellman, January 25, 2006. LQTM.

Sirirathasuk Sikoun, Pang Xiong. Interview by Heather Gibson, June 20, 2003. Alliance for American Quilts, Quilters' S.O.S.—Save Our Stories. http://www.allianceforamericanquilts.org/qsos/interview.php?pbd=qsos-a0a2v9–a.

Smucker, Leroy, and Elizabeth Smucker. Interview by Rachel Pellman, March 10, 2005. LQTM.

Smucker, Moses, and Susie Smucker. Interview by Rachel Pellman, March 26, 2004. LQTM.

Stoltzfoos, Hannah. Interview by Rachel Pellman, February 2, 2004. LQTM.

Stoltzfus, Arie. Interview by Rachel Pellman, March 3, 2004. LQTM.

Stoltzfus, Emma. Interview by Rachel Pellman, August 10, 2006. LQTM.

Stoltzfus, Fannie. Interview by Rachel Pellman, February 4, 2004. LQTM.

Stoltzfus, Katie. Interview by Rachel Pellman, October 19, 2004. LQTM.

Stoltzfus, Miriam. Interview by Rachel Pellman, January 18, 2006. LQTM.

Stoltzfus, Sarah, and Emma Stoltzfus. Interview by Rachel Pellman, October 27, 2004. LQTM.

Woodard, Thomas, and Blanche Greenstein. Interview by Marsha MacDowell, October 28, 2003. Quilt Treasures, Project of the Alliance for American Quilts and Michigan State University Museum, and MATRIX: Center for Humane, Arts, and Social Sciences Online. http://www.allianceforamericanquilts.org/treasures/main.php?id=15.

Yang, Houa. Interview by Heather Gibson, August 22, 2003. Alliance for American Quilts, Quilters' S.O.S.—Save Our Stories. http://www.allianceforamericanquilts.org/qsos/interview.php?pbd=qsos-a0a2w2–a.

Yoder, Emanuel. Interview by Eve Wheatcroft Granick. 1984. EWG UNL.

Yoder, Lena. Interview by Eve Wheatcroft Granick, March 19, 1984. EWG UNL.

Yoder, Mrs. Levi. Interview by Eve Wheatcroft Granick, 1984. EWG UNL.

Yoder, Mary. Interview by Rachel Pellman, March 28, 2006. LQTM.

Witmer, Emma. Interview by Heather Gibson, October 20, 2003. Alliance for American Quilts, Quilters' S.O.S. — Save Our Stories. www.allianceforamericanquilts.org/qsos/interview.php?pbd=qsos-a0a2y2–a.

Zook, Elizabeth. Interview by Rachel Pellman, July 27, 2006. LQTM.

Zook, Katie. Interview by Rachel Pellman, March 13, 2004. LQTM.

PUBLISHED SOURCES

1001 Questions and Answers on the Christian Life. Aylmer, ON: Pathway Publishers, 1992.

"About the Designer: Hansine Pederson Goran." www.currentcarpets.com/info/CC_about.html.

Adamson, Glenn. "Craft Paradigms: The Studio Craft Movement and the Avant-garde, 1966–1972." PhD diss., Yale University, 2001.

———. *Thinking Through Craft.* Oxford, New York: Berg Publishers, 2007.

Agnew, Eleanor. *Back From the Land: How Young Americans Went to Nature in the 1970s, and Why They Came Back.* Chicago: Ivan R. Dee, 2004.

Alloway, Lawrence. *Systemic Painting.* New York: Solomon R. Guggenheim Foundation, 1966.

Ames, Kenneth. *Beyond Necessity: Art in the Folk Tradition.* Winterthur, DE: Winterthur Museum; Distributed by W.W. Norton, 1977.

———. "Folk Art: The Challenge and the Promise." In *Perspectives on American Folk Art,* edited by Ian M. G. Quimby and Scott T. Swank, 293–324. Winterthur, DE: Published for the Henry Francis du Pont Winterthur Museum, distributed by W.W. Norton, 1980.

"Amish: The Art of the Quilt." *Triptych,* August 1990.

Andrews, Edward D. *The Community Industries of the Shakers.* New York State Museum Handbooks 15. Albany: New York State Museum, 1933.

Appadurai, Arjun. "Introduction: Commodities and the Politics of Value." In Appadurai, *The Social Life of Things: Commodities in Cultural Perspective,* 3–63. Cambridge: Cambridge University Press, 1986.

Ardery, Julia S. *The Temptation: Edgar Tolson and the Genesis of Twentieth-century Folk Art.* Chapel Hill: University of North Carolina Press, 1998.

Arnett, William, Paul Arnett, Joanne Cubbs, and E. W. Metcalf. *Gee's Bend: The Architecture of the Quilt.* Atlanta, GA: Tinwood Books, 2006.

Arnett, William, Alvia Wardlaw, Jane Livingston, and John Beardsley. *The Quilts of Gee's Bend: Masterpieces from a Lost Place.* Atlanta, GA: Tinwood Books, 2002.

Attfield, Judith. *Wild Things: The Material Culture of Everyday Life.* Oxford: Berg Publishers, 2000.

Auther, Elissa. "Fiber Art and the Hierarchy of Art and Craft, 1960–80." *Journal of Modern Craft* 1, no. 1 (March 2008): 13–33.

———. *String, Felt, Thread: The Hierarchy of Art and Craft in American Art.* Minneapolis: University of Minnesota Press, 2010.

———. "The Decorative, Abstraction, and the Hierarchy of Art and Craft in the Art Criticism of Clement Greenberg." *Oxford Art Journal* 27, no. 3 (March 2004): 339–64.

Barker, Garry. *The Handcraft Revival in Southern Appalachia, 1930–1990.* Knoxville: University of Tennessee Press, 1991.

Beardsley, John. "Freedom Quilting Bee." In *Gee's Bend: The Women and their Quilts*, 178–85. Atlanta: Tinwood Books, in association with the Museum of Fine Arts, Houston, 2002.

Bearley, Darwin D. "A Thirty Year Collection." In *The Darwin D. Bearley Collection: Antique Ohio Amish Quilts*, 153–60. [Switzerland]: Bernina, 2006.

Becker, Howard S. *Art Worlds.* 2nd ed. Berkeley and Los Angeles: University of California Press, 2008.

Becker, Jane S. *Selling Tradition: Appalachia and the Construction of an American Folk, 1930–1940.* Chapel Hill: University of North Carolina Press, 1998.

———. "Selling Tradition: The Domestication of Southern Appalachian Culture in 1930s America." PhD diss., Boston University, 1993.

Benberry, Cuesta. "Quilt Cottage Industries: A Chronicle." *Uncoverings* (1986): 83–100.

———. "The 20th Century's First Quilt Revival." Pts. 1, 2, and 3. *Quilter's Newsletter Magazine,* July-August 1979, September 1979, October 1979.

Bender, Sue. *Plain and Simple: A Woman's Journey to the Amish.* San Francisco: Harper and Row, 1989.

Benjamin, Walter. "The Work of Art in the Age of Mechanical Reproduction." In *Illuminations.* New York: Schocken Books, 1968.

Benner, Cheryl, and Rachel T. Pellman. *Country Bride Quilt Collection.* Intercourse, PA: Good Books, 1991.

———. *Country Lily Quilt.* Intercourse, PA: Good Books, 1990.

———. *The Country Paradise Quilt.* Intercourse, PA: Good Books, 1991.

———. *The Country Love Quilt.* Intercourse, PA: Good Books, 1989.

Berlo, Janet Catherine. "'Acts of Pride, Desperation, and Necessity': Aesthetics, Social History, and American Quilts." In *Wild by Design: Two Hundred Years of Innovation and Artistry in American Quilts*, by Janet Catherine Berlo and Patricia Cox Crews, 5–34. Lincoln: International Quilt Study Center at the University of Nebraska in association with University of Washington Press, Seattle, 2003.

Berlo, Janet Catherine, and Patricia Cox Crews. *Wild by Design: Two Hundred Years of Innovation and Artistry in American Quilts.* Lincoln, NE: International Quilt Study Center at the University of Nebraska-Lincoln in Association with University of Washington Press, Seattle, 2003.

Berman, Linda and Irwin. "Collecting Children's Quilts: The Lure of the Chase." *The Clarion,* Summer 1979.

Bernick, Susan E. "A Quilt Is an Art Object When It Stands Up Like a Man." In *Quilt Culture: Tracing the Pattern,* edited by Cheryl B. Torsney and Judy Elsley, 134–50. Columbia and London: University of Missouri Press, 1994.

Binkley, Sam. *Getting Loose: Lifestyle Consumption in the 1970s.* Durham, NC: Duke University Press, 2007.

Bishop, Robert, and Elizabeth Safanda. *A Gallery of Amish Quilts: Design Diversity from a Plain People.* New York: Dutton, 1976.

Bishop, Robert, William Secord, and Judith Reiter Weissman. *Quilts, Coverlets, Rugs and Samplers.* The Knopf Collectors' Guides to American Antiques. New York: Alfred A. Knopf, 1982.

Bixby, Brian. "Consuming Simple Gifts: Shakers, Visitors, Goods." In *The Business of Tourism: Place, Faith, and History,* edited by Philip Scranton and Janet D. Davidson, 85–108. Hagley Perspectives on Business and Culture. Philadelphia: University of Pennsylvania, 2007.

Bordes, Marilynn Johnson. *12 Great Quilts from the American Wing.* [New York]: Metropolitan Museum of Art, 1974.

Bourdieu, Pierre. *Distinction: A Social Critique of the Judgement of Taste.* Translated by Richard Nice. Cambridge, MA: Harvard University Press, 1984.

Boynton, Linda. "Recent Changes in Amish Quiltmaking." *Uncoverings* 6 (1985): 33–46.

Brackman, Barbara. "American Adaptation: Block-Style Quilts." In *American Quilts in the Modern Age, 1870–1940: The International Quilt Study Center Collections,* edited by Marin F. Hanson and Patricia Cox Crews, 20–25. Lincoln: University of Nebraska Press, 2009.

———. *Clues in the Calico: A Guide to Identifying and Dating Antique Quilts.* Charlottesville, VA: Howell Press, 1989.

———. *Encyclopedia of Appliqué: An Illustrated, Numerical Index to Traditional and Modern Patterns.* McLean, VA: EPM Publications, 1993.

———. *Encyclopedia of Pieced Quilt Patterns.* Paducah KY: American Quilter's Society, 1993.

———. "New Amish Quilts." *Quilter's Newsletter Magazine,* August 1988.

———. *Patterns of Progress: Quilts in the Machine Age.* Los Angeles: Autry Museum of Western Heritage, 1997.

Brandt, Mindy, and Thomas E. Gallagher. "Tourism and the Old Order Amish." *Pennsylvania Folklife* 43, no. 2 (April 1993).

Brant, Sandra, and Elissa Cullman. *Andy Warhol's "Folk and funk": September 20, 1977–November 19, 1977.* New York: Museum of American Folk Art, 1977.

Braunstein, Peter, and Michael William Doyle. "Introduction: Historicizing the American Counterculutre of the 1960s and 1970s." In *Imagine Nation: The American Counterculture of the 1960s and '70s,* 5–14. New York and London: Routledge, 2002.

Brody, David. "The Building of a Label: The New American Folk Art Museum." *American Quarterly* 55, no. 2 (2003): 257–276.

Broude, Norma, and Mary D. Garrard. "Introduction: Feminism and Art in the 20th Century." In *The Power of Feminist Art: The American Movement of the 1970s,* edited by Norma Broude and Mary D. Garrard, 10–29. New York: Abrams, 1994.

Bsumek, Erika Marie. *Indian-Made: Navajo Culture in the Marketplace, 1868–1940.* Lawrence: University Press of Kansas, 2008.

Cadogan, Heather. "Artistic Creation: Amish Quilts and Abstract Art." *Uncoverings* 26 (2005): 121–53.

Cahill, Holger, and Rita Wellman. "American Design: From the Heritage of Our Styles Designers are Drawing Inspiration to Mold National Taste." *House and Garden* (July 1938): 15–16.

Caldwell, Margaret B. "Bernard & S. Dean Levy." *Art and Auction,* September 1984.

———. "The Year in Review 1987–88." *Art and Auction,* September 1988.

Callahan, Nancy. "'Helping the Peoples to Help Themselves.'" *Quilt Digest,* no. 4 (1986): 20–29.

———. *The Freedom Quilting Bee.* Tuscaloosa: University of Alabama Press, 1987.

Chave, Anna C. "Dis/Cover/ing the Quilts of Gee's Bend, Alabama." *Journal of Modern Craft* 1, no. 2 (July 2008): 221–53.

Chicago, Judy. *The Dinner Party: A Symbol of our Heritage.* Garden City, NY: Anchor Press/Doubleday, 1979.

Christensen, Erwin. *The Index of American Design.* New York: Macmillan, 1950.

Clark, Ricky. "Germanic Aesthetics, Germanic Communities." In *Quilts in Community: Ohio's Traditions,* 21–45. Nashville, TN: Rutledge Hill Press, 1991.

Clifford, James. "Histories of the Tribal and the Modern." In *The Predicament of Culture: Twentieth-Century Ethnography, Literature, and Art,* 189–214. Cambridge, MA: Harvard University Press, 1988.

———. "On Collecting Art and Culture." In *The Predicament of Culture: Twentieth-Century Ethnography, Literature, and Art,* 215–50. Cambridge, MA: Harvard University Press, 1988.

Colgan, Susan. "Collecting Quilts: Where it all Began." *Art and Antiques,* October 1983.

"Comeback of the Quilt." *Reader's Digest,* March 1973.

Cooper, Patricia, and Norma Bradley Buferd. *The Quilters: Women and Domestic Art.* New York: Doubleday, 1977.

Crystal, Eric. "Hmong Traditions in the Crucible of Social Change." In *Michigan Hmong Arts: Textiles in Transition,* edited by C. Kurt Dewhurst and Marsha MacDowell, 74. East Lansing, MI: Folk Arts Division, Michigan State University, 1984.

Cunningham, Joe. "All in the Details: The Making of Amish Quilts." In *Amish Abstractions: Quilts from the Collection of Faith and Stephen Brown,* 39–48. San Francisco: Pomegranate in collaboration with the Fine Arts Museums of San Francisco, 2009.

———. "Convention and Innovation in Amish Quilts." In *Amish Quilts 1880 to 1940 from the Collection of Faith and Stephen Brown,* 21–27. Ann Arbor, MI: University of Michigan Museum of Art, 2000.

Curry, David Park. "Rose-Colored Glasses: Looking for 'Good Design' in American Folk Art." In *An American Sampler: Folk Art from the Shelburne Museum,* 24–41. Washington, DC: National Gallery of Art, 1987.

———. "Slouching Towards Abstraction." *Smithsonian Studies in American Art* 3, no. 1 (Winter 1989): 48–71.

———. "Time Line." In *An American Sampler: Folk Art from the Shelburne Museum.* Washington, DC: National Gallery of Art, 1987.

Deloria, Philip. "Counterculture Indians and the New Age." In *Imagine Nation: The American Counterculture of the 1960s and '70s,* 159–88. New York and London: Routledge, 2002.

Detweiler, Lowell. *The Hammer Rings Hope: Photos and Stories from Fifty Years of Mennonite Disaster Service.* Scottdale, PA: Herald Press, 2000.

Dewhurst, C. Kurt, and Marsha MacDowell, eds. *Michigan Hmong Arts: Textiles in Transition.* East Lansing: Michigan State University Museum, 1984.

———. "The Marketing of Objects in the Folk Art Style." *New York Folklore* 12, no. 1–2 (1986): 43–47.

Dietz, Andrew. *The Last Folk Hero: A True Story of Race and Art, Power and Profit.* Atlanta, GA: Ellis Lane Press, 2006.

Dilworth, Leah. "'Handmade by an American Indian': Souvenirs and the Cultural Economy of Southwestern Tourism." In *The Culture of Tourism: The Tourism of Culture: Selling the Past to the Present in the American Southwest,* edited by Hal K. Rothman. Albuquerque: University of New Mexico Press, 2003.

———. *Imagining Indians in the Southwest: Persistent Visions of a Primitive Past.* Washington, DC: Smithsonian Institution Press, 1996.

"Diversity within Tradition: Amish Quilts at the Met." *Antiques and the Arts Online,* December 2, 2003. http://antiquesandthearts.com/GH-2003-12-02-12-27-29p1.htm.

Doheny, Marilyn. *Bargello Tapestry Quilts: The Ultimate Quilt of the '90s.* Edmonds, WA: Doheny Publications, 1994.

Donnelly, Nancy D. *Changing Lives of Refugee Hmong Women.* Seattle: University of Washington Press, 1994.

Doss, Erika. *Twentieth-century American Art.* Oxford History of Art. Oxford: Oxford University Press, 2002.

Downing, Crystal. "Witnessing the Amish: Plain People on Fancy Film." In *The Amish and the Media,* edited by Diane Zimmerman Umble and David Weaver-Zercher, 25–41. Baltimore: Johns Hopkins University Press, 2008.

Ducey, Carolyn. *The Collector's Eye: Amish Quilts from the International Quilt Study Center Collections, Gallery Guide.* Lincoln, NE: International Quilt Study Center, University of Nebraska–Lincoln, 2005.

Eaton, Linda. *Quilts in a Material World: Selections from the Winterthur Collection.* New York: Abrams, 2007.

Elsley, Judy. "The Smithsonian Quilt Controversy: Cultural Dislocation." *Uncoverings* 14 (1993): 119–36.

Emmerling, Mary Ellisor. *American Country: A Style and Source Book.* New York: C.N. Potter; Distributed by Crown Publishers, 1980.

———. *Collecting American Country: How to Select, Maintain, and Display Country Pieces.* New York: C.N. Potter: Distributed by Crown Publishers, 1983.

Erickson, Julia, and Gary Klein. "Women's Roles and Family Production among the Old Order Amish." *Rural Sociology* 46, no. 2 (1981): 282–96.

Faubion, Trish. "The Amish and the Hmong: Two Cultures and One Quilt." *Piecework* 1 (1993): 26–35.

Ferrero, Pat, Linda Reuther, and Julie Silber. "A Legacy of Hearts and Hands." In *American Quilts: A Handmade Legacy,* edited by L. Thomas Frye. Oakland, CA: The Oakland Museum, 1981.

Fine, Gary Alan. *Everyday Genius: Self-taught Art and the Culture of Authenticity.* Chicago: University of Chicago Press, 2004.

Finley, Ruth. *Old Patchwork Quilts and the Women Who Made Them.* Philadelphia: J. B. Lippincott, 1929.

Fisher, Laura. "The Artistic Journey of Amish Quilts." In *Diamonds and Bars: Die Kunst der Amischen/ The Art of the Amish People,* 10–15. Stuttgart: Arnoldsche, 2007.

Fleischmann-Heck, Isa, and Brigette Tietzel. *Quilts Der Amish Aus Privatsammlungen: Eine Ausstellung Im Deutschen Textilmuseum Krefeld = Amish Quilts from Private Collections: An Exhibition at the Deutsches Textilmuseum Krefelf.* Translated by Jean Reinirkens. Krefeld: Stadt Krefeld, 2008.

Folsom, Jan. "The Amish and the Hmong: A Personal Perspective." *Piecework* 1 (1993): 36–38.

Foster, Thomas W. "Amish Society: A Relic of the Past Could Become a Model for the Future." *The Futurist,* December 1981.

Fox, Judy Kellar. "Amish Quilts: Old Quilts and New, Both Part of the Amish Heritage are found in Lancaster County, Pennsylvania." *Fiberarts,* April 1993.

Frank, Dana. *Buy American: The Untold Story of Economic Nationalism.* Boston: Beacon Press, 1999.

Frye, L. Thomas, ed. *American Quilts: A Handmade Legacy.* Oakland, CA: Oakland Museum, 1981.

Garoutte, Sally. "Early Colonial Quilts in a Bedding Context." *Uncoverings* 1 (1980): 18–27.

Gehman, Richard. "Amish Folk: Plainest of Pennsylvania's Plain People." *National Geographic,* August 1965.

Gibson, Heather. "Embroidered History and Familiar Patterns Textiles As Expressions of Hmong and Mennonite Lives." MA thesis, University of Delaware, 2006.

Goldman, Marilyn. "The Wilkinson Quilt Company: 'America's Original Makers of Fine Quilts.'" *Uncoverings* 23 (2002).

Good, Phyllis Pellman. *Quilts from Two Valleys: Amish Quilts from the Big Valley and Mennonite Quilts from the Shenandoah Valley.* Intercourse, PA: Good Books 1999.

Goodman, Wendy. *The World of Gloria Vanderbilt.* New York: Abrams, 2010.

Gordon, Beverly. "Intimacy and Objects: A Proxemic Analysis of Gender-Based Response to the Material World." In *The Material Culture of Gender, The Gender of Material Culture,* edited by Katherine Martinez and Kenneth L. Ames, 237–52. Winterthur, DE: Winterthur Museum, distributed by University Press of New England, 1997.

———. "The Whimsey and Its Contexts: A Multi-Cultural Model of Material Culture Study." *Journal of American Culture* 9 (Spring 1986): 61–76.

Granick, Eve Wheatcroft. *The Amish Quilt.* Intercourse, PA: Good Books, 1989.

———. "Amish Quilts of Lancaster County." In *Amish Quilts of Lancaster County,* 13–33. San Francisco: Esprit de Corp, 1990.

———. "Amish Quilts: Icons of Faith." In *Amish Quilts 1880 to 1940 From the Collection of Faith and Stephen Brown,* 11–18. Ann Arbor, MI: University of Michigan Museum of Art, 2000.

Graybill, Beth E. "Amish Women, Business Sense: Old Order Women Entrepreneurs in the Lancaster County, Pennsylvania, Tourist Marketplace." PhD diss., University of Maryland, 2009.

Graydon, Nicola "Buying Sanctuary." *Ecologist* 36, no. 4 (2006): 28–35.

Greene, Elaine. "Taking a Dream, Making it Real." *House and Garden,* January 1982.

"Groundbreaking $2.2 Million Collection Donated to Quilt Center." *UNL News Releases,* May 5, 2003. http://www.unl.edu/ucomm/ucomm/2003/0503/050503anews.html.

Gruen, John. "Sophisticated Primitives." *New York Magazine,* September 6, 1971.

Gunn, Virginia. "From Myth to Maturity: The Evolution of Quilt Scholarship." *Uncoverings* 13 (1992): 192–205.

———. "Perfecting the Past: Colonial Revival Quilts." In *American Quilts in the Modern Age, 1870–1940: The International Quilt Study Center Collections,* edited by Marin F. Hanson and Patricia Cox Crews, 228–86. Lincoln: University of Nebraska Press, 2009.

———. "Quilts: The Art of the Amish." In *America's Glorious Quilts,* edited by Dennis Duke and Deborah Harding, 110–31. New York: Hugh Lauter Levin Associates; Distributed by Macmillan, 1987.

———. *Sunshine and Shadow: The Amish and Their Quilts.* New York: Universe, 1976.

Hall-Patton, Colleen. "Jean Ray Laury in the 1960s: Foremother of a Quilt Revival." *Uncoverings* 26 (2005): 65–92.

———. "Quilting Between the Revivals: The Cultural Context of Quilting 1945–1970." PhD diss., University of Nevada, Las Vegas, 2004.

Halle, David. *Inside Culture: Art and Class in the American Home.* Chicago: University of Chicago Press, 1993.

Hamilton-Merritt, Jane. *Tragic Mountains: The Hmong, the Americans, and the Secret Wars for Laos, 1942–1992.* Bloomington: Indiana University Press, 1993.

Hanson, Marin, and Janneken Smucker. "Quilts as Manifestations of Cross-Cultural Contact: East-West and Amish-'English' Examples." *Uncoverings* 24 (2003): 99–129.

Hanson, Marin F., and Patricia Cox Crews, eds. *American Quilts in the Modern Age, 1870–1940: The International Quilt Study Center Collections.* Lincoln: University of Nebraska Press, 2009.

Harding, Deborah. "Quilts: America's Folklore." In *America's Glorious Quilts,* edited by Dennis Duke and Deborah Harding. New York: Hugh Lauter Levin Associates; Distributed by Macmillan, 1987.

Hawley, Jana. "The Commercialization of Old Order Amish Quilts: Enduring and Changing Cultural Meanings." *Clothing and Textiles Research Journal* 23, no. 2 (2005): 102–14.

———. "Maintaining Business While Maintaining Boundaries: An Amish Woman's Entrepreneurial Experience." *Entrepreneurship, Innovation, and Change* 4 (1995): 315–28.

Hedges, Elaine. "The Construction of Quilts in the 1990s." *Quilt Journal* 3, no. 2 (1994).

Heisey, Craig N., and Rachel T. Pellman. *The Country Bride Quilt.* Intercourse, PA: Good Books, 1988.

Henry, Jean. "Hmong and Pennsylvania German Textiles: Needlework Traditions in Transition in Lancaster County." *Folk Art* (Summer 1995): 40–46.

Herr, Patricia T. *Amish Quilts of Lancaster County.* Atglen PA: Schiffer, 2004.

———. "Lancaster Amish Quilts: 1869–1996, Are Amish Quilting Traditions Dying or Simply Evolving?" *Fiberarts,* February 1997.

———. *Quilting Traditions: Pieces from the Past.* Atglen, PA: Schiffer, 2000.

———. "Quilts within the Amish Culture." In *A Quiet Spirit: Amish Quilts from the Collection of Cindy Tietze & Stuart Hodosh,* 45–67. Los Angeles: UCLA Fowler Museum of Cultural History, 1996.

Holstein, Jonathan. "A Plain Art: Ohio's Amish Quilts." In *The Darwin D. Bearley Collection: Antique Ohio Amish Quilts,* 21–33. [Switzerland]: Bernina, 2006.

———. *Abstract Design in American Quilts.* New York: Whitney Museum of American Art, 1971.

———. *Abstract Design in American Quilts: A Biography of an Exhibition.* 1st ed. Louisville, KY: Kentucky Quilt Project, 1991.

———. *American Pieced Quilts.* [Lausanne]: Editions des Massons S. A.; distributed by Paul Bianchini, New York, 1972.

———. "Problems in Quilt Scholarship." In *Expanding Quilt Scholarship: The Lectures, Conferences and Other Presentations of Louisville Celebrates the American Quilt,* edited by Shelly Zegart and Jonathan Holstein. Louisville, KY: Kentucky Quilt Project, 1994.

———. "The Aesthetics of Amish Quilts." In *A Quiet Spirit: Amish Quilts from the Collection of Cindy Tietze & Stuart Hodosh,* 69–121. Los Angeles: UCLA Fowler Museum of Cultural History, 1996. New York: Scribner, 1977.

———. *The Pieced Quilt: An American Design Tradition.* Greenwich, CT: New York Graphic Society, 1973.

———. "The Whitney and After . . . What's Happened to Quilts." *The Clarion* 11 (Spring/Summer 1986): 80–85.

Hornberger, Charlotte. "Amish Quilter, Lancaster County, Pa." *Antique Collecting,* January 1978.

Hornberger, D. Patrick. "Country Contemporary: Country Antiques & Folk Art in a Modern Setting." *Antique Collecting,* September 1978.

Hostetler, John A. *Amish Society.* 4th ed. Baltimore: Johns Hopkins University Press, 1993.

Hufnagl, Florian. *Diamonds and Bars: Die Kunst der Amischen/ The Art of the Amish People.* Stuttgart: Arnoldsche, 2007.

Hughes, Robert. *American Visions: The Epic History of Art in America.* New York: Alfred A. Knopf, 1997.

———. *The Shock of the New.* New York: Knopf; Distributed by Random House, 1981.

Hughes, Robert, and Julie Silber. *Amish: The Art of the Quilt*. New York: Alfred A. Knopf, 1990.

Humes, Edward. *Eco Barons: The Dreamers, Schemers, and Millionaires Who Are Saving Our Planet*. New York: Ecco, 2009.

Hunter, Sam, and John Jacobus. *Modern Art*. 3rd ed. New York: Prentice Hall and Harry N. Abrams, 1992.

Huntington, Abbie Gertrude Enders. "Dove at the Window: A Study of an Old Order Amish Community in Ohio." PhD diss., Yale University, 1956.

Hutchinson, Elizabeth. *The Indian Craze: Primitivism, Modernism, and Transculturation in American Art, 1890–1915*. Durham, NC: Duke University Press, 2009.

Jacob, Jeffrey. *New Pioneers: The Back-to-the-Land Movement and the Search for a Sustainable Future*. University Park: Pennsylvania State University Press, 1997.

Jellison, Katherine. "The Chosen Women: The Amish and the New Deal." In *Strangers at Home: Amish and Mennonite Women in History*, edited by Kimberly Schmidt, Diane Zimmerman Umble, and Steven Reschly, 102–18. Baltimore: Johns Hopkins University Press, 2002.

Jenkins, Emyl. *Emyl Jenkins' Appraisal Book: Identifying, Understanding, and Valuing Your Treasures*. New York: Crown Publishers, 1989.

Jenkins, Mary. *Making Welsh Quilts: The Textile Tradition that Inspired the Amish?* Iola, WI: KP Books, 2005.

Jones, Suzi. "Art by Fiat, and Other Dilemmas of Cross-Cultural Collecting." In *Folk Art and Art Worlds*, edited by John Michael Vlach and Simon J. Bronner, 243–65. Ann Arbor, MI: UMI Research Press, 1986.

Joyce, Rosemary O. "'Fame Don't Make the Sun Any Cooler': Folk Artists and the Marketplace." In *Folk Art and Art Worlds*, edited by John Michael Vlach and Simon J. Bronner, 225–41. Ann Arbor, MI: UMI Research Press, 1986.

Julius, Anthony. "Minister of Culture." *New York Times*, December 31, 2006, sec. Books / Sunday Book Review.

Junhke, James C. *Vision, Doctrine, War: Mennonite Identity and Organization in America, 1890–1930*. The Mennonite Experience in America, vol. 3. Scottdale, PA: Herald Press, 1989.

Kadolph, Sara J., and Anna Langford. *Textiles*. 9th ed. Upper Saddle River, NJ: Prentice Hall, 2001.

Keller, Patricia J. "The Quilts of Lancaster County, Pennsylvania: Production, Context, and Meaning, 1750–1884." PhD. diss., University of Delaware, 2007.

Keyser, Alan G. "Beds, Bedding, Bedsteads and Sleep." *Der Reggeboge* 12, no. 4 (October 1978): 1–28.

Kile, Michael. "Free Spirit in the West." In *Quilt Digest*, no. 1 (1983): 56–61.

———. "Looking Toward the Future: The Collector." *Quilt Digest*, no. 2 (1984): 16–25.

———. "On the Road." *Quilt Digest*, no. 4 (1986): 76–85.

Kindig, Eileen Silva. "Darwin Bearley, Akron, Ohio." *Antique Collecting*, January 1978.

Kiracofe, Roderick. *The American Quilt: A History of Cloth and Comfort, 1750–1950*. 1st ed. New York: Clarkson Potter, 1993.

Kiracofe, Roderick, and Sandi Fox. *Going West!: Quilts and Community*. Washington, DC: Smithsonian American Art Museum in association with D. Giles, Ltd., London, 2007.

Kladzyk, Pamela. "The Sacred Hoop." In *Women Designers in the USA, 1900–2000: Diversity and Difference*, edited by Pat Kirkham, 101–21. New Haven, CT: Yale University Press, 2000.

Klimuska, Ed. "300 New Quilts at Auction." In *Lancaster County: Quilt Capital U.S.A.*, 33. Lancaster, PA: Lancaster New Era.

———. "Aprons Aside, Plain Sect Women Prove They're Sharp Executives." In *Lancaster County: Quilt Capital U.S.A.*, 38–40. Lancaster, PA: Lancaster New Era, 1987.

———. "Collectors Pay Thousands for Local 'Folk Art' Antique Quilts." In *Lancaster County: Quilt Capital U.S.A.*, 2–6. Lancaster, PA: Lancaster New Era, 1987.

———. "Dismayed by Loss of Prize Quilts, 2 Urge Museum & Heritage Project." In *Lancaster County: Quilt Capital U.S.A.*, 22–24. Lancaster, PA: Lancaster New Era, 1987.

———. "How One Woman Built, Manages a Thriving Quilt Business." In *Lancaster County: Quilt Capital U.S.A.*, 40–41. Lancaster, PA: Lancaster New Era, 1987.

———. "It's War! Dealers Wage Battle for Best Quilters." In *Lancaster County: Quilt Capital U.S.A.*, 32–3. Lancaster, PA: Lancaster New Era, 1987.

———. *Lancaster County: Quilt Capital U.S.A.* Lancaster, PA: Lancaster New Era, 1987.

———. "New Quilts: They Sell By Thousands, Make Work for Hundreds." In *Lancaster County: Quilt Capital U.S.A.*, 27–31. Lancaster, PA: Lancaster New Era, 1987.

———. "Old Amish Quilts: Why They Are Treasured as Art, How They Were Found and Sold." In *Lancaster County: Quilt Capital U.S.A.*, 10–14. Lancaster, PA: Lancaster New Era, 1987.

———. "Swanky New York Dealers Buy Precious Quilts from 'The Amish Connection.'" In *Lancaster County: Quilt Capital U.S.A.*, 18. Lancaster, PA: Lancaster New Era, 1987.

———. "Thanks to Grandma, Minerva Kauffman's Business is Booming." In *Lancaster County: Quilt Capital U.S.A.*, 33–4. Lancaster, PA: Lancaster New Era, 1987.

———. "The Men Raise Barns, The Creative Women Run Quilting Bees." In *Lancaster County: Quilt Capital U.S.A.*, 7–8. Lancaster, PA: Lancaster New Era, 1987.

———. "Tourist Business Changed the Way the Amish Make Money and Quilts." In *Lancaster County: Quilt Capital U.S.A.*, 35–37. Lancaster, PA: Lancaster New Era, 1987.

Kopytoff, Igor. "The Cultural Biography of Things: Commoditization as Process." In Appadurai, *The Social Life of Things: Commodities in Cultural Perspective*, edited by Arjun Appadurai, 64–91. Cambridge: Cambridge University Press, 1986.

Kraybill, Donald B., ed. *The Amish and the State*. Baltimore: Johns Hopkins University Press, 1993.

———. "Introduction: The Struggle to be Separate." In *The Amish Struggle with Modernity*, edited by Donald B. Kraybill and Marc A. Olshan, 1–17. Hanover, NH: University Press of New England, 1994.

———. "Plotting Social Change Across Four Affiliations." In Kraybill and Olshan, *The Amish Struggle with Modernity*, 53–74.

———. *The Riddle of Amish Culture*. Rev. ed. Baltimore: Johns Hopkins University Press, 2001.

Kraybill, Donald, Patricia Herr, and Jonathan Holstein. *A Quiet Spirit: Amish Quilts from the Collection of Cindy Tietze & Stuart Hodosh*. Los Angeles: UCLA Fowler Museum of Cultural History, 1996.

Kraybill, Donald, and Steven M. Nolt. *Amish Enterprise: From Plows to Profits*. 2nd ed. Baltimore: Johns Hopkins University Press, 2004.

Lasansky, Jeannette. *A Good Start: The Aussteier or Dowry*. Lewisburg, PA: Oral Traditions Project of the Union County Historical Society, 1990.

———. "Quilts in the Dowry." In *Bits and Pieces: Textile Traditions*, edited by Jeannette Lasansky, 48–55. Lewisburg, PA: Oral Traditions Project of the Union County Historical Society, 1991.

———. "Myth and Reality in Craft Tradition: Were Blacksmiths Really Muscle-bound? Were Basketmakers Gypsies? Were Thirteen Quilts in the Dowry Chest?" In *On the Cutting Edge,* edited by Jeannette Lasansky. Lewisburg: PA: Oral Traditions Project, 1994.

Laury, Jean Ray. *Appliqué Stitchery.* New York: Reinhold, 1966.

———. *Quilts & Coverlets, A Contemporary Approach.* New York: Van Nostrand Reinhold, 1970.

———. "The 1970s Redefined Quiltmaking as We Knew It." In *The Quilt: A History and Celebration of an American Art Form,* edited by Elise Roberts, 52–55. St. Paul, MN: Voyageur Press, 2007.

Lee, Douglas, and Jerry Irwin. "The Plain People of Pennsylvania." *National Geographic,* April 1984.

Lewis, Alfred. *The Mountain Artisans Quilting Book.* New York: Macmillan, 1973.

Linch, Lauri, and Alice Schmude. "Hmong Needle Treasures." *Quilter's Newsletter Magazine,* October 1984.

Lipman, Jean. *American Primitive Painting.* London, New York: Oxford University Press, 1942.

———. *Provocative Parallels: Naïve Early Americans, International Sophisticates.* New York: Dutton, 1975.

Lipman, Jean, and Alice Winchester. *The Flowering of American Folk Art, 1776–1876.* New York: Viking Press in cooperation with the Whitney Museum of American Art, 1974.

Lippard, Lucy R. "Up, Down, and Across: A New Frame for New Quilts." In *The Artist and the Quilt,* edited by Charlotte Robinson, 32–43. New York: Knopf, 1983.

Lippuner, Rosemarie. *Quilts des Amish, 1870–1930: Collection Monika Muller, Wetzikon, Collection Brigitte et Bruno Widmer, Zurich, Collection Privee, Zurich: exposition ourverte du 26 mars au 29 mai 1988.* [Lausanne]: Musee des Arts Decoratifs de la ville de Lausanne, 1988.

Lipsett, Linda Otto. *Remember Me: Women & Their Friendship Quilts.* San Francisco: Quilt Digest Press, 1985.

Livingston, Jane. "Reflections on the Art of Gee's Bend." In *The Quilts of Gee's Bend,* 50–58. Atlanta: Tinwood Books, 2002.

Loscalzo, Anita B. "The History of the Sewing Machine and Its Use in Quilting in the United States." *Uncoverings* 26 (2005): 175–83.

Luthy, David. *Amish Settlements Across America.* Aylmer, ON and LaGrange, IN: Pathway Publishers, 2009.

———. "Marketing the Amish." *Family Life,* January 1994.

———. "Only Thread and Time." *Family Life,* July 1993.

———. *The Amish in America: Settlements That Failed, 1840–1960.* Aylmer, ON, and Lagrange, IN: Pathway Publishers, 1986.

———. "The Origin and Growth of Amish Tourism." In *The Amish Struggle with Modernity,* edited by Donald B. Kraybill and Marc A. Olshan, 113–23. Hanover, NH: University Press of New England, 1994.

M'Closkey, Kathy. *Swept Under the Rug: A Hidden History of Navajo Weaving.* Albuquerque: University of New Mexico Press, 2002.

MacCannell, Dean. "Staged Authenticity: Arrangements of Social Space in Tourist Settings." *American Journal of Sociology* 79, no. 3 (Nov. 1973): 589–603.

MacDowell, Marsha. "Old Techniques of Paj ntaub, New Patterns of Expression." *Folk Life* (1993): 26–30.

Macleish, Archibald. "Rediscovering the Simple Life." *McCall's,* April 1972.

Mainardi, Patricia. "Great American Cover-Ups." *ArtNews,* Summer 1974.

———. "Quilts, The Great American Art." *Feminist Art Journal* 2, no. 1 (1973): 1, 18–23.

Maines, Rachel. "Paradigms of Scarcity and Abundance: The Quilt as an Artifact of the Industrial Revolution." In *In the Heart of Pennsylvania,* edited by Jeannette Lasansky, 84–88. Lewisburg, PA: Union County Historical Society, 1986.

Martorella, Rosanne. *Corporate Art.* New Brunswick, NJ: Rutgers University Press, 1990.

McLary, Kathleen. *Amish Style: Clothing, Home Furnishing, Toys, Dolls, and Quilts.* Bloomington: Indiana University Press, 1993.

Metcalf, Eugene W. "Artifacts and Cultural Meaning: The Ritual Collecting of American Folk Art." In *Living in a Material World: Canadian and American Approaches to Material Culture,* edited by Gerald L. Pocius, 199–207. St. John's, NL: Institute of Social and Economic Research, Memorial University of Newfoundland, 1991.

———. "The Politics of the Past in American Folk Art History." In *Folk Art and Art Worlds,* edited by John Michael Vlach and Simon J. Bronner, 27–50. Ann Arbor, MI: UMI Research Press, 1986.

Meyers, Thomas J. "Amish Tourism: 'Visiting Shipshewana is Better Than Going to the Mall.'" *Mennonite Quarterly Review* 77 (January 2003): 109–126.

———. "Lunch Pails and Factories." In The Amish Struggle with Modernity, edited by Donald B. Kraybill and Marc A. Olshan, 165–81. Hanover, NH: University Press of New England, 1994.

———. "Population Growth and its Consequences in the Elkhart-Lagrange Old Order Amish Settlement." *Mennonite Quarterly Review* 65 (July 1991): 308–21.

———. "The Old Order Amish: To Remain in the Faith or to Leave." *Mennonite Quarterly Review* 68 (July 1994): 378–95.

Miller, M. Stephen. "Designed for Sale: Shaker Commerce with the World." In *Shaker Design: Out of this World,* edited by Jean Burks, 63–90. New Haven CT: Yale University Press, 2008.

Miller, Timothy. *The 60s Communes: Hippies and Beyond.* 1st ed. Syracuse NY: Syracuse University Press, 1999.

Mohanty, Gail Fowler. "Woven Documents: Technological & Economic Factors Influencing Rhode Island Textile Production to 1840." In *Down by the Old Mill Stream: Quilts in Rhode Island,* edited by Linda Welters and Margaret Ordoñez, 51–82. Kent, OH: Kent State University Press, 2000.

Montgomery, Charles. "The Connoisseurship of Artifacts." In *Material Culture Studies in America,* ed. Thomas J. Schlereth. Nashville, TN: American Association for State and Local History, 1982.

Murray, Michael Lawrence. "Beyond American Folk Art: The Emergence of Folk Art as a Museum Object, 1924–2001." PhD diss., University of Pennsylvania, 2006.

Museum of Contemporary Crafts. *Fabric Collage.* Exhibition catalog. New York: Museum of Contemporary Crafts, 1965.

Nash, Ann Bodle. "Gail van der Hoof, 1943–2004." In *The Quilters Hall of Fame,* 141–144. Marian, IN: The Quilters Hall of Fame, 2004.

Nolt, Steven. *A History of the Amish.* Rev. and updated. Intercourse PA: Good Books, 2003.

———. "Inscribing Community: The Budget and Die Botschaft in Amish Life." In *The Amish and the Media,* edited by Diane Zimmerman Umble and David Weaver-Zercher, 181–200. Baltimore: Johns Hopkins University Press, 2008.

Nolt, Steven M., and Thomas J. Meyers. *Plain Diversity: Amish Cultures and Identities.* Baltimore: Johns Hopkins University Press, 2007.

Nomura, Nao, and Janneken Smucker. "From Fibers to Fieldwork: A Multifaceted Approach to Re-Examining Amish Quilts." *Uncoverings* 27 (2006): 123–55.

Olshan, Marc A. "Amish Cottage Industries as Trojan Horse." In *The Amish Struggle with Modernity,* edited by Donald B. Kraybill and Marc A. Olshan, 133–46. Hanover, NH: University Press of New England, 1994.

———. "Conclusion: What Good are the Amish?" In Kraybill and Olshan, *The Amish Struggle with Modernity,* 231–42.

Olshan, Marc A., and Kimberly D. Schmidt. "Amish Women and the Feminist Conundrum." In Kraybill and Olshan, *The Amish Struggle with Modernity,* 215–29.

Ordoñez, Margaret. "Technology Reflected: Printed Textiles in Rhode Island Quilts." In *Down by the Old Mill Stream: Quilts in Rhode Island,* edited by Linda Welters and Margaret Ordoñez, 122–60. Kent, OH: Kent State University Press, 2000.

Osler, Dorothy. *Amish Quilts and the Welsh Connection.* Atglen, PA: Schiffer, 2011.

———. "The Spatial Distribution of Amish and Welsh Settlements in Nineteenth Century Pennsylvania: Implications for Cultural Cross-over in Quiltmaking," presented at The Global Quilt: Cultural Contexts — International Quilt Study Center & Museum 4th Biennial Symposium, Lincoln, NE, April 3, 2009.

———. *Traditional British Quilts.* London: B.T. Batsford, 1987.

Parrish, Kathleen. "A Way of Life Woven from Misery for Hmong Quilters." *Morning Call (Allentown, PA),* April 24, 2006.

———. "Hmong, Now Thais, Transform Pennsylvania Dutch Quilt Industry." *Morning Call (Allentown, PA),* May 2, 2006.

———. "How a Hill Tribe from Laos Changed a Pennsylvania Tradition." *Morning Call (Allentown, PA),* May 4, 2006.

———. "Imports Buoy Thai Villages, Hurt Lancaster County Sales." *Morning Call (Allentown),* April 26, 2006.

———. "Moment of Truth for Quilts." *The Morning Call (Allentown, PA),* April 24, 2006.

———. "Prosperity Amid New Set of Troubles." *Morning Call (Allentown, PA),* April 25, 2006.

Peck, Amelia. *American Quilts & Coverlets in the Metropolitan Museum of Art.* New York: Metropolitan Museum of Art, 1990.

Pellman, Rachel T., and Kenneth Pellman. *A Treasury of Amish Quilts.* Good Books, 1990.

———. *The World of Amish Quilts.* Intercourse, PA: Good Books, 1984.

Pellman, Rachel, and Joanne Ranck. *Quilts Among the Plain People.* Intercourse, PA: Good Books, 1981.

Peterson, Karin Elizabeth. "Discourse and Display: The Modern Eye, Entrepreneurship, and the Cultural Transformation of the Patchwork Quilt." *Sociological Perspectives* 46 (November 2003): 461–90.

Peterson, Sally. "A Cool Heart and a Watchful Mind: Creating Hmong Paj Ntaub in the Context of Community." In *Pieced By Mother: Symposium Papers,* edited by Jeannette Lasansky, 35–45. Lewisburg, PA: Oral Traditions Project of the Union County Historical Society, 1988.

———. "From the Heart and the Mind: Creating Paj Ntaub in the Context of Community." PhD diss., University of Pennsylvania, 1990.

———. "We Try to Be Strong: Pang Xiong Sirirathasuk Sikoun." *Works in Progress,* Winter 2006.

Philadelphia Folklore Project. "We Try To Be Strong: 28 Years of Hmong Textiles in Philadelphia." *Philadelphia Folklore Project.* http://www.folkloreproject.org/programs/exhibits/hmong/index.php.

Pottinger, David. *Quilts from the Indiana Amish: A Regional Collection.* New York: E.P. Dutton in association with the Museum of American Folk Art, 1983.

Prendergast, Susan Margaret. "Fabric Furnishings Used in Philadelphia Homes, 1700–1775." MA thesis, University of Delaware, 1977.

Pumphery, Linda M. "The Stearns & Foster Company, 1846–1900: The Inside Story." *Uncoverings* 30 (2009): 103–33.

Quick, Ernest S. "The Merchant and the Museum: Reproducing American Folk Art." *The Clarion,* Summer 1978.

Quimby, Ian M. G., and Scott T. Swank, eds. *Perspectives on American Folk Art.* Winterthur, DE: Published for the Henry Francis du Pont Winterthur Museum, distributed by W.W. Norton, 1980.

Quincy, Keith. *Hmong, History of a People.* Cheney: Eastern Washington University, 1995.

Reich, Charles A. *The Greening of America: How the Youth Revolution Is Trying to Make America Livable.* 1st ed. New York: Random House, 1970.

Reschly, Steven D., and Katherine Jellison. "Production Patterns, Consumption Strategies, and Gender Relations in Amish and Non-Amish Farm Households in Lancaster County, Pennsylvania, 1935–1936." *Agricultural History* 67, no. 2 (Spring 1993): 134–62.

Rhode Island School of Design Museum of Art. *Mountain Artisans: An Exhibition of Patchwork and Quilting, Appalachia.* Providence, RI: Museum of Art, Rhode Island School of Design, 1970.

Robacker, Ada. "Quilts of Quality: How to Judge an Outstanding Quilt." *Antique Collecting,* January 1978.

Roberts, J. Baylor. "Pennsylvania Dutch—In a Land of Milk and Honey." *National Geographic,* July 1938.

Robertson, Helie. *Esprit, the Making of an Image.* San Francisco, CA: Esprit, 1985.

Robinson, Charlotte, ed. *The Artist and the Quilt.* New York: Knopf, 1983.

Rogers, Kory. "In the Spirit: Twentieth-Century and Contemporary Shaker-Inspired Design." In *Shaker Design: Out of this World,* edited by Jean Burks, 187–205. New Haven CT: Yale University Press, 2008.

Rohrer, Warren. "My Experience with Quilts (A Bias)." In *Pennsylvania Quilts: One Hundred Years, 1830–1930.* Philadelphia: Moore College of Art, 1978.

Rosenberg, Susan. *Warren Rohrer: Paintings 1972–93.* Philadelphia, PA: Philadelphia Museum of Art, 2002.

Rumford, Beatrix T. "Uncommon Art of the Common People: A Review of Trends in the Collecting and Exhibiting of American Folk Art." In *Perspectives on American Folk Art,* edited by Ian M. G. Quimby and Scott T. Swank, 13–53. Winterthur, DE: Published for the Henry Francis du Pont Winterthur Museum, distributed by W. W. Norton, 1980.

Ruth, Phil Johnson. "Merle Good and Phyllis Pellman Good: 'Sort of a Business, Sort of the Church, Sort of the Arts.'" In *Entrepreneurs in the Faith Community: Profiles of Mennonites in Business,* edited by Calvin W. Redekop and Benjamin W. Redekop. Scottdale, PA: Herald Press, 1996.

Scheper-Hughes, Nancy. "Anatomy of a Quilt: The Gee's Bend Freedom Quilting Bee." *Southern Cultures* 10, no. 3 (2004): 88–98.

Schlabach, Theron F. *Peace, Faith, Nation: Mennonites and Amish in Nineteenth-Century America.* The Mennonite Experience in America, vol. 2. Scottdale, PA.: Herald Press, 1988.

Schulman, Bruce J. *The Seventies: The Great Shift in American Culture, Society, and Politics.* New York: The Free Press, 2001.

Schumacher, E. F. *Small Is Beautiful: Economics as If People Mattered.* New York: Harper & Row, 1973.

Seaman, Gloria Allen. "Bed Coverings, Kent County, Maryland, 1710–1820." Uncoverings 6 (1985): 9–32.

Shapiro, Miriam. "Geometry and Flowers." In *The Artist and the Quilt,* edited by Charlotte Robinson, 26–31. New York: Knopf, 1983.

Shaw, Robert. Introduction to *Amish Quilts 1880 to 1940 From the Collection of Faith and Stephen Brown.* Ann Arbor, MI: University of Michigan Museum of Art, 2000.

———. *Quilts: A Living Tradition.* New York: Hugh Lauter Levin Associates, 1995.

———. *American Quilts: The Democratic Art, 1780–2007.* New York: Sterling, 2009.

Shirer, Marie. "Lancaster County Celebrates Quilts." *Quilter's Newsletter Magazine,* August 1988.

Silber, Julie. *Amish Quilts of Lancaster County.* San Francisco: Esprit De Corp., 1990.

———. Foreword to *Amish: The Art of the Quilt.* New York: Knopf, 1990.

———. *The Esprit Quilt Collection.* San Francisco, CA: Esprit de Corp, 1985.

Singal, Daniel Joseph. "Towards a Definition of American Modernism." *American Quarterly* 39, no. 1 (Spring 1987): 7–26.

Smith, Karen. "Women's Mission to Stitch: Aesthetic Boundaries, Community Faith, and the Michiana Mennonite Relief Sale Quilt Auction," presented at The Global Quilt: Cultural Contexts—International Quilt Study Center & Museum 4th Biennial Symposium, Lincoln, NE, April 3, 2009.

Smith, R. Scudder. "Joel Kopp: His Imagination Runs Free to Create a Whimsical World." *Antiques and the Arts Online.* http://antiquesandthearts.com/2008-07-30_11-22-49.html&page=1.

Smucker, Janneken. "Destination Amish Quilt Country: The Consumption of Quilts in Lancaster County, Pennsylvania." *Mennonite Quarterly Review* 80, no. 2 (April 2006): 184–206.

———. "From Rags to Riches: Amish Quilts and the Crafting of Value." PhD diss., University of Delaware, 2010.

Smucker, Janneken, Patricia Cox Crews, and Linda Welters. *Amish Crib Quilts from the Midwest: The Sara Miller Collection.* Intercourse, PA: Good Books, 2003.

Smucker, Janneken, Robert Shaw, and Joe Cunningham. *Amish Abstractions: Quilts from the Collection of Faith and Stephen Brown.* San Francisco, CA: Pomegranate, in collaboration with the Fine Arts Museums of San Francisco, 2009.

Solis-Cohen, Lita. "Heritage Center Museum Buys 82 Amish Quilts." *Maine Antique Digest,* August 2002.

Spooner, Brian. "Weavers and Dealers: The Authenticity of an Oriental Carpet." In *The Social Life of Things: Commodities in Cultural Perspective,* edited by Arjun Appadurai, 195–235. Cambridge: Cambridge University Press, 1986.

Stauffer, Elmer C. "In the Pennsylvania Dutch Country." *National Geographic,* July 1941.

Stearns & Foster Company. *Stearns & Foster Catalogue of Quilt Pattern Designs and Needle Craft Supplies.* Cincinnati, OH: Stearns & Foster Co.

Stein, Judith. *Warren Rohrer: Morning Fogs Trees and Leaves: November 1–December 14, 2002.* Philadelphia, PA: Locks Gallery, 2002.

Stewart, Susan. *On Longing: Narratives of the Miniature, the Gigantic, the Souvenir, the Collection.* Durham, NC: Duke University Press, 1993.

Stillinger, Virginia. "From Attics, Sheds, and Secondhand Shops: Collecting Folk Art in America, 1880–1940." In *Drawing on America's Past: Folk Art, Modernism, and the Index of American Design,* 45–60. Washington DC: National Gallery of Art, 2002.

Stoltzfus, Katie. *Country Lane Quilts and Family Cooking.* Lancaster, PA: Whitmore Printing, 2007.

Stoltzfus, Louise. *Traces of Wisdom: Amish Women and the Pursuit of Life's Simple Pleasures.* New York: Hyperion, 1998.

Strasser, Susan. *Waste and Want: A Social History of Trash.* New York: Holt Paperbacks, 1999.

Swank, Scott T. *Arts of the Pennsylvania Germans.* Publications of the Pennsylvania German Society. New York: Published for the Henry Francis du Pont Winterthur Museum by Norton, 1983.

———. "From Dumb Dutch to Folk Heroes." In Swank, *Arts of the Pennsylvania Germans,* 61–76.

———. "Proxemic Patterns." In Swank, *Arts of the Pennsylvania Germans,* 35–60.

———. Introduction to *Perspectives on American Folk Art,* edited by Ian M. G. Quimby and Scott T. Swank, 1–12. Winterthur, DE: Published for the Henry Francis du Pont Winterthur Museum, distributed by W.W. Norton, 1980.

Tanenhaus, Ruth Amdur. "Pennsylvania German Quilts: Amish and Mennonite Fancywork in a Plain Tradition." *American Art and Antiques* (July–Aug. 1979): 54–63.

Taylor, Ann Stoltzfus. "A Demographic and Developmental Profile of Newly-emerging Entrepreneurs among Married Women in the Old-Order Amish Society of Lancaster County, Pennsylvania." EdD diss., Temple University, 1995.

Tepper, Terri P., and Nona Dawe Tepper. "Naomi Fisher: Designer, Manufacturer, and Retailer of Quilts." In *The New Entrepreneurs: Women Working from Home,* 68–70. New York: Universe Books, 1980.

Tharp, Bruce M. "Ascetical Value: Consumption and the Materiality of Spirituality among the Old Order Amish." PhD diss., University of Chicago, 2006.

"Thos. K. Woodard & Blanche Greenstein, New York, N.Y." *Antique Collecting,* January 1978.

Tompkins, Doug. "A Very Warm Welcome!" In *The Esprit Quilt Collection,* by Julie Silber, 2. San Francisco: Esprit de Corp, 1985.

———. Afterword to *Amish: The Art of the Quilt.* New York: Knopf, 1990.

———. *Esprit, The Comprehensive Design Principle.* Tokyo: Robundo, 1989.

Trollinger, Susan. *Selling the Amish: The Tourism of Nostalgia.* Baltimore: Johns Hopkins University Press, 2012.

Tuttle, Virginia Clayton. "Picturing a 'Usable Past.'" In *Drawing on America's Past: Folk Art, Modernism, and the Index of American Design.* Washington, DC: National Gallery of Art, 2002.

Umble, Diane, and David Weaver-Zercher, eds. *The Amish and the Media.* Baltimore: Johns Hopkins University Press, 2008.

Umble, Diane Zimmerman. *Holding the Line: The Telephone in Old Order Mennonite and Amish Life.* Baltimore: Johns Hopkins University Press, 1996.

Vlach, John Michael, and Simon J. Bronner, eds. *Folk Art and Art Worlds.* Ann Arbor, MI: UMI Research Press, 1986.

Vlach, John Michael. "Holger Cahill as Folklorist." *Journal of American Folklore* 98, no. 388 (June 1985): 148–162.

Wagler, David. *The Mighty Whirlwind.* Aylmer, Ont.: Pathway Publishers, 1966.

Walbert, David J. *Garden Spot: Lancaster County, the Old Order Amish, and the Selling of Rural America*. Oxford and New York: Oxford University Press, 2002.

Waldvogel, Merikay. "The Origin of Mountain Mist Patterns." *Uncoverings* 16 (1995): 95–138.

Wass, Janice Tauer. *Illinois Amish Quilts: Sharing Threads of Tradition*. Springfield: Illinois State Museum Society, 2004.

Weaver-Zercher, David. *The Amish in the American Imagination*. Baltimore: Johns Hopkins University Press, 2001.

———. "Pursuing Paradise: Nonfiction Narratives of Life with the Amish." In *The Amish and the Media*, edited by Diane Zimmerman Umble and David Weaver-Zercher, 90–109. Baltimore: Johns Hopkins University Press, 2008.

Webster, Marie D. *Quilts: Their Story and How to Make Them*. Garden City, NY: Doubleday, 1915.

Weiner-Johnson, Karen M. "Selling the Past: Authenticity, Amishness and New Traditions in the Marketplace," unpublished paper, 2002.

Wenger, John C. "Old Order Mennonites," *Global Anabaptist Mennonite Encyclopedia Online*, 1956, http://www.gameo.org/encyclopedia/ contents/0544.html.

Winchester, Alice. "Antiques for the Avant Garde." *Art in America* 49 (April 1961): 64–73.

Winterthur Museum. *Beyond Necessity: Art in the Folk Tradition, Gallery Guide and Guide Training Manual*. Winterthur, DE: Winterthur Museum, 1977.

Yoder, Paton. *Tradition and Transition: Amish Mennonites and Old Order Amish, 1800–1900*. Scottdale, PA: Herald Press, 1991.

Zebrowski, Jeanne-Marie. "Any Amish Quilts for Sale?" *American Art & Antiques*, August 1979.

Zelizer, Viviana A. *The Social Meaning of Money: Pin Money, Paychecks, Poor Relief, and Other Currencies*. New York: Basic Books, 1994.

Index

appliqué: as used in Amish quilts, 11, 55, 74, 165, 167–69, 236–37n47; as used in Hmong *paj ntaub*, 206–8, 222
Arch Associates, 211, 214
art: as distinguished from craft, 74–81, 89, 94; market for quilts as, 116, 123, 125–28, 134–35, 166. *See also* abstract art
auction houses: as sellers of Amish quilts, 127–29
auctions, public: quilts sold at, 185–87
Aussteier, 37
authenticity: appeal of to quilt pickers, 121–22; inherent in Amish quilts, 99, 107–8, 109–10, 230; as issue with new quilts, 176–78; as issue with mass-produced quilts, 216–21
Autumn Splendor quilt, 169

--- B ---

Bargello quilt, 169, 170
barn raisings, 42
Bars quilt, 74, 76, 92, 144, 151, 242n4
Basch, Peter, 90
Basket of Flowers quilt, 38, 51, 55
Baskets quilt, 15, 47, 48, 51, 71, 156, 159
batistes, 150
batting, 18, 153, 171–72, 176, 233n30
Bearley, Darwin, 119, 126, 155
bedspreads, 37, 188
Beiler, Barbara, 182
Beiler, Mary, 169–70, 171
Bender, Sue, 1, 10, 18
Beyond Necessity: Art in the Folk Tradition, 92, 93
Bishop, Robert, 153
Block, Jared, 213
Boisson, Judi, 211–13
Bontrager, Amos, 131–32
Bontrager, Bertha, 131–32, 137
Bordes, Marilynn Johnson, 99–100
Brackman, Barbara, 18, 238n27
Brandywine River Museum, 92
Breuer, Marcel, 77, 78
Broken Star quilt, 211, 212
Budget, The: quilt pickers as advertisers in, 118, 119
Buferd, Norma Bradley, 95

--- C ---

Cabin Creek Quilters, 193
Camacraft, 205
Center Diamond quilt, 16, 31, 33, 83, 102, 104, 105, 128, 135, 142, 143, 144, 150, 151, 172, 174, 210, 242n4
Center Square quilt, 80, 82, 144
Checkerboard quilt, 110
Chicago, Judy, 94
China: quilts mass-produced in, 213
Chinese Coins quilt, 153, 175
Christian Aid Ministries, 42
Christian and Missionary Alliance (CAMA), 205
Christie's, 127–28, 133
Church Germans, 25
Colonial Revival, 88; quiltmaking as aspect of, 22–23, 28

color: as used in art, 67, 80; as used in quilt design, 67, 80, 81, 154–55, 175–76
connoisseurship of Amish quilts: criteria for, 141–53, 225; dating as aspect of, 153–54, 243n40, 243n41; fabric as aspect of, 145–53
Cooper, Patricia, 95
cotton, 145, 150
counterculture, 89–90
Country Bride quilt, 167–71, 210
Country Lane Quilts, 165, 182–83
Country Quilt Shoppe, 196
craft revival (1960s), 89–91
crazy quilt, 121
crepe, 145–50
crib quilts, 156
Crosses and Losses quilt, 61

--- D ---

Dacron, 153
Dahlia quilt, 169
Delagrange, George, 144, 166, 175–78, 213, 221
Delagrange, Susan, 166, 175–78
de La Renta, Oscar, 91
de Young Museum (San Francisco): quilt exhibition at, ix, x, 112, 227
Doty, Robert, 77
Double Nine Patch quilt, 145–50, 177
Double Wedding Ring quilt, 53
Douglas County, Illinois, 26
Druckman, Nancy, 127
du Pont, H. F., 88, 92
Dutch Roses quilt, 14
Dwork, Melvin, 102–3
Dylan, Bob, 126

--- E ---

Eames, Ray, 90
Elkhart County, Indiana, 26, 123
embroidery, 11
Emmerling, Mary Ellisor, 105
Epstein, Stacey, 155
Esh, Rebecca, 37, 196
Esh, Sallie, 59
Esprit: corporate quilt collection of, 105–12, 136

--- F ---

Fabric Collage, 87
fabrics used in quiltmaking, 56–58; cheater cloth, 195, 216; as criterion for value, 145–53, 154; natural fibers, 61, 145, 171–72, 175; printed, 154, 171; synthetic, 33, 56, 61, 145, 153, 176
factory-made quilts. *See* outsourced quilts
fakes, 155–59
family sales, 58
Fans quilt, 39, 45, 47
Farm, The, 89–90
Federal Art Project, 88
feed sacks, 53, 54, 56, 234n13, 237n49
feminist art movement, 87; as expressed in quiltmaking, 94–96